The Metropolitan Museum of Art Symposia

# Age of Transition

The Metropolitan Museum of Art Symposia

# Age of Transition
## Byzantine Culture in the Islamic World

Edited by
Helen C. Evans

THE METROPOLITAN MUSEUM OF ART, NEW YORK

DISTRIBUTED BY YALE UNIVERSITY PRESS, NEW HAVEN AND LONDON

This publication is made possible by Mary and Michael Jaharis.

All essays in this volume were presented at The Metropolitan Museum of Art in the following programs: "Sunday at the Met," March 18, 2012, The Grace Rainey Rogers Auditorium, presented through the generosity of the Coexist Foundation; "Perspectives on Byzantium and Islam: A Symposium," March 20, 2012, The Grace Rainey Rogers Auditorium, organized by The Metropolitan Museum of Art and Yeshiva University Center for Israel Studies, with additional support from gifts in honor of Froso Beys and from Mr. and Mrs. John Bilimatsis; "Floor Mosaics in the Late Antique Mediterranean: A Kallinikeion Colloquium in Byzantine Studies Symposium," May 11, 2012, Bonnie J. Sacerdote Lecture Hall, sponsored by the Center for Byzantine and Modern Greek Studies, Queens College, CUNY, through Warren Woodfin, Kallinikeion Assistant Professor, and made possible through the generosity of the Kallinikeion Foundation; "A Scholars' Day Workshop: Collecting Byzantine and Islamic Art," June 4, 2012, in the "Byzantium and Islam: Age of Transition" exhibition galleries and the Galleries for the Art of the Arab Lands, Turkey, Iran, Central Asia, and Later South Asia, presented by The Metropolitan Museum of Art and the Center for the History of Collecting, The Frick Collection, through Inge Reist, Director of the Frick Collections' Center for the History of Collecting, with support from the Samuel H. Kress Foundation.

Major support for "Byzantium and Islam: Age of Transition" was provided by Mary and Michael Jaharis, The Stavros Niarchos Foundation, and The Hagop Kevorkian Fund. Additional support was provided by the National Endowment for the Arts. It was supported by an indemnity from the Federal Council on the Arts and the Humanities.

**Published by The Metropolitan Museum of Art, New York**

Mark Polizzotti, Publisher and Editor in Chief
Gwen Roginsky, Associate Publisher and General Manager of Publications
Peter Antony, Chief Production Manager
Michael Sittenfeld, Managing Editor
Robert Weisberg, Senior Project Manager

Edited by Emily Radin Walter
Production by Sally VanDevanter
Bibliography and notes edited by Jean Wagner
Map by Anandaroop Roy

Design implemented by Nancy Sylbert, based on a format established by Tsang Seymour Design Inc.
Typeset in Bembo Std
Printed on 150 gsm LumiSilk Matte Artpaper
Separations by Professional Graphics, Inc., Rockford, Illinois
Printed and bound by Oceanic Graphic Printing, Hong Kong, China

Jacket illustrations (front): Saint Mark baptizing Anianos. Eastern Mediterranean or Egypt, 7th–8th century. Castello Sforzesco, Milan; (back): Date palm tree, from the floor mosaic of the synagogue at Hammam Lif, Tunisia, 6th century. Brooklyn Museum, New York

Frontispiece, page ii: Carved limestone fragment. In situ, archaeological site of Qasr al-Mshatta, Jordan (Courtesy of the Department of Antiquities, Amman)

Frontispiece, page xii: Christ Pantokrator, 6th–7th century. The Holy Monastery of Saint Catherine, Sinai, Egypt

Photographs of works in the Metropolitan Museum's collection by The Photograph Studio, The Metropolitan Museum of Art, unless otherwise noted.

Pages 82–93, figures 5–11: Reproduced with the permission of The Holy Monastery of Saint Catherine, Sinai, Egypt

Pages 132–43, figures 1, 2, 4, 6–10: Courtesy of the Franciscan Custody of the Holy Land, Mount Nebo, and the American Center of Oriental Research, Amman

Pages 145–59, figure 2: Courtesy Egypt Exploration Society, and Imaging Papyri Project, Oxford

The Metropolitan Museum of Art
1000 Fifth Avenue
New York, New York 10028
metmuseum.org

Distributed by
Yale University Press, New Haven and London
yalebooks.com/art
yalebooks.co.uk

Cataloguing-in-Publication Data is available from the Library of Congress.

ISBN 978-1-58839-559-7 (The Metropolitan Museum of Art)
ISBN 978-0-300-21111-5 (Yale University Press)

# Contents

# Acknowledgments

There are many who must be thanked for making this volume possible. Most especially, Mary and Michael Jaharis, who supported its publication. The exhibition "Byzantium and Islam: Age of Transition," which inspired these papers, was funded by Mary and Michael Jaharis, The Stavros Niarchos Foundation, The Hagop Kevorkian Fund, the National Endowment for the Arts, and the Federal Council on the Arts and the Humanities.

Multiple generous donors enabled the Museum to hold a variety of public events associated with the exhibition through the Education Department, which yielded the papers included in this volume. The essays offer eloquent testimony to the critical role that public programs can play in generating new scholarship around exhibitions organized and presented by The Metropolitan Museum of Art. The donors involved in supporting these programs have been instrumental in expanding the reach and impact of the exhibition itself. The generosity of the Coexist Foundation made possible the Museum's "Sunday at the Met" for the exhibition, where the papers by Hieromonk Justin of Sinai, Steven Fine, Alan Gampel, and Lawrence Nees were presented. The Yeshiva University Center for Israel Studies, under Professor Steven Fine, together with the Metropolitan Museum held a joint symposium on the topic "Perspectives on Byzantium and Islam." Gifts in honor of Froso Beys and from Mr. and Mrs. John Bilimatsis provided additional support for the event. The papers by Robert Schick, Arnold Franklin, Annie Labatt, and Claus-Peter Haase were offered there. In collaboration with the Samuel H. Kress Foundation and Inge Reist, Director of the Frick Collection's Center for the History of Collecting, the Museum presented a Scholars' Day on "Collecting Byzantine and Islamic Art." Lisa Brody, Lyle Humphrey, and Edward Bleiberg presented their papers at that venue. The Center for Byzantine and Modern Greek Studies of Queens College, CUNY, through Warren Woodfin, Kallinikeion Assistant Professor, supported a Kallinikeion Colloquium in Byzantine Studies on "Floor Mosaics in the Late Antique Mediterranean at the Museum," made possible through the generosity of the Kallinikeion Foundation. The paper by Lisa Brody and Carol Snow also originated in part at that event.

This volume could not have been realized without the efforts of many individuals in the Museum. Thomas P. Campbell, Director, Carrie Rebora Barratt, Deputy Director for Collections and Administration, and Peter Barnet, Senior Curator, Department of Medieval Art and The Cloisters, encouraged its publication. In the Medieval Department, Constance Alchermes worked extensively on the project, especially in the acquisition of photographs. Stephanie Caruso also provided invaluable assistance. Alzahraa Ahmed and Agnieszka E. Szymanska advised on translations. Brandie Ratliff, Research Associate for the exhibition and now Executive Director, the Mary Jaharis Center for Byzantine Art and Culture, was also most generous in providing useful advice on sources and procedures.

In the Editorial Department Mark Polizzotti, Publisher and Editor in Chief, Michael Sittenfeld, Managing Editor, and Peter Antony, Chief Production Manager, provided support throughout the project. Emily Radin Walter was the insightful and thoughtful editor of the essays. The notes and references were edited with care by Jean Wagner. Sally VanDevanter lent her calm expertise to all production issues. We thank Nancy Sylbert for her work on the layouts, as well as Steven Chanin.

For their assistance and that of many others, we are most appreciative.

C. Griffith Mann
Michel David-Weill Curator in Charge
Department of Medieval Art and The Cloisters

Helen C. Evans
Mary and Michael Jaharis Curator
of Byzantine Art
Department of Medieval Art and The Cloisters

# Contributors

Edward Bleiberg
Curator, Egyptian, Classical, Ancient Near Eastern Art, Brooklyn Museum

Lisa R. Brody
Associate Curator of Ancient Art, Yale University Art Gallery

Helen C. Evans
Mary and Michael Jaharis Curator of Byzantine Art, Department of Medieval Art and
The Cloisters, The Metropolitan Museum of Art

Steven Fine
Dr. Pinkhos Churgin Professor of Jewish History, Yeshiva University, New York

Arnold E. Franklin
Associate Professor, History Department, Queens College, City University of New York

Alan Gampel
Doctoral Candidate, Université Paris–Sorbonne

Claus-Peter Haase
Director Emeritus, Museum für Islamische Kunst, Staatliche Museen zu Berlin–
Stiftung Preussischer Kulturbesitz, and Honorary Professor of Islamic Art and Archaeology,
Freie Universität Berlin

Hieromonk Justin of Sinai
Librarian, The Holy Monastery of Saint Catherine, Sinai, Egypt

Lyle Humphrey
GlaxoSmithKline Curatorial Fellow, North Carolina Museum of Art

Annie Montgomery Labatt
Assistant Professor, University of Texas, San Antonio

Lawrence Nees
Professor, Department of Art History, University of Delaware

Robert Schick
Research Fellow, Historisches Seminar–Byzantinistik, Universität Mainz

Carol Snow
Deputy Chief Conservator and Alan J. Dworsky Senior Conservator of Objects,
Yale University Art Gallery

# Introduction

The exhibition "Byzantium and Islam: Age of Transition," held at The Metropolitan Museum of Art in 2012, received high praise for its exploration of Byzantium's lasting artistic and cultural impact on the empire's wealthy eastern Mediterranean and North African provinces as they became part of the emerging Islamic world from the period spanning the seventh through the ninth century. Curated by Helen C. Evans with Brandie Ratliff and supported by an outstanding array of experts on Byzantium, Early Christianity, Judaism, and Islam, the exhibition clearly recognized the diversity of the peoples in the region, including their alliances with various forms of Christianity, Judaism, and Islam, and the significance of the trade routes that reached from China and India through the Red Sea to Alexandria and Constantinople. Trade was demonstrated to be a driving force in the transmission of images between the Byzantine world, with its origins in Greek and Roman traditions, and the new power of Islam as it sought to create a visual identity for itself within the Byzantine provinces newly under its rule. Among the exhibition's many accolades, the National Endowment for the Arts found visitors to be inspired, amazed, and informed. In 2014 the Islamic Republic of Iran presented its World Book Award to the catalogue as the best new book in the field of Islamic Studies.

The present publication extends the catalogue's innovative research by investigating other aspects of the contact between Byzantium and Islam in the seventh through the ninth century, including music. The papers in this volume were presented during the run of the exhibition in a variety of symposia and study events organized by the Museum, often in collaboration with other institutions. Here they are arranged in a logical progression of ideas rather than by the sessions in which they were presented, with the essays often offering complementary insights about the same works, monuments, and traditions.

The first papers consider the impulses that inspired the initial generations of scholars and collectors of early Jewish, Christian, and Islamic works in the mid-nineteenth to early twentieth century. In "Collecting Christianity on the Nile: J. Pierpont Morgan and The Metropolitan Museum of Art," Lyle Humphrey, University of North Carolina, reveals the interest of the Metropolitan Museum's great patron J. Pierpont Morgan in objects relevant to the origins of Christianity, especially objects from Egypt. "The Gerasa City Mosaic: History and Treatment at the Yale University Art Gallery" provides a comprehensive description, by the Art Gallery's Lisa Brody and Carol Snow, of the great floor mosaic from Gerasa (Jerash), Jordan, its acquisition by Yale in the 1920s, and its recent innovative restoration and installation in the new Yale University Art Gallery. "Art and Assimilation: The Floor Mosaics from the Synagogue at Hammam Lif," by Edward Bleiberg, Brooklyn Museum, is the first of several papers that address Jewish issues. Bleiberg's text provides a historiography of the understanding of the synagogue floor mosaic from Tunisia beginning with its discovery in 1883 through to the acquisition of many of its elements by the Brooklyn Museum in 1905 and raises new questions concerning our interpretation of the site.

Jewish themes are also considered from new perspectives by Steven Fine, Yeshiva University, and Arnold Franklin, Queens College, CUNY. Fine's "When is a Menorah 'Jewish'?: On the Complexities of a Symbol during the Age of Transition" recognizes images of the menorah as a symbol of Judaism during the exhibition's time frame while offering evidence that the seven-branched candelabra was also meaningful for other groups, especially Samaritans and Christians,

and, briefly, Muslims. Using medieval documents preserved in the Cairo Genisa, Franklin, in his "Untidy History: Reassessing Communal Boundaries in the Light of the Cairo Geniza Documents," demonstrates the unexpectedly extensive interaction that existed between the differing Rabbanite and Karaite Jewish communities, as well as Jewish interaction with local Sufis of the Muslim world.

Annie Labatt, University of Texas, San Antonio, in "The Transmission of Images in the Mediterranean," identifies widespread pan-Mediterranean correspondences in Christian imagery from Rome to the Holy Land. Hieromonk Justin of Sinai similarly links East and West in "The Icons of Sinai: Continuity at a Time of Controversy," considering the meaning of icons through some of the earliest examples that survive in the Monastery of Saint Catherine at Sinai.

Two of the earliest great monuments of Islamic culture are placed firmly within the broader cultural context of their time by Lawrence Nees, University of Delaware, and Claus-Peter Haase, Museum für Islamische Kunst, Berlin. In "Muslim, Jewish, and Christian Traditions in the Art of 7th-Century Jerusalem," Nees reconsiders earlier scholarly analyses of the Dome of the Rock in Jerusalem, arguing that its location was important for Muslims in part because of biblical associations, and identifies the small Dome of the Chain as the original mihrab at the site. Haase,

in his "Qasr al-Mshatta and the Structure of Late Roman and Early Islamic Façades," identifies the elaborate, often figurative decoration of the secular palace's entrance wall as the evolution of classical and Byzantine motifs into designs providing a new cosmology for Muslim rulers. In contrast, Robert Schick, Universität, Mainz, in "The Destruction of Images in 8th-Century Palestine," considers whether the careful mutilation of figurative floor mosaics in selected churches and synagogues was in part a response to religious strictures associated with Islam.

In the final essay, Alan Gampel, Université Paris–Sorbonne, in "The Origins of Musical Notation in the Abrahamic Religious Traditions," extends the discussion of cultural interconnections into the realm of music through a study of ostraka and papyri from Egypt.

Each of these essays contributes compelling evidence that the era of transition from Byzantine to Islamic rule in the eastern Mediterranean and North Africa was a complex process drawing on the cultural traditions of the region to create a new voice for Islam, a process increasingly recognized as far more intertwined than scholars and collectors recognized when the study of this period began in the nineteenth century.

Helen C. Evans
Mary and Michael Jaharis Curator
of Byzantine Art

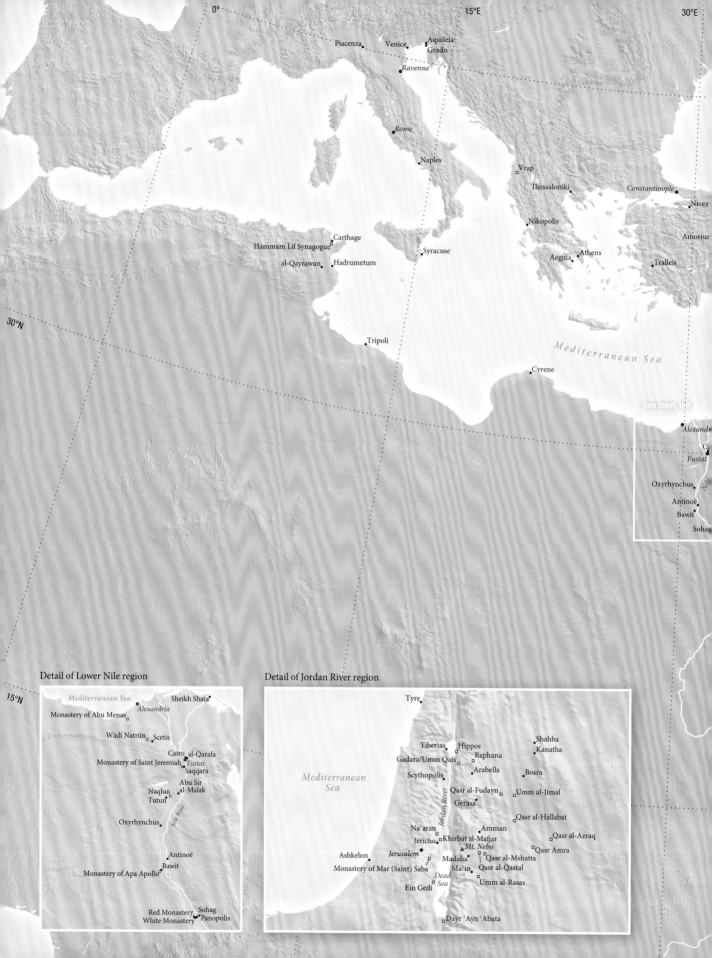

0°  15°E  30°E

Piacenza
Venice  Aquileia
Grado
*Ravenna*
Rome
Naples
Vrap
Thessaloniki
*Constantinople*
Nicea
Nikopolis
Amoriur
Carthage
Hammam Lif Synagogue
Syracuse
Aegina  Athens
Tralleis
al-Qayrawan  Hadrumetum

*Mediterranean Sea*

30°N

Tripoli

Cyrene

See Inset, left

*Alexand*
*C*
*Fustat*

Oxyrhynchus
Antinoë
Bawit
Soha

15°N

**Detail of Lower Nile region**

*Mediterranean Sea*  Sheikh Shata
Monastery of Abu Menas  *Alexandria*
Wādī Natrūn  Scetis
Cairo  al-Qarafa
Monastery of Saint Jeremiah  *Fustat*
Saqqara
Abu Sir
al-Malak
Naqlun
Tutun
Oxyrhynchus

Antinoë
Bawit
Monastery of Apa Apollo

Red Monastery  Sohag
White Monastery  Panopolis

**Detail of Jordan River region**

Tyre

*Mediterranean
Sea*

Shahba
Kanatha
Tiberias  Hippos
Raphana
Gadara/Umm Qais
Arabella
Scythopolis  Bosra
Qasr al-Fudayn  Umm al-Jimal
Gerasa
Qasr al-Hallabat
Na'aran  Amman
Khirbat al-Mafjar  Qasr al-Azraq
Jericho
*Mt. Nebo*  Qasr Amra
Ashkelon  *Jerusalem*
Madaba  Qasr al-Mshatta
Monastery of Mar (Saint) Saba  Ma'in  Qasr al-Qastal
Ein Gedi  *Dead
Sea*  Umm al-Rasas

Dayr 'Ayn 'Abata

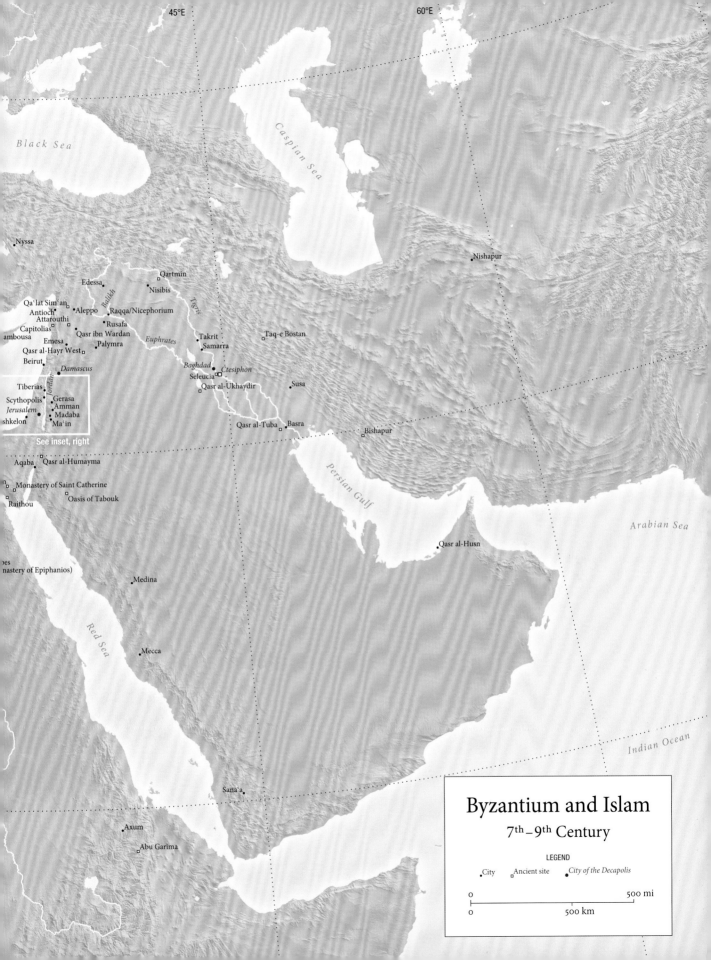

Nyssa

Edessa
Qartmin
Nisibis

Qaʿlat Simʿan
Antioch
Attarouthi
Aleppo
*Balikh*
Raqqa/Nicephorium

Capitolias
ambousa
Qasr ibn Wardan
Rusafa

Emesa
Qasr al-Hayr West
Palymra
*Euphrates*

Beirut
*Damascus*

Tiberias
*Jordan*

Scythopolis
Gerasa
Amman
*Jerusalem*
Madaba
shkelon
Maʿin

See inset, right

Aqaba
Qasr al-Humayma

Monastery of Saint Catherine
Raithou
Oasis of Tabouk

bes
nastery of Epiphanios)

*Black Sea*

*Caspian Sea*

Nishapur

Takrit
Samarra
*Tigris*

Taq-e Bostan

*Baghdad*
Seleucia
*Ctesiphon*
Qasr al-Ukhaydir
Susa

Qasr al-Tuba
Basra
Bishapur

*Persian Gulf*

*Arabian Sea*

Qasr al-Husn

Medina

*Red Sea*

Mecca

*Indian Ocean*

Sanaʿa

Axum
Abu Garima

## Byzantium and Islam
### 7th–9th Century

**LEGEND**

· City   ▫ Ancient site   • *City of the Decapolis*

0             500 mi

0             500 km

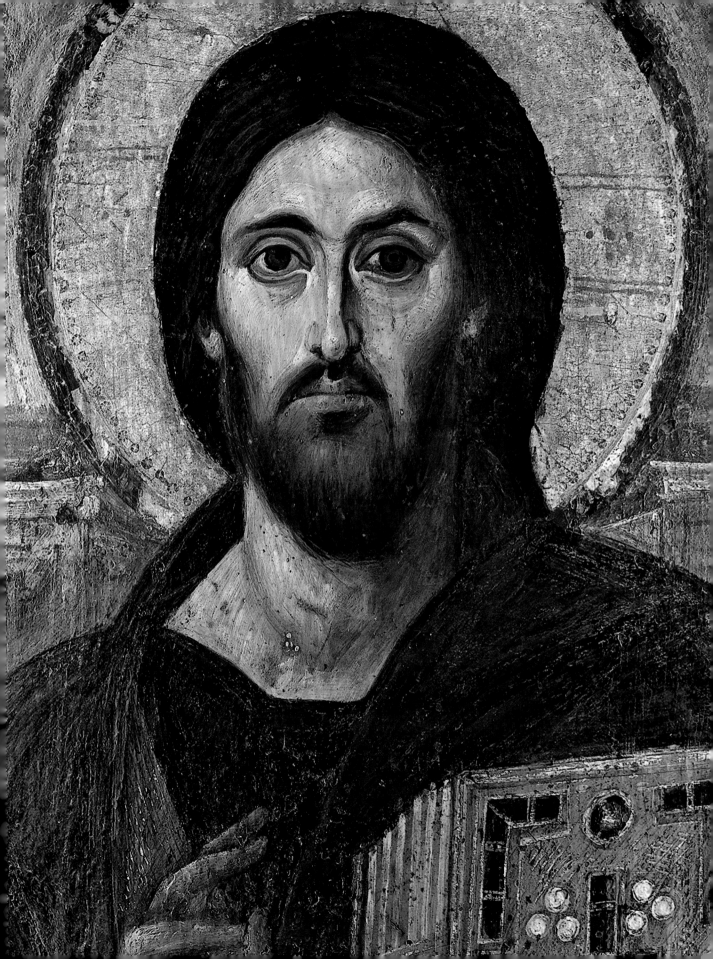

# Age of Transition

*Lyle Humphrey*

# Collecting Christianity on the Nile: J. Pierpont Morgan and The Metropolitan Museum of Art

The exhibition "Byzantium and Islam: Age of Transition" presented several works acquired in the early twentieth century by the celebrated American financier John Pierpont Morgan (1837–1913; fig. 1).[1] Included among these were seven superlative objects from The Metropolitan Museum of Art: six silver plates with scenes from the life of David, part of an important early Byzantine hoard discovered on Cyprus in 1902 and known as the Second Cyprus Treasure; and one of the earliest known containers for a fragment of the True Cross, the Fieschi Reliquary (later the Fieschi Morgan Reliquary), an exquisite early-ninth-century gold and silver box figured with cloisonné enamel and niello.[2]

The David plates (fig. 2), marked with imperial control stamps dating to 613–29/30 (reign of Heraclios), were made in Constantinople for a member of the Byzantine elite and were most likely buried when Arabs invaded Cyprus in the mid-seventh century. They were unearthed, along with three other plates from the same series, numerous pieces of gold jewelry, at least two silver cross-monogram plates, and several bronze objects, by Greek quarrymen mining among

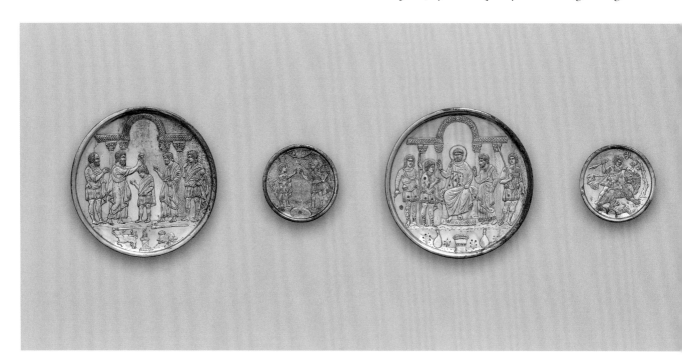

the ruins of the Byzantine town of Lapithos (modern Lambousa), below the village of Karavás. Although Cypriot and British colonial authorities attempted to prevent the treasure's export, a cabal of international antiquities dealers assisted by local merchants, law enforcement insiders, and the French consul to Cyprus managed to smuggle a large portion of it to Paris.[3] The loot attracted many prospective buyers, among them the British Museum and the Musée du Louvre, but the exorbitant asking price and illegal status of the treasures meant that only a wealthy individual not subject to Cypriot law could acquire them. Pierpont Morgan purchased the hoard—consisting of the David silver, a ceremonial belt of gold medallions and coins, and six pieces of jewelry—from C. & E. Canessa Antiquaires, Paris, in 1906–7 for the sum of £29,100 (fig. 3).[4] These objects were part of the large donation to the Metropolitan Museum made by Morgan's son John ("Jack") Pierpont Morgan Jr. (1867–1943) in 1917.[5]

Also in 1906 the financier obtained from the Paris dealer Jacques Seligmann the ninth-century Reliquary of the True Cross,

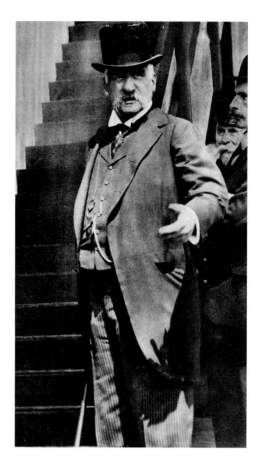

Figure 1. J. Pierpont Morgan (1837–1913), ca. 1910. Archives of The Metropolitan Museum of Art

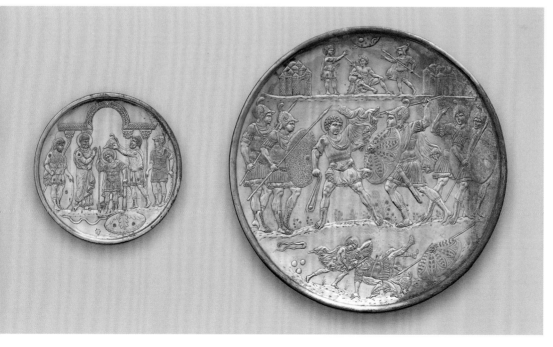

Figure 2. Plates with scenes from the life of David. Constantinople, 629–30. Silver, cast, hammered, engraved, punched, and chased. The Metropolitan Museum of Art, Gift of J. Pierpont Morgan, 1917 (17.190.394–.399)

3

which had been part of the Oppenheim collection in Cologne and, prior to that, the Fieschi collection in Genoa (see fig. 1 on page 71).[6] According to tradition, the reliquary was brought home from the Crusades and belonged to Sinibaldo Fieschi (Pope Innocent IV; r. 1243–54).[7]

All these objects are quintessentially Morgan: finely crafted from precious materials, designed for religious and/or ceremonial use, bearing a distinguished

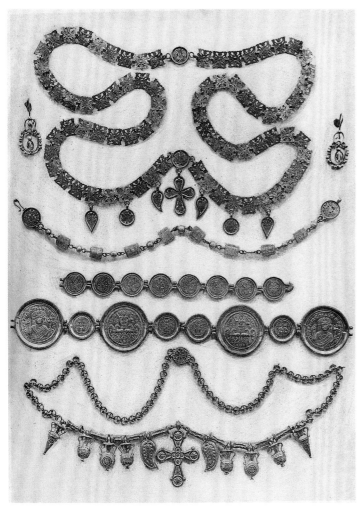

Figure 3. Jewelry from the Second Cyprus Treasure. Left to right, top to bottom: gold earrings with pearls and sapphires (17.190.145, .146); gold necklace with cross pendant (17.190.150); necklace with beads of pearl and plasma (17.190.153); gold ceremonial belt (17.190.147); gold necklace with cross and other pendants (17.190.151) (from Sambon 1906: 129)

provenance, and rare.[8] Indeed, it was Morgan's purchase of the Fieschi Reliquary that initiated his quest for Byzantine enamels.[9]

The other Morgan works exhibited in "Byzantium and Islam" are a circa seventh-century gold necklace with *opus interrasile* pendants—not connected with the Cyprus Treasure—acquired in Paris in 1911, and a pair of carved tusk fragments depicting the Ascension of Christ (fig. 4a, b).[10] Radiocarbon analysis dates the carving of the tusks to between 720 and 1010, when the eastern Mediterranean was under Muslim control. Stylistic comparisons with wood carvings of the same period from the Church of Abu Serga, a Coptic church in Old Cairo, suggest an Egyptian provenance.

The sculpted tusks from Egypt were among the ivories purchased by Morgan between 1902 and 1912 and on display— along with much of his collection—at the Victoria and Albert Museum, London, until mid-December 1912.[11] Morgan began transferring his art collection from London to New York in early 1912, and the ivories on loan to the V&A were among the last objects to be shipped.[12] Before they were removed from South Kensington, director Cecil Harcourt-Smith requested permission to produce casts "from a few of the more important specimens."[13] The group of eight ivories Smith selected included one of the Coptic Ascensions, presumably the larger of the two. This work embodies what Morgan's trusted librarian, Belle da Costa Greene, characterized in a letter to Bernard Berenson as "the luxury and gorgeous barbaric beauty of the Church in the early days."[14]

The historical and spiritual associations of Coptic art, combined with Morgan's romantic fascination with Egypt, prompted him, as president of the Metropolitan, to galvanize and finance the Museum's rapid accumulation of early Byzantine art (330– 646) from Egypt. Most of the Egyptian Christian art exhibited today beneath the Grand Staircase was acquired during his presidency, either by the Department of

Egyptian Art, which he established in 1906, or by Morgan privately, and includes architectural sculpture, decorative textiles, and a hoard of gold jewelry. The story of the Metropolitan's "Coptic" (Byzantine and other Christian Egyptian) holdings, elucidated in firsthand accounts of Morgan's travels on the Nile around 1900, not only confirms what we know of him as a benefactor of the Metropolitan and an owner of early medieval art but also sheds light on the cultural attitudes, aesthetic preferences, and collecting practices of Western museums in the eastern Mediterranean in the early twentieth century.[15]

## MORGAN AND THE DEPARTMENT OF EGYPTIAN ART

J. Pierpont Morgan did not begin collecting art seriously until about 1890, when, after the death of his father, Junius Spencer Morgan, he inherited the family fortune. His early interests were rare books, first editions, autographs, and illuminated manuscripts, for which he commissioned from Charles Follen McKim in 1902 the elegant library on East Thirty-Sixth Street (now The Morgan Library & Museum).[16] He began buying medieval objects in 1901. In the ensuing eleven years, he amassed works that ranged in date from the late Roman period to the Renaissance. Morgan's voracious consumption of medieval art has been well documented by his biographers and recent scholars of collecting, as has his visionary and forceful leadership of the Metropolitan between 1904 and his death in 1913.[17] During his tenure, he made prestigious hires to the administrative and curatorial staffs and strategic appointments to the board, created new departments, increased the quality and size of collections, initiated archaeological fieldwork, and oversaw the Museum's third major expansion, begun in 1904 by McKim, Mead & White.[18]

Morgan made two key decisions early in his presidency. In December 1905 he approved the board's hiring of Edward Robinson, former director of the Museum of Fine Arts,

Figure 4a, b. Tusk fragments with the Ascension of Christ. Egypt, ca. 720–1010. Ivory. The Metropolitan Museum of Art, Gift of J. Pierpont Morgan, 1917 (17.190.46, .48)

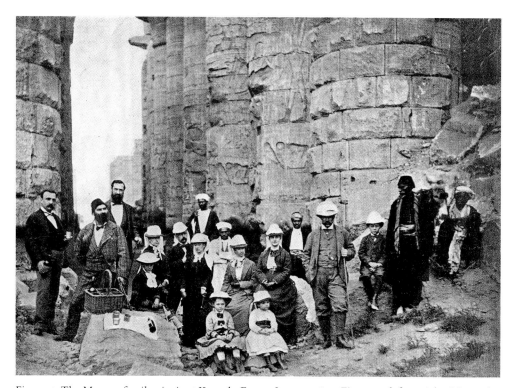

Figure 5. The Morgan family picnic at Karnak, Egypt, January 1877. First row, left to right: Morgan's three daughters, Louisa with picnic basket, Juliet, and Anne; second row (standing): "Clemmy" the waiter, their interpreter Ibrahim, the Morgans' maid Mrs. Gibbons, their courier Caesar Cesario, the children's nurse Abby, Fanny's cousin Mary Huntington and Fanny (both seated), Morgan, Morgan's son Jack, and the consular agent at Luxor. The bearded man standing behind the interpreter is the French physician who accompanied the Morgans on the Nile (from Satterlee 1939, fig. opp. page 161)

Boston, to fill the newly created positions of assistant director and curator of classical art.[19] Robinson served as the powerful second-in-command to director Sir Caspar Purdon Clarke until the latter's resignation in 1910, at which point Robinson assumed his position, remaining until 1931.[20] In October 1906, at the urging of trustee William M. Laffan (1848–1909), publisher and editor of the New York *Sun*, Morgan founded the Department of Egyptian Art, which he envisioned would soon "rank permanently as the best in America."[21] At the same time, he arranged for the Metropolitan to begin archaeological exploration in Egypt and established a fund to finance it. Earlier that year Laffan had visited the excavation at Giza, sponsored jointly by Boston's Museum of Fine Arts and Harvard University, and realized that archaeological fieldwork could help museums build collections. Upon his return from Egypt, Laffan met Morgan in Paris and promptly convinced him to take advantage of the Egyptian government's policy of granting foreign institutions that sponsored digs at designated sites the right to export half their finds. Laffan boasted of his influence over Morgan and the Metropolitan in a letter to a colleague in New York:

> The Museum has been immersed in Egyptology up to its neck, nolente volente, by my eccentricities on the Nile. . . . I see Morgan daily and have spent a million or more of his money since I arrived, the acquisition yesterday

*Age of Transition: Byzantine Culture in the Islamic World*

Figure 6. The Metropolitan Museum of Art Egyptian Expedition. Kharga Oasis, 1911. Archives of The Morgan Library & Museum, New York (ARC 1469)

of the famous Oppenheim collection [of which the Fieschi Reliquary was a part] being the last of it. . . . What a whale of a man! And I need not say that the Egyptian business is all due to his big way of looking at things and doing them.[22]

Morgan himself had been nurturing an interest in what he called "my beloved Egypt" since the 1870s.[23] By the mid-nineteenth century Cairo had become a stop on the Grand Tour.[24] In the winter of 1871–72, Morgan made his first voyage to Egypt with his second wife, Fanny (née Frances Louisa Tracy), and their three young daughters, and he would return regularly until shortly before his death.[25] The family typically took a steamship from Italy to Alexandria. Once in Cairo they chartered a *dehabiyeh* ("thing of gold"), a large Egyptian houseboat, from Thomas Cook to sail up the Nile. A memorable group photograph taken in January 1877 shows Morgan and his family with many attendants having luncheon in the temple complex at Karnak and enjoying the comforts of their affluent American lifestyle (fig. 5).

Morgan's heartfelt appreciation for sacred places is well documented. He recorded his impressions of the Holy Land in the winter of 1881–82, when he accompanied his parents on a cruise in the eastern Mediterranean and kept a journal from which he sent weekly installments to Fanny. Describing a voyage from Jaffa to Jerusalem in open wagons, he wrote:

Just outside of the city, we stopped at a small prayer station, built upon the site of the house of Dorcas . . . and then continued our route over the plains of Sharon, covered with wild flowers. . . . In the distance we saw Zorah, where Samson was born, and various other points of historical interest, either biblical or of the times of the Crusaders, and I enjoyed it immensely. . . . Just at dark we stopped to water the horses at an inn on the bank of the brook near which David fought Goliath of Gath and from which he picked the pebble with which he slew him.[26]

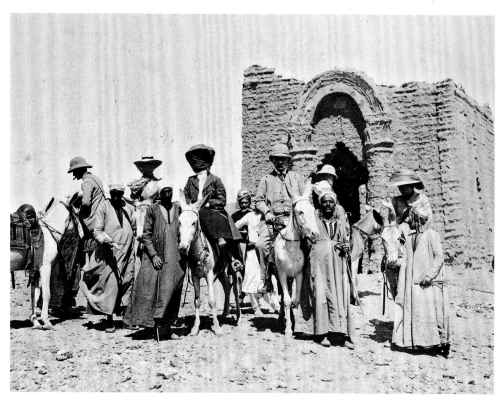

Figure 7. The Morgan party at Kharga Oasis, 1909, before a tomb chapel at Bagawat cemetery. Archives of The Morgan Library & Museum, New York, purchased in 2003 (ARC 1425)

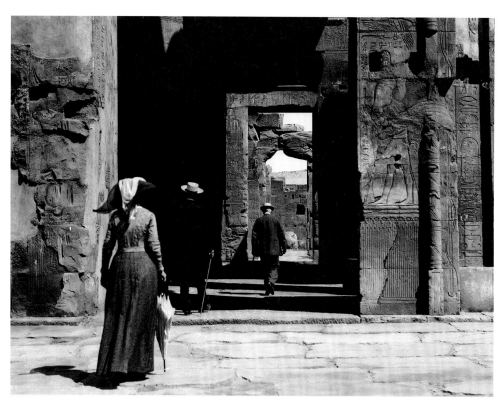

Figure 8. Morgan and his travel companions entering the right gateway to the Temple of Kom Ombo (305–30 B.C.E.), near Aswan, ca. 1909–12. Archives of the Department of Egyptian Art, The Metropolitan Museum of Art

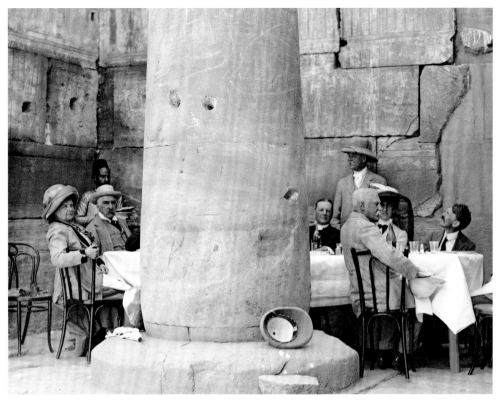

Figure 9. The Morgan party at lunch in the Temple of Hibis (after 500 B.C.E.). Kharga Oasis, 1912. Archives of the Department of Egyptian Art, The Metropolitan Museum of Art

Recounting his visit to the Church of the Holy Sepulchre the following day, Morgan described "descending the stairs to the Church" and wandering "through chapel after chapel, built by different creeds, Greeks, Catholics, Copts, Armenians," and ultimately falling on his knees before "the slab on which He was laid."[27] His fervid reaction helps explain his later urge to spend lavishly on early Byzantine objects.

Egypt's hold on Morgan clearly motivated his generous investment in the Metropolitan's Department of Egyptian Art. When staffing the new division he again drew from the Boston Museum of Fine Arts. Laffan had been impressed by the Harvard Egyptologist Albert M. Lythgoe (1868–1934), the chief field officer at the excavation of Giza and the Boston museum's curator of Egyptian art from 1902 to 1906, and convinced Morgan to appoint him head of the Metropolitan's new venture. Lythgoe, in turn, brought in his talented deputy,

Herbert E. Winlock (1884–1950), who worked for the Egyptian Expedition until 1931 and would succeed Edward Robinson as director of the Metropolitan in 1932. This "raid" on Boston, as Calvin Tomkins described it, was rooted in the Metropolitan's competition with an art museum that had been founded the same year, 1870, and that had already surpassed it in the acquisition of Greek antiquities.[28]

The Egyptian government granted the Metropolitan Museum concessions at two sites, the pyramids at Lisht and the Oasis at Kharga, and Morgan established a fund to cover operating expenses.[29] Lythgoe hired the British Egyptologist Arthur C. Mace (1874–1928) to direct the work at the pyramid of Senwosret I at Lisht, which began in January 1907, and appointed Winlock to supervise the Museum's dig at Kharga. Commonly known as the Great Oasis, Kharga lies in the Libyan Desert, about 400 miles southwest of Cairo and

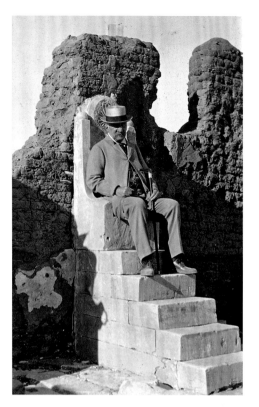

Figure 10. J. Pierpont Morgan enthroned as "Father Jeremias." Saqqara (Memphis), Egypt, 1909. Archives of The Morgan Library & Museum, New York (ARC 1425; purchased in 2003)

120 miles due west of the Nile Valley at Thebes. Rich in Greco-Roman and early Christian remains, the site was expected to yield material that would "place [the] Egyptian collection on a sound footing in its representation of this latest phase of Egyptian civilization and art" (fig. 6).[30]

Winlock led the Metropolitan's excavation at Kharga from the winter of 1908 until June 1910. His frequent letters to his mentor in New York provide a colorful picture of daily life at the camp. He described the oasis as a "curious place . . . [with] a combination of the finest climate and the finest views and the most abominable plagues I have seen yet. If there is wind you are choked out with sand, if no wind the mosquitoes and flies and gnats are enough to drive you mad. But these things balance themselves so nicely that this is a perfect paradise."[31] Harsh conditions and the threat of typhoid forced Winlock to close the site two years later.[32] Throughout this period, however, he never lost his Victorian sense of decorum, as testified by his

Figure 11. Morgan's dehabiyeh, the *Khargeh*, 1912. Archives of the Department of Egyptian Art, The Metropolitan Museum of Art

*Age of Transition: Byzantine Culture in the Islamic World*

dispatch for finger bowls, white tablecloths, and white linen suits, in addition to a "great many yards of mosquito netting."[33]

Winlock's letters document setting up the camp, payments for materials, construction, and labor, visits to antiquities shops in Cairo, negotiations with the local antiquities czar, Sir Gaston Camille Charles Maspero (1846–1916), and visits by the expedition's patron. Morgan came regularly from 1909 on (figs. 7–10). The first year, Lythgoe accompanied him and his party through Egypt, taking him from Lisht up the Nile by a dehabiyeh to the Kharga Oasis. Dubbed an "Egyptomaniac" by some former traveling companions, Morgan was reportedly so happy that he did not want to leave.[34] These visits were a mixed blessing for the curators. Though generous with the expedition, Morgan could be ornery and willful.[35] When Winlock took Morgan and his party up the Nile during his 1911 visit, Morgan irritated the curator by overspending at the Cairo antiquities market.[36] Morgan, in turn, was annoyed to discover that the curator was getting first pick of offerings there.[37] Tempers flared again when Winlock learned that Morgan had commissioned a dehabiyeh of his own.[38]

This boat, which Morgan named the *Khargeh* in honor of the Museum's dig, was ready in 1912 (fig. 11), when he came to visit the ruins of the Monastery of Epiphanios.[39] Since 1910 the Metropolitan had been exploring several ancient and Byzantine sites around ancient Thebes, including a seventh-century monastery founded by the Theban anchorite Apa Epiphanios. It was here that papyri, ostraka, and other objects of daily life were found, including a woven rug and a wooden lute.[40] During Morgan's visit workers clearing the site discovered a Coptic censer with a lioness attacking a boar (fig. 12), which they allowed Morgan to lift out of the ground with his own hands. Reporting the episode to Robinson, Lythgoe noted that Morgan "carried it back in triumph to the steamer. He was delighted, and it is now his most treasured possession. His

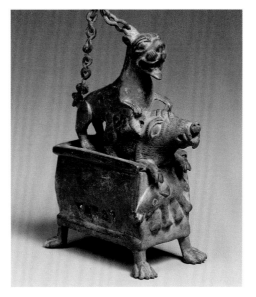

Figure 12. Coptic censer with a lioness attacking a boar, from the Monastery of Epiphanios, 6th–7th century. The Metropolitan Museum of Art, Rogers Fund, 1944 (44.20a, b)

only fear is that Maspero will take it away from him, but I have assured him that we can arrange the matter."[41] Indeed, Maspero permitted Morgan to keep the censer, which is now in the collection of the Metropolitan Museum. Evidently Morgan's family was aware of his attachment to the object, as they retained it in his estate until 1944.

## ACQUIRING COPTIC ART IN EGYPT, 1907–12

Morgan's fears about Gaston Maspero's authority to confiscate the censer were not unfounded. As director general of excavations and antiquities for the Egyptian government (1881–86; 1899–1914), Maspero wielded enormous power, deciding what foreign institutions could keep from their own fieldwork and what they could purchase from other archaeological sites.[42] It was Maspero who ceded Coptic objects from monasteries at Bawit and Saqqara, under excavation by the French and English respectively, to the Metropolitan Museum. The Metropolitan's Egyptian department began seeking such art soon after its arrival in Egypt. One of its earliest acquisitions was a carved bone depicting Silenus, which was purchased in 1907 from the Cairo dealer Maurice Nahman

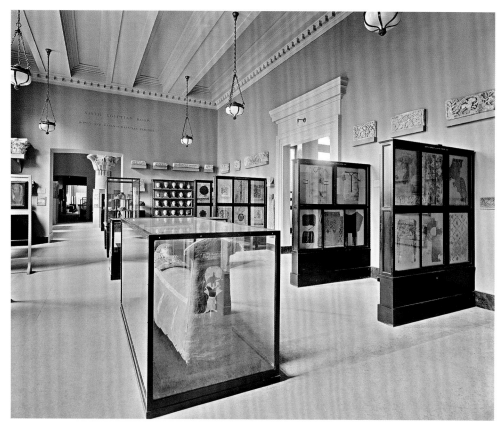

Figure 13. Installation view, ninth Egyptian gallery. The Metropolitan Museum of Art, October 18, 1911. Archives of the Department of Egyptian Art, The Metropolitan Museum of Art

(1868–1948)[43] and paid for by the Rogers Fund, established in 1904 thanks to an unexpected bequest of $5,000,000 from Jacob S. Rogers, a locomotive manufacturer from Paterson, New Jersey.[44]

By 1909 Maspero was setting aside Coptic fragments for consideration by Winlock, and in 1910 the Museum purchased some 125 of these, plus another forty objects from the Cairo antiquities dealer Michel Casira.[45] The acquisitions included architectural fragments from the Monastery of Apa Apollo at Bawit.[46] The following year the curators purchased another forty-two objects from Nicolas Tano of Cairo (1866–1924).[47] Letters between Lythgoe and Winlock reveal that the curators were keen to bolster the Museum's holdings of early Christian Egyptian art. Because it was inexpensive

compared to Egyptian antiquities, Lythgoe had no difficulty persuading the trustees to authorize en bloc purchases.[48] Moreover, Morgan was excited about the material. After a Purchasing Committee meeting in January 1910, Lythgoe told Winlock,

> Please select *everything which you think will be of value to us*. It will not cost much comparatively and whatever price Maspero puts upon it please accept his valuation without referring the matter to me. . . . Mr. Morgan and the Committee were very much pleased yesterday when I told them about Maspero's letting us have the Coptic material . . . so get all you can from Maspero in order to buck up our showing![49]

*Age of Transition: Byzantine Culture in the Islamic World*

## DISPLAYING COPTIC ART AT THE METROPOLITAN MUSEUM, 1911–2013

By 1910 the Museum's Egyptian holdings had expanded to the point that curators began planning their reinstallation in McKim, Mead & White's addition to the Great Hall (Wing E, completed in the winter of 1910). Lythgoe was elated and received "carte blanche" for the project from Morgan.[50] The art of Roman and early Christian Egypt, represented by textiles, architectural sculpture, and ivory and wood carvings, occupied the ninth of the ten rooms of the new Egyptian galleries, which opened to the public on November 5, 1911 (fig. 13). The *Bulletin* of the Metropolitan Museum proclaimed the curators' mission to illustrate "the whole history of Egyptian art, from its crude beginnings in pre-dynastic times to its last expressions in the Coptic period."[51] Lythgoe secretly hoped that the exhibition would "make [their] neighbors in Boston look like relics of bygone ages."[52]

The Egyptian galleries continued to expand in the second decade of the twentieth century.[53] By 1939, however, the department had stretched beyond its capacity and transferred its large Coptic collection to the Department of Near Eastern Art (established in 1932), which housed other early Christian material from the Near East.[54] When this department was split into Ancient Near Eastern Art and Islamic Art in 1963, the collection of Egyptian Christian art was dismantled and placed in basement storage.

In 1976 the Department of Egyptian Art created a small installation of Byzantine Egyptian art that remained on view until the late 1990s. By this time the Coptic collection had found a more art-historically appropriate home: the Mary and Michael Jaharis Galleries for Byzantine Art, which opened in 2000. The Crypt Gallery (fig. 14) displays many of the architectural fragments purchased around 1910, such as sculpture from Bawit, carved tusks, and a spectacular assortment of gold jewelry from the Assiut Hoard, discovered in Egypt about 1900, allegedly in Tomet near Assiut

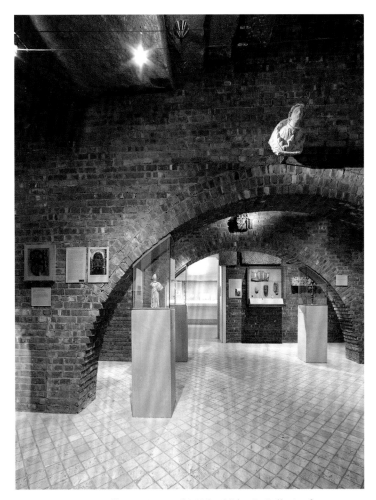

Figure 14. Crypt Gallery, Mary and Michael Jaharis Galleries for Byzantine Art. The Metropolitan Museum of Art, 2013

in Upper Egypt though possibly in the ancient city of Antinoë. When some pieces purportedly from the treasure surfaced on the Cairo art market between 1909 and 1912, the Metropolitan's curators selected on behalf of Morgan a pectoral, a necklace, a pair of earrings, and two pairs of bracelets, plus two necklaces said to have been found in Alexandria.[55] Morgan's share of the Assiut Hoard passed to the Metropolitan via Jack Morgan in 1917.[56] The 1912 acquisition in Cairo is yet another manifestation of mutual collaboration between Metropolitan curators and their patron.

Unlike the Louvre in Paris and the Kaiser-Friedrich-Museum in Berlin (now the Skulpturensammlung und Museum für Byzantinische Kunst, Staatliche Museen zu Berlin, Preußischer Kulturbesitz), which were already carrying off finds from archaeological campaigns in Egypt by 1895, the Metropolitan got a late start.[57] However, in the lustrum between 1906 and 1911 the American museum played catch-up and built an impressive collection of Egyptian art that spanned some 4,500 years. In 1908 Ormonde M. Dalton (1866–1945), who joined the Department of British and Medieval Antiquities and Ethnography at the British Museum in 1885 and rose to assistant keeper under Sir Charles Hercules Read in 1909 (he would become keeper in 1921), expressed regret that his museum was not accumulating Byzantine Egyptian art at the same pace as his colleagues in Germany and America. He publicly bemoaned Britain's failure to enrich its collections through exploitation of its colonial possessions:

> It is especially to be regretted that the illustration of the Christian art of Egypt should not be systematically pursued by the country which has for years occupied the position of the most favoured nation in the Nile Valley. Capitals and decorative fragments of a kind unrepresented in England are finding their way not only to Germany but to America, where they appear to find a readier appreciation than with us. We need grudge neither America nor Germany acquisitions which they deserve to possess: but it remains a matter for regret that we do not follow their example.[58]

Dalton and Read had aggressively pursued the Second Cyprus Treasure in 1902–6 and were chagrined when the British Colonial Office would not support their efforts to acquire the hoard.[59] Read himself was one of Morgan's principal advisers on medieval art. The two scholars must have witnessed Morgan's simultaneous private collecting and patronage of the Egyptian department at the Metropolitan with considerable envy.

On the centennial of J. Pierpont Morgan's death, one can say that Byzantine Egyptian art in the Metropolitan's collection is the fortunate result of converging historical circumstances: the munificence of the Museum's great president and patron Pierpont Morgan and his trustees; the vision, hard work, and competitive spirit of the Metropolitan's first curators and their desire to educate the American public; Egypt's then-practiced generous system of partitioning finds granted by the Egyptian Antiquities Authority; and the fortuitous donation by Jacob S. Rogers. No less important was Morgan's "romantic and historical feeling for the splendour of past ages," an inclination noted in the obituary that appeared in the *Burlington Magazine for Connoisseurs* following Morgan's death: "What he recognized in an object," the anonymous writer noted, "was primarily its importance, the part it had played in the evolution of civilization."[60] This appreciation for the ethnographic value of objects was the impulse that drove Pierpont Morgan to finance and personally oversee the Metropolitan Museum's first archaeological exploration in Egypt and his curators to add remnants of the early Christian period to their major collecting agenda.

This paper began as a research project undertaken as a Metropolitan Museum of Art/Institute of Fine Arts Curatorial Studies program intern in the Department of Medieval Art and The Cloisters in 1999. I am grateful for the support and guidance of my internship sponsor and supervisors—Peter Barnet, Barbara Drake Boehm, and Helen C. Evans—and my unofficial adviser on Byzantine Egypt, Thelma K. Thomas, as well as many others within and outside the Museum who provided advice and needed access.

1. Evans 2012.
2. Ibid.: 16–17, no. 6a–f, and 88–89, no. 54.
3. The objects associated with the 1902 discovery at Lambousa were unearthed on the periphery of the Monastery of Acheiropoietos, near the find site of an earlier silver hoard known as the First Cyprus Treasure, uncovered in the 1890s and acquired by the British Museum in 1899. The circumstances of the Second Treasure's discovery, dispersal, and pursuit by various collectors and dealers are discussed in A. Stylianou and J. Stylianou 1969: 17–21; Entwistle 2003; and Durand 2012. The other three plates from the David series are in the Cyprus Museum, Nicosia (J452, J453, and J454); see Phryni Hadjichristophi in Lazaridou 2011: 162–63, nos. 133a–133c; and Durand and Giovannoni 2012: 67–73, nos. 19a–19e. The early accounts of the discovery of the Second Cyprus Treasure are Dalton 1906, Sambon 1906, and Dalton 1907.
4. Morgan acquired the Cyprus Treasure in two discrete transactions separated by a year. The first group of objects—five silver plates from the David series, a pair of bracelets, a pair of earrings, and three necklaces totaling £13,100—was invoiced from Paris on April 19, 1906; the second—a single plate costing £16,000—on March 29, 1907. Both invoices are preserved at the Morgan Library & Museum, Morgan Collections Correspondence (ARC 1310), in the folder C Canessa, C. and E., dealer, Paris and Naples 1906. The splitting up of the sale was the result of the largest of the six plates, representing David's combat with Goliath, having been smuggled separately from the rest of the treasure, in late 1906 or early 1907. Its whereabouts was still listed as unknown as late as Dalton 1907: 361.

    The sum of £29,100 for Morgan's share of the Cyprus Treasure exceeds previously published figures for the purchase, listed variously as £10,000 or £13,000. Based on the percentage increase in the UK Retail Price Index from 1906 to 2012, the relative value of £29,100 is about £2,650,000 today; see Clark 2013 and Officer and Williamson 2013.

    Although C. & E. Canessa sold the exported Cyprus Treasure objects to Morgan, the individual responsible for their illegal export from Cyprus to Paris was Mihran Sivadjian, an Armenian dealer active in Paris circa 1894–1909, as noted in A. Stylianou and J. Stylianou 1969: 19, and Entwistle 2003: 226–27. Sivadjian marketed the hoard at his gallery at 17, rue le Peletier, from about 1903 until late 1905, and was apparently assisted in the sale by Joseph-Ange Durighello (1863–1924), of 31, rue de Richelieu. The only reference to Sivadjian in the Metropolitan's object file on the Cyprus plates is a note written by William H. Forsyth on October 18, 1948,

reporting that "Kouchakji told Mr. Forsyth in October 1948 that a certain art dealer in Paris—Sivadjian—brought word to Canessa about these plates." I thank Christine Brennan for uncovering this memorandum (June 27, 2013).
5. They are as follows: the six David plates (17.190.394–.399); a large, gold ceremonial belt (17.190.147 supplemented by 1991.136); a pair of gold bracelets with vine-scroll openwork decoration (17.190.148, .149); a gold necklace with square openwork links, cross pendant, and other ornaments (17.190.150); a gold necklace with cross and other pendants (17.190.151); a necklace with beads of pearl and plasma (17.190.153), and gold earrings with pearls and sapphires (17.190.145, .146).
6. Jacques Seligmann (1858–1923), a German émigré, moved to France in 1874 and established a gallery in Paris, Jacques Seligmann & Cie, in 1880. He would become one of Morgan's most important providers of medieval objects after 1903; see Gennari-Santori 2010b: 83–84. On the reliquary's iconography, see Barbara Drake Boehm in Bagnoli et al. 2010: 81–82, no. 37.
7. Dalton 1912: 65–66.
8. An unsigned obituary of J. Pierpont Morgan published in the Burlington Magazine for Connoisseurs (1913: 66) notes the collector's attraction to the "accessory historical or romantic associations" of objects, and characterizes his motivation for collecting thus: "He was quite as much moved by works of art which had originally a purely religious or ceremonial function, and his collections of Byzantine and early Gothic art show how fortunate a result this catholicity of taste has produced."
9. On the importance of the Morgan collection of Byzantine enamels, see Gennari-Santori 2010b: 82–84.
10. Evans 2012: 190, no. 130, and 74, no. 45a, b.
11. On the loan to the V&A, which was said to fill thirty to forty display cases and included non-medieval objects as well, see Rottner 1996: 124, 126n37 (citing Times 1912: 6); Gennari-Santori 2010b: 82 and 83–84 (on the ivories in general).
12. Strouse 1999: 641–42.
13. Harcourt-Smith to J. Pierpont Morgan, November 13, 1912 (Morgan Library & Museum, Morgan Collections Correspondence [ARC 1310], V–Misc. Victoria and Albert Museum), in which he requested: "The Consular Diptych from the Aynard Collection (1347), the Coptic Relief of the Ascension (760), the two small Byzantine reliefs of Adam and Eve from the Pulszky collection (1352, 1353), the Byzantine standing figure of the Virgin and Child (1340), the South Italian relief of the Crucifixion and Entombment (1548), and if possible the two small figures of the Virgin and Child (French, 14th century, No. 1233); and the Magdalene (French, early 16th century, 1158)."

Smith expressed his desire to add these copies to the series of sixteen casts prepared from ivories in Morgan's collection in 1907. Morgan eventually replied in the affirmative, as indicated in a telegram to Jacques Seligmann dated November 19, 1912, authorizing a delay of several weeks in the shipment of the ivories to accommodate the production of the casts and in Seligmann's confirmatory response to Morgan of November 21, 1912; both letters in the Morgan Library & Museum, Morgan Collections Correspondence (ARC 1310), Seligmann June–Dec. 1912 folder 4 of 6. See also Gennari-Santori 2010b: 83–84, and 96n17.

14. Greene to Berenson, September 20, 1913, Villa I Tatti, Florence, quoted in Strouse 2000: 22.

15. For definitions of Coptic, see Elizabeth Bolman, "Coptic Christianity," in Evans 2012: 69–70.

16. Strouse 1999: 487–91, on the library commission.

17. On Morgan's collecting of medieval art, see Taylor 1970; Rottner 1996; Strouse 1999; Brown 2000; Strouse 2000; Wixom 2000; Gennari-Santori 2010a and 2010b; and Brennan 2013.

18. On Morgan's connection with the Metropolitan Museum, see Saarinen 1958: 56–91; Tomkins 1970: 95–100; and Strouse 2000, esp. 35–55. Morgan contributed his first $1,000 to the Museum in 1871, becoming one of its fifty original patrons. He joined the board in 1889 and served on the executive committee from 1892 to 1894 and again from 1901 until his death in 1913. He was elected first vice-president of the Museum in February 1904. When Frederick W. Rhinelander died that fall, Morgan succeeded him and became the institution's fourth president. Morgan's board appointments included Henry Walters, Henry Clay Frick, John G. Johnson, George F. Baker, and Edward S. Harkness. On the Museum's 1904–26 expansion by Charles Follen McKim and McKim, Mead & White, see Heckscher 1995: 39–53.

19. Morgan and de Forest 1906; Tomkins 1970: 113. Robinson, director and curator of classical art at the Boston Museum of Fine Arts from 1902, resigned suddenly in the summer of 1905 over that museum's relocation plans.

20. Sir Caspar Purdon Clarke was hired in January 1905 from the Victoria and Albert Museum to replace the Metropolitan's first director, General Luigi Palma di Cesnola, director from 1879 to 1904, who died at the end of 1904; see MMA Bulletin 1905: 3–5, and Tomkins 1970: 102, 113.

21. Tomkins 1970: 114.

22. Laffan to Edward P. Mitchell, April 24, 1906, published in Mitchell 1924: 360–61.

23. Strouse 1999: 145.

24. This history is summarized in ibid.: 146.

25. Satterlee 1939: 151–52, 571–77; Strouse 1999: 145–47.

26. Quoted in Satterlee 1939: 202–4.

27. Ibid.

28. Tomkins 1970: 121, 135–36; see also Saarinen 1958: 85–87.

29. Lythgoe 1907.

30. Lythgoe 1908: 84.

31. Winlock to Lythgoe, February 23, 1908; The Metropolitan Museum of Art, Department of Egyptian Art Archives (hereafter, Egyptian Art Archives).

32. On the need to abort the excavation, see especially Winlock to Lythgoe, June 12, 1910; Egyptian Art Archives.

33. Winlock (Matania, North Kharga) to Lythgoe, February 23, 1908; Egyptian Art Archives. On Matania, see James 2006: 159.

34. Lythgoe to Edward Robinson, March 5, 1909: "It was perfectly magnificent. I don't think I ever enjoyed anything so much before in my life"; Egyptian Art Archives. On Morgan's general fascination with Egypt and the epithet "Egypto-maniac," see Strouse 1999: 202–5, 633–36.

35. Strouse 2000: 45–48. During his 1911 visit, Morgan gave the Metropolitan a group of important Dynasty 19 reliefs and part of a chapel from Abydos dating to the time of Seti I (1294–1279 B.C.E.).

36. Regarding Morgan's extravagance, see Winlock (SS Chonsu, Cooks Nile Service) to Lythgoe, February 20, 1911; Egyptian Art Archives (quoted in Strouse 2000: 47–48).

37. Winlock (SS Chonsu) to Lythgoe, February 17, 1911: "Morgan says with a twinkle in his eye [that] he arrived in Egypt too late and found everything had been bought up by the Metropolitan"; Egyptian Art Archives.

38. Winlock (SS Chonsu) to Lythgoe, February 20, 1911; Egyptian Art Archives (quoted in Strouse 1999: 634–35).

39. Strouse (ibid.: 635) notes that the boat cost $60,000 and was unusually luxurious for a dehabiyeh. It was 130 feet long and had a glass observation deck, dining room, and three staterooms on the main deck and seven additional staterooms and servants' quarters on the lower level. See New York Times 1912.

40. Winlock 1912: 189–90. See Evans 2012: 25–26, no. 15a, b, for two of the ostraka.

41. Lythgoe to Robinson, February 19, 1912; Egyptian Art Archives (quoted in Strouse 1999: 635).

42. Dawson and Uphill 1972: 197–98.

43. Evans 2012: 20, no. 10b. Another early acquisition was a child's dress allegedly from Panopolis (Akhmim), donated in 1890 by trustee George F. Baker. Baker had acquired the dress from the Cairo dealer Emil Brugsch Bey (1842–1930); see ibid.: 170–71, no. 113.

44. The wealthy Jacob Rogers died in the summer of 1901. He had no direct heirs and left $8,000,000 to the Metropolitan Museum, stipulating that the

*Age of Transition: Byzantine Culture in the Islamic World*

money be invested as an endowment fund, the income of which was to be used only for the purchase of art or books for the library. His heirs contested the will, but after two years of litigation abandoned their claims to the estate in return for $250,000. The Museum's share came to $5,000,000 (Tomkins 1970: 87–90).

45. The 1910 cession from the Egyptian government was divided into two separate lots: in April the Museum purchased approximately twenty-four "oddments" dug from Kalabsheh, Antinoë, and Saqqara for £E40, and in June, another 102 items (10.75.28–.130) for £E280. The plans to purchase are discussed in Winlock (Grand Continental Hotel, Cairo) to Lythgoe, November 17, 1909; Winlock (Kharga) to Lythgoe, January 5, 1910; Lythgoe (Century Club, New York) to Winlock, January 25, 1910; Winlock (Kharga) to Lythgoe, March 27, 1910; Winlock (Kharga) to Lythgoe, April 14, 1910; Winlock (Kharga) to Lythgoe, April 17, 1910; Winlock (Kharga) to Lythgoe, April 20, 1910; all correspondence, Egyptian Art Archives.

46. Three architectural elements exhibited in "Byzantium and Islam" were among these acquisitions. The fragment of a door jamb with geometric and vegetal motifs (10.175.77) was purchased from the Egyptian government and the relief with the Miracle of the Loaves and Fishes (10.176.21) was purchased from the Cairo dealer Michel Casira, both with the Rogers Fund in 1910. The capital (14.7.5) was acquired by the Museum through a 1914 donation of trustee Edward S. Harkness of Ohio, a collector of Coptic art and one of Morgan's appointees to the board. See Evans 2012: 83–84, no. 51a–c.

47. 12.182.86–.130.

48. Lythgoe (Century Club, New York) to Winlock, January 25, 1910; Egyptian Art Archives.

49. Lythgoe (Century Club, New York) to Winlock, January 25, 1910; Egyptian Art Archives.

50. Lythgoe to Winlock, May 6, 1910; Egyptian Art Archives.

51. MMA *Bulletin* 1911; see also Metropolitan Museum 1911.

52. Lythgoe (Stratford House, New York) to Winlock, March 26, 1911; Egyptian Art Archives.

53. The *Handbook of the Egyptian Rooms*, published in 1911, was revised in 1913, 1916, and 1918 to reflect new accessions and additions to the Egyptian galleries; see Metropolitan Museum 1911.

54. Breck 1932: 18–19; Lansing 1939: 74.

55. Maurice Nahman was the dealer of the jewelry, which is mentioned in at least two letters between Lythgoe and Winlock: Winlock (Luxor) to Lythgoe, December 23, 1911: "Hardly anything to buy from dealers in the country. For Mr. Morgan,

however, there are excellent things. The Byzantine jewelry at Nahman's—there is a lot more—is magnificent"; Egyptian Art Archives. See also Lythgoe (Hotel Continental, Cairo) to Winlock, May 5, 1912, Egyptian Art Archives; Dennison 1918; and Deppert-Lippitz 2000: 64–66, 73–74.

56. 17.190.1664–.1671.

57. For a history of the Coptic collection in the Musée du Louvre, see Rutschowscaya 1999. The Coptic collection of the Staatliche Museen zu Berlin is one of the most extensive and important outside Egypt; see Effenberger 2013.

58. Dalton 1910: 235.

59. On this incredible story, see Entwistle 2003.

60. *Burlington Magazine for Connoisseurs* 1913: 66.

## REFERENCES

**Bagnoli, Martina, et al., eds.**
**2010**  *Treasures of Heaven: Saints, Relics, and Devotion in Medieval Europe*. Exh. cat. Cleveland: Cleveland Museum of Art; Baltimore: Walters Art Museum; London: The British Museum.

**Breck, Joseph**
**1932**  "The Department of Near Eastern Art." *Bulletin of The Metropolitan Museum of Art* 27, no. 1 (January): 18–19.

**Brennan, Christine E.**
**2013**  "Hoentschel's Gothic Importance." In *Salvaging the Past: Georges Hoentschel and French Decorative Arts from The Metropolitan Museum of Art*, edited by Danïelle Kisluk-Grosheide, Deborah L. Krohn, and Ulrich Leben: 145–63. Exh. cat. New York: Bard Graduate Center: Decorative Arts, Design History, Material Culture; The Metropolitan Museum of Art.

**Brown, Katharine Reynolds**
**2000**  "Morgan and the Formation of the Early Medieval Collection." In Brown, Kidd, and Little 2000: 8–11.

**Brown, Katharine Reynolds, Dafydd Kidd, and Charles T. Little, eds.**
**2000**  *From Attila to Charlemagne: Arts of the Early Medieval Period in The Metropolitan Museum of Art*. New York: The Metropolitan Museum of Art.

**Burlington Magazine for Connoisseurs**
**1913**  "Mr. John Pierpont Morgan." *Burlington Magazine for Connoisseurs* 23, no. 122 (May): 65–67.

**Clark, Gregory**
**2013**  "What Were the British Earnings and Prices Then? (New Series)." *MeasuringWorth*. www.measuringworth.com/ukearncpi/.

**Dalton, Ormonde M.**
**1906** "A Second Silver Treasure from Cyprus" (lecture delivered at the Society of Antiquaries of London, March 30, 1905). *Archaeologia: or, Miscellaneous Tracts Relating to Antiquity, Presented by the Society of Antiquaries of London*, ser. 2, 10: 1–24.

**1907** "Byzantine Plate and Jewellery from Cyprus in Mr. Morgan's Collection." *Burlington Magazine for Connoisseurs* 10, no. 48 (March): 355–62.

**1910** Review of *Königliche Museen zu Berlin. Altchristliche und Mittelalterliche, Byzantinische und Italienische Bildwerke*, by Oscar Wulff. *Burlington Magazine for Connoisseurs* 17, no. 88 (July): 235–36.

**1912** "Byzantine Enamels in Mr. Pierpont Morgan's Collection." *Burlington Magazine for Connoisseurs* 21, no. 110 (May): 65–73.

**Dawson, Warren R., and Eric P. Uphill**
**1972** *Who Was Who in Egyptology: A Biographical Index of Egyptologists*. 2nd ed. London: The Egypt Exploration Society.

**Dennison, Walter**
**1918** *A Gold Treasure of the Late Roman Period*. New York and London: Macmillan.

**Deppert-Lippitz, Barbara**
**2000** "Late Roman and Early Byzantine Jewelry." In Brown, Kidd, and Little 2000: 58–77.

**Durand, Jannic**
**2012** "Le Double Trésor de Lamboussa-Lapithos." In Durand and Giovannoni 2012: 59–65.

**Durand, Jannic, and Dorota Giovannoni, eds.**
**2012** *Chypre: Entre Byzance et l'Occident, IVᵉ–XVIᵉ siècle*. Exh. cat. Paris: Musée du Louvre/Somogy.

**Effenberger, Arne**
**2013** "State Museum of Berlin." In *Claremont Coptic Encyclopedia*, CE: 2146a–2147b. Accessed July 8, 2013. http://ccdl.libraries.claremont.edu/cdm/ref/collection/cce/id/1774.

**Entwistle, Chris**
**2003** "'Lay not up for yourselves treasures upon earth': The British Museum and the Second Cyprus Treasure." In *Through a Glass Brightly: Studies in Byzantine and Medieval Art and Archaeology Presented to David Buckton*, edited by Chris Entwistle: 226–35. Oxford: Oxbow Books; Oakville, Conn.: David Brown Book Co.

**Evans, Helen C., ed.**
**2012** *Byzantium and Islam: Age of Transition, 7th–9th Century*. Exh. cat. New York: The Metropolitan Museum of Art.

**Gennari-Santori, Flaminia**
**2010a** "'I was to have all the finest': Renaissance Bronzes from J. Pierpont Morgan to Henry C. Frick." *Journal of the History of Collections* 22, no. 2: 307–24.

**2010b** "Medieval Art for America: The Arrival of the J. Pierpont Morgan Collection at The Metropolitan Museum of Art." *Journal of the History of Collections* 22, no. 1: 81–98.

**Heckscher, Morrison H.**
**1995** "The Metropolitan Museum of Art: An Architectural History." *The Metropolitan Museum of Art Bulletin* 53, no. 1 (Summer).

**James, T. G. H.**
**2006** *Howard Carter: The Path to Tutankhamun*. Rev. ed. London: Tauris Parke.

**L[ansing], A[mbrose]**
**1939** "Notes: Changes in the Egyptian Galleries." *Bulletin of The Metropolitan Museum of Art* 34, no. 3 (March): 74.

**Lazaridou, Anastasia, ed.**
**2011** *Transition to Christianity: Art of Late Antiquity, 3rd–7th Century AD*. Exh. cat., Onassis Cultural Center, New York. New York: Alexander S. Onassis Public Benefit Foundation; Athens: Byzantine & Christian Museum.

**L[ythgoe], A[lbert] M.**
**1907** "The Egyptian Expedition." *Bulletin of The Metropolitan Museum of Art* 2, no. 4 (April): 60–63.

**1908** "The Egyptian Expedition." *Bulletin of The Metropolitan Museum of Art* 3, no. 5 (May): 83–86.

**Metropolitan Museum**
**1911** *A Handbook of the Egyptian Rooms*. New York: The Metropolitan Museum of Art. Revised 1913, 1916, and 1918.

**Mitchell, Edward P.**
**1924** *Memoirs of an Editor: Fifty Years of American Journalism*. New York and London: Charles Scribner's Sons.

**MMA *Bulletin***
**1905** "Our New Director." *Bulletin of The Metropolitan Museum of Art* 1, no. 1 (November): 3–5.

**1906** "Department of Egyptian Art." *Bulletin of The Metropolitan Museum of Art* 1, no. 12 (November): 149–50.

**1911** "The New Egyptian Galleries." *Bulletin of The Metropolitan Museum of Art* 6, no. 11 (November): 203–5.

**Morgan, J. Pierpont, and Robert W. de Forest**
**1906** "Notes: The Assistant Director." *Bulletin of The Metropolitan Museum of Art* 1, no. 2 (January): 19.

***New York Times***
**1912** "J. P. Morgan Dug into Egypt's Past." *New York Times*, March 16: 8, col. 5.

**Officer, Lawrence H., and Samuel H. Williamson**
**2013** "Purchasing Power of British Pounds from 1245 to Present." *MeasuringWorth.* www.measuringworth.com/ppoweruk/.

**Rottner, R. Aaron**
**1996** "J. P. Morgan and the Middle Ages." In *Medieval Art in America: Patterns of Collecting, 1800–1940*, edited by Elizabeth Bradford Smith: 115–27. Exh. cat. University Park, Pa.: Palmer Museum of Art, Pennsylvania State University.

**Rutschowscaya, Marie-Hélène**
**1999** "Aux origines de la collection d'art copte du Musée du Louvre." In *Egyptes . . . L'Egyptien et le copte*, edited by Nathalie Bosson and Sydney H. Aufrère: 141–43. Exh. cat. Lattes, France: Musée Archéologique Henri Prades.

**Saarinen, Aline B.**
**1958** *The Proud Possessors: The Lives, Times, and Tastes of Some Adventurous American Art Collectors*. New York: Random House.

**Sambon, A[rthur]**
**1906** "Trésor d'orfèvrerie et d'argenterie trouvé à Chypre et faisant partie de la collection de M. J. Pierpont Morgan." *Le Musée: Revue d'art mensuelle* 3: 121–29.

**Satterlee, Herbert L.**
**1939** *J. Pierpont Morgan: An Intimate Portrait*. New York: Macmillan.

**Strouse, Jean**
**1999** *Morgan: American Financier*. New York: Random House.

**2000** "J. Pierpont Morgan: Financier and Collector." *The Metropolitan Museum of Art Bulletin* 57, no. 3 (Winter).

**Stylianou, A[ndreas], and J[udith] Stylianou**
**1969** *Hoi Thēsauroi tēs Lambousa / The Treasures of Lambousa*. Nicosia: Zavallis Press.

**Taylor, Francis Henry**
**1970** *Pierpont Morgan as Collector and Patron, 1837–1913*. Rev. ed. New York: The Pierpont Morgan Library.

***Times***
**1912** "Mr. Pierpont Morgan and South Kensington: Withdrawal of His Loan Collection." *Times* (London), January 26: 6.

**Tomkins, Calvin**
**1970** *Merchants and Masterpieces: The Story of The Metropolitan Museum of Art*. New York: E. P. Dutton.

**W[inlock], H[erbert] E.**
**1912** "The Work of the Egyptian Expedition." *Bulletin of The Metropolitan Museum of Art* 7, no. 10 (October): 184–90.

**Wixom, William D.**
**2000** "Morgan—The Man and the Collector." In Brown, Kidd, and Little 2000: 2–7.

*Lisa R. Brody and Carol Snow*

# The Gerasa City Mosaic: History and Treatment at the Yale University Art Gallery

Ancient Gerasa, located beneath the modern city of Jerash on the Chrysorhoas River in Jordan, is a site that contributes much to scholars' understanding of the Roman and Byzantine Near East (fig. 1). Its long and significant history has been revealed by its high level of preservation and years of systematic archaeological exploration. The site was first excavated in the 1920s and 1930s by a team cosponsored by Yale University, the British School of Archaeology in Jerusalem, and the American Schools of Oriental Research.[1] These excavations concentrated primarily on the early Byzantine churches and their associated pagan temples. The area has been further investigated since 1982 by the Jerash Archaeological Project, sponsored by Jordan's Department of Antiquities and composed of a team of international scholars. The current expedition has expanded its investigations to other aspects of the Roman city, such as the hippodrome, as well as the site's Islamic structures, which include houses, shops, and a large Umayyad mosque.[2]

## ANCIENT GERASA AND ITS MOSAICS

Gerasa is the best-preserved city of the Decapolis, a collective of ten cities in Roman Judaea and Syria.[3] It is considered to have been one of the most important cities in the Roman Near East, primarily owing to its strategic position on ancient trade routes. Although some historical sources, including Pliny the Elder,[4] suggest that all the cities of the Decapolis were founded during the Hellenistic period (ca. 323–63 B.C.E.), excavations at Gerasa have found evidence of occupation at least as early as the Bronze Age (third to second millennium B.C.E.). The first and second centuries C.E. were a time of great prosperity for Gerasa, reflected architecturally by its paved and colonnaded streets, theaters, temples, baths, fountains, grand public squares, and hippodrome, all essential elements of a flourishing Roman city. At its peak Gerasa is estimated to have had a population of approximately twenty thousand. The city's wealth gradually diminished during the third century, as overland trade routes were superseded by shipping routes.

By the fourth century Gerasa began to foster a significant Christian community.[5] The fifth and sixth centuries saw the construction of more than a dozen churches, including a cathedral, most of them adorned with elaborate mosaic floors and architectural decoration. Citizens of ancient Gerasa would have reached the Church of Saints Peter and Paul (fig. 2) by taking a short walk southwest from the city center. Entering the central nave of the church, they would have seen under their feet a spectacular mosaic pavement (figs. 3, 4). The mosaic featured a lengthy and carefully rendered dedicatory inscription set within a traditional Roman *tabula ansata* and surrounded by fruit-bearing trees and grapevines growing out of an amphora. The focal point of the composition depicted the Egyptian cities of Memphis and Alexandria, including Alexandria's famed Pharos, or lighthouse, within a lush Nilotic landscape.

The founder of the church, Bishop Anastasios, is named in the inscription on the nave floor and in two other inscriptions from the building.[6] Construction is dated by internal evidence and by comparison with other churches at Gerasa. In the composition of its

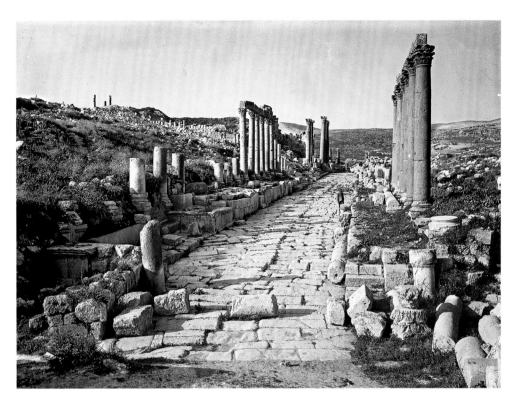

Figure 1. Via
Antoninianus.
Gerasa (Jerash),
Jordan, 1931.
Yale University
Art Gallery, Gerasa
Collection (B189)

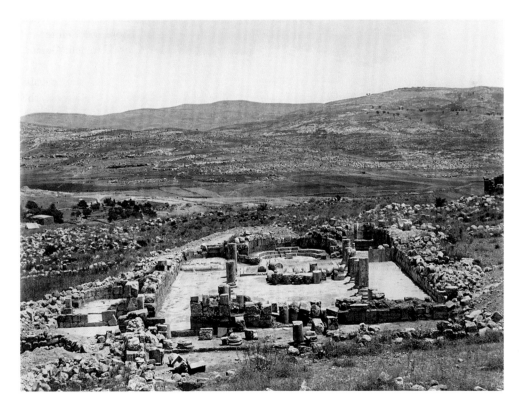

Figure 2. Church
of Saints Peter
and Paul. Gerasa
(Jerash), Jordan, 1932.
Yale University Art
Gallery, Gerasa
Collection (B34.173)

21

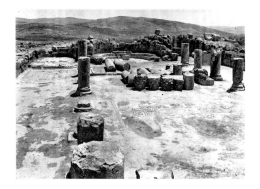

Figure 3. View of the nave toward the apse, Church of Saints Peter and Paul. Gerasa (Jerash), Jordan, 1932. Yale University Art Gallery, Gerasa Collection (C96 B34.174)

mosaic and the details of its design, it is closest to the Church of Bishop Paul, or the Prokopios Church (526–27), and the Church of Saint John the Baptist (531), but the quality of the details suggests that it is the latest of these three buildings and was constructed around 540.[7] Both the Prokopios Church and the Church of Saint John were built in the time of Bishop Paul, and it seems likely that Bishop Anastasios was his immediate successor.[8] The Church of Saints Peter and Paul is basilical in plan, with three apses and an eastward orientation. As with other churches at Gerasa (and early Byzantine churches generally), its plain exterior contrasts with an elaborately decorated interior with carved ornament and mosaic floors. The church's architecture is characterized by classical details such as columns, capitals, and moldings. The mosaics, on the other hand, display an emerging Byzantine aesthetic and style and relate closely to other such floors, both at Gerasa and at other Jordanian sites.

The nave mosaic belongs stylistically to a group of floor mosaics that include schematic representations of cities, frequently with specific attributes (such as Alexandria's Pharos) and identifying labels.[9] Several of these "city mosaics" are found in and near Jordan. One of the earliest, dated to circa 450 C.E., comes from Antioch on the Orontes.[10] At least one other church at Gerasa also contained a city mosaic: fragments from the Church of Saint John the Baptist, mentioned above, preserve images of Alexandria as well as several other cities.[11] One of the most elaborate and well-preserved versions

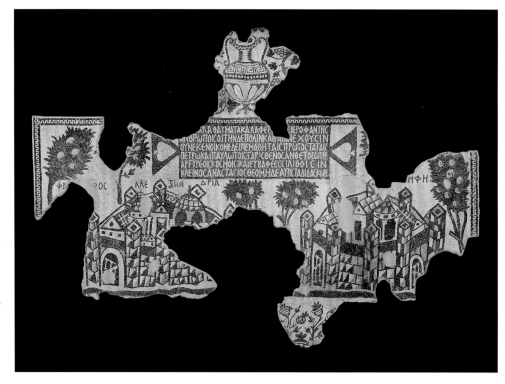

Figure 4. Floor mosaic depicting the cities of Memphis and Alexandria, from the Church of Saints Peter and Paul. Gerasa (Jerash), Jordan. Yale University Art Gallery (1932.1735)

of the genre is the so-called Madaba Map mosaic from the early Byzantine Church of Saint George in Madaba, Jordan, dated to about 560–65.[12] Several other examples are found at a number of sites in Jordan from the seventh century.[13] Topographic representations continued under the Umayyad dynasty in the eighth century as well. One, in the acropolis church at Maʿin, dates to 719/20 and depicted eleven cities of Palestine and Transjordan.[14] Another remarkable example is the mosaic from the Church of Saint Stephen at Kastron Mefaa (Umm al-Rasas), also eighth century. The rectangular central portion of this pavement, which depicts a variety of animals and foliage, is surrounded by a border that includes images of several cities in Jordan, Palestine, and Egypt.[15] As beautifully shown in the selection of objects exhibited in "Byzantium and Islam: Age of Transition," cities were a significant iconographic element throughout Byzantine and Early Islamic art. Other features of the Gerasa mosaic, including the fruit-laden trees, the grapevines, and the amphora, are also recurring themes.[16]

Although the Persian invasion of 614 and the Muslim conquest of 636 led to the city's decline, recent excavations have revealed that Gerasa again thrived during the Umayyad period (661–750).[17] Then in 749 the city was hit hard by a series of earthquakes and its population decreased sharply. Gerasa would soon be virtually abandoned, its ruins remaining a feature of the landscape. The site was rediscovered in 1806 by the German traveler Ulrich Jasper Seetzen, followed by Johann Ludwig Burckhardt and James Silk Buckingham in 1812 and 1816, respectively, all travelers who explored the area and recorded visible archaeological remains.[18]

EXCAVATION AND CONSERVATION OF THE CITY MOSAIC

The Church of Saints Peter and Paul was excavated in 1928–29 by the joint Yale–British School Archaeological Expedition. Approximately fifteen to twenty percent of the original nave floor was preserved. After discovery, the pavement was lifted from the ground in five sections and, according to terms of the expedition's partage agreement with Jordan, shipped to New Haven, where it entered the collection of the Yale University Art Gallery. In 1933, Robert G. Eberhard, a professor of sculpture at the Yale University School of Art, supervised treatment of the mosaic. It was first redivided into five rectangular panels. With the panels face down, plaster was applied to the back surface of the tesserae. While the plaster was still wet, a welded steel interior grid with exterior frame was applied. Lines were then scored into the wet plaster within the squares defined by the steel bars, and concrete—Portland cement with aggregate—was poured over the entire plaster and steel grid. This method of backing mosaics with reinforced concrete was a standard conservation practice of the time.[19] The mosaic was hung on a masonry wall in the Art Gallery, where Professor Eberhard also served as curator. After being on view at the museum for about a decade, the mosaic was placed in storage in the 1940s for safekeeping.

In 2009, during the planning stages of the expansion of the Art Gallery's permanent installations, the condition of the Gerasa city mosaic was reassessed to prepare it for installation as the centerpiece of the renovated Isabel B. and Wallace S. Wilson Gallery of Ancient Art, which opened in December 2012. Although the mosaic's years in storage had taken their toll, conservators were confident that treatment would allow the work to be hung once again on the masonry wall of the 1928 Italianate Gothic building. During the course of discussions concerning available treatment options, a loan request was received from the Metropolitan Museum for the mosaic to be prominently displayed at the entrance to the exhibition "Byzantium and Islam." The request was unanimously approved. This new development made it clear that any decisions made about treatments would have to take into consideration challenges

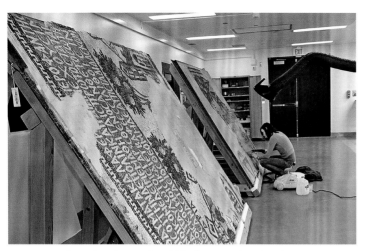

Figure 5. Yale student intern Rae Bichell steam-cleaning the mosaic in 2010 (Courtesy Yale University Art Gallery)

not only of display but also of transport. An interdisciplinary team of designers, engineers, conservators, curators, and collections and exhibitions staff was assembled to undertake the project.

Of highest priority was removal of the corroded steel and severely cracked concrete backings that were gravely threatening the preservation of the mosaic's limestone and marble tesserae. The weight of the mosaic in this state, more than 5,000 pounds, added to its instability and complicated any attempts to maneuver or transport it. Before a treatment plan could be developed, however, thorough documentation of the mosaic's condition and analysis of the materials used in 1933 were essential. The coating on the front surface of the mosaic was identified as linseed oil. Tests for asbestos, sometimes added to concrete mixtures in the first half of the twentieth century, were fortunately negative. Also auspicious was detection of the layer of plaster that separated the concrete from the ancient tesserae. Once all this information was gathered, cleaning and stabilization of the mosaic could begin.

The front surface of the mosaic was cleaned with a combination of steam and organic solvents (fig. 5). A reversible acrylic coating was used to seal the newly cleaned surfaces.

Cracks in the mosaic were consolidated by injecting from the front a mixture of acrylic resin and glass microspheres, a material that is compatible with but distinctly different from the ancient mortar. The front of each mosaic panel was then faced with cotton muslin fabric and animal glue, a traditional water-based system that is strong but easy to remove. Each panel was placed face down on a cushioned torsion box custombuilt for the process of removing the concrete backing.

The concrete removal was achieved by adapting a computer numeric controlled (CNC) cutting machine to mill the concrete using braze-bonded diamond routing bits, a dust extractor, and a Ranque-Hilsch vortex tube spot cooler (fig. 6). The precise locations of the reinforcing steel bars and frames were measured, mapped out, and entered into the computer. To give the machine intervals of time for cooling, during the initial round of milling circles were cut within the squares defined by the interior steel grids (fig. 7). The next round of milling created diagonal cuts through the drilled circles. Any concrete remaining between the squares was easily chiseled off, and the exposed interior steel bars and exterior frame could be removed if there was a bond failure between the concrete and the steel. The final round of milling was done using diagonal passes to achieve a surface to which new composite materials could be bonded, leaving a .25 inch layer of the 1933 plaster that remained securely bonded to the back of the tesserae. This plaster layer was consolidated with acrylic resin, and all cracks were injected with the same acrylic and glass microsphere mixture that was used on the front of the mosaic to serve as a fill material, though not as a structural adhesive. Woven fiberglass was applied with epoxy as a reinforcing layer between the mosaic and the new rigid support.

A review of conservation and industrial literature prompted a reevaluation of materials currently used for backing mosaics and the testing of promising new materials. Laminates of epoxy resin with fiberglass, carbon fiber,

Figure 6. ShopBot computer numeric controlled (CNC) machine milling concrete to expose reinforced steel frame (Courtesy Yale University Art Gallery)

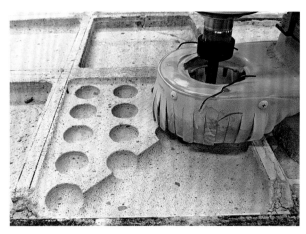

Figure 7. Detail of CNC machine milling through concrete backing (fig. 6) (Courtesy Yale University Art Gallery)

and Kevlar® fiber were tested first. To increase rigidity, composites were made with a poly-ethylene foam core and facings of the three fibers. Engineers were consulted to review the new laminates and composites and to choose compatible backing materials that would provide the additional stiffness required for safe handling, transport, vertical or horizontal exhibition, and long-term preservation. As a reversible alternative to honeycomb aluminum, a composite panel that maximizes stiffness and minimizes the coefficient of thermal expansion was chosen (fig. 8). It is faced with polyester and fiberglass over a 1-inch core of AIREX® T90 closed-cell structural polyester foam that is used by the aerospace, architecture, marine, transit, and wind energy industries.

The polyester foam is available internationally through 3A Composites Core Materials. This was an additional factor in the choice of material, made in the hope that the technique could be adapted by institutions in the Mediterranean region and elsewhere around the world. Fiberglass and polyester foam composite panels with Rotaloc® stainless steel threaded inserts were fabricated by Composite Panel Solutions. The inserts were embedded into the panels as attachment points for custom-made hanging hardware.

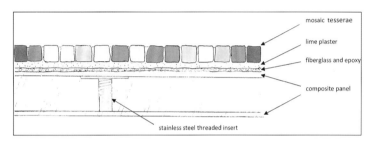

Figure 8. Schematic drawing of new backing materials (Courtesy Yale University Art Gallery)

The flanged anchor was oriented toward the front of the mosaic to increase load-bearing capability. Each new panel weighs less than 1.1 pound per square foot. The composite panels were attached to the backs of the mosaic

Figure 9. Reverse of mosaic showing composite panel with aluminum framework for vertical installation (Courtesy Yale University Art Gallery)

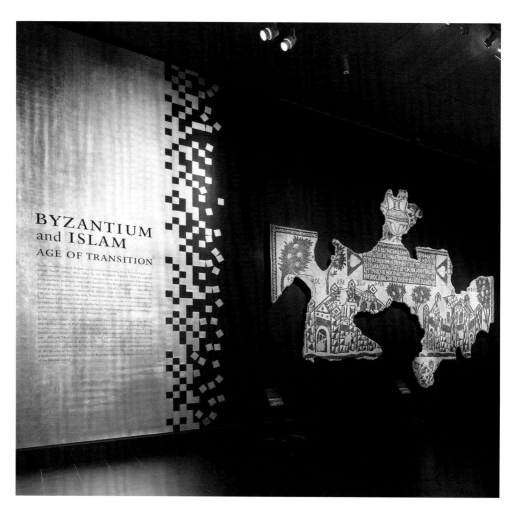

Figure 10. Installation view showing entrance wall to the exhibition "Byzantium and Islam: Age of Transition," The Metropolitan Museum of Art, 2012

panels with epoxy bulked with fumed silica to fill voids and improve bond strength.

Once the mosaic panels were backed they were flipped, the facings were removed, and the mosaic surfaces were cleaned with warm water to remove any remnant of the facing adhesive. With the mosaic face up and all edges visible, excess plaster from the 1930s along the exterior edges was trimmed further with the CNC cutter and a 3-inch diamond-edged circular saw. Areas of the new fiber-glass and composite panel were trimmed with a jigsaw. Edges were given a skim coat of water-based acrylic emulsion paste mixed with clean sand. Losses present at the time of excavation were filled with the same material. Losses between panels were filled with polyethylene foam carved and painted

as tesserae, the patterns of which had been reconstructed using the Art Gallery's digitized archive of excavation photographs.

As a final step, a brace of 3 x 3 inch tubular aluminum was welded with aluminum plate "feet" for mechanical attachment to the steel inserts on the reverse of the panels (fig. 9). The brace hangs on aluminum cleats that are attached to the wall with anchor bolts. The conservation treatment reduced the weight of the mosaic from approximately 21 pounds per square foot to 5 pounds per square foot; its overall weight was reduced from over 5,000 pounds to just under 1,300 pounds. Installation of the complete mosaic thus required a team of only five people, two lifts, and two ladders.

*Age of Transition: Byzantine Culture in the Islamic World*

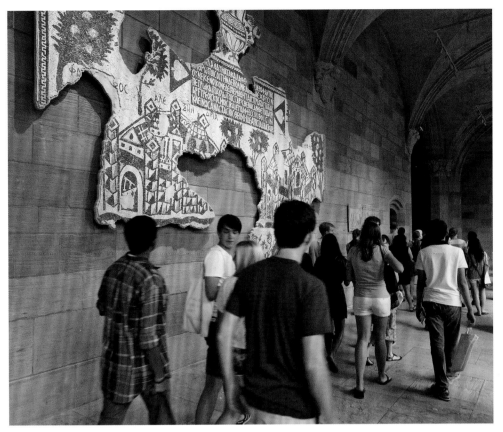

Figure 11. Gerasa city mosaic installed in the Isabel B. and Wallace S. Wilson Gallery of Ancient Art, Yale University Art Gallery, 2013 (Photo: Jessica Smolinsky)

During the course of the Gerasa mosaic project there were many discussions among the participating conservators and curators. Treatments deemed necessary for the safety and stability of the object were weighed together with aesthetic preferences and decisions about installation. One of the first issues to be discussed involved how to frame the preserved fragments and how much of the missing areas to fill and/or reconstruct. Some options had been discussed during previous assessments of the mosaic and proposals for its treatment.[20] Ultimately, the curators at Yale decided to reconstruct as little as possible around the preserved section of the mosaic, preferring an aesthetic that would be quite different from that of the rectangular framework into which the fragments were set in the 1930s. The objective was to focus on the work itself, so that viewers could easily imagine the floor extending in all directions. The composite panel backing made this highly viable, since there would be no structural need for any additions to the preserved section. The only exception to this decision occurs on either side of the narrow strip of mosaic that connects the main section to the small fragment with the tree in the upper left. Here it was necessary to make the backing panel larger than the preserved area in order to reinforce it.

When preparing a floor mosaic for exhibition several factors must be taken into account. Installing it on the floor of course gives visitors the best sense of its original context and function. Other considerations, however, can lead to a vertical, wall-hung installation. One of these, which is purely practical, is whether there is the necessary square footage to make a floor installation possible. Furthermore, even if there is enough space, a horizontal installation leaves less room for cases and pedestals in which other objects can be displayed.

The curators at both the Metropolitan Museum and the Yale Art Gallery eventually decided that it would make for a better and more comprehensive installation overall if the Gerasa mosaic were to hang vertically (figs. 10, 11). And, in fact, because the mosaic is so large and has so much detail, elements such as the inscription and the amphora were more easily legible from the wall. A vertical installation of the mosaic would have been structurally impossible and unsafe when it still retained its old cracked concrete backing from the 1930s. The innovative conservation treatment—removal of the concrete and development of the relatively lightweight and strong composite panel backing—afforded greater flexibility and control in creating an effective installation design. If so desired, the mosaic can also be displayed on the floor.

The Yale Art Gallery's collection of artifacts from the excavations at Gerasa includes several other mosaics, of which one from House VI, or the House of the Choristers, is on permanent view.[21] The smaller size of this fragment (approximately 50 x 100 inches) and its simpler decorative scheme led to the decision to install it on the floor. Like the city mosaic, the Choristers mosaic was lifted from the site in the 1920s and backed with the same combination of concrete and steel, but its condition was stable enough that removal of the backing was unnecessary. In the collection of the Art Gallery is also a large geometric mosaic from the Church of Bishop Paul (Prokopios Church) that had never been on display. Excavated in the same season as the city mosaic, this geometric pavement was also lifted in sections (originally ten, nine of which survive today) and then backed with concrete reinforced only with iron chicken wire–type mesh. This mosaic was the centerpiece of the exhibition "Roman in the Provinces: Art on the Periphery of Empire," on view at Yale from August 2014 to January 2015, and the McMullen Museum of Art at Boston College from February to June 2015. In this exhibition the geometric mosaic was installed horizontally on the floor. Its treatment, completed in 2014, was based on the innovative technologies and methods that were so successfully used to clean, stabilize, and exhibit the city mosaic from Gerasa.

1. Surface surveys and very small-scale excavations were undertaken in the late nineteenth and early twentieth centuries. Continuous interest in the site led to more systematic exploration and conservation of the ruins after World War I, culminating in the expedition begun by Yale University and the British School of Archaeology in Jerusalem (1928–30) and continued by Yale and the American Schools of Oriental Research (1930–31; 1933–34). See Crowfoot 1931 and Kraeling 1938.
2. Zayadine 1986–89. See also Ostrasz 1989 and Damgaard and Blanke 2004.
3. See Browning 1982.
4. *Naturalis Historia* 5.16.74.
5. For discussions of the later history of Gerasa, see March 2009 and Wharton 1995.
6. The dedicatory inscription, as translated, reads: "Certainly, my bishop brings beautiful marvels to the people who inhabit this city and land, because he built a house [of worship] to Peter and Paul, the chiefs of the disciples (for the Savior imparted the authority to them), and adorned it with silver and beautifully colored stones; the renowned Anastasios, who teaches the true precepts of God."
7. Kraeling 1938: 251.
8. Piccirillo 1992: 34, 292.
9. Ling 1998: 99.
10. Levi 1947, vol. 1: 319.
11. Piccirillo 1992: 34, 273–75, 288.
12. Ibid.: 26–34, and Donner 1992.
13. Piccirillo 1992: 34–35.
14. Dunbabin 1999: 202; Piccirillo 1992: 35–36, 200–201.
15. Dunbabin 1999: 203; Piccirillo 1992: 36–37, 238–39; *Jordan Jubilee* n.d.
16. Evans 2012, nos. 2, 23, 24a–n, 67, 79a, b, and 141.
17. On the Umayyad mosque discovered at Jerash, see Walmsley 2003a and 2003b and Walmsley and Damgaard 2005.
18. See Seetzen 1854; Burckhardt 1822; and Buckingham 1822.
19. See the Worcester Art Museum publication on Antioch mosaics, Becker and Kondoleon 2005.
20. See Podany and Matheson 1999 and Brody and Snow 2010.
21. On the mosaics from Gerasa, see the website of the Yale University Art Gallery (artgallery.yale.edu).

# REFERENCES

**Becker, Lawrence, and Christine Kondoleon, eds.**
**2005**    *The Arts of Antioch: Art Historical and Scientific Approaches to Roman Mosaics and a Catalogue of the Worcester Art Museum Antioch Collection.* Worcester, Mass.: Worcester Art Museum.

**[Brody, Lisa, and Carol Snow]**
**2010**    "A Floor Mosaic from Gerasa." In "Time Will Tell: Ethics and Choices in Conservation," *Yale University Art Gallery Bulletin,* 2010: 81–83.

**Browning, Iain**
**1982**    *Jerash and the Decapolis.* London: Chatto & Windus.

**Buckingham, J[ames] S[ilk]**
**1822**    *Travels in Palestine, through the Countries of Bashan and Gilead, East of the River Jordan; Including a Visit to the Cities of Geraza and Gamala, in the Decapolis.* 2nd ed. 2 vols. London: Longman, Hurst, Rees, Orme, and Brown.

**Burckhardt, [Johann Ludwig]**
**1822**    *Travels in Syria and the Holy Land.* London: John Murray.

**Crowfoot, John Winter**
**1931**    *Churches at Jerash: A Preliminary Report of the Joint Yale–British School Expeditions to Jerash, 1928–1930.* British School of Archaeology in Jerusalem, Supplementary Papers 3. London: Beccles; printed by W. Clowes and Sons.

**Damgaard, Kristoffer, and Louise Blanke**
**2004**    "The Islamic Jarash Project: A Preliminary Report on the First Two Seasons of Fieldwork." *Assemblage,* no. 8. www.assemblage.group.shef.ac.uk /issue8/damgaardandblanke.html.

**Donner, Herbert**
**1992**    *The Mosaic Map of Madaba: An Introductory Guide.* Kampen: Kok Pharos Publishing House.

**Dunbabin, Katherine M. D.**
**1999**    *Mosaics of the Greek and Roman World.* Cambridge: Cambridge University Press.

**Evans, Helen C., ed.**
**2012**    *Byzantium and Islam: Age of Transition, 7th–9th Century.* Exh. cat. New York: The Metropolitan Museum of Art.

***Jordan Jubilee***
**n.d.**    "The Mosaics of the Madaba Plateau of Jordan." In *Ruth's Jordan Jubilee.* www.jordanjubilee.com /history/mosaics.htm.

**Kraeling, Carl H.**
**1938**    *Gerasa: City of the Decapolis; An Account Embodying the Record of a Joint Excavation Conducted by Yale*

University and the British School of Archaeology in Jerusalem (1928–1930), and Yale University and the American Schools of Oriental Research (1930–1931, 1933–1934). New Haven, Conn.: American Schools of Oriental Research.

**Levi, Doro**
**1947**    *Antioch Mosaic Pavements.* 2 vols. Princeton, N.J.: Princeton University Press.

**Ling, Roger**
**1998**    *Ancient Mosaics.* London: British Museum Press.

**March, Charles**
**2009**    *Spatial and Religious Transformations in the Late Antique Polis: A Multi-disciplinary Analysis with a Case-Study of the City of Gerasa.* BAR International Series 1981. Oxford: Archaeopress.

**Ostrasz, Antoni A.**
**1989**    "The Hippodrome of Gerasa: A Report on Excavations and Research 1982–1987." *Syria* 66: 51–77.

**Piccirillo, Michele**
**1992**    *The Mosaics of Jordan.* Edited by Patricia M. Bikai and Thomas A. Dailey. American Center of Oriental Research 1. Amman, Jordan: American Center of Oriental Research.

**Podany, Jerry, and Susan B. Matheson**
**1999**    "Urban Renewal: The Conservation of a City Mosaic from Ancient Gerasa." *Yale University Art Gallery Bulletin:* 21–31.

**Seetzen, Ulrich Jasper**
**1854**    *Reisen durch Syrien, Palästina, Phönicien, die Transjordan-Länder, Arabia Petraea und Unter-Aegypten.* Edited by Fr. Kruse. 4 vols. in 2 parts. Berlin: G. Reimer.

**Walmsley, Alan**
**2003a**   "The Friday Mosque of Early Islamic Jarash in Jordan: The 2002 Field Season of the Danish-Jordanian Islamic Jarash Project." *Journal of the David Collection* 1: 111–31.

**2003b**   "The Newly-Discovered Congregational Mosque of Jarash in Jordan." *Al-'Usur al-Wusta: The Bulletin of Middle East Medievalists* 15, no. 2: 17–24.

**Walmsley, Alan, and Kristoffer Damgaard**
**2005**    "The Umayyad Congregational Mosque of Jarash in Jordan and Its Relationship to Early Mosques." *Antiquity* 79 (June): 362–78.

**Wharton, Annabel Jane**
**1995**    *Refiguring the Post Classical City: Dura Europos, Jerash, Jerusalem and Ravenna.* Cambridge: Cambridge University Press.

**Zayadine, Fawzi, ed.**
**1986–89**  *Jerash Archaeological Project.* 2 vols. Amman: Department of Antiquities of Jordan.

*Edward Bleiberg*

# Art and Assimilation: The Floor Mosaics from the Synagogue at Hammam Lif

In 1905 the Brooklyn Museum purchased twenty-one panels of mosaic, part of the floor of a synagogue built about 500 C.E. Excavated in 1883 eleven miles east of Tunis in Hammam Lif, Tunisia, the synagogue was located on the plain between the Mediterranean Sea and Mount Bou Kornine. It was the first of nearly three hundred ancient synagogues that would be discovered around the Mediterranean in the course of the next hundred years. The floor embellished a space that measured approximately 9 x 5 meters (fig. 1). This paper considers why the Brooklyn Museum, a secular, public institution, might have been interested in acquiring these objects in 1905. Beginning with interpretations of the mosaics by scholars prior to their acquisition by the museum, it then explores issues of interpretation in the twenty-first century, drawing on research done for an exhibition on the mosaics organized by the Brooklyn Museum in 2005.[1]

## DISCOVERY AND RECEPTION

The synagogue and floor were discovered February 17, 1883, by Capt. Ernest de Prudhomme, a member of the French military then occupying Tunisia. Prudhomme had ordered soldiers under his command to dig a vegetable garden for him. Almost immediately they began to uncover multiple colored stones. Although Prudhomme had no archaeological training, he recognized the stones as mosaic tesserae, and henceforth he treated his garden site as an archaeological excavation.

Within days of the discovery Prudhomme consulted with eminent French classicists to determine what he had found. The experts included an impressive number of both classical archaeologists and philologists. Yet each of these scholars, in the later years of the nineteenth century, was heir to the universalist principles of the French Revolution and were to some extent influenced by the reactionary nationalism and clericalism of late-nineteenth-century France, which found expression in the Dreyfus Affair. These principles and reaction to them form the cultural context for the reception of the ancient synagogue—the first such discovery in modern times. Previous to Prudhomme's discovery, the nature of decoration in ancient synagogues had been forgotten and it was generally believed that the Jewish tradition did not allow for a figurative art.[2]

The first expert to arrive at the site was Father A. L. Delattre (1850–1932), founder of the Musée Alaoui in Tunis, today the Bardo National Museum. Father Delattre examined the mosaics and believed that he recognized the Greek letters alpha and omega flanking one of the two images of a menorah that appear in the mosaic floor (fig. 2). The presence of these letters suggested to Delattre that the floor had been part of a church, on the basis of a quotation from the Book of Revelation (22:13), in which Jesus declares: "I am the Alpha and the Omega, the beginning and the end, the first and the last." Delattre's explanation for the presence of the menorahs—symbols of the Jewish faith—was that the building had originally been a synagogue and was later converted to a church. He attributed the figurative decoration to the later, Christian owners of the building.[3]

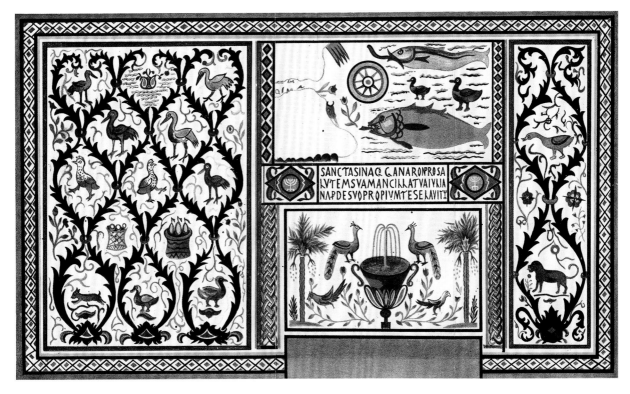

Figure 1. Mosaic floor from the synagogue at Hammam Lif, Tunisia, 6th century. Watercolor by Corporal Peco, 1883 (from Renan 1884, pls. VII, VIII)

The earliest rendering of the mosaic, a watercolor dating to 1883 (see fig. 1 above), does not in fact show anything that resembles the two Greek letters. Further complicating evaluation of Delattre's observations, the floor in its present state shows neither the menorahs with the shapes that Delattre interpreted as the alpha and omega nor the two shapes represented in the watercolor. Evidently, some change had taken place between 1883, when the watercolor was made, and 1905, when the mosaic arrived—mounted in cement in an iron frame—at the Brooklyn Museum.

The second expert to visit the site was the historian and numismatist Gustave Schlumberger (1844–1929). Schlumberger's visit was especially significant for his attention to the donor inscriptions from the

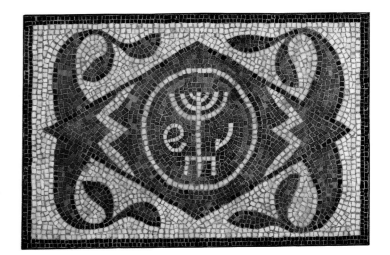

Figure 2. Mosaic with menorah, from the synagogue at Hammam Lif, Tunisia, 6th century. Brooklyn Museum, New York, Museum Collection Fund (05.26)

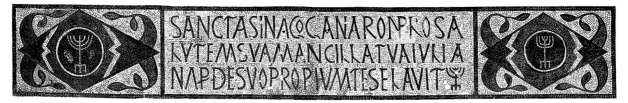

Figure 3. Donor inscription, in Latin, from the floor mosaic of the synagogue at Hammam Lif, Tunisia, 6th century (from Renan 1884, pls. IX, X)

site, of which there were three, all in Latin. Schlumberger sent copies of the inscriptions to Ernest Renan (1823–1892), who published them in his prestigious *Revue archéologique*. Renan's publications outlined the philological problems with the inscriptions and are today still valuable sources.[4] The most important of the inscriptions reads, in translation: "Your servant Julia Nap, at her own expense, paved the holy synagogue of Naro [the ancient name of Hammam Lif] with mosaic for her salvation" (fig. 3).[5] Based on this inscription, Renan accepted that the building was a Jewish synagogue, although the word *sinagoga* in the original Greek from which the Latin was derived could have the more general meaning of a meeting place for any kind of group.

Renan, the greatest Latin philologist of his day, was also a devout Christian. Renan popularized the fact that Jesus had been a Jew who lived in a world that could be known through archaeology. Like many religious people of his generation, he was interested in recovering the world of the historical Jesus, both through archaeological objects from the first century C.E. and through a thorough knowledge of the languages that were used around the Mediterranean at that time. He was also comfortable with the idea that ancient synagogues were recoverable archaeological sites that could reveal more about the history of Christianity.[6] Moreover, his scholarship supported the notion that Jewish culture contributed to the development of European culture. Although Renan was critical of Judaism and its rejection of the teachings of Jesus, his ideas were widely believed to validate Jewish

participation in nineteenth-century European culture and thus were welcomed by European Jewish scholars then emerging in the world of academe, especially in France.

Two Jewish classicists, David Kaufmann (1852–1899) and Salomon Reinach (1858–1932), also examined the drawings of the mosaics. Kaufmann and Reinach expressed differing opinions of what they represented. Their discussions were published in the *Revue des études juives* in 1886.[7] Kaufmann was a German-speaking Hungarian Jew living in Budapest and a subject of the Austro-Hungarian Empire. Writing from the viewpoint of the so-called German school of Jewish studies, he emphasized Jewish particularism and the isolation of the Jewish experience in the classical world. This isolation was in some ways reflected in Kaufmann's own experience, living as he did in a culture where Jews were not fully accepted in society. They could not, for example, attain the status of university professor. For Kaufmann the two images of the menorah on the mosaic floor combined with the reference in the donor inscription to the building as a "synagogue" left no question that this discovery represented an early synagogue. He thus came to the same conclusion as had Renan.

The experience of Salomon Reinach, living in France, was quite different. In 1789, France had become the first European country to grant resident Jews full citizenship. In France, unlike in German-speaking lands, Jews could hold academic and museum posts. Furthermore, many French Jewish scholars wanted to reinstate the idea of Judaism as a "constitutive element in the

making of the West and modernity."[8] This impulse supported recognition of the assimilationist tendencies among Jews living in the Roman Empire, which reflected Reinach's own experience in France. Nevertheless, Reinach's interpretation of the synagogue floor was complicated by his own philosophical legacy.

As a Darwinian and an heir to the Enlightenment, Reinach believed that religion would eventually die out as reason came to replace superstition. He also believed that Judaism, while it was the earliest form of monotheism, was destined to evolve into a belief system that would jettison such "superstitious" practices as restrictive dietary laws, retaining only its core of ethical beliefs. These beliefs, for Reinach, coincided with universalist French modernity in his own time. He certainly identified as a Jew, understood that society responded to him as a Jew, and was involved in Jewish causes. He was, for example, a leader in defending Captain Dreyfus from charges of treason. But his preexisting belief system strongly influenced his interpretation of the Hammam Lif mosaics.

Reinach recognized that the images of the menorahs on the mosaic floor were Jewish symbols and was well aware that the donor inscription called the building a synagogue. But he maintained that in Roman times Jews had not yet evolved sufficiently to have figurative art in their buildings. In Reinach's defense, the idea that Jewish synagogues in the Roman world had mosaic decoration similar to that of contemporaneous buildings designed for their Christian neighbors was still new. But in spite of the clear evidence that would overturn his preconceptions, Reinach argued that only the menorahs were original to the synagogue; the figurative elements of the floor must have been added after the building became a church. His argument was thus based on his Darwinian construct of the natural progression of Judaism, but it was a construct with no supporting data, an instance of fitting "evidence" into an already existing pattern of belief. Reinach's conclusions were,

coincidentally, the same as those of the Jesuit, Father Delattre.

## THE MOSAICS AFTER EXCAVATION

Captain Prudhomme, in whose vegetable garden the tesserae had first appeared, took twenty-five mosaic panels back to France when he was released from the army. An unknown number of panels (now lost) were acquired by the Musée Alaoui; three remain in the collection of the Bardo Museum.[9]

The twenty-one panels later purchased by the Brooklyn Museum were next seen in 1891, at the Hôtel Drouot, the large Paris auction house, where they were purchased by Edouard Schenk of Toulouse, about whom virtually nothing is known save that he was described as a jeweler.[10] In 1898 the archaeologists René Cagnat (1852–1937) and Paul Gauckler (1866–1911) claimed that Schenk had given several of the mosaics to the Musée de Toulouse.[11] But in fact it was only photographs of the mosaics—not the mosaics themselves—that had been deposited there.[12] (The photographs are now lost.)

The mosaics again appeared on the market in 1905, in Paris, at the antiquities dealer Rollin et Feuardent. They were acquired that year by the Brooklyn Museum through the agency of Henri de Morgan. Depicted in the mosaics were a fish and a date palm tree from the panels above and below the inscription; a duck, another bird, and a basket with fruit from the panel at left; and the lion from the panel at right (fig. 4a–f).

## THE MOSAICS IN BROOKLYN

The brothers Henri (1854–1909) and Jacques (1857–1924) de Morgan were archaeologists and antiquities dealers, a combination not uncommon in the late nineteenth and early twentieth centuries. As archaeologists they excavated in Egypt for the Brooklyn Museum from 1905 to 1909, and through the process of partage, whereby the archaeological finds were divided between the excavators and the Egyptian government,

Figure 4a–f. Details of a fish, a date palm tree, a duck, a bird in a vine, a basket with fruit, and a lion, from the floor mosaic of the synagogue at Hammam Lif, Tunisia, 6th century (see fig. 1). Brooklyn Museum, New York, Museum Collection Fund (05.15, 05.14, 05.21, 05.34, 05.24, 05.18)

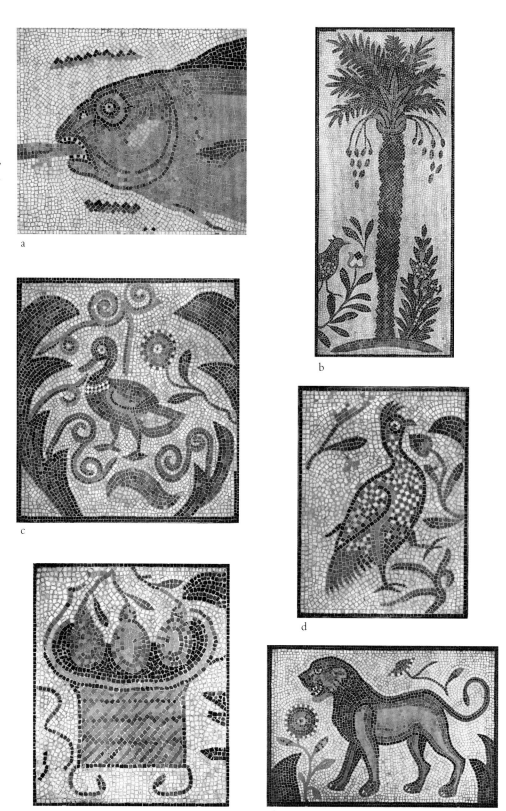

a

b

c

d

e

f

*Age of Transition: Byzantine Culture in the Islamic World*

they helped the Brooklyn Museum acquire its first substantial collections of Egyptian antiquities. The de Morgan brothers had a similar arrangement with the Musée d'Archéologie Nationale et Domaine National in Saint-Germain-en-Laye. The director of that museum in 1905 was none other than Salomon Reinach, who had taken so much interest in the Hammam Lif mosaics nearly two decades earlier. Although the mosaics would not have been of interest to Reinach's institution, it is not impossible that Reinach could have brought the sale of the mosaics to the de Morgan brothers' attention.

In 1905, when the mosaics were offered for sale, the Brooklyn Museum had just completed a second phase of construction. Large new galleries had to be filled, and the museum was expanding its collections in many directions. In addition to the synagogue mosaics, the other major art acquisition of this period, in 1900, was *The Life of Our Lord Jesus Christ*, a set of 350 watercolors by the French painter and illustrator James Tissot (1836–1902), first presented in Paris in 1894.[13] The watercolors depict events from the Life of Christ in an archaeologically correct setting. Like Renan, Tissot believed that the Life should be understood within the context of first-century Roman Judaea and that the physical setting could properly be understood and determined through archaeology. That this archaeology had a Jewish context might well have been of interest to the museum's major patron in this period, Abraham Abraham (1843–1911).

Abraham had a strong connection to the Brooklyn Museum. The museum was at that time part of the Brooklyn Institute of Arts and Sciences, incorporated in 1890.[14] Abraham was a founding member of the institute's board of trustees. His generous donation at the time of incorporation resulted in a life membership granted to him in 1891. He served on the board until his death in 1911.

Abraham Abraham led a life in Brooklyn that was in some ways similar to that of his contemporary in France, Salomon Reinach. Abraham's father had immigrated to New York from Bavaria. Abraham, like Reinach, benefitted from the right to full citizenship granted Jews in the United States. But unlike Reinach, whose father had made a fortune that allowed Salomon to dedicate his life to scholarship, Abraham made the family fortune himself, founding an early department store, Wechsler & Abraham, in Brooklyn in 1865. In 1893 the Straus family purchased Wechsler's share of the business, which was then renamed Abraham & Straus.

Abraham also devoted himself to a variety of philanthropies in addition to the Brooklyn Museum. His interest in antiquity was demonstrated in his donation of Babylonian and Assyrian cuneiform tablets to Cornell University. His charitable work benefitted both Jewish and secular institutions in Brooklyn. He was president of the board of trustees of the Hebrew Orphan Asylum and the Jewish Hospital, vice president of the Society for the Prevention of Cruelty to Children, and director of the Brooklyn Bureau of Charities. In the words of the Brooklyn Museum board's directive to establish a memorial fund for Abraham, "He was a generous friend and supporter of many movements in the interests of Brooklyn and the entire City."[15] Though a businessman and not a scholar like Reinach, he seems to have shared with Reinach a wide-ranging view of the role Jews could play in modern secular society. It is therefore not surprising that Abraham Abraham took an active interest in the Hammam Lif mosaics, the first clear archaeological evidence of Jewish assimilation in Roman times.

## CONTEMPORARY ISSUES

Today, while popular interest in the mosaics stems in part from this association, the patron's inscription quoted above leads to a question that is perhaps more relevant in the twenty-first century, namely, the role of women in religion during antiquity.[16] That the patron of the synagogue floor—Julia Nap—was a woman does not appear to have

been of interest to any of the nineteenth-century commentators on the history and meaning of the floor. In contrast, my own education in the 1970s and 1980s led me, as curator of the 2005 exhibition on the mosaics, to devote an entire section of the catalogue to the role of women in Judaism during the Greek and Roman period.[17]

One hundred years after the Brooklyn Museum acquired the Hammam Lif mosaics, Steven Fine produced an art-historical study of Jewish art from antiquity that includes a consideration of the nineteenth-century scholarship that has been under review in this essay.[18] He not only identifies the prejudices of early scholars that prevented them from recognizing the presence of Jewish art, he clears away the objections to acknowledging its existence in the ancient world. For in spite of the common misconception that rabbinic law forbade art-making in ancient times, the prohibition against images of the deity was much more narrowly interpreted by ancient Jews. The scholarship of Margaret Olin also illustrates the thought processes and prejudices of nineteenth-century scholars who viewed Jews as a "nation without art."[19] Thus in our own time does the interpretation of such works as the Hammam Lif mosaics continue to evolve.

1. The exhibition "Tree of Paradise: Jewish Mosaics from the Roman Empire" was held at the Brooklyn Museum from October 28, 2005, to February 12, 2006, and then traveled to the Lowe Art Museum, Miami, the McMullen Museum of Art, Boston, and the Dayton Art Institute.
2. Olin 2001.
3. Delattre published articles about the mosaics in the *Journal officiel tunisien* on March 18 and 29, 1883, and again on May 11, 1883, according to an unpublished letter from Henri de Morgan to the *New York Times* dated June 21, 1905. The draft of the letter is in the departmental files of the Egyptian, Classical, and Ancient Near Eastern Art collection of the Brooklyn Museum.
4. Renan 1883: 158.
5. Quoted in Bleiberg 2005: 25.
6. Rodrigue 2004: 9–10.
7. Kaufmann 1886; Reinach 1886.
8. Rodrigue 2004: 9.
9. La Banchère and Gauckler 1897. Three of the inscriptions and the representation of a bird, "un canard," are listed on page 12, nos. 15–18. The remainder of the figurative elements have not been located.
10. Archives of the Brooklyn Museum. I have attempted to locate descendants of Edouard Schenk without success.
11. "Les fragments de mosaïques conservés par M. de Prudhomme ont été vendus après sa mort, et sont aujourd'hui au Musée de Toulouse"; Cagnat and Gauckler 1898: 152n2. See also Evans 2012: 110, no. 73a.
12. For a descriptive list of the photographs, see *Bulletin de la Société Nationale des Antiquaires de France*, 1895: 150–52.
13. See Dolkart 2009.
14. Information on Abraham Abraham is drawn from the Director's file, Archives of the Brooklyn Museum.
15. Ibid., 1911.
16. See, for example, Kraemer 1992.
17. See "The Donor's Inscription" and "Women in Synagogues," in Bleiberg 2005: 25–26, 61–62.
18. Fine 2005.
19. Olin 2001.

## REFERENCES

**Bleiberg, Edward**
2005   *Tree of Paradise: Jewish Mosaics from the Roman Empire.* Exh. cat. Brooklyn: Brooklyn Museum.

**Cagnat, René, and Paul Gauckler**
1898   *Les Monuments historiques de la Tunisie.* Part 1, *Les Monuments antiques; les temples païens.* Paris: Ernest Leroux.

**Dolkart, Judith F., ed.**
2009   *James Tissot, The Life of Christ: The Complete Set of 350 Watercolors.* Texts by Judith F. Dolkart, David Morgan, and Amy Sitar. London and New York: Merrell Publishers in association with the Brooklyn Museum.

**Evans, Helen C., ed.**
2012   *Byzantium and Islam: Age of Transition, 7th–9th Century.* Exh. cat. New York: The Metropolitan Museum of Art.

**Fine, Steven**
2005   *Art and Judaism in the Greco-Roman World: Toward a New Jewish Archaeology.* Cambridge: Cambridge University Press.

**Kaufmann, David**
1886   "Etudes d'archéologie juive, I: La Synagogue de Hammam-Lif." *Revue des études juives* 13: 46–61.

**Kraemer, Ross Shepard**
1992   *Her Share of the Blessings: Women's Religions among Pagans, Jews, and Christians in the Greco-Roman World.* New York: Oxford University Press.

**La Banchère, Feu du Coudray, and P[aul] Gauckler**
1897   *Catalogue du Musée Alaoui.* Paris: Ernest Leroux.

**Olin, Margaret**
2001   *The Nation without Art: Examining Modern Discourses on Jewish Art.* Lincoln: University of Nebraska Press.

**Reinach, Salomon**
1886   "Notes sur la Synagogue d'Hammam el Enf." *Revue des études juives* 13: 217–23.

**Renan, Ernest**
1883   "Les Mosaïques de Hamman-Lif." *Revue archéologique,* ser. 3, 1: 157–63.

1884   "La Mosaïque de Hamman-Lif. Nouvelles observations." *Revue archéologique,* ser. 3, 3: 273–75.

**Rodrigue, Aron**
2004   "Totems, Taboos, and Jews: Salomon Reinach and the Politics of Scholarship in *Fin de Siècle* France." *Jewish Social Studies,* n.s., 10, no. 2: 1–19.

Steven Fine

# When Is a Menorah "Jewish"?: On the Complexities of a Symbol during the Age of Transition

On September 9, 2013, the archaeologist Eilat Mazar announced the discovery of a large trove of Byzantine gold coins, the latest dated no later than 602 C.E., a silver bar, and gold jewelry that was uncovered just fifty meters south of the Temple Mount, Haram al-Sharif, in Jerusalem.[1] The most spectacular of these finds was a large medallion (10 cm in diameter) suspended from an elegant Byzantine chain, of the sort that in Christian contexts is embellished with images of Christ, the Virgin, and other saints (fig. 1).[2] At the center of the medallion is a large seven-branched menorah flanked at left by an angular horn—likely a ram's horn, or shofar—and on the right by an object that is not so clearly identified.[3] The archaeologists suggest that the treasure was taken to Jerusalem shortly after the Sasanian capture of the city in 613 C.E., to be used to contribute to the construction of synagogues, or even to "rebuild the Temple."[4] It was lost, and not retrieved, they speculate, when the city reverted to the Christians. Other scenarios for the loss of such a valuable treasure are, of course, just as likely—though perhaps less romantic. The "Age of Transition" from the world of New Rome to the Islamic Caliphate was

not a smooth and peaceful development by any means.[5]

My objective in this paper is to trace the trajectory of one element of the Jerusalem medallion: its menorah. I will begin by contextualizing the image as it appears in the Roman East during the centuries encompassed by the exhibition "Byzantium and Islam"—called by some the Byzantine and Early Islamic periods, by others Late Antiquity, and by the curator of the exhibition, Helen Evans, simply, the Age of Transition. I will then discuss ways that Jewish and other communities in Palestine, beginning with the Samaritans, used this image, and continue with an exploration of the supersession of temple imagery—particularly the menorah—first by Christians and then by the Umayyads.

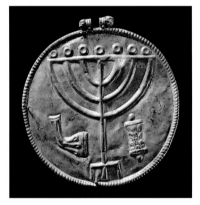

Figure 1. Gold medallion with seven-branched menorah, from the Menorah Treasure. Temple Mount, Jerusalem, 6th–7th century (Courtesy Dr. Eilat Mazar and the Israel Antiquities Authority. Photo: Vladimir Neichen)

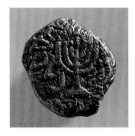

Figure 2. Bronze lepton of Mattathias Antigonos, ca. 39 B.C.E. Collection of Shlomo Moussaieff (Courtesy George Blumenthal, Center for Online Judaic Studies)

Most menorahs that appear on artifacts from Late Antiquity were placed there as markers of Jewish identity.[6] The large and diverse Jewish population of the Roman Empire, stretching from Spain to Hungary, Asia Minor, North Africa, and the Near East, with its center in Judaea (Palestine after the Second Jewish Revolt of 132–35), used this "symbol" as a marker of identity and presence in a broad range of contexts—from synagogue decoration to ritual objects, funerary monuments to personal jewelry.[7] This usage is known as early as 39 B.C.E., when the menorah, signifying the Temple of Jerusalem, appeared on the leptons of the last Hasmonean king, Mattathias Antigonos (fig. 2), who used the coins to fund his unsuccessful battle against the Romans and the usurper Herod.[8] The menorah was used more broadly in first-century Judaea before the destruction of the Temple by Vespasian and Titus in 70 C.E. There it appeared in tomb decoration; on a sundial (fig. 3), etched in plaster in a patrician villa in Jerusalem; and, most publicly and so significantly, on a recently discovered object from a synagogue in Magdala on the Sea of Galilee, where it is depicted resting upon a decorated pedestal (fig. 4).[9] The seven-branched golden menorah in the Temple of Jerusalem, on which these images are based, was something like eighteen handbreadths tall. Alight within the *naos* of the Temple, it was apparently placed on public display during the Jewish festivals much as cult objects were occasionally displayed in "pagan" temples.[10] Its unique form overshadowed the other sacred artifacts in visual depictions, overpowering the less distinctive though equally significant biblical artifact the Table of the Presence.[11]

The menorah undoubtedly became more widely known throughout the empire in the centuries that followed owing to the outstanding depiction of the golden menorah on the Arch of Titus reliefs and the public display of this artifact meters away in Vespasian's Temple of Peace, likely until the Visigoth sacking of Rome in 410 C.E. (figs. 5, 6).[12] From the fourth century onward, the menorah became ubiquitous in Jewish visual culture as a cipher for Judaism and Jewishness. This usage was likely strengthened by the parallel development of the cross as a cipher for Christianity and the rather callous destruction of non-Christian religion, evidenced by the demolition of Jewish synagogues and the defacement of the menorah (fig. 7).[13]

A biblical icon of unique form, the menorah has been recognized as a sign of Jewish presence for centuries. Its depiction was so standardized during Late Antiquity that it is often difficult to distinguish the origins of a menorah in one region from that in another. Even small design elements were often consistent across vast distances, as, for example,

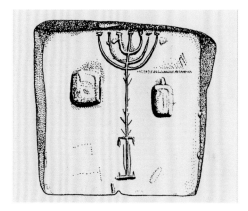

Figure 3. Drawing of a sundial with menorah decoration. Jerusalem, 1st century C.E. (from Hachili 2001: 44, fig. II.3)

Figure 4. Stone object with menorah. Magdala, Israel, 1st century C.E. (Courtesy R. Steven Notley)

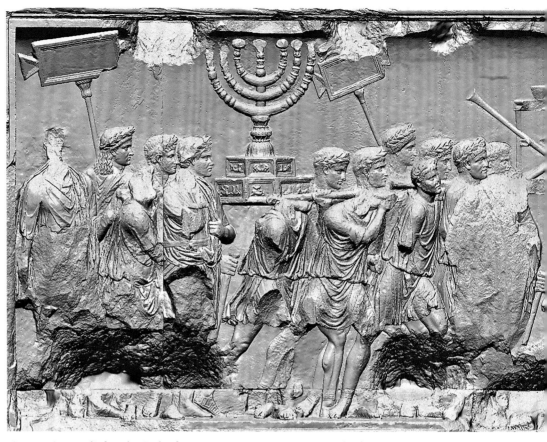

Figure 5. Stone relief on the Arch of Titus. Rome, 1st century C.E. (Arch of Titus Digital Restoration Project, 3-D scan)

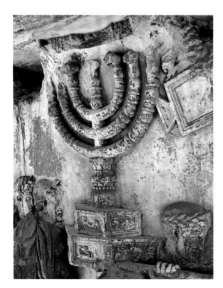

Figure 6. Detail of relief on the Arch of Titus (fig. 5) (Photo: Steven Fine)

the depiction of all the flames oriented toward the central flame—a detail noted by Palestinian rabbis who claimed to have seen this configuration on the menorah in Rome and on menorah images from Palestine to Asia Minor to Rome (figs. 8, 9).[14] Regional forms, however, did appear—most distinctly in depictions from Asia Minor, which show volutes beneath the branches, reflecting the localization of the image (figs. 10, 11).[15] The volutes were sometimes functional, supporting the branches of the actual lamps that illuminated synagogues in Asia, as in the synagogue at Sardis (fig. 12). Full-sized seven-branched menorahs have been discovered in synagogues in Palestine as well, most notably a limestone lamp in bas-relief from Tiberias (fig. 13) and openwork limestone menorahs from Susiya and Ma'on in

*Age of Transition: Byzantine Culture in the Islamic World*

Figure 7. Marble column drum with a cross superimposed on a menorah. Laodicea, Turkey, 5th–6th century (holylandphotos.org. Photo: Carl Rasmussen)

the southern Judaean Hills.[16] The menorah was thus both a symbolic object for Jewish communities and a functional one, illuminating the synagogue and connecting it to the Temple and to the Tabernacle from which it increasingly drew inspiration.

The Jerusalem medallion is one of only two such artifacts to have survived from this period. The other gold medallion—this one without provenance—with a similarly designed menorah is in the collection of the Jewish Museum London (fig. 14).[17] That piece is inscribed in Greek with a dedication by one Jacob, a pearl setter, suggesting that such artifacts had a public function. Interpreters have regarded these medallions as decorations for the Torah scroll, on the model of the modern Torah breastplate.[18] Leon Yarden reasonably describes this artifact

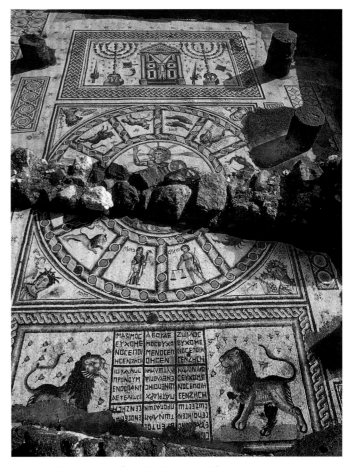

Figure 8. Floor mosaic from the Hammat Tiberias Synagogue. Hammat Tiberias, Israel, 4th–5th century (www.BibleLandPictures.com/Alamy)

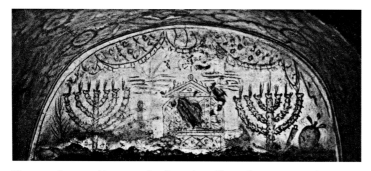

Figure 9. Image with menorahs, from the Villa Torlonia Catacomb. Rome, 3rd–4th century (from Reifenberg 1937, pl. 53)

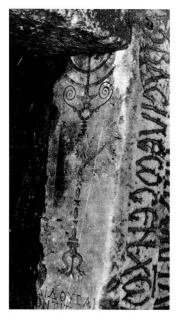

Figure 10. Stone ashlar with an inscribed menorah. Nicaea, Turkey, 5th–6th century (Photo: Marvin Labinger)

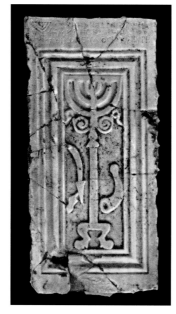

Figure 11. Stone panel with menorah and volutes beneath branches. Andriake, Turkey, 5th–6th century (from Çevik et al. 2010, fig. 27)

in discussing the Jewish Museum medallion, writing simply that it is "pierced for wearing."[19] Scholars have argued that this object originated in "the Eastern Mediterranean," perhaps Asia Minor.[20] The angular shofar of the Jerusalem medallion may point in that direction as well, but nothing is certain in this regard. The golden richness of these medallions is reminiscent of gold described—likely with some exaggeration—by the monk Bar Sauma in a synagogue that he destroyed in Rabbat Amman, Jordan:

> There were inside the sanctuary a golden ark and a golden table, chains of gold, chandeliers, and golden lamps, not to mention the gold on the doors, the walls, and gates, [and also] silver, bronze, and precious stones, precious ornaments, linseed flax, silk and pure linen. The disciples of the illustrious Bar Sauma brought naphtha and sulfur . . . which they threw on the walls and on the roof of the house. The fire ignited immediately throughout the house and burned the wood, stone, bronze, iron, gold, silver, rich ornaments, and gemstones.[21]

Traces of gold have yet to be discovered on the stone architectural remains of ancient synagogues in Palestine, although bronze objects—which were likely brightly polished—are depicted on mosaics and small objects have been discovered. Remains identified as glue for gilding were uncovered on the Torah shrine of a synagogue in distant Ostia Antica, the port of Rome, and the now bare stones of synagogue remains were most certainly colored, perhaps brilliantly.[22] It seems to me unlikely that the Jerusalem medallion was suspended from a Torah scroll, as Mazar has tentatively suggested, if for no other reason than the fact that Torah scrolls during this period were stored horizontally, not vertically.[23] I wonder, though, if such an artifact might have been worn by an officiant during some ceremonial that we know nothing about—perhaps a

as "a gold disk with a hole for a necklace." Nicholas De Lange notes, for comparison, votive plaques in Romaniot (Byzantine) rite synagogues in Greece "made of silver or base metal . . . inscribed with dedicatory texts in Hebrew and fitted with a ring at the top so that they could be attached to the curtain in front of the Holy Ark." Erwin Goodenough is rightly more circumspect

*Age of Transition: Byzantine Culture in the Islamic World*

priest or rabbinic figure, a wealthy pilgrim from Asia Minor, or even someone with Davidic connections in a liminal moment of deep messianic aspiration.[24] We will never know. It might, however, be noted that these large medallions parallel smaller glass and lead medallions and amulets worn as jewelry, usually discovered in Jewish burial contexts (fig. 15).[25]

Jewish use of the menorah as an identity marker continued unabated under Islam. The earliest example is a lintel discovered in the Western Wall excavations (fig. 16).[26] At the center of the lintel Byzantine craftsmen had carved a cross within a roundel. The roundel was filled with plaster and two menorahs were painted on in red ocher, flanking the erased but now visible cross. What was once a Christian space was now a small synagogue. The effacement of a cross by Jews would have been unthinkable during the later Byzantine Empire. This symbolic transformation becomes all the more significant, however, in light of the Jerusalem medallion, bracketing the period when the medallion was buried in the shadow of the Temple Mount near the start of the Sasanian invasion and the Islamic takeover just a generation later.

## SAMARITAN MENORAHS

In Roman antiquity the Samaritans—who identify themselves as the descendants of the northern tribes of Israel—were a major community in the cultural mix of Palestine, numbering, by some guesses, up to a million people.[27] Samaritanism is the second lobe of Israelite religion to have survived to the present. Its teachings are drawn from the Pentateuch, their singular and unique biblical text, and from traditions developed over the last two thousand years—many of which are preserved in literary sources and oral tradition. The holy mountain of the Samaritans is Mount Gerizim, above modern Nablus, which was a major center for pilgrimage and a sacrificial center in antiquity. The Jewish Roman historian Flavius

Figure 12. Stone menorah, from the synagogue at Sardis. Sardis, Turkey, ca. 5th century (© Archaeological Exploration of Sardis/Harvard University)

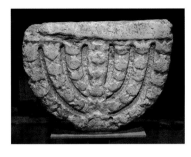

Figure 13. Limestone carving of a menorah, from the Hammat Tiberias Synagogue. Hammat Tiberias, Israel, 4th–6th century (Courtesy George Blumenthal, Center for Online Judaic Studies)

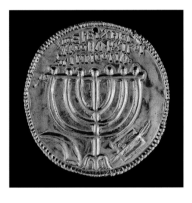

Figure 14. Gold medallion with image of a menorah, ca. 5th–6th century. Jewish Museum London

Josephus relates that John Hyrcanus I destroyed a Samaritan temple on Mount Gerizim in 112–111 B.C.E.[28] An impressive sacrificial precinct dating to the sixth century B.C.E., and active until Hyrcanus's time, was in fact discovered on the site.[29]

The Samaritan population was concentrated in central Palestine, in a region known as Samaria, although evidence of Samaritan settlement has been discovered from the southern end of the Carmel Mountain range to the southern coastal plain cities of Emmaus and farther south to what is today Kibbutz Na'an. Diaspora communities are also well known, with archaeological evidence having

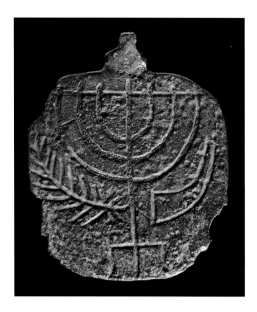

Figure 15. Menorah pendant, ca. 4th–6th century. Lead (?). Collection of Shlomo Moussaieff (Courtesy George Blumenthal, Center for Online Judaic Studies)

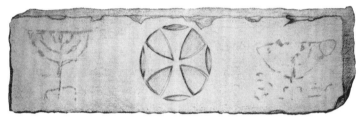

Figure 16. Byzantine marble lintel reused in a synagogue, after 636 C.E. Western Wall excavations, Jerusalem (from Mazar 2003: 177, fig. II.5)

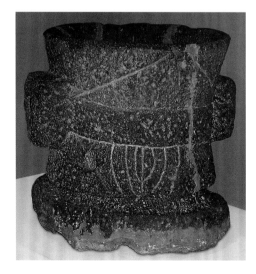

Figure 17. Samaritan basalt millstone. Horvat Migdal (Zur Natan), Israel, 5th century (Photo: Steven Fine)

been uncovered in Thessaloniki, Corinth, and even Dalmatia.[30] Examples of Samaritan visual culture in Late Antiquity were discovered during the nineteenth century, identified through Samaritan use of the ancient biblical script in Hebrew inscriptions (rather than the Aramaic, or "Assyrian," script used by Jews). The significance and richness of Samaritan visual culture in Greco-Roman antiquity became evident only in the 1990s, with the excavation of the Samaritan ritual compound on Mount Gerizim and important synagogue sites in the West Bank.[31] It is now apparent that the image of the menorah is ubiquitous in Samaritan visual culture of this period, to no less a degree than it is in Jewish art.

Menorahs appear on oil lamps that bear Samaritan inscriptions;[32] they appear inscribed on a basalt millstone from the Samaritan community at Horvat Migdal (Zur Natan; fig. 17);[33] and, most significantly, they appear on the floor mosaics of Samaritan synagogues (as these building are called in medieval documents).[34] It is often difficult to identify artifacts with menorahs as Samaritan rather than Jewish, not only because of scholarly predilection but because Jewish examples are far more numerous. Context is often the key.[35]

The first Samaritan mosaic was uncovered in 1949, at Salbit (today Shalavim), on the southern coastal plain of modern Israel.[36] Dating to the fifth century, it shows two menorahs flanking a stepped pyramid-like structure that scholars have identified, probably correctly, with Mount Gerizim. Were it not for the distinctly Samaritan inscription at the site, it is likely that this building, called a *eukterion*, or "place of prayer," in the Greek inscription, would have been called a Jewish synagogue without hesitation, especially since this region had a large Jewish population in antiquity.[37]

The same may be said of a mosaic discovered in the diversely populated city of Scythopolis (Hebrew: Beth Shean; Aramaic: Beisan), a Decapolis city in the eastern Jezreel Valley near the Jordan River. A

synagogue mosaic discovered there was identified as Jewish because of its iconographic connections to the synagogue at Beth Alpha and the fact that sections were made by named craftsmen who also worked at Beth Alpha.[38] This is so even though a Samaritan inscription was found in one of the side rooms. Before the Torah ark was a beautiful mosaic depiction of an ark flanked by two apparently metal menorahs surmounted by glass lamps. There is nothing particularly Samaritan about this imagery, and a similar depiction of the menorah appears in the floor mosaic of a small building of clearly Jewish provenance—likely a rabbinic study room (*beit midrash*)—also discovered at Beth Shean.[39] While consistent with Jewish iconography, however, one small distinction supports this identification. The Samaritan mosaic lacks the image of the palm frond bunch (*lulav*) and citron (*etrog*) so common to Jewish ritual and depictions but not used in Samaritan ritual.[40] Thus Jews and Samaritans in this city of the Decapolis employed the same imagery on their synagogue floors, with the Samaritans distinguishing theirs through the use of Samaritan script and by not including the *lulav*. These are relatively subtle differences. No doubt other signs of Samaritan-ness could have been seen by sixth-century visitors to this synagogue—on the walls, in the furnishings, and certainly in the liturgy. Today, all we have to judge by is the floor pavement, which can only hint at these distinctions.

The synagogue at El-Hirbe, near Nablus, is another fine example.[41] This synagogue, with its apse oriented toward Mount Gerizim and not toward Jerusalem (as is generally the case for Jewish buildings), had a beautiful mosaic pavement at the center of its main nave (fig. 18). Now preserved at the Museum of the Good Samaritan in El-Hirbe, the mosaic depicts a large gabled shrine set at an angle so as to display its fine roof and masonry. At the center is a jeweled table arrayed with cups and foodstuffs.[42] To the right is a large menorah flanked by horns

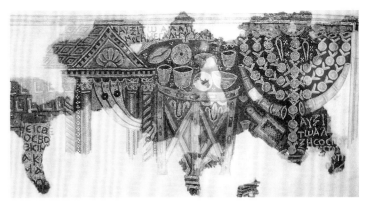

Figure 18. Samaritan mosaic pavement from the synagogue at El-Hirbe. El-Hirbe, West Bank, 5th century. Museum of the Good Samaritan, El-Hirbe (Photo: Steven Fine)

and an incense shovel. The menorah is carefully crafted in shades of white- and ivory-colored stone, rendering in detail the bulbs and flowers of the biblical lampstand (Exod. 37:19). The excavator, Yitzchak Magen, identifies the shrine, somewhat ambiguously, as representing a "combination of the temple's façade and the Holy Ark." My own sense is that it uses the image of a synagogue Torah shrine, which (as in Jewish contexts) is conceptually conflated with the biblical Ark. Magen identifies the table as the biblical Table of the Presence,[43] based on a similar round table in the mosaic pavement of the Jewish synagogue at Sepphoris in the Galilee, which clearly shows the twelve round breads of the Presence.[44]

At El-Hirbe, however, we see a meal rather than a group of carefully arranged breads. We do not know what kinds of rituals took place in Samaritan synagogues. Nor do we know whether this image represents a meal in Late Antiquity or is simply a poor representation of the Table of the Presence. Indeed, if this arrangement had been discovered in a Jewish mosaic, the iconography could easily be interpreted as having a Jewish context, as communal meals were held within synagogues.[45] A fragmentary Jewish gold glass discovered in Rome shows a round table, circled by a sigma-shaped couch, upon which is a tray with a large

fish.[46] Rome is far from Palestine, and we do not know if this image represents a Jewish communal meal; nonetheless, the parallel is suggestive. Samaritans and Jews used very similar iconography in Late Antique Palestine, resulting in considerable overlap. I would suggest that the minority Samaritan community borrowed these forms from the far more numerous Jewish communities, just as both Jews and Samaritans took so much from the colonizing Christians, making it their own.

For this reason Samaritan art is often nearly invisible, hiding in plain sight. A fine example is a large—though fragmentary—bronze plate discovered near Naanah (Kibbutz Na'an) during the early 1880s by the intrepid Charles Clermont-Ganneau (fig. 19).[47] The rim of the plate is incised with the image of a Torah shrine as well as a menorah. This artifact was first shown in the United States in "Sacred Realm: The Emergence of the Synagogue in the Ancient World," an exhibition I curated at Yeshiva University Museum in 1996.[48] At that time, recent Samaritan discoveries were just beginning to enter the scholarly literature, and while cognizant of them, I was not aware of their implications. Following the important English and Hebrew secondary literature, I identified the artifact as Jewish and left it at that. Clermont-Ganneau, however, knew better. The plate had been discovered together with an Ionic capital that was inscribed in Samaritan script, the legend reading "One God" (*Eis Theos*) on one side and "There is none like unto the God of Jeshurun" (Deut. 33:26) on the other. Based on the script, Clermont-Ganneau posited that the plate was of Samaritan origin. He was well aware that a similar capital had been uncovered close by, at Emmaus, to the north (fig. 20). The iconography of the Torah ark and the menorah could be either Jewish or Samaritan. Missing, however, is the telltale *lulav*, replaced by another plant—perhaps an olive branch. If the *lulav* were there, this would undoubtedly be a Jewish artifact; without it, the scales lean toward Samaritan origins. The Samaritan capital tips the balance. Most significant, the image of a plate similar to this one appears on the table of the El-Hirbe mosaic. A gray plate, also decorated with images of small flowers, appears in that mosaic on the table stand. The menorah thus symbolized not only the Jews but both Israelite peoples in Late Antique Palestine. It was shared by both communities, and each continues to claim it as its own to this day. The extent to which this was the case beyond the Holy Land is unknown, as so little Samaritan material is extant from diaspora communities and no images of the menorah appear in these contexts.

## CHRISTIAN MENORAHS

Christian interest in the menorah dates perhaps as far back as the Book of Revelation, where the narrator recalls, "I turned . . . and being turned, I saw seven golden candlesticks" (Rev. 1:12), later identified (Rev. 1:20) with the seven churches of Asia Minor. An association between church architecture and the Jerusalem Temple appears first in a letter sent from Eusebius of Caesarea to Paulinus, bishop of Tyre (ca. 317). Eusebius praises Paulinus's reconstruction and enlargement

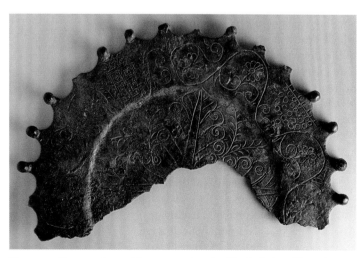

Figure 19. Bronze plate with a menorah and a Torah shrine. Naanah (Kibbutz Na'an), Israel, 4th–7th century. Musée du Louvre, Paris (Franck Raux, Réunion des Musées Nationaux/Art Resource, NY; Scala)

of his local church, drawing on Temple imagery,[49] and describes Paulinus as the new Zerubbabel, citing the name of the leader who rebuilt the Jerusalem Temple after the Babylonian captivity.

Christian awareness of the Jerusalem menorah is evident in the *Secret History* of Prokopios, who imagined that it was taken first to North Africa (or, in another legend, Marseilles), then to Constantinople, and eventually back to the Church of the Holy Sepulchre in Jerusalem.[50] Menorahs appear occasionally in obviously Christian contexts from Late Antiquity, as Marcel Simon has noted.[51] A menorah flanked by crosses is seen on the sixth-century tombstone of a monk at Avdat in the Negev desert, for example.[52] Unlike most Jewish examples, the branches of this menorah are angular rather than rounded, another indication that this is a Christian artifact—if the two flanking crosses were not enough!

It is sometimes suggested that Christian use of the menorah is supersessionist, as it undoubtedly is, although not every usage need be construed as explicitly polemical. One example is a Late Antique red slip oil lamp from North Africa (fig. 21).[53] Karen Stern has noted that "many to whom I have shown this image have responded in similar ways. . . . Most say that this lamp symbolizes the triumph of orthodox Christianity over Judaism."[54] She rightly questions this identification:

> Should the lamp's "obvious" interpretation be considered definitive? Does the lamp actually reflect Christianity's defeat of Jewish populations, or, alternatively, did an artist render its decoration to reflect a patron's desired reality? Even more provocative is the possibility that the inverted seven-armed menorah was not a sign of Jews *qua* Jews at all. Could the image, rather, allude to intra-Christian conflicts over the role of the Old Testament in light of the New? If so, might it represent the notion that the followers

of Christ stand, and continue to stand, upon a Jewish tradition that Christians had superceded?[55]

This is quite a burden for one small mass-produced North African oil lamp to bear! When I look at it I see a workshop with two molds: one of a man with a cross (likely Jesus), the second, a menorah. The artisan fit both molds onto the lamp and used the base of the molded image of Jesus as the baseline for the menorah. When viewed with the handle above, as it was drawn when last seen in 1895, the image could be taken as a reflection of Christian supersession (or, as Stern has it, internal Christian disputes). But what if the lamp is flipped, with the nozzle pointed upward? The message might be very different. The menorah and the good shepherd appear because they are both Christian symbols, sold to Christian clients. It does not seem to have been a terrifically popular model, since only one example appears to be known. Like the "usable Jew" in contemporaneous Christian literature, who serves as a straw man and is a projection of Christian

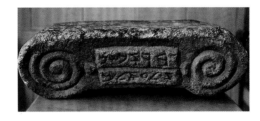

Figure 20. Capital from a Samaritan synagogue. Emmaus, Israel, 5th–7th century (Courtesy Sr. Anne-Françoise, Carmelite Convent, Bethlehem)

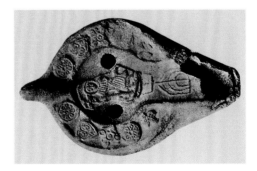

Figure 21. Oil lamp with menorah. Carthage, 6th century (?) (from Bloch 1961: 67, fig. 46)

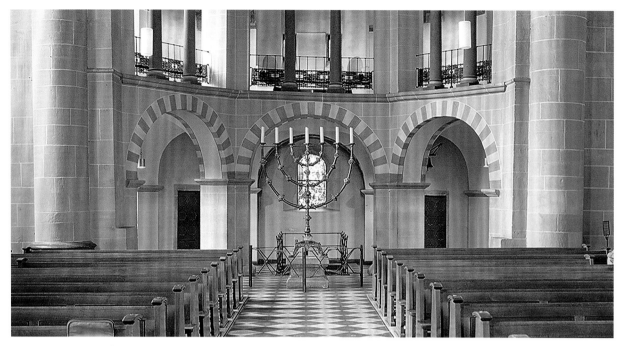

Figure 22. Bronze menorah, 973–1101. Treasury of Essen Cathedral (Photo: Erich Lessing/Art Resource, NY)

concerns rather than the representation of a real Jew, the Christian menorah—a minor Christian symbol to be sure—was indeed a Christian symbol. Large seven-branched menorahs illuminated the new temple—the church—as early as the ninth century, albeit in the West. This tradition continued through the Middle Ages; the most outstanding preserved example, 2.2 meters in height and with a span of 1.8 meters, still illuminates the cathedral in Essen, Germany (fig. 22). A series of blown and cast glass jugs from Jerusalem are similarly problematic.[56]

## THE UMAYYAD MENORAH[57]

Early Islamic coin designers made extensive use of both Byzantine and Sasanian models, borrowing their basic iconography while adapting it to the developing aesthetic of Islam. Thus a small number of gold coins, probably minted in Damascus, copy a nomisma of Heraclios with his son Heraclios Constantine. Significantly, the prominent "cross on steps" that appears on the reverse of the Byzantine coins was transformed into a "bar on a pole on steps,"[58] thus neutralizing its overtly "idolatrous" Christian content. Stefan Heidemann notes that a new era of numismatic experimentation began with the reign of 'Abd al-Malik ibn Marwan (r. 685–705), which coincided with his construction of the Dome of the Rock and the Aqsa Mosque in Jerusalem in 691 C.E.

Figure 23. Umayyad bronze coin with menorah, after 696/97. American Numismatic Society, New York (1936.999.191)

*Age of Transition: Byzantine Culture in the Islamic World*

One issue of bronze coins dated to the Umayyad post-reform era (after 696/97) may be particularly significant for our study (fig. 23). A group of bronze issues shows the image of seven- and later five-branched menorahs surmounted by a crosspiece like those that appear on many Jewish menorahs, but with the Arabic legend "There is no god but Allah alone and Muhammad is Allah's messenger"—uniquely, on both faces of the coin. Dan Barag suggests that the use of a five-branched candlestick is an attempt to move away from a Jewish or a likely Christian prototype.[59] He notes that the menorah stem of some issues is decorated with "two leaves," which he associates with Christian images of the menorah during the same period. And he speculates that the menorahs could be based on Christian rather than Jewish models, although spirals appear in the same spot on images of Jewish menorahs from Asia Minor (though not from Palestine).[60]

This short-lived currency coincided with the Islamicization of Jerusalem and its folklore, with a particular interest in the Temple of David and Solomon.[61] In fact, under the Umayyads the city of Jerusalem was often referred to in Arabic as *madinat bayt al-maqdis*, "city of the Temple." As Andreas Kaplony describes it: "By integrating pieces of bedrock and ruins, architecture stresses that the Haram [Haram al-Sharif, the Temple Mount] is the Former Temple rebuilt."[62] The coins of Jerusalem thus suggest that as the Temple was rebuilt, for one brief moment the menorah of the Temple became a possession of Islam. This would respond to both Jewish and Christian claims of having taken possession of this object. The coin iconography parallels continued Jewish use of the image under the Islamic Caliphate, as we see in the post-conquest synagogue in Jerusalem and in synagogue mosaics at Jericho and elsewhere.[63] This experiment in visual supersession was unique. To the best of my knowledge, the menorah appears only once in the Islamic art of Late Antiquity.

CONCLUSION

The Jerusalem medallion is indeed a spectacular discovery. Not only is this gold artifact notable in its own right, but its discovery near the Temple Mount adds a dramatic element that well expresses the transitions that took place in this Age of Transition. The medallion exemplifies a visual vocabulary developed by Jews across the ancient world, one whose significance continues to our own day. The Jewish community was not, however, the only one for whom the image of the menorah was meaningful. Samaritans developed a comparable iconography for reasons very similar to those of the Jews, and Christians adopted it as well for reasons wholly Christian. On one occasion Muslims, believing that Islam had superseded both Judaism and Christianity, took on this image as part of their own attempt to both localize and absorb the Holy City into the new Islamic Caliphate.

This essay is dedicated to my mentor Selma Holo, former director of the Museum Studies Program of the University of Southern California.

1. "Rich History Unearthed" 2013. See now: Mazar 2013.
2. See, for example, Weitzmann 1979: 312–13, 316, 319–21. A useful parallel is a medallion showing on one side the Annunciation and the Baptism of Christ, also from the eastern Mediterranean and found in Palestine, dated to the fifth–sixth century. See Iliffe 1950: 97–99, and Israeli and Mevorah 2000: 148–49, 223.
3. The excavators identify the object to the right as a Torah scroll, although the image of a biblical scroll from antiquity is known to have had a stave. Wooden rollers are mentioned, however, in the Jerusalem Talmud Megillah I (71b–72a) and elsewhere. See Mazar 2013: 36, and Reuben 2013: 93. See also Sukenik 1932: 30–31; Fine and Rutgers 1996; and Schiffman 2014: 107.
4. Mazar 2013: 101–2.
5. See my comments in Fine 2013: 14–15.
6. Ibid.: 148–65.
7. The range of objects is surveyed in Hachlili 2001.
8. Fine 2013: 149–50.
9. See Notley 2014.
10. Mishnah Hagigah 3:8; *Papyrus Oxyrhynchus* 840. See Fine 2013: 152, and Kruger 2005, esp. 94–144, and the bibliography cited by each. Recent publications include Anderson 2008, and Z. Safrai and C. Safrai 2011. Compare Fraade 2009.
11. Fine 2013: 149–50. For sources, see Weiss 2007.
12. The most recent discussions of these sources are Boustan 2008 and Sivertsev 2011: 125–38.
13. Fine 2013: 195–214.
14. Ibid.: 81–82.
15. Fine and Rutgers 1996.
16. Hachlili 2001, figs. II.10, II.11.
17. Barnett 1974: 4; Cohen-Mushlin 1979: 82; De Lange 2002; Ameling 2004: 40–42.
18. Barnett 1974; Cohen-Mushlin 1979.
19. Yarden 1971: 31; De Lange 2002: 54; Goodenough 1953–68, vol. 2 (1953): 222.
20. See the previous note.
21. Nau 1913: 384–85.
22. Floriani Squarciapino 1963; Fine and Della Pergola 1994: 54; Runesson 2001: 53; Fine 2012b.
23. See Yaniv 1997: 16–33, and Mazar 2013.
24. See Fine 2013: 81–94.
25. See Goodenough 1953–68, vol. 4 (1954): 1019, 1020, 1023, and Dan Barag in Spaer 2001: 173–85, pls. 29, 30.
26. See Mazar 2013: 163–86.
27. On the Samaritans in general, see Pummer 1987; Crown 1989; and E. Stern and Eshel 2002.
28. Magen, Misgav, and Tsfania 2004: 1–16.
29. Contemporary Samaritans object to the identification of this precinct as a "temple," as their tradition does not include such a building, which they see as a usurpation of the role of the biblical Tabernacle.
30. Noy, Panayotov, and Bloedhorn 2004: 27–28, 100–105, 186–89.
31. On Samaritan synagogues, see Magen 2008: 117–80, and Pummer 1999.
32. Sussman 2002; Magen 2008: 243–48.
33. Neidinger, Matthews, and Ayalon 1994: 6.
34. Fine 2012a.
35. See the trenchant comments of Leah Di Signi (1999: 51).
36. Sukenik 1949; Reich 1994.
37. Sukenik 1949.
38. Zori 1967.
39. Bahat 1981; Fine 2013: 132–36.
40. Jacoby 2000.
41. Magen 2008.
42. Ibid.: 134–37.
43. Ibid.
44. Weiss 2007.
45. Z. Safrai 1995: 196–97.
46. Cohen-Mushlin 1979: 381–82, no. 348; Fine 1996: 158.
47. Clermont-Ganneau 1884: 78–79, no. 62.
48. Fine 1996: 172.
49. Eusebius, *Historia Ecclesiastica* 10.4.36, as cited in White 1997: 95, 97.
50. See note 12 above.
51. Simon 1962: 181–87.
52. Hachlili 2001: 272.
53. K. Stern 2008: ix–x. This discussion is based on my review of Stern's volume; see Fine 2009.
54. K. Stern 2008: x.
55. Ibid.
56. See Evans 2012: 92, 110, nos. 60, 72.
57. Barag 1988–89.
58. Heidemann (2010: 160) notes that "Hoard evidence suggests for these imitations a date not much later than 680 CE."
59. Barag 1988–89: 47.
60. Ibid.: 44.
61. Soucek 1976; Kaplony 2009: 105–14, 123–25.
62. Kaplony 2009: 106.
63. On the Jericho synagogue, see Foerster 1993.

## REFERENCES

**Ameling, Walter, ed.**
**2004** *Inscriptiones Judaicae Orientis.* Vol. 2, *Kleinasien.* Tübingen: Mohr Siebeck.

**Anderson, Gary A.**
**2008** "To See Where God Dwells: The Tabernacle, the Temple, and the Origins of the Christian Mystical Tradition." *Letter & Spirit* 4: 13–45.

**Bahat, Dan**
**1981** "A Synagogue at Beth-Shean." In *Ancient Synagogues Revealed,* edited by Lee I. Levine: 82–85. Jerusalem: Israel Exploration Society.

**Barag, Dan**
**1988–89** "The Islamic Candlestick Coins of Jerusalem." *Israel Numismatic Journal* 10: 40–48.

**Barnett, R[ichard] D., ed.**
**1974** *Catalogue of the Permanent and Loan Collections of the Jewish Museum, London.* London: Harvey Miller; Greenwich, Conn.: New York Graphic Society.

**Bloch, Peter**
**1961** "Siebenarmige Leuchter in christlichen Kirchen." *Wallraf-Richartz-Jahrbuch* 23: 55–190.

**Boustan, Ra'anan S.**
**2008** "The Spoils of the Jerusalem Temple at Rome and Constantinople: Jewish Counter-Geography in a Christianizing Empire." In *Antiquity in Antiquity: Jewish and Christian Pasts in the Greco-Roman World,* edited by Gregg Gardner and Kevin L. Osterloh: 327–72. Tübingen: Mohr Siebeck.

**Çevik, Nevzat, Özgü Çömezoğlu, Hüseyin Sami Öztürk, and İnci Türkoğlu**
**2010** "A Unique Discovery in Lycia: The Ancient Synagogue at Andriake, Port of Myra." *Adalya,* no. 13: 335–66.

**Clermont-Ganneau, Ch[arles]**
**1884** *Mission en Palestine et en Phénicie entreprise en 1881: Cinquième rapport.* Paris: Imprimerie Nationale.

**C[ohen]-M[ushlin], A[viva]**
**1979** "Fragments of Cup Bottom with Torah Ark and Temple Implements" and "Medallion with Menorah." In Weitzmann 1979: 381–82, nos. 348, 349.

**Crown, Alan David, ed.**
**1989** *The Samaritans.* Tübingen: J. C. B. Mohr.

**De Lange, Nicholas**
**2002** "A Gold Votive Medallion in the Jewish Museum, London." In *Zutot 2001,* edited by Shlomo Berger, Michael Brocke, and Irene E. Zwiep: 48–55. Dordrecht and London: Kluwer Academic.

**Di Signi, Leah**
**1999** "The Samaritans in Roman-Byzantine Palestine: Some Misapprehensions." In *Religious and Ethnic Communities in Later Roman Palestine,* edited by Hayim Lapin: 51–66. Bethesda: University Press of Maryland.

**Evans, Helen C., ed.**
**2012** *Byzantium and Islam: Age of Transition, 7th–9th Century.* Exh. cat. New York: The Metropolitan Museum of Art.

**Fine, Steven**
**1996** as editor. *Sacred Realm: The Emergence of the Synagogue in the Ancient World.* Exh. cat., Yeshiva University Museum, New York. Oxford and New York: Oxford University Press and Yeshiva University Museum.

**2009** Review of Stern 2008. *Review of Biblical Religion,* published February 2. http://bookreviews.org /bookdetail.asp?TitleId=6370&CodePage=6370.

**2012a** "'For This School House Is Beautiful': A Note on Samaritan 'Schools' in Late Antique Palestine." In *Shoshannat Yaakov: Studies in Honor of Yaakov Elman,* edited by Shai Secunda and Steven Fine: 65–75. Leiden: Brill.

**2012b** "Menorahs in Color: Polychromy in Jewish Visual Culture of Roman Antiquity." *Images: A Journal of Jewish Art and Visual Culture* 6: 3–25.

**2013** *Art, History, and the Historiography of Judaism in Roman Antiquity.* Leiden: Brill.

**Fine, Steven, and Miriam Della Pergola**
**[1994]** "The Synagogue of Ostia and Its Torah Shrine." In *The Jewish Presence in Ancient Rome,* edited by Joan Goodnick Westenholz: 42–57. Exh. cat. Jerusalem: Bible Lands Museum.

**Fine, Steven, and Aaron Koller, eds.**
**2014** *Talmuda de-Eretz Israel: Archaeology and the Rabbis in Late Antique Palestine.* Studia Judaica 73. Berlin and Boston: De Gruyter.

**Fine, Steven, and Leonard Victor Rutgers**
**1996** "New Light on Judaism in Asia Minor during Late Antiquity: Two Recently Identified Inscribed Menorahs." *Jewish Studies Quarterly* 3: 1–23.

**Floriani Squarciapino, Maria**
**1963** "The Synagogue at Ostia" (translated by Lionel Casson). *Archaeology* 16, no. 3: 194–203.

**Foerster, Gideon**
**1993** "The Synagogue at Tell es-Sultan." In *The New Encyclopedia of Archaeological Excavations in the Holy Land,* edited by Ephraim Stern, vol. 2: 698–99. Jerusalem: Israel Exploration Society & Carta; New York: Simon & Schuster.

**Fraade, Steven D.**
**2009**    "The Temple as a Marker of Jewish Identity before and after 70 CE: The Role of the Holy Vessels in Rabbinic Memory and Imagination." In *Jewish Identities in Antiquity: Studies in Memory of Menahem Stern*, edited by Lee I. Levine and Daniel R. Schwartz: 237–65. Tübingen: Mohr Siebeck.

**Goodenough, Erwin R.**
**1953–68**    *Jewish Symbols in the Greco-Roman Period.* 13 vols. Bollingen Series 37. New York: Pantheon.

**Hachlili, Rachel**
**2001**    *The Menorah, the Ancient Seven-Armed Candelabrum: Origin, Form and Significance.* Supplements to the Journal for the Study of Judaism, Book 68. Leiden: Brill.

**Heidemann, Stefan**
**2010**    "The Evolving Representation of the Early Islamic Empire and Its Religion on Coin Imagery." In *The Qur'ān in Context: Historical and Literary Investigations into the Qur'ānic Milieu*, edited by Angelika Neuwirth, Nicolai Sinai, and Michael Marx: 149–95. Texts and Studies on the Qur'ān 6. Leiden: Brill.

**Iliffe, J[ohn] H.**
**1950**    "A Byzantine Gold Enkolpion from Palestine (about Sixth Century)." *Quarterly of the Department of Antiquities in Palestine* 14: 97–99.

**Israeli, Yael, and David Mevorah, eds.**
**2000**    *Cradle of Christianity.* Exh. cat. Jerusalem: Israel Museum.

**Jacoby, Ruth**
**2000**    "The Four Species in Jewish and Samaritan Traditions." In *From Dura to Sepphoris: Studies in Jewish Art and Society in Late Antiquity*, edited by Lee I. Levine and Zeev Weiss: 225–30. Journal of Roman Archaeology Supplementary Series 40. Portsmouth, R.I.: Journal of Roman Archaeology.

**Kaplony, Andreas**
**2009**    "635/638–1099: The Mosque of Jerusalem (*Masjid Bayt al-Maqdis*)." In *Where Heaven and Earth Meet: Jerusalem's Sacred Esplanade*, edited by Oleg Grabar and Benjamin Z. Kedar: 100–131. Jerusalem: Yad Izhak Ben Zvi Press; Austin: University of Texas Press.

**Kruger, Michael J.**
**2005**    *The Gospel of the Savior: An Analysis of P.Oxy. 840 and Its Place in the Gospel Traditions of Early Christianity.* Leiden: Brill.

**Magen, Yitzhak**
**2008**    *The Samaritans and the Good Samaritan.* Translated by Edward Levin. Jerusalem: Staff Officer of Archaeology, Civil Administration of Judea and Samaria, Israel Antiquities Authority.

**Magen, Yitzhak, Haggai Misgav, and Levana Tsfania**
**2004**    *Mount Gerizim Excavations.* Vol. 1, *The Aramaic, Hebrew and Samaritan Inscriptions.* Jerusalem: Staff Officer of Archaeology, Civil Administration of Judea and Samaria, Israel Antiquities Authority.

**Mazar, Eilat**
**2003**    *The Temple Mount Excavations in Jerusalem 1968–1978 Directed by Benjamin Mazar: Final Reports.* Vol. 2, *The Byzantine and Early Islamic Periods.* Qedem 43. Jerusalem: Institute of Archaeology, The Hebrew University of Jerusalem.

**2013**    *The Discovery of the Menorah Treasure at the Foot of the Temple Mount: In Honor of the State of Israel That Chose the Seven-Branched Menorah as Its National Symbol.* Jerusalem: Shoham—Academic Research and Publication.

**Nau, F[rançois]**
**1913**    "Résumé de monographies syriaques: Barsauma, Abraham de la Haute Montagne, Siméon de Kefar 'Abdin, Yaret l'Alexandrin, Jacques le reclus, Romanus, Talia, Asia, Pantaléon, Candida (suite)." *Revue de l'Orient chrétien* 18 (ser. 2, 8): 379–89.

**Neidinger, William, Eulah Matthews, and Etan Ayalon**
**1994**    "Excavations at Zur Natan: Stratigraphic, Architectural and Historical Report." In *Reports on TFAHR Excavations at: Zur Natan, Israel; Silistra, Bulgaria; and Ulanci, Macedonia*: 5–14. Houston: Publications of the Texas Foundation for Archaeological and Historical Research.

**Notley, R. Steven**
**2014**    "Genesis Rabbah 98:17—'And Why Is It Called Gennosar?': Literary and Archaeological Evidence for a Priestly Presence on the Plain of Gennosar." In Fine and Koller 2014: 141–58.

**Noy, David, Alexander Panayotov, and Hanswulf Bloedhorn, eds.**
**2004**    *Inscriptiones Judaicae Orientis.* Vol. 1, *Eastern Europe.* Tübingen: Mohr Siebeck.

**Pummer, Reinhard**
**1987**    *The Samaritans.* Iconography of Religions, sect. 23, Judaism, fasc. 5. Leiden: Brill.

**1999**    "Samaritan Synagogues and Jewish Synagogues: Similarities and Differences." In *Jews, Christians and Polytheists in the Ancient Synagogue: Cultural Interaction during the Greco-Roman Period*, edited by Steven Fine: 105–42. London: Routledge.

**Reich, Ronny**
**1994**    "The Plan of the Samaritan Synagogue at Sha'alvim." *Israel Exploration Journal* 44: 228–33.

**Reifenberg, Adolf**
**1937**    *Denkmäler der jüdischen Antike.* Berlin: Schocken.

**Reuben, Peretz**
**2013**    "The Symbols on the Ophel Medallion." In Mazar 2013: 93.

**"Rich History Unearthed"**
**2013**    "Rich History Unearthed in Jerusalem." *The Trumpet.com.* Posted September 9, 2013. www.thetrumpet.com/article/10945.18.0.0/middle-east/israel/rich-history-unearthed-in-jerusalem.

**Runesson, Anders**
**2001**    "The Synagogue at Ancient Ostia: The Building and Its History from the First to the Fifth Century." In *The Synagogue of Ancient Ostia and the Jews of Rome: Interdisciplinary Studies*, edited by Birger Olsson, Dieter Mitternacht, and Olof Brandt: 29–99. Skrifter utgivna av Svenska Institutet i Rom, 40, 57. Stockholm: Svenska Institutet i Rom.

**Safrai, Ze'ev**
**1995**    "The Communal Functions of the Synagogue in the Land of Israel in the Rabbinic Period." In *Ancient Synagogues: Historical Analysis and Archaeological Discovery*, edited by Dan Urman and Paul V. M. Flesher, vol. 1: 181–204. Leiden: Brill.

**Safrai, Ze'ev, and Chana Safrai**
**2011**    "Papyrus Oxyrhynchus 840." In *Halakhah in Light of Epigraphy*, edited by Albert I. Baumgarten, Hanan Eshel, Ranon Katzoff, and Shani Tzoref: 255–82. Göttingen: Vandenhoeck & Ruprecht.

**Schiffman, Lawrence H.**
**2014**    "Jerusalem Talmud Megillah 1 (71b–72a)—'Of the Making of Books': Rabbinic Scribal Arts in Light of the Dead Sea Scrolls." In Fine and Koller 2014: 97–110.

**Simon, Marcel**
**1962**    *Recherches d'histoire judéo-chrétienne.* Paris: Mouton.

**Sivertsev, Alexei M.**
**2011**    *Judaism and Imperial Ideology in Late Antiquity.* Cambridge and New York: Cambridge University Press.

**Soucek, Priscilla P.**
**1976**    "The Temple of Solomon in Islamic Legend and Art." In *The Temple of Solomon: Archeological Fact and Medieval Tradition in Christian Islamic and Jewish Art*, edited by Joseph Gutmann: 73–123. Missoula, Mont.: Scholars Press.

**Spaer, Maud**
**2001**    *Ancient Glass in the Israel Museum, Beads and Other Small Objects.* Jerusalem: The Israel Museum.

**Stern, Ephraim, and Hanan Eshel, eds.**
**2002**    *Sefer ha-Shomronim* [The Samaritans]. Jerusalem: Yad Izhak Ben-Zvi Institute.

**Stern, Karen**
**2008**    *Inscribing Devotion and Death: Archaeological Evidence for Jewish Populations of North Africa.* Leiden: Brill.

**Sukenik, Eleazar L.**
**1932**    *The Ancient Synagogue of Beth Alpha: An Account of the Excavations Conducted on Behalf of the Hebrew University, Jerusalem.* Jerusalem: The University Press; London: Oxford University Press.

**1949**    "The Samaritan Synagogue at Salbit: Preliminary Report." *Louis M. Rabinowitz Fund for the Exploration of Ancient Synagogues, Bulletin* 1: 26–32.

**Sussman, Varda**
**2002**    "Samaritan Oil Lamps." In E. Stern and Eshel 2002: 339–71.

**Weiss, Zeev**
**2007**    "'Set the Showbread on the Table before Me Always' (Exodus 25:30): Artistic Representations of the Showbread Table in Early Jewish and Christian Art." In *The Archaeology of Difference: Gender, Ethnicity, Class and the "Other" in Antiquity; Studies in Honor of Eric M. Meyers*, edited by Douglas R. Edwards and C. Thomas McCollough: 381–90. Boston: American Schools of Oriental Research.

**Weitzmann, Kurt, ed.**
**1979**    *Age of Spirituality: Late Antique and Early Christian Art, Third to Seventh Century.* Exh. cat. New York: The Metropolitan Museum of Art.

**White, L. Michael**
**1997**    *The Social Origins of Christian Architecture.* Vol. 2, *Texts and Monuments for the Christian Domus Ecclesiae in Its Environment.* Valley Forge, Pa.: Trinity Press International.

**Yaniv, Bracha**
**1997**    *Ma'aśeh ḥoshev: Ha-tik le-sefer Torah ve-toldotav* [Torah case: Its history and design]. Ramat Gan: Bar-Ilan University Press; Jerusalem: Yad Izhak Ben-Zvi Institute.

**Yarden, Leon**
**1971**    *The Tree of Light: A Study of the Menorah, the Seven-Branched Lampstand.* London: East and West Library.

**Zori, N.**
**1967**    "The Ancient Synagogue at Beth-Shean" [in Hebrew]. *Eretz-Israel* 8: 149–67.

*Arnold E. Franklin*

# Untidy History: Reassessing Communal Boundaries in Light of the Cairo Geniza Documents

Critical examination of distinctions, both real and imagined, that differentiate people, events, and places is fundamental to the work of the historian. At the same time, there is the danger that the historian, in focusing on such divisions, will generate an image of the past that obscures as much as it clarifies by failing to capture the nuance and complexity of any specific historical moment. In this context the documents from the Cairo Geniza have proven to be an invaluable corrective inasmuch as they have brought the historian into direct contact with the lively and complex nature of Jewish life in the Middle Ages. I explore in this essay the ways in which materials from this important but still relatively under-appreciated archive challenge prevailing assumptions about Jewish society in the medieval Islamic world, exposing the limitations of the categories through which it has often been described. Specifically, I draw attention to instances in which the Geniza sources reveal the fluidity of communal boundaries and the capacity of individuals to move between seemingly incompatible domains.

According to an ancient Jewish custom still observed today, religious texts that are worn, damaged, or otherwise unusable must be disposed of in a manner commensurate with their intrinsic sanctity. Of particular concern is preventing the desecration of the written name of God. The Hebrew term *geniza* refers both to the practice of appropriately "hiding away" or "concealing" such texts and to the receptacle or site to which they are consigned. While different communities followed a variety of practices, most often the custom of *geniza* was observed by burying the writings in the ground, typically in a cemetery.[1]

The Cairo Geniza is the most renowned example of this ancient custom's implementation, and it is the historian's good fortune that it is also a most atypical *geniza*. We can be certain that the Jews of medieval Egypt knew of the more conventional practice of discarding sacred material through burial. But for reasons that remain obscure, Jewish residents of Fustat—originally an independent town that was subsequently absorbed into the sprawling metropolis of Cairo—chose to dispose of at least some of their sacred writings in a storage chamber in a local house of worship, a site today called the Ben Ezra Synagogue but which was known in the Middle Ages simply as "the synagogue of the Jerusalemites" or "the synagogue of the Palestinians." The significance of this decision cannot be overstated, for it resulted in the unintended preservation of an astounding cache of manuscript material. Left in a structure that stood undisturbed for centuries, these writings were spared the deterioration that interment in the ground would likely have caused.[2] This in turn paved the way for their reclamation by modern historians.

Over the course of the nineteenth century these remarkable sources came to the attention of Western collectors and scholars,

a number of whom managed to acquire items for their personal libraries. A major turning point—often (and misleadingly) hailed as the "discovery" of the Cairo Geniza—came in 1896, however, when Solomon Schechter (1847–1915), a lecturer in the Talmud and a reader in Rabbinic at the University of Cambridge, came to recognize the scholarly value of the Geniza sources and, with the financial backing of his Cambridge colleague the Hebraist Charles Taylor, traveled to Egypt, where he succeeded in retrieving some 140,000 items from the premises of the Ben Ezra Synagogue. These manuscripts were taken to England and later given to the Cambridge University Library, establishing it as home to the largest and most important collection of Geniza texts.[3]

Aside from the unusual fact that its contents were never buried, there is another reason the Cairo Geniza is atypical, which has to do with the kinds of materials that it contained. While the vast majority of the items consigned to it—an estimated ninety to ninety-five percent—were texts one would expect to find in a repository for sacred refuse (pages from biblical codices, rabbinic works, liturgical texts, and so forth), a small but substantial body of more mundane material was also left there. This category included communal records, dockets of the local Jewish court, business contracts, and correspondence of all sorts. A number of theories have been advanced to explain the presence of these documentary sources, the most likely being that when people delivered batches of papers that had accumulated in their homes to the Geniza they simply did not bother to separate the sacred from the nonsacred. The documents, which total between ten and fifteen thousand individual items, are most abundant for the years between 1000 and 1250 and thus provide a unique window on to the social and economic history of medieval Egypt under the Fatimid and Ayyubid rulers. Indeed, in the absence of the kinds of archives that are available for medieval Europe and for the later Ottoman period in the Near East, the Geniza sources constitute one of the best ways of investigating daily life in the Muslim world during the Middle Ages.

## CONGREGATIONAL AFFILIATIONS

One of the areas in which the Geniza has led to an adjustment in our understanding of medieval Jewish society involves the way individuals affiliated with particular synagogues and the religious rites associated with them. Fustat, like many of the larger towns in the Near East, was home to three different Jewish congregations, each of which maintained its own synagogue, court, and chief judge. Two of the congregations were Rabbanite, meaning that they adhered to the religious traditions of the rabbis of the Talmud and accepted the authority of their medieval successors and interpreters, the *ge'onim* (sing., *ga'on*), the heads of the rabbinic academies, as binding; the third was a congregation of Karaites, who rejected the authority of the rabbis.

Of the two Rabbanite congregations, one operated under the jurisdiction of the religious authorities in Iraq and was known as the Babylonian congregation, while the other was administered by the rabbinic leadership in Palestine and was called the Jerusalemite congregation. The synagogue in which the Geniza was found belonged to the Palestinians, the more dominant of the two Rabbanite congregations during the eleventh and twelfth centuries. While the existence of the two rites and the details of some of the more important ritual differences between them had long been known, the Geniza documents provided the first glimpse of the social context in which they operated and at times came into competition with one another.

The general assumption among historians was that membership in a congregation was largely a function of one's family's place of origin. Members of the Palestinian

Figure 1. Letter from Solomon ben Semah al-'Attar to Ephraim ben Shemarya, 1030s. Paper. Cambridge University Library, Taylor–Schechter Genizah Collection, Cambridge (T–S 10J29.13r)

congregation in Fustat and elsewhere were assumed to be descended from families that originated in lands that were once part of the Byzantine Empire and had a historical connection to the rabbinic leadership in Palestine, while those who belonged to Babylonian congregations were thought to come from Iraq or from regions subject to its authority. And yet while ancestral ties surely were an important factor in determining one's congregational affiliation, the Geniza records make it clear that other, more pragmatic considerations could also play a role.[4] A letter from Solomon ben Semah al-'Attar, a scribe of the Palestinian *yeshiva* (rabbinic academy) in the second quarter of the eleventh century, to Ephraim ben Shemarya, head of the Palestinian congregation in Fustat, reveals this more complicated reality (fig. 1). In the letter, which can be dated to the 1030s, Solomon reprimands Ephraim for having driven people out of the Palestinian synagogue with his overbearing conduct. "Here in Palestine have we not received numerous letters," he asks rhetorically, "the longest of which was signed by thirty-odd witnesses, complaining that you have been alienating the congregation with your arrogance and imperious behavior? Because of you and your son-in-law, many people have switched over to the other [Iraqi-rite] synagogue and to the Karaite congregations."[5] Solomon's letter underscores the fact that one's congregational affiliation was anything but given, and that individuals might easily change allegiances if they so desired (on the movement between the Rabbanite and Karaite camps, also mentioned in the letter, more will be said below).

Still other Geniza letters reveal the extensive efforts undertaken by the two Rabbanite congregations in their competition for adherents among the local population. The Babylonians succeeded in enticing individuals to join their congregation with the promise of highly prized honorary titles dispensed by the Iraqi religious establishment. We learn of one such episode in a letter of about 1029 from Solomon ben Judah, the *ga'on* of the

Palestinian *yeshiva*, to the same Ephraim ben Shemarya in Fustat:

> We sent you letters, our dear one, after the holidays informing you of the well-being of the people and in response to your letters regarding the one who rejected "the waters of Siloam" to drink from "the waters of the Euphrates." Only to himself did he cause injury in preferring the title *alluf* [an Iraqi honorific] to that of *haver* [the Palestinian equivalent]. We cannot coerce him. He disparaged the honor of his mother in saying that she has forgotten her Torah and lavished praise on his stepmother by insisting that her traditions have been kept alive. But He Who has maintained a remnant in [Jerusalem] will avenge her detractors and remember His promise that her Torah will never be forgotten or cut off.[6]

Although Solomon seeks to console Ephraim, his outrage over the defection of a former supporter to the Iraqi congregation is palpable: the unnamed renegade has not only made the foolish decision to abandon the life-giving wells of Jerusalem, he has disgraced his own mother in the process.

The Palestinian congregation, for its part, also had ways of competing and drawing in new members. Its leaders emphasized, among other things, the fine appurtenances that adorned their synagogue: the valuable biblical codices, the magnificent Torah scroll, and the beautiful carpets upon which attendees would sit. They also noted that the weekly Torah portions in their synagogue were shorter than those read in the Babylonian rite and, moreover, were customarily chanted by young boys rather than a professional cantor, something deemed appealing to parents who wished to see their sons take an active role in the prayer service.[7] While family custom and historical ties surely influenced the choice of a synagogue, the Geniza documents thus make it

Figure 2. Formulary for a marriage contract between a Karaite woman and a Rabbanite man, 1082. Bodleian Library, University of Oxford, MS Heb. d 66, folio 50r

clear that such factors were not always entirely determinative. Indeed, a range of practical considerations—one's rapport with the congregational leadership, opportunities for social advancement, and the aesthetics of the service itself—might also play a role, from time to time prompting an individual to switch from one tradition to another.

## KARAITE–RABBANITE RELATIONS

As has already been noted, another major fault line in medieval Jewish society involved the authority of rabbinic tradition, that is, the ritual norms and exegetical interpretations found in the Talmud and related texts. On one side were the Rabbanites, who regarded that tradition as the definitive expression of the divine message; and on the other side were the Karaites, who rejected the teachings of the rabbis as baseless innovations and who proclaimed their allegiance to scripture alone.

The Karaite position resulted in a number of significant divergences from the practices of the Rabbanites. Karaites rejected central elements of the Rabbanite prayer service, for example, and in their synagogues used instead a distinctive liturgy made up almost exclusively of biblical passages. They also followed different customs for the ritual slaughter of meat and rejected the rabbinic inclusion of fowl under the prohibition of consuming meat and dairy together. As a consequence Karaites and Rabbanites would not, at least in theory, have been able to eat in one another's homes. The Karaite observance of the Sabbath and other festivals also differed markedly from that of the Rabbanites. Whereas Rabbanites permitted the use of fire kindled before the Sabbath (for such purposes as illumination and warming food), Karaites, at least initially, adopted a more restrictive practice that prohibited the use of fire regardless of when it was kindled. Here, too, one can easily discern the social impact that such differences would have had, as visits on the Sabbath by Karaites to the homes of Rabbanites would have been virtually precluded. Furthermore, in keeping with their generally more ascetic outlook, Karaites, unlike Rabbanites, considered sexual intercourse a violation of the Sabbath.

Before the discovery of the Geniza our understanding of the relations between the two groups was shaped by our knowledge, on the one hand, of ritual differences such as these, and, on the other, by a substantial body of hostile polemical literature exchanged between writers in the two camps. The resulting picture was one of mutually felt antagonism and almost complete social segregation. The Geniza's discovery, however, dramatically revised this overly neat picture of social isolation resulting from disagreements in matters of theology and ritual law. The more we learn about the social and economic aspects of life for medieval Jews, the more we realize how inseparably connected the two communities in fact were.[8]

The Geniza provides us with abundant evidence that Karaites and Rabbanites regularly participated in joint business ventures. Even more impressively, we learn that Karaites were at times generous donors to Rabbanite religious institutions, the very embodiment of the traditions they ostensibly reviled. And as we saw in the letter of Solomon ben Semah al-'Attar, discussed above, individuals might in fact move between the two communities with little effort or religious compunction. But the most remarkable illustration of the more accommodative attitude that prevailed in Egypt during the eleventh and twelfth centuries is the corpus of contracts for marriages between Karaite and Rabbanite partners, essentially *ketubot* for "mixed marriages."[9]

Geniza records indicate that marriages of this sort were not exceptional during the eleventh century and were formally recognized in both communities.[10] The Geniza has even preserved a page from a formulary for scribes, which includes the heading: "These are the terms for [the marriage of] a Karaite woman to a Rabbanite man" (fig. 2).[11] A special heading was warranted because such contracts included a number of clauses designed to guarantee mutual tolerance,

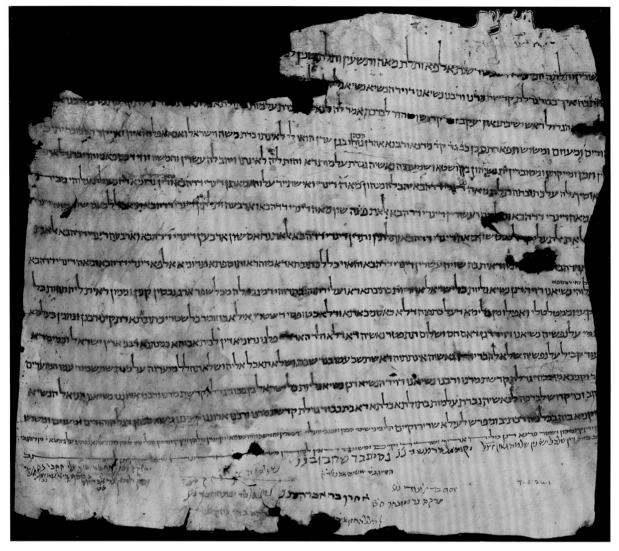

Figure 3. Marriage contract between David ben Daniel and Nashiya, 1082. Vellum. Cambridge University Library, Taylor-Schechter Genizah Collection, Cambridge (T-S 24.1)

each party undertaking to respect the religious traditions of the other. We find, for example, the stipulation that a Rabbanite husband will not bring into his house various animal parts ("the fatty tail, the kidneys, and the lobe of the liver") that were permitted for consumption by Rabbanites but prohibited by Karaites. Other stipulations concerned the observance of the Sabbath and the festivals. The Rabbanite husband promises, for example, not to permit any fire in his house on the Sabbath. In yet another clause we find a Rabbanite husband agreeing not to have intercourse with his Karaite wife on the Sabbath and on festivals "as though they were regular week days." For her part, the Karaite wife typically promises to observe the festivals with her husband, a not insignificant concession when one takes into consideration the fact that Rabbanites and Karaites followed different calendars.

*Age of Transition: Byzantine Culture in the Islamic World*

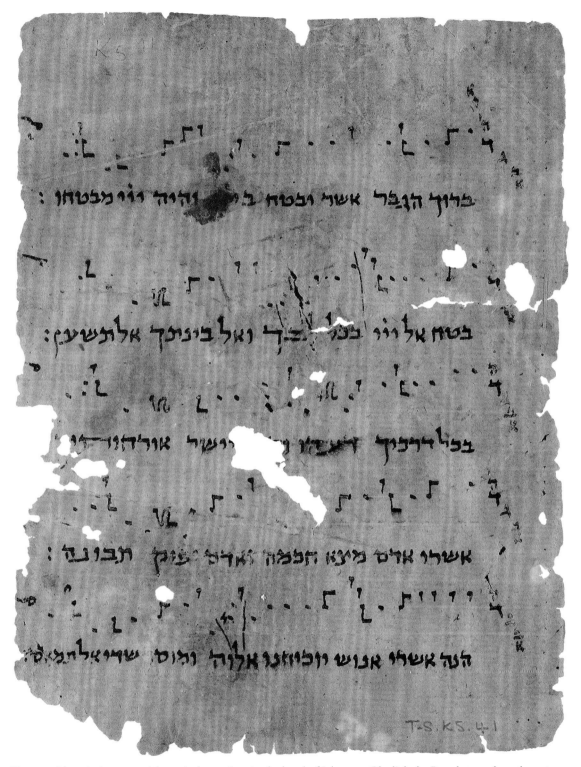

Figure 4. Liturgical poetry with musical notations in the hand of Johannes-Obadiah the Proselyte, early 12th century. Paper. Cambridge University Library, Taylor-Schechter Genizah Collection, Cambridge (T-S κ5.41)

Figure 5. Ordinance to impose decorum at the Jewish pilgrimage site of Dammuh, early 11th century. Paper. Cambridge University Library, Taylor-Schechter Genizah Collection, Cambridge (T-S 20.117v)

A notable example of such a marriage is that concluded between David ben Daniel and Nashiya, the daughter of Moses ha-Kohen ben Aaron, in 1082 (fig. 3).[12] As in most (but not all) of the known cases of such a mixed union, the groom was a Rabbanite and the bride a Karaite. What makes this particular union so interesting is what else we know of David's biography: his father was the *ga'on* of the Palestinian *yeshiva* in Jerusalem from 1051 to 1062, and he himself would go on to serve as the head of Egypt's Jewish community from 1082 to 1094. We are not, in other words, dealing with a marginal or religiously suspect figure but rather with someone at the very center of Rabbanite society. David ben Daniel's marriage to Nashiya thus exemplifies how porous the divide between Karaites and Rabbanites could be and offers an invaluable corrective to earlier, overly schematic understandings of the way the two communities interacted.

## CONVERSION

Conversion to and from Judaism offered yet another opportunity for individuals to traverse communal boundaries, and in this context as well the Geniza has shed considerable light.[13] The most well known conversion story reconstructed from the Geniza is that of Johannes of Oppido, the son of an aristocratic Norman family in southern Italy who was born in the late eleventh century. While his twin brother, Roger, went off to become a knight, Johannes was chosen to enter the priesthood. The young man evidently had religious doubts, however, and when he began to study the Hebrew Bible he became impressed by the way its traditions seemed to be preserved in contemporary Jewish practice. He had himself circumcised and began to observe Jewish customs. When he learned that Andreas, the archbishop of Bari, had moved to Egypt to convert to Judaism, he took it as a sign that he should follow a similar course. And so Johannes moved to Constantinople, studying Judaism more intensively and writing pamphlets

*Age of Transition: Byzantine Culture in the Islamic World*

that challenged Christian beliefs. In 1102 he converted to Judaism and from that point on was known as Obadiah. Traveling on his spiritual quest from Constantinople to Baghdad, Aleppo, and Tyre before eventually settling in Cairo, he came into direct contact with some of the most vital centers of Jewish culture in the East.

We know as much as we do about Johannes-Obadiah thanks to two important sources: a fascinating autobiographical chronicle written in Hebrew and a letter of introduction written on his behalf by Barukh ben Isaac of Aleppo.[14] But the transitions from Christianity to Judaism and from western Christendom to the Islamic East are perhaps even more poignantly captured by several pages from the Geniza, evidently written in Obadiah's own hand, on which Jewish liturgical hymns are set to musical notations (fig. 4).[15] Such notations are exceptionally rare in medieval Jewish texts. Indeed, these pages constitute the very earliest extant transcriptions of synagogue music. What makes some of them all the more interesting is their hybrid nature: while the liturgical text is Jewish and of Eastern provenance, the notation marks and the melody come straight out of the Gregorian neumic tradition. In other words, even as he embraced a new religious identity in a new part of the world, Obadiah maintained something of his earlier monastic life in Italy. Reflected in these pages, then, is the proselyte's role as cultural and religious mediator, facilitating the transmission of traditions and ideas across communal boundaries.

## Religious Convergences

If conversion provided one means whereby religious boundaries could be crossed, there were also opportunities for adherents of different religions to come together while maintaining their distinct identities. Shared religious shrines, which often lay on the periphery of the more organized and carefully monitored urban settings of communal life, offered one physical site for such

contacts. The famous medieval traveler Benjamin of Tudela, who wandered across the Near East in the last third of the twelfth century, describes a number of pilgrimage sites in Islamic lands that were venerated simultaneously by Jews, Muslims, and Christians, the most famous of these being the tomb of the biblical prophet Ezekiel in al-Kifl, in southeastern Iraq.[16]

From the Geniza we learn about another such site at Dammuh, on the west bank of the Nile several kilometers southwest of Cairo. There Jews maintained a shrine they identified with the biblical Moses. While the shrine could be visited at all times of the year, there were two main pilgrimage occasions: on the seventh of the Jewish month of Adar, the traditional date of Moses's birth, and on the festival of Shavu'ot, which falls in the late spring. While most of the rituals that would have been observed as part of the pilgrimage ceremonial are not described in our sources, an ordinance issued by the leaders of the Jewish community of Fustat at the beginning of the eleventh century includes a description of at least some of the things that took place at Dammuh (fig. 5).[17]

Drafted in response to the perceived breakdown of religious and social norms at the pilgrimage site, the ordinance, as described by Joel Kraemer, who edited the text, sought to "control dangerous, unregulated space" through the imposition of strict regulations.[18] A fascinating mirror image of the bacchanalian atmosphere that prevailed at the site, it attempts to impose decorum, banning frivolity and various forms of entertainment, including gambling and chess. It also bans the staging of marionette shows, singing and dancing, and brewing beer. Nor are the sexes to mingle: the edict forbids men to socialize with women, sit near them, or even look at them. Especially noteworthy is a clause prohibiting men from being alone with young boys, a clause that may be concerned with the possibility of homoerotic encounters.

More relevant to our discussion, however, is a clause that specifically forbids the Jewish pilgrim from bringing a gentile or an apostate

Figure 6. Letter of appeal from the wife of Basir the bell maker to the nagid of Egypt's Jewish community, David II ben Joshua, mid-14th century. Paper. Cambridge University Library, Taylor-Schechter Genizah Collection, Cambridge (T-S 8J26.19)

*hasidim*, and in so doing they deliberately drew on an old biblical model of pietism. The origins of their self-designation notwithstanding, the mystical traditions of these *hasidim* were in reality heavily indebted to the contemporary Islamic Sufi tradition. We know, for example, that they were avid readers of the classic works of Islamic Sufism: pages from the works of al-Hallaj, Ibn al-'Arif, al-Ghazzali, and Suhrawardi were found among the Geniza manuscripts. They also produced original Sufi-inspired texts of their own. Devotional practices that mirrored those of the Sufis played an important role in their religious program: they wore special woolen tunics and emphasized the importance of nightly vigils, daily fasting, meditation in solitude, and abstention from sex. And they tried to introduce a number of innovations into the synagogue service, including ablutions of hands and feet before prayer, frequent prostrations on the ground, and sitting on the floor in rigidly straight rows.

This was anything but a fringe movement. During the thirteenth century one of its leading proponents was Abraham ben Moses (d. 1237), the son of Maimonides and the administrative head of Egypt's Jewish community.[19] Abraham was the author of a monumental and highly innovative work entitled *The Comprehensive Guide for the Servants of the Lord* that sought to reinterpret biblical and rabbinic texts in light of Sufi doctrines and practices.[20] What is perhaps most astonishing about this endeavor is that Abraham was unabashed about the fact that he was imitating his Muslim contemporaries, his rationale being that he was facilitating the reclamation of practices that had originally been Jewish. Sufi mystics, he maintained, had learned them from the prophets of ancient Israel. "Surely you are aware," he writes, "that the customs of the ancient saints of Israel are only minimally observed among the Jews today, while they have become the practice of the Sufis of Islam. . . . This is why we borrow from them and emulate them."[21] In urging his coreligionists

to the sanctuary. This prohibition illustrates the efforts of the Jewish religious authorities to erect firm boundaries between Jews and non-Jews, while at the same time suggesting a social reality in which such boundaries were routinely blurred.

A highly creative Jewish mystical movement in thirteenth- and fourteenth-century Egypt offers yet another instance of such a convergence. Its adherents called themselves

to copy the practices of Sufis, Abraham maintained that he was in reality restoring long-forgotten Jewish traditions.

Abraham's treatise was directed at a select and highly elite group of mystical devotees. But a captivating letter from the Geniza reveals the way such currents could have an influence on non-elites as well (fig. 6). The letter was written by a Jewish woman whose husband, the bell maker Basir, had become an admirer of the Islamic Sufi master al-Kurani and had taken to living with him and a group of his followers in the desert outside of town. The letter is addressed to David II ben Joshua (ca. 1335–1415), the nagid of Egypt's Jewish community (and the great-great-great-grandson of Maimonides), imploring him to intercede in the matter and bring Basir back to his responsibilities as a parent and a Jew. She writes:

> The maidservant, the wife of Basir the bell-maker, informs our Master that she has on her neck three children because her husband is infatuated with life on the mountain with al-Kurani . . . a place where there is no Torah. . . . He goes up the mountain and mingles with the Sufis. . . . The maidservant is afraid there may be there some bad man who may induce her husband to forsake the Jewish faith. . . . The maidservant almost perishes because of her solitude and her search after food for the little ones. It is her wish that our Master go after her husband and take the matter up with him. . . . The only thing which the maidservant wants is that her husband cease to go up the mountain. . . . If he wishes to devote himself to God, he may do so in the synagogue, attending regularly morning, afternoon and evening prayers, and listening to the words of the Torah, but he should not occupy himself with useless things.[22]

While we have no way of knowing what action, if any, David ben Joshua took

Figure 7. List of Byzantine Jews in Egypt receiving alms, dated October 30, 1107. Paper. Cambridge University Library, Taylor-Schechter Genizah Collection, Cambridge (T-S K15.39)

in this matter, the appeal itself provides a tantalizing glimpse of Jews and Muslims meeting at a site on the margins of the urban environment. And as in the case of the shrine at Dammuh, the purpose of the meeting was of an overtly spiritual nature. While it is common to observe that Jews and Muslims rubbed elbows in the bustling marketplaces of the medieval Islamic world, the Dammuh ordinance and Basir's wife's letter remind us that such interactions were by no means restricted to the neutral economic sphere but could take place in religiously charged settings as well.

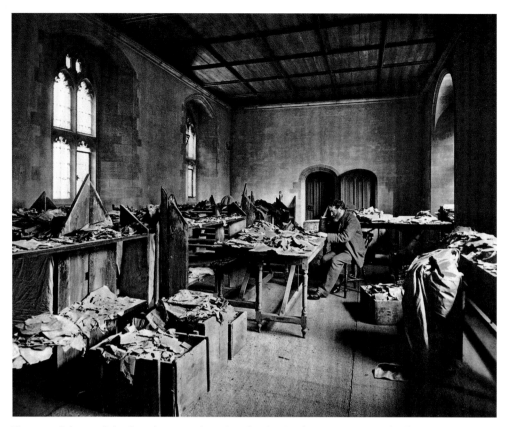

Figure 8. Solomon Schechter (1847–1915) sorting the Geniza documents at Cambridge University Library, 1898 (Reproduced with permission of the Syndics of Cambridge University Library)

## BYZANTINE IMMIGRANTS

As we have already observed in considering the life of Johannes-Obadiah, the boundaries traversed in the Geniza were not always lines of a purely conceptual nature. Indeed, linguistic, cultural, and political borders could be no less permeable than those separating confessional affiliations. Of special note is the frontier between Byzantine and Islamic lands, and a variety of sources from the Geniza attest to movement in both directions.[23] Trade, of course, constituted a regular incentive for travel, though typically this involved only a temporary crossing.[24] A Hebrew and Arabic letter dating to July 1137, on the other hand, sheds light on migration for the purpose of settlement.[25] The letter was written by a Jewish physician originally from Egypt who may at one time have been in the service of the Fatimid navy. But as we learn from his missive he had since settled in Seleucia (Silifke), married a local Greek-speaking Jewish woman, and prospered. "God has favored me and replaced my losses. . . . I am well liked here," he writes, with evident satisfaction, of his new home, "and successful in my profession." The letter, which was sent to Fustat, is addressed to the writer's brother-in-law (i.e., his sister's husband) and repeatedly urges the recipient to follow through on his expressed intention to emigrate as well. "If you come here, as you intend to, you will not miss any of the things you left there," the writer promises. Especially interesting is the fact that he is able to provide his correspondent with news about eleven other Egyptian Jews who had settled in Byzantine towns, including Constantinople. The

*Age of Transition: Byzantine Culture in the Islamic World*

letter indicates that in the first half of the twelfth century Jews from the Fatimid realm were aware of the prosperity of Byzantium and, in certain cases, were persuaded to settle there.

While some Jews sought success in Byzantine lands, others evidently tried to improve their fortunes by moving in the opposite direction. A particularly telling picture of the migration of Byzantine Jews to Egypt in the early twelfth century emerges from a series of communal alms lists preserved in the Geniza. The lists, which comprise the names of individuals receiving disbursements of money, food, or clothing on a given day, document the social makeup of the Jewish poor, as well as the communal mechanisms implemented to alleviate their plight.[26] Often appended to the entries are brief descriptions of the beneficiary's occupation, origins, and personal circumstances.[27]

Foreigners tend to appear in significant numbers, and one of the most conspicuous groups is that identified as the Rum, a general term that in this context almost certainly refers to immigrants from Byzantine lands.[28] They are especially prominent in a series of lists from about the year 1107 that were originally leaves of a single record book.[29] One of the pages, which bears the date October 30, 1107, includes a separate heading for the Rum, under which at least forty-nine individuals are registered (fig. 7).[30] Another page, written in the same hand, has a section for the Rum that includes forty names. It has been suggested that these Byzantine immigrants made their way to Fustat in the wake of the Crusaders' march through Asia Minor in 1098. Most of them have Greek names or names common among Greek-speaking Jews. Curiously, however, a few of the names are Arabic, raising the possibility that the ancestors of some of these individuals had once been inhabitants of Arabic-speaking lands who had subsequently settled in Asia Minor, perhaps in the aftermath of Byzantine incursions into Syria in the 960s and 970s. The relocation of their descendants to Fustat in the beginning of

the twelfth century would thus mark the family's second crossing of the border separating Byzantium from the Islamic world in the space of only four or five generations.

## CONCLUSION

One of the most famous photographs of Solomon Schechter, taken in 1898, shows the scholar alone in a room at Cambridge University Library, engrossed in deciphering the newly acquired materials from the Geniza (fig. 8). Schechter's pose—seated with hand raised to head in intense concentration—has been wonderfully described as a "rabbinic version of Rodin's *The Thinker*."[31] The figure of Schechter is just one of several elements in the picture that together form a study in contrasts. The upper half of the photograph invites us into the stately and symmetrical physical space. The room is grand, spacious, and orderly. It has high ceilings and intricately carved windows; the walls are clean and spare. The bottom half, on the other hand, is dominated by an unruliness, a chaos created primarily by the disorganized heaps of manuscripts but also by the unkempt appearance of Schechter himself. The Geniza fragments appear as unbidden, disheveled intruders that have infiltrated the tranquil setting, throwing it into confusion. With great prescience this iconic photograph captures what would emerge as one of the Geniza's great contributions, namely, its disruption of much of what historians thought they understood about the way religious communities interacted in the medieval Islamic world. The neat and overly simplistic categories that we often fall back on, the idea that Jews, Christians, and Muslims lived in more or less ghettoized communities—these are rendered less tidy and far more complicated by the revelations of the Cairo Geniza.

My thanks to Jay Diehl, Lauren Mancia, Sara McDougall, Janine Peterson, Andrew Romig, and Neslihan Senocak for reading and commenting on an earlier draft of this essay.

1. On the Jewish practice of *geniza*, see Cohen and Stillman 1985. On a similar concern with the proper disposal of religious writings among Muslims, see Cohen 2006. See also Sadan 1980 and 1986.

2. For an architectural history of the Ben Ezra Synagogue, see Le Quesne 1994.

3. On the circumstances that led to Schechter's recognition of the importance of the Geniza and his expedition to Egypt, see the gripping accounts in Hoffman and Cole 2011: 4–94, and Reif 2000: 47–97.

4. Goitein 1967–88, vol. 2 (1971): 52.

5. Cambridge University Library, Taylor-Schechter Genizah Collection (hereafter T-S) 10J29.13r, lines 20–23. See the letter in Gil 1983, vol. 2: 371–74 (doc. 205).

6. T-S 13J15.1, lines 7–13, in ibid.: 149–50 (doc. 82).

7. Library of the Alliance Israélite Universelle VII A 17, edited in Chapira 1909: 125–26; summary in Goitein 1967–88, vol. 2 (1971): 52.

8. Rustow 2008.

9. Ibid.: 239–65; Olszowy-Schlanger 1998: 252–56.

10. Rustow 2008: 245. Strictly speaking, marriages between Karaites and Rabbanites were not entirely unknown before the discovery of the Geniza, but their significance was hardly appreciated. See, for example, Schechter 1901: 218.

11. Bodleian Library, University of Oxford, MS Heb. d 66, folios 49v–50r, edited and translated in Olszowy-Schlanger 1998: 432–36.

12. T-S 24.1, edited in Schechter 1901.

13. Goitein 1967–88, vol. 2 (1971): 299–311.

14. Edited and discussed in Golb 1981.

15. See Golb 1965a, 1965b, and 1967.

16. Adler 1907: 43–45.

17. T-S 20.117v, translated and discussed in Kraemer 1999.

18. Ibid.: 583.

19. Fenton 1998.

20. Partial edition and translation in Rosenblatt 1927–38.

21. Ibid., vol. 1 (1927): 153.

22. T-S 8J26.19, translated and discussed in Goitein 1967–88, vol. 5 (1988): 473–74. See also Goitein 1953.

23. On Geniza materials by and about Byzantine Jews, see De Lange 1992; Jacoby 2001; and Outhwaite 2009.

24. On trade between Byzantium and Egypt, see Jacoby 2012: 245–47.

25. T-S 13J21.17, in Goitein 1964.

26. On these lists, see Goitein 1967–88, vol. 2 (1971): 126–38, 438–70.

27. For a thorough study of poverty in the Geniza on the basis of these and other sources, see Cohen 2005a. For translations and discussions of individual documents, see Cohen 2005b.

28. Goitein 1967–88, vol. 2 (1971): 127, identifies them as refugees from Europe fleeing the disturbances caused by the First Crusade. See, however, Jacoby 2001: 89n27.

29. Goitein 1967–88, vol. 2 (1971): 443.

30. T-S K15.39, translated and discussed in Cohen 2005b: 130–34.

31. Hoffman and Cole 2011: 88.

## REFERENCES

**Adler, Marcus Nathan**

**1907** *The Itinerary of Benjamin of Tudela: Critical Text, Translation, and Commentary.* 2 vols. in 1. London: Henry Frowde.

**Chapira, Bernard**

**1909** "Un Document judéo-arabe de la Gueniza du Caire." In *Mélanges Hartwig Derenbourg, 1844–1908:* 125–30. Paris: Ernest Leroux.

**Cohen, Mark R.**

**2005a** *Poverty and Charity in the Jewish Community of Medieval Egypt.* Princeton, N.J.: Princeton University Press.

**2005b** *The Voice of the Poor in the Middle Ages: An Anthology of Documents from the Cairo Geniza.* Princeton, N.J.: Princeton University Press.

**2006** "Geniza for Islamicists, Islamic Geniza, and the 'New Cairo Geniza.'" *Harvard Middle Eastern and Islamic Review* 7: 129–45.

**Cohen, Mark R., and Yedida K. Stillman**

**1985** "The Cairo Geniza and the Custom of Geniza among Oriental Jewry: An Historical and Ethnographic Study" [in Hebrew]. *Pe'amim* 24: 3–35.

**De Lange, Nicholas**

**1992** "Byzantium in the Cairo Genizah." *Byzantine and Modern Greek Studies* 16: 34–47.

**Fenton, Paul B.**

**1998** "Abraham Maimonides (1187–1237): Founding a Mystical Dynasty." In *Jewish Mystical Leaders and Leadership in the 13th Century,* edited by Moshe Idel and Mortimer Ostow: 127–54. Northvale, N.J.: Jason Aronson.

**Gil, Moshe**

**1983** *Eres-Yisra'el ba-tequfa ha-muslemit ha-rishona (634–1099)* [Palestine during the first Muslim period (634–1099)]. 3 vols. Tel Aviv: Tel Aviv University and the Ministry of Defense.

**Goitein, S. D.**

**1953** "A Jewish Addict to Sufism in the Time of the Nagid David II Maimonides." *Jewish Quarterly Review,* n.s., 44: 37–49.

**1964** "A Letter from Seleucia (Cilicia) Dated 21 July 1137." *Speculum* 39: 298–303.

**1967–88** *A Mediterranean Society: The Jewish Communities of the Arab World as Portrayed in the Documents of the Cairo Geniza.* 5 vols. Berkeley: University of California Press.

**Golb, Norman**
**1965a** "Concerning Obadiah the Proselyte and His Musical Work" [in Hebrew]. *Tarbiz* 35: 1–63.

**1965b** "Obadiah the Proselyte: Scribe of a Unique Twelfth-Century Hebrew Manuscript Containing Lombardic Neumes." *Journal of Religion* 45: 153–56.

**1967** "The Music of Obadiah the Proselyte and His Conversion." *Journal of Jewish Studies* 18: 1–18.

**1981** "The Scroll of Obadiah the Proselyte" [in Hebrew]. In *Mehkere 'edot u-Genizah* [Studies in Geniza and Sepharadi Heritage], edited by Shelomo Morag, Issachar Ben-Ami, and Norman A. Stillman: 77–107. Jerusalem: Magnes Press.

**Hoffman, Adina, and Peter Cole**
**2011** *Sacred Trash: The Lost and Found World of the Cairo Geniza*. New York: Schocken.

**Jacoby, David**
**2001** "What Do We Learn about Byzantine Asia Minor from the Documents of the Cairo Genizah?" In David Jacoby, *Byzantium, Latin Romania and the Mediterranean*: 83–95. Variorum Collected Studies. Aldershot: Ashgate.

**2012** "The Jews in the Byzantine Economy (Seventh to Mid-Fifteenth Century)." In *Jews in Byzantium: Dialectics of Minority and Majority Cultures*, edited by Robert Bonfil: 219–55. Leiden: Brill.

**Kraemer, Joel L.**
**1999** "A Jewish Cult of the Saints in Fatimid Egypt." In *L'Egypte fatimide: Son Art et son histoire; actes du colloque organisé à Paris les 28, 29 et 30 mai 1998*, edited by Marianne Barrucand: 579–601. Paris: Presses de l'Université de Paris-Sorbonne.

**Le Quesne, Charles**
**1994** "The Synagogue." In *Fortifications and the Synagogue: The Fortress of Babylon and the Ben Ezra Synagogue, Cairo*, edited by Phyllis Lambert: 79–97. London: Weidenfeld and Nicolson.

**Olszowy-Schlanger, Judith**
**1998** *Karaite Marriage Documents from the Cairo Geniza: Legal Tradition and Community Life in Mediaeval Egypt and Palestine*. Leiden: Brill.

**Outhwaite, Ben**
**2009** "Byzantium and Byzantines in the Cairo Genizah: New and Old Sources." In *Jewish Reception of Greek Bible Versions: Studies in Their Use in Late Antiquity and the Middle Ages*, edited by Nicholas De Lange, Julia G. Krivoruchko, and Cameron Boyd-Taylor: 182–215. Tübingen: Mohr Siebeck.

**Reif, Stefan C.**
**2000** *A Jewish Archive from Old Cairo: The History of Cambridge University's Genizah Collection*. Richmond, Surrey: Curzon Press.

**Rosenblatt, Samuel**
**1927–38** *The High Ways to Perfection of Abraham Maimonides*. 2 vols. New York: Columbia University Press; Baltimore: Johns Hopkins University Press.

**Rustow, Marina**
**2008** *Heresy and the Politics of Community: The Jews of the Fatimid Caliphate*. Ithaca, N.Y.: Cornell University Press.

**Sadan, Joseph**
**1980** "Storage and Treatment of Used Sacred Books (Genizah) in the Muslim Tradition and Jewish Parallels" [in Hebrew]. *Kiryat Sefer* 55: 398–410.

**1986** "Genizah and Genizah-like Practices in Islamic and Jewish Traditions." *Bibliotheca Orientalis* 43: 36–58.

**Schechter, S[olomon]**
**1901** "Genizah Specimens: A Marriage Settlement." *Jewish Quarterly Review* 13, no. 2: 218–21.

*Annie Montgomery Labatt*

# The Transmission of Images in the Mediterranean

Iconography as an art-historical study is often dismissed as an assemblage of lists, caricatured as a series of inventories of forms and subjects. One writer's recent juxtaposition of the codes found in a well-known potboiler with the art-historical codes deciphered by Erwin Panofsky reflects the persistent concerns about naïve and simplistic interpretations in iconographic studies.[1] But reading iconographies, moving beyond taxonomies, we can identify significant variations between objects with the same narrative subject matter. The shifting and mobile iconographies of the medieval period provided a pan-Mediterranean common language and a means of fertile cross-cultural exchange. Reading one object leads inevitably to others that participate in the common language of its imageries.[2]

The Fieschi Morgan Reliquary in The Metropolitan Museum of Art, a casket made to hold a relic of the True Cross, is such an object (fig. 1).[3] The lid displays an enameled representation of the Crucifixion. That lid slides and comes off entirely. The reliquary is an object that can well be understood in the context of John of Damascus, who insisted that our cognition must employ all our senses. Writing in the first half of the eighth century, John described the senses as the means by which the soul apprehends the material world. Color and movement, he wrote, are perceived through sight: "Now sight is primarily perception of colour, but along with the colour it discriminates the body that has colour, and its size and form, and locality, and the intervening space and the number: also whether it is in motion or at rest." But sight cannot operate alone because, John says, it is possible only in "straight lines," whereas we need multiple kinds of perception, such as "heat and cold, softness and hardness, viscosity and brittleness, heaviness and lightness . . . up and down."[4]

John's emphasis on movement is particularly suited to a reading of the Fieschi Morgan Reliquary. The enameled exterior depicts the body of Christ melding with the cross. The earthy brown at the base, where Christ's feet rest, becomes a celestial blue above, both behind Christ's arms and above his head in the form of the titulus. Along the body of Christ, the cross takes on an ethereal quality; base brown wood is transmuted, spiritualized. The vertical progression facilitated by the coloristic shift from brown to blue, reflected in the brown cape worn by the saint beneath the cross and the blue titulus worn by the saint above, draws the eye of the viewer along an axis that culminates in the latch. The vertical axis is extended when the lid is slid upward to open the box, further emphasizing the form of Christ's body. The interior, partitioned in the shape of the cross, holds the relic of the True Cross.

Sliding the lid and flipping it over, the engaged viewer is drawn into a dramatization of Christ's complex nature. Turning over the lid activates a major shift, one that switches from blues, greens, and browns to impressionistic grooves and incisions. In essence, when the lid is turned over, the grooved metal of the border on the exterior becomes the new medium, since the representations of the Annunciation, the Nativity, the Crucifixion, and the Anastasis or Harrowing of Hell are all in the same black metallic material (fig. 2). Initiating the Christological narrative is a quote from Luke: "Hail, full of grace" (Luke 1:28), which proclaims the arrival of the Christ

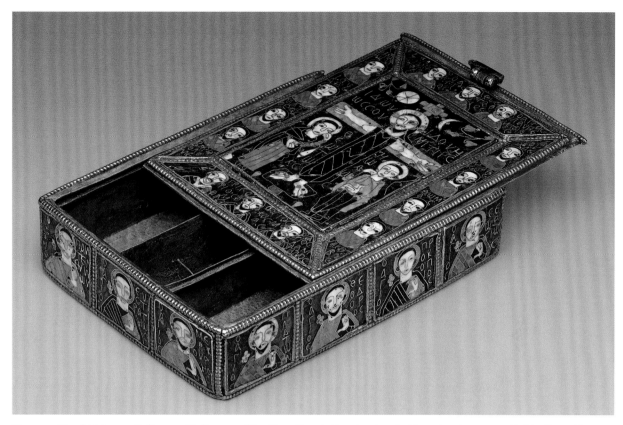

Figure 1. Fieschi Morgan Reliquary (Reliquary of the True Cross). Constantinople (?), early 9th century. Gold, silver, silver gilt, cloisonné enamel, niello. The Metropolitan Museum of Art, Gift of J. Pierpont Morgan, 1917 (17.190.715a, b)

Child. The next quadrant, labeled the Nativity, follows directly from the previous episode—the pronouncement has been fulfilled. The Crucifixion, like the Annunciation, makes visible the words of scripture. Along the left side of Christ's body, inscribed in Greek, are the words of Jesus to his mother: "Woman, behold thy son!" while on the right are the words of John the Baptist: "Behold thy mother!" (John 19:26–27). These phrases replicate the inscriptions that appear on the front of the lid, but this time without identifying Mary and John.

On the enameled exterior inscriptions fill the background. On the underside of the lid they are simpler and shorter, until finally, in the Anastasis, they disappear altogether. It is almost as though the final quadrant is a visualizing of observations made by John

Figure 2. Underside of lid, Fieschi Morgan Reliquary (fig. 1)

of Damascus that "images and sermons might serve the same purpose"; by the ninth-century patriarch Nikephoros I (ca. 758–828) that "through calligraphic genius the teachings of divine history appear to us. . . . By the excellence of painting, those same things are shown to us"; or by the patriarch Photios (810–891) that sight could supersede text: "Martyrs have suffered . . . and their memory is contained in books. These deeds they are also seen performing in pictures, and painting presents the martyrdom of those blessed men more vividly to our knowledge. . . . These things are conveyed both by stories and by pictures, but it is the spectators rather than the hearers who are drawn to emulation."[5]

It is striking that the scene that has no words, that is silent, makes the most resonant statement in the series. The Anastasis, in which Christ descends into hell and liberates the souls of the virtuous, became and remains the standard Orthodox expression of the Resurrection of Christ and the extension to mankind of his victory over death. The message of the Anastasis—of salvation and resurrection—highlights the relationship of the reliquary to the end of days, when all relics and all bodies will be reassembled and made whole. The scene also underscores the dual nature of Christ. He is both dead and alive, human and divine, and he inhabits an undefined realm in time and place. Even as he crushes the basilisk under his weight and pulls Adam's arm with strength and vigor, he is imbued with weightlessness, as indicated by his fluttering cloak. The broken gates of Hades, which float in the upper right corner of the Anastasis quadrant, also suggest a strange defiance of gravity.

The hovering gates also draw attention to the role of doors and doorways. The gates continue the direction of the strong diagonal of Christ's body, which runs from his right foot, along his right thigh (emphasized by a patch of peculiarly deep, angled hatching), and through the slanted angle of the nimbus. The shape created by the rectangular gates mirrors that of the cross in the nimbus. It also corresponds to the basin above, in which the Christ Child is bathed. Indeed, the T-shaped basin in the Nativity has essentially been turned upside down and transformed into the broken gates below, as if to illustrate the intricate link between birth and resurrection.

The imagery of doors and doorways takes on a further dimension of meaning by virtue of the fact that the lid is a physical door and the viewer must engage with it in a physical way. By removing the lid and reading the scenes, the viewer enacts Christ's gesture of opening doors in the Anastasis. And as Christ shifts between the earthly and the otherworldly, the viewer, in experiencing the reliquary, transitions between two worlds—from the variegated and richly hued to the achromatic, from the literal to the abstract, from exterior and overt to interior and hidden, from many voices and words and names to silence.

Perhaps the scene of the Anastasis needs no inscription because Christ's descent into hell is beyond comprehension, beyond the capacity of words. Or perhaps the Anastasis image is doing what John of Damascus, Nikephoros, and Photios were saying could happen, making images serve in place of words. Iconographic forms could, in fact, act as a type of vocabulary. The "forms" and "shapes" (the very words used by John of Damascus) could create a scene that would be instantly recognizable to the devout viewer.

Such iconographies were shared. They constitute a common language, one that was cross-cultural and pan-Mediterranean. Indeed, the art of the medieval world is built on images that were repeated, a repetition with variations that extended across vast distances. In reading the internal dynamics of a scene such as the Anastasis on the Fieschi Morgan Reliquary, we are led to make comparisons with other expressions of that same common language. In making such comparisons, we recreate in our own time the language and the dialogue between images that at some level always

operated in the early centuries of the Christian era.

Doors, movement, and liminality, the themes suggested by the Anastasis on the Fieschi Morgan Reliquary, also inform an Anastasis that appears in the Church of Santa Maria Antiqua in the Roman Forum (fig. 3). The painting shows Christ in a mandorla, stepping on the basilisk and grabbing the arm of Adam, who waits in a blocky sarcophagus. Eve, who appears above, opens her hands to Christ. This image, dated to 705, decorates a large panel on the ramp leading from the church to the summit of the Palatine Hill, connecting the holy space of the church with the political space of the palaces above. Its placement near this doorway is significant because it is the first and last image the viewer sees on entering and leaving the church. This Anastasis is liminal in a literal sense—it is actually on a threshold between two spaces and two worlds. One might think that the sense of movement and transition would be limited on a flat wall. But this is not so. Even when standing in front of the painting, there is a sense of uncertainty and instability because the viewing experience is awkward. The viewer is on an incline, in a small space, and standing so close to the painting that it takes a moment to register the entirety of the composition.

The sense of gravity as the visitor moves along the image, down the incline of the ramp, gives to the painted sarcophagus a physical reality, as the visitor next steps down to what looks like a painted stair. By the same token, when exiting the church the viewer moves upward, as though he, like Adam and Eve, is being saved. Diagonals are important. They are meant to refer to, echo, and counterbalance the incline of the ramp. The connection between the painting's diagonals and the physical slope of the ramp engages the viewer in such a way that he becomes a participant in the painting and, by extension, in the moment of salvation that it represents. In his writings John of Damascus frequently emphasizes the importance of memory as a storehouse

Figure 3. Anastasis. Santa Maria Antiqua, Rome, 705. Fresco (from Wilpert 1917, vol. 4, fig. 168.2)

of information that facilitates perception. Images, he asserts, are essential in creating memories and reminding us of past deeds.[6] As its own alpha and omega, as the first and last thing witnessed by the churchgoer, the painting marks the memory of the viewer with the image of resurrection. There is dynamic movement and an active involvement on the part of the viewer, as with the Fieschi Morgan Reliquary.

The message of the Anastasis therefore resonates on many levels, both as a celebration of the salvation of mankind in general

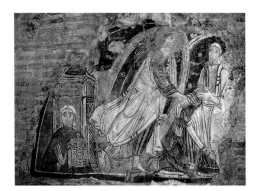

Figure 4. Anastasis. Lower church, San Clemente, Rome, 9th century. Fresco (Photo: Annie M. Labatt)

and as a message directed specifically toward the individual witnessing the image. The individual assumes a central role in another, later ninth-century fresco of the Anastasis in the Church of San Clemente in Rome (fig. 4). In a recessed space removed from the more trafficked areas of the church is a lunette showing, again, the scene of Christ stepping on the basilisk and pulling Adam and Eve from their tombs.[7] This version, however, includes a portrait of Saint Cyril, the famous missionary who converted the Slavic peoples to Christianity and after whom the Cyrillic alphabet is named.[8] In 867, Cyril and his brother Methodios were summoned from Thessaloniki to Rome by Pope Nicholas I to defend their translation of the liturgy into Slavonic. The two brothers carried the relics of Saint Clement to Rome, depositing them beneath the high altar at the church of the same name. Cyril died two months after they arrived, and it is likely the tomb under the painting of the Anastasis is in fact Cyril's.

As with the sliding lid of the Fieschi Morgan Reliquary and the sloping painting at Santa Maria Antiqua, doors and portals are essential to the discussion of the San Clemente image. Cyril stands in what appears to be a doorway—perhaps the entry to his tomb, perhaps a path to paradise. His features provide details that emphasize the portrait as that of a specific individual. The shape of

Figure 5. Saint Abba Pishoi (b. 320). Monastery of Saint Antony the Great, Egypt, early 13th century. Secco painting (from Bolman and Godeau 2002, fig. 5.9) (Photo: Patrick Godeau, ADP/SA)

Cyril's face, long and drawn, is accentuated by the dark brown beard and handlebar mustache. His eyes are heavily lined and his forehead creased. His eyebrows, dark and thick, are arched to suggest an expression of saintliness. His nose is also particularized, with a long thin shaft ending in two bulb-like shapes.

The most telling mark of identity is Cyril's head covering, a white textile decorated with red patterns. No other depiction of headgear of this sort exists in Rome. Images of monastic figures in hoods appear in Roman churches such as San Crisogono, Sant'Ermete, San Sebastiano al Palatino, and San Saba, but these hoods are pointed and dark. The thirteenth-century paintings of standing monastic saints at the Monastery of Saint Anthony in Egypt are better visual sources.[9] The portrait of Saint Pishoi (b. 320) shows the monk wearing a white head covering with black and white designs similar to those worn by Cyril (fig. 5). This image is admittedly four centuries later than the portrait of Cyril, but it documents the practice of wearing this type of headgear. The likelihood is that Cyril was being distinguished as a representative of a monastic community, one with ties to the Holy Land.

The portrait of Cyril shares several attributes with that of the seventh-century portrait of the fourth-century monastic figure Abbot Shenoute (346–465) at the Red Monastery Church near Sohag, Egypt (fig. 6). Shenoute's facial features correspond to those of the saint in the Roman fresco. Both monastics are framed in a way that emphasizes their iconic stature. This format recalls the bust-length figures on the Fieschi Morgan Reliquary.

Another representation of an Eastern monastic figure that resonates visually with these portraits is that of Symeon Stylites at San Felice in Cimitile, painted in the ninth century (fig. 7).[10] Symeon was one of the famous Christian ascetics known as stylites, who expressed their devotion by living on the top of a pillar.[11] It is not known which Symeon is depicted—the Elder (389–459) or the Younger (521–562)—but the distinction in this context is not significant as both are represented in similar ways. Symeon wears a dark, pointed hood much like those worn by the monks in the ninth-century painting at San Saba in Rome. But despite their different headgear, Symeon, Cyril, and Shenoute share a number of formal features: deep-set eyes, thick arching eyebrows, a

Figure 6. Abbot Shenoute (346–465). Red Monastery Church, near Sohag, Egypt, 7th century. Secco painting (© ARCE. Photo: Patrick Godeau)

pointed beard, and weighty sloping shoulders. Furthermore, the portraits of all three holy men are bust length and enclosed within a painted frame. They share a visual vocabulary, one that speaks a language of monastic holiness and the Holy Land.

In addition to their facial similarities, Cyril and Symeon also relate to their surroundings in comparable ways. In both cases columns play a central role in the transition between the two realms. The

Figure 7. Symeon Stylites. San Felice, Cimitile, 9th century. Fresco (from Belting 1962, fig. 53)

Figure 8. Crucifixion and Anastasis. San Felice, Cimitile, 9th century. Fresco (from Belting 1962, fig. 4)

column at Cyril's right simultaneously sets off and connects the saint to the events of the Anastasis in the next painted zone. Its blue and white grooves also connect Symeon to the tightly set folds of both Christ's and Adam's undergarments. Christ's fluttering cloak cuts right through the middle of the column, introducing further cross-columnar correspondences. The stars on Cyril's blue cloak, for example, match those that decorate the concentric frames in the mandorla surrounding Christ.

Symeon's portrait, like Cyril's, appears next to a scene of the Anastasis, but is set off from it. Tucked into the corner of a wall that shows both the Crucifixion and the Anastasis (fig. 8), Symeon occupies a small section that is not visible to someone looking directly at the wall. Symeon nevertheless plays an important role in linking the two events. In a way, he can be compared with the saints on the Fieschi Morgan Reliquary who frame the Crucifixion, standing guard even when the lid has been opened to reveal the Anastasis inside. Here, Symeon leads the viewer from the Crucifixion to the representation of the Anastasis. By looking to the left he draws attention to the Crucifixion, while the pinnacle of his column, composed of tightly conjoined and longitudinal ovals, links visually to the wrappings of the patient sinners who await salvation in the Anastasis. These same oval shapes also appear on Christ's cloak under his right arm and around his left hand.

Symeon's column, the central feature of the saint's veneration and iconography, is another example of cross-cultural imagery. Not all representations of Symeon from the period suggest mobility. On a large relief now in the Skulpturensammlung und Museum für Byzantinische Kunst, Berlin, the stylite is represented almost as though he has become one with the column, a kind of petrifaction accentuated by the thick, heavy basalt of which the relief is composed.[12] The columns associated with major stylites were also celebrated and reified in monastic complexes, such as the pilgrimage site of

Qal'at Sem'an in Syria, built sometime after 470 in honor of Symeon the Younger, and the Wondrous Mountain, west of Antioch, completed between 541 and 551, in honor of Symeon the Elder. The pilgrims who visited these sites left with objects that commemorated their travels, and easily portable jugs and tokens bearing stylite iconography made their way from the Syrian sites to areas throughout the Mediterranean. Pilgrims came from Syria, Cilicia, Armenia, Asia Minor, and the Persian frontier.[13] Italy was clearly in the mix as well.

Bodies of saints, repeated shapes, and shared narratives acted as conduits of meaning, part of a fluid exchange that did not conform to any traditional East versus West model. Images and shared iconographies reveal points of contact between communities and territories that were seemingly far from each other, both geographically and culturally. One example is the standing figure of David from the seventh-century Syriac translation of the Book of I Kings,

Figure 9. Syriac translation of the Book of 1 Kings with a portrait of King David. Syria, 7th century. Ink and gold on parchment; 19 folios. The Holy Monastery of Saint Catherine, Sinai, Egypt

Figure 10. Emperor Justinian and Archbishop Maximianus with members of their courts. Basilica of San Vitale, Ravenna, 527. Wall mosaic (Alfredo Dagli Orti/Art Resource, NY)

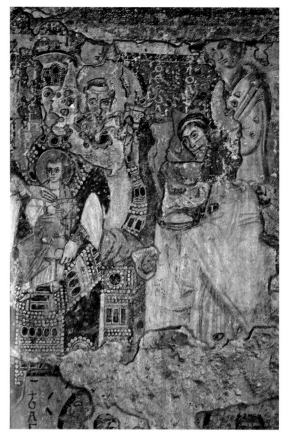

Figure 11. Rabbula Gospels, folio 4v. Syria (?), completed in 586. Ink and colors on parchment (Plut. I. 56). Biblioteca Medicea Laurenziana, Florence (Courtesy Ministero per i Beni e Attività Culturali—Italia)

Figure 12. Maria Regina. Santa Maria Antiqua, Rome, 6th century. Fresco (HIP/Art Resource, NY)

whose pose is virtually the same as that of the Byzantine emperor Justinian (r. 527–65) depicted on the walls of San Vitale in Ravenna (figs. 9, 10). Exchanging Justinian's ceremonial bowl for David's lyre and converting the tablion into a large golden codex, the Syriac manuscript painter nonetheless borrowed the pose, dress, and coloration of the sixth-century Italian mosaic. By using Justinian's form for David, the artist emphasized the imperial authority of the biblical king, placing David's power in the context of imperial iconography. A similar representation of David—the same pose, red shoes, aubergine cloak, and halo—appears in the upper right corner of the sixth-century Rabbula Gospels (fig. 11), although here

David appears without the jeweled crown and holds his right hand in benediction.[14] Below the Rabbula David, in a depiction of the Nativity, Mary holds her arms dramatically crossed. That same cross-armed pose corresponds not only to the stance of John the Baptist on the same page at left but also to that of Mary in the Nativity on the underside of the lid of the Fieschi Morgan Reliquary (see fig. 2), which in turn mimics the crossed arms of Christ in the Anastasis just below and in the Anastasis at Cimitile (see fig. 8).

It is remarkable how far these connections can be seen to carry. Like the Anastasis, the Maria Regina, which shows the Virgin as Queen of Heaven and wearing a garment

Figure 13. Empress Theodora. San Vitale, Ravenna, 527. Wall mosaic (© Guido Baviera/Grand Tour/Corbis)

embellished with pearls (fig. 12), is an iconography that appeared many times from the seventh to the ninth century in Rome, and as such really appears nowhere else.[15] This iconography shows Christ as both wholly human (as a child) and divine (as the future king of heaven). The transformation of the Virgin from the humble mother of Christ (see figs. 2, 11) to the regal Madonna with hanging pearls was significant and dramatic. The visual similarity between the Maria Regina crown and that worn by Justinian's wife, Empress Theodora, in a mosaic at San Vitale (fig. 13), is an obvious connection. But the pearls go much farther afield. They draw on associations with paradise and the end of time, associations identified by Finbarr Barry Flood in pearls decorating the eighth-century Great Mosque of Damascus.[16]

Thus large-scale mosaics and painted church walls—immobile monuments—can be seen, paradoxically, as participants in a fluid iconographic conversation. Following

the interrelationships of iconographies naturally leads us to draw Roman churches into conversation with a monastery in Egypt, to bring a seventh-century Syriac manuscript into a discussion with sixth-century Ravenna, all the while considering the images of the lid of the ninth-century Fieschi Morgan Reliquary. Iconography is far more than an assemblage of lists, a series of inventories of forms and subjects. The mobile iconographies of the medieval period provided a common language, a means of fertile cross-cultural exchange. The study of iconography helps us to step away from traditional scholarly classifications and preconceived assumptions about a Christian world divided into East and West. As an art-historical study, iconography reveals to us a vast world of myriad correspondences.

1. D'Elia 2008: 287; Panofsky 1939. See also Cassidy 1993. A recent conference entitled "Post-Iconography: Beyond Influence" (International Medieval Congress, Leeds, 2011) addressed the concerns of iconography in current scholarship. These themes were further discussed at the 2012 NORDIK Conference for Art History in the session "Iconography Revisited." Iconographic study is also the subject of an ongoing online research program run by the University of Oslo, *The Medieval Image: Meaning and Interpretation* (https://wiki.uio.no/hf/ifikk/medieval_iconography/index.php/Main_Page).

2. Nancy Patterson Ševčenko (1999: 165) describes art as an "international language."

3. For scholarship and recent bibliography about the Fieschi Morgan Reliquary, see Evans 2012: 88–89, no. 54, and Brubaker and Haldon 2011: 348–50. On the origin of the reliquary, see Buckton 1982; Kartsonis 1986: 94–116; and Buckton 1988.

4. John of Damascus, "Concerning Sensation," in *An Exact Exposition of the Orthodox Faith* 2.18; Salmond, *NPNF²* 9: 34.

5. Quoted in Brubaker 1999: 47–48.

6. John of Damascus, *On Holy Images*; Allies 1898, passim.

7. See Osborne 1981; Osborne 1984, passim; and Kartsonis 1986: 82–84.

8. For a discussion on the identity of the painted figure, see Osborne 1981: 280–87.

9. For examples of these types of head coverings, see Bolman and Godeau 2002, figs. 4.19, 4.21, 5.9–5.12, 12.1. See also Innemée 1992: 78.

10. On the decorations at San Felice in Cimitile, see Belting 1962; Belting 1978; and Kessler 2002: 83–84.

11. See Ratliff 2012.

12. Evans 2012: 96–97, no. 63.

13. Ratliff 2012: 94.

14. Evans 2012: 67–68, no. 39.

15. For recent scholarship, see Thunø 2002: 34–35; Osborne 2008; and Noble 2009: 129–33.

16. Flood 2001: 15–56.

## References

**Allies, Mary H., trans.**
**1898** *St. John of Damascene On Holy Images, Followed by Three Sermons on the Assumption.* London: Thomas Baker.

**Belting, Hans**
**1962** *Die Basilica dei SS. Martiri in Cimitile und ihr frühmittelalterlicher Freskenzyklus.* Wiesbaden: Franz Steiner.

**1978** "Cimitile: Le pitture medievali e la pittura meridionale nell'alto medioevo." In *L'Art dans l'Italie méridionale, aggiornamento dell'opera di Emile Bertaux,* edited by Adriano Prandi, vol. 4: 183–88. Rome: Ecole Française de Rome.

**Bolman, Elizabeth S., ed., and Patrick Godeau, photographer**
**2002** *Monastic Visions: Wall Paintings in the Monastery of St. Antony at the Red Sea.* Atlanta: American Research Center in Egypt; New Haven, Conn.: Yale University Press.

**Brubaker, Leslie**
**1999** *Vision and Meaning in Ninth-Century Byzantium: Image as Exegesis in the Homilies of Gregory of Nazianzus.* Cambridge Studies in Palaeography and Codicology 6. Cambridge: Cambridge University Press.

**Brubaker, Leslie, and John Haldon**
**2011** *Byzantium in the Iconoclast Era (c. 680–850): A History.* Cambridge: Cambridge University Press.

**Buckton, David**
**1982** "The Oppenheim or Fieschi-Morgan Reliquary in New York, and the Antecedents of Middle Byzantine Enamel." *Byzantine Studies Conference Abstracts of Papers* 8: 35–36.

**1988** "Byzantine Enamel in the West." *Byzantinische Forschungen* 13: 235–44.

**Cassidy, Brendan, ed.**
**1993** *Iconography at the Crossroads: Papers from the Colloquium Sponsored by the Index of Christian Art, Princeton University 23–24 March 1990.* Princeton, N.J.: Princeton University Press.

**D'Elia, Una Roman**
**2008** "Assessments. Popular Elitism: Renaissance Art as a Secret Code." In *Renaissance Theory*, edited by James Elkins and Robert Williams: 286–90. New York: Routledge.

**Evans, Helen C., ed.**
**2012** *Byzantium and Islam: Age of Transition, 7th–9th Century.* Exh. cat. New York: The Metropolitan Museum of Art.

**Flood, Finbarr Barry**
**2001**  *The Great Mosque of Damascus: Studies on the Makings of an Umayyad Visual Culture.* Islamic History and Civilization 33. Leiden: Brill.

**Innemée, Karel C.**
**1992**  *Ecclesiastical Dress in the Medieval Near East.* Studies in Textile and Costume History 1. Leiden: Brill.

**John of Damascus, Saint**
**1899**  *An Exact Exposition of the Orthodox Faith.* Translated by S. D. F. Salmond. In *A Select Library of Nicene and Post-Nicene Fathers of the Christian Church,* ser. 2, edited by Philip Schaff and Henry Wace, vol. 9. New York: Charles Scribner's Sons.

**Kartsonis, Anna D.**
**1986**  *Anastasis: The Making of an Image.* Princeton, N.J.: Princeton University Press.

**Kessler, Herbert L.**
**2002**  *Old St. Peter's and Church Decoration in Medieval Italy.* Spoleto, Italy: Centro Italiano di Studi sull'Alto Medioevo.

**Noble, Thomas F. X.**
**2009**  *Images, Iconoclasm, and the Carolingians.* Philadelphia: University of Pennsylvania Press.

**Osborne, John L.**
**1981**  "The Painting of the Anastasis in the Lower Church of San Clemente, Rome: A Re-examination of the Evidence for the Location of the Tomb of St. Cyril." *Byzantion* 51: 255–87.

**1984**  *Early Mediaeval Wall-Paintings in the Lower Church of San Clemente, Rome.* Outstanding Theses from the Courtauld Institute of Art. New York: Garland.

**2008**  "The Cult of Maria Regina in Early Medieval Rome." *Acta ad Archaeologiam et Artium Historiam Pertinentia* 21: 95–106.

**Panofsky, Erwin**
**1939**  *Studies in Iconology: Humanistic Themes in the Art of the Renaissance.* New York: Oxford University Press.

**Ratliff, Brandie**
**2012**  "The Stylites of Syria." In Evans 2012: 94–95.

**Ševčenko, Nancy Patterson**
**1999**  "The 'Vita' Icon and the Painter as Hagiographer." *Dumbarton Oaks Papers* 53: 149–65.

**Thunø, Erik**
**2002**  *Image and Relic: Mediating the Sacred in Early Medieval Rome.* Rome: L'Erma di Bretschneider.

**Wilpert, Josef, ed.**
**1917**  *Die römischen Mosaiken und Malereien der kirchlichen Bauten vom IV. bis XIII. Jahrhundert.* 2nd ed. 4 vols. Freiburg im Breisgau: Herder.

*Hieromonk Justin of Sinai*

# The Icons of Sinai: Continuity at a Time of Controversy

### INSCRIPTIONS AND IMAGES IN THE ROMAN CATACOMBS

The eighth and ninth centuries witnessed an intense debate over the very principles of Christian imagery. This was the Iconoclastic Controversy. It extended over a period of one hundred years, from its beginnings in the year 726 to its final resolution in 843. But the issues then in conflict were not new. We can better understand them if we begin by looking briefly at the earliest surviving examples of Christian art. Found in the Roman catacombs—the vast underground cemeteries that surrounded the city of Rome—these epitaphs and tomb paintings date primarily from the second to the fourth century.

The first example, now in the Vatican Museums, is dated to the fourth century and is thought to have come from the catacomb of either Saint Callixtus or Praetextatus (fig. 1). It reads in translation: "Aurelius Castus [who lived] eight months. Antonia Sperantia made [this] for her son." Below the inscription is the depiction of a shepherd bearing a lamb on his shoulders, with two sheep at his feet.

The early Christians expressed their faith in both words and images. But inscriptions are accessible in a way that imagery is not. Depictions such as this one were for the initiate, and required explanation. Jesus told the parable of the Good Shepherd, who went out to find the sheep that had gone astray, and bearing it on his shoulders, he returned, rejoicing, "for I have found my sheep which was lost" (Luke 15:4–6). He also said, "I am the good shepherd: the good shepherd giveth his life for the sheep" (John 10:11). The early medieval Gelasian Sacramentary, which preserves some of the oldest Latin liturgical prayers, includes a prayer for the burial service that refers to the dead as "carried home on the shoulders of the Good Shepherd."[1] Other recurring Christian symbols are the anchor and the dove bearing an olive branch in its beak. On later epitaphs we find more overt

Figure 1. Gravestone of Aurelius Castus with depiction of the Good Shepherd, 4th century, from the catacomb of Saint Callixtus or Praetextatus. Musei Vaticani, Museo Laterano (inv. no. 32457)

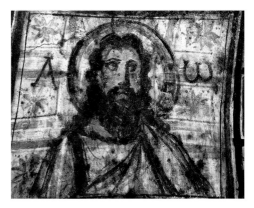

Figure 2. Bust of Christ, from the catacomb of Commodilla. Rome, late 4th century. Fresco (DeAgostini/DeAgostini)

Christian emblems: the Chi-Rho monogram and the alpha and omega.

The catacomb of Commodilla has an image of Christ dating from the late fourth century (fig. 2). And in the catacomb of Saint Priscilla is a depiction of the Virgin and Child with a prophet dated to the second century (fig. 3). Here also, in the third century, Christians painted the Good Shepherd and doves bearing olive branches. They also painted the Three Hebrews in the Fiery Furnace of Babylon, reminders of God's protection at a time of persecution (fig. 4).

The epitaphs of these early Christians reveal much about their faith: "To dear Cyriacus, sweetest son. Mayest thou live in the Holy Spirit." "Regina, mayest thou live in the Lord Jesus." "Matronata Matrona, who lived a year and fifty-two days. Pray for thy parents." "Anatolius made this for his well-deserving son, who lived seven years, seven months, and twenty days. May thy spirit rest well in God. Pray for thy sister."[2] It has been said that the catacomb inscriptions are ill-composed, poorly written in intermingled Greek and Latin, and not infrequently misspelled. And yet,

> Neither bad grammar nor defective orthography, nor rude art nor cramped space, nor damp nor darkness can dim or distort the light with which the

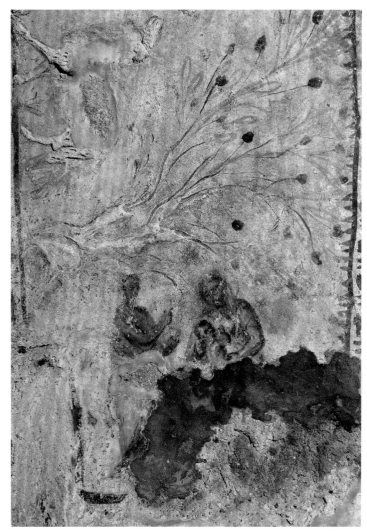

Figure 3. The Virgin and Child with a prophet, from the catacomb of Priscilla. Rome, 2nd century. Fresco (Scala/Art Resource, NY)

Figure 4. The Three Hebrews in the Fiery Furnace, from the catacomb of Priscilla. Rome, second half 3rd century. Fresco (Scala/Art Resource, NY)

consciousness of an immortality floods and glorifies these subterranean vaults. All here is joy and brightness and hope. The often-repeated inscription "In peace" tells its own tale.[3]

Such inscriptions are popular expressions of the same hope that we find in the theological treatise *De mortalitate*, written by Cyprian of Carthage in the year 252. Cyprian reminds his flock that death "is not an ending, but a transit, and, this journey being traversed, a passage to eternity."[4] The dead "are not lost, but sent before."[5] And he continues:

> We regard paradise as our country—we already begin to consider the patriarchs as our parents: why do we not hasten and run, that we may behold our country, that we may greet our parents? There a great number of our dear ones is awaiting us, and a dense crowd of parents, brothers, children, is longing for us, already assured of their own safety, and still solicitous for our salvation.[6]

## CHRISTIAN OR PAGAN?

In this spontaneous expression of their faith through words and images had Christians gone too far? The Roman world was filled with paintings and statues of the pagan deities. The Jews had always been careful to distance themselves from this idolatry. There were those who felt that such Christian depictions were an unguarded appropriation from the pagan world. The Gospels tell the story of the woman with "an issue of blood twelve years" who was healed by Christ (Matt. 9:20–22). Eusebius, bishop of Caesarea, in his fourth-century *Church History* relates that the same woman commissioned a bronze statue to commemorate the miracle. Christ was depicted standing as he offered his blessing, while the woman was portrayed kneeling at his feet, looking up to him in gratitude. Eusebius writes

that he had himself seen the statue. He goes on to say—and we cannot miss the note of disapproval,

> Nor is it strange that those of the Gentiles who, of old, were benefited by our Saviour, should have done such things, since we have learned also that the likenesses of his apostles Paul and Peter, and of Christ himself, are preserved in paintings, the ancients being accustomed, as it is likely, according to a habit of the Gentiles, to pay this kind of honor indiscriminately to those regarded by them as deliverers.[7]

One would want to know what these fourth-century paintings of Christ, and of the apostles Paul and Peter, looked like. But paintings are fragile, and by and large they have not survived from the world of Late Antiquity. One exception is the icons in the Holy Monastery of Saint Catherine in Sinai. This remote desert monastery, with its dry, consistent climate and an unbroken history that extends back to the early fourth century, holds what is today the most important collection of panel icons, thirty-six of which have been dated to the sixth or seventh century.

## 6TH-CENTURY SINAI ICONS

The icon with Christ Pantokrator is the most well known (fig. 5). It was painted in the wax encaustic technique, in which wax is used as the medium for the colors. The golden halo is set off by alternating four- and eight-petaled punched rosettes; the mantle and tunic are rendered in a saturated purple. Christ blesses with his right hand, while in his left he holds the Gospel, a thick volume closed with two clasps. The cover is adorned with a cross executed in precious stones and embellished with pearls. The formal, frontal depiction of Christ projects a sense of timelessness, yet the many intentional departures from strict symmetry—most vividly, in the eyes and

brows—add a softening naturalism. In this subtle manner the artist has conveyed both the divine and human natures of Christ.

A second icon depicts the Virgin and Child Enthroned (fig. 6). Here, too, the Child blesses with his right hand; in his left he holds a scroll. The Virgin wears red shoes, an imperial prerogative. Watchfully, she supports the Child. The soldier saints Theodore and George stand at either side, wearing the ceremonial robes of the imperial guard. Above, two archangels holding scepters gaze toward heaven. The hand of God extends down from an orb, casting a ray of light on the Holy Virgin. The archangels, rendered in a style that continues the Hellenistic tradition, contrast with the Virgin and Child and the two soldier saints, who reflect the splendors of the imperial court, lending the icon a rich complexity.

The third icon shows the apostle Peter (fig. 7). In his right hand he holds the keys to the kingdom of heaven (Matt. 16:19) and in his left, a staff surmounted by a cross. The artist has painted the garments in shades of olive, using crisscrossing highlights rendered in bold brushstrokes. The viewer is drawn to Peter's calm, pensive eyes, his face set off by whirling tufts of hair and beard. With the demeanor of a sunburned fisherman, he has also the aristocratic bearing of a leader of the church. The three medallions above depict Christ in the center. Kurt Weitzmann identified the other two images as portraits of John the Theologian and the Virgin Mary,[8] although it has recently been suggested that they may instead be ex voto images included as an expression of thanksgiving by those who commissioned the icon.[9]

ICONOCLASM

All three icons are thought to have been painted in Constantinople and may have been sent to the monastery in the sixth century as gifts of imperial patronage, when Emperor Justinian ordered the construction of the great basilica and the surrounding fortress walls.[10] As such, they are examples of the

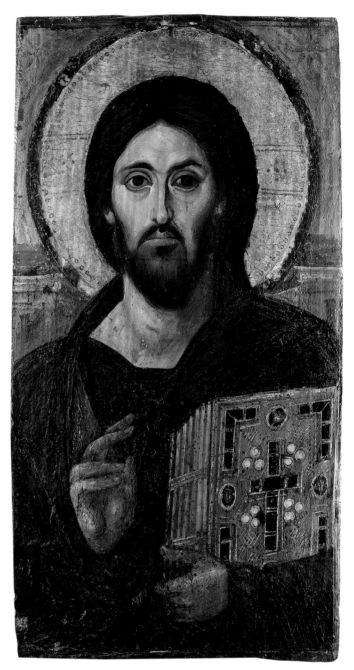

Figure 5. Icon with Christ Pantokrator, 6th–7th century. Encaustic on wood. The Holy Monastery of Saint Catherine, Sinai, Egypt

icons that would have been in Constantinople at the beginning of the Iconoclastic period, which was initiated under Leo III in the year 726. There were two phases to

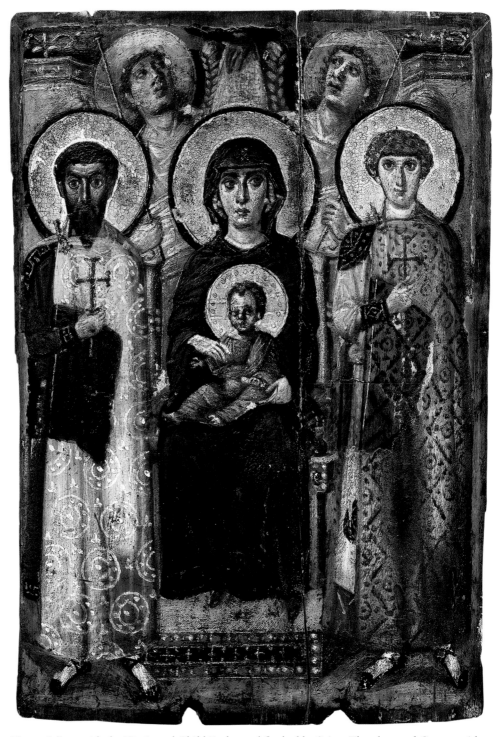

Figure 6. Icon with the Virgin and Child Enthroned flanked by Saints Theodore and George with archangels, 6th–7th century. Encaustic on wood. The Holy Monastery of Saint Catherine, Sinai, Egypt

Byzantine Iconoclasm. The first came to an end under Empress Irene in 787. An Iconoclastic policy was again instituted in 815 by Leo V. This second phase was brought to an end in 843 by Empress Theodora.

The origins of Iconoclasm have been much debated. The seventh century was a time of transition in the Byzantine Empire, the culmination of a long process of centralization during which Constantinople emerged as the dominant focus of power. During this century the empire lost Syria, Egypt, and North Africa to the Arab world, while Slavs threatened its hold in the Balkans and the Lombards became more assertive in Italy. Arab forces attacked Constantinople itself in 674–78 and again in 717–18, the Greeks famously defending their city with Greek fire. These far-reaching changes and conflicts led to a reassessment of the still unresolved issues concerning Christian imagery. It is to these conflicts that we must look for the origins of Iconoclasm, rather than to the infiltration within the church and the empire of foreign ideas.

The central charge brought by the Iconoclasts was that of idolatry. Any image made for use in worship was deemed to focus attention on the visible, material world rather than on the invisible Creator. Thus had God commanded of Moses:

> Thou shalt not make unto thee any graven image, or any likeness of any thing that is in heaven above, or that is in the earth beneath, or that is in the water under the earth: Thou shalt not bow down thyself to them, nor serve them. (Exod. 20:4–5)

Saint Paul, in his Epistle to the Colossians, refers to Christ as "the image [εἰκών] of the invisible God" (Col. 1:15). In the language of the Creed, Christ is one in essence (ὁμοούσιος), "consubstantial" with the Father. The Iconoclasts argued that for an image to be true, it must be the same in essence as that which it represents. There must be a formal identity between a model and its archetype,

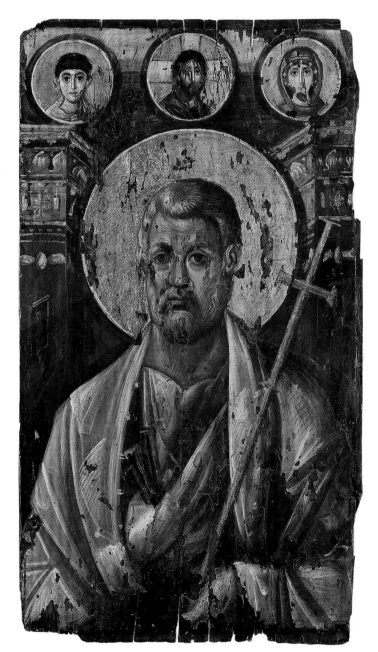

Figure 7. Icon with Saint Peter, 6th–7th century. Encaustic on wood. The Holy Monastery of Saint Catherine, Sinai, Egypt

and because a portrayal differs in its very nature from that which it represents, it is insufficient, if not deceptive. An image must not be allowed to intrude in worship, which must partake only of the spiritual.

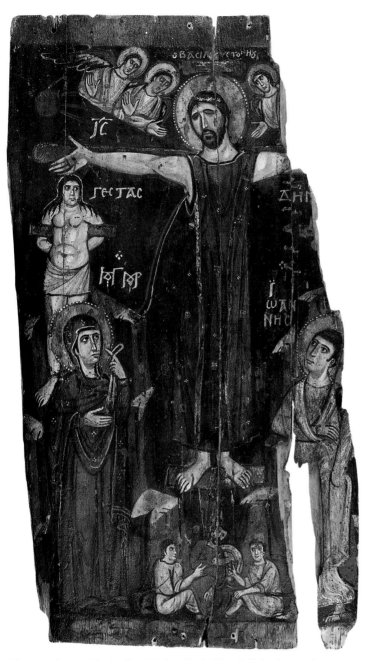

Figure 8. Icon with the Crucifixion. Early Islamic Palestine, perhaps Sinai, 8th century. Tempera on wood. The Holy Monastery of Saint Catherine, Sinai, Egypt

God is a Spirit: and they that worship him must worship him in spirit and in truth. (John 4:24)

In a number of churches, icons of Christ were replaced by depictions of the cross. A symbol, not a representation, the cross did not detract from the worship that is due to God alone.

One of the most important upholders of Orthodoxy, unyielding in his veneration of the holy icons, was the eighth-century monk martyr Saint Stephen the New. Around the year 764, Saint Stephen was brought before the emperor to defend his beliefs. Constantine V, under whose rule Iconophiles were zealously persecuted, posed a question: "Do you imagine that Christ is trampled upon when we trample on these images?" Saint Stephen, having expected to be asked this question, had brought with him a coin. He showed it to the emperor: "Whose is this image and superscription?" "It is mine," answered the emperor. Stephen then placed the coin on the ground and trampled on it. The emperor's guards were outraged at this affront to the imperial dignity, but the emperor stopped them from taking action. The saint had made his point.[11]

In many ways icons, while they had had a presence in the church for centuries, had been taken for granted. There were passing references to them in the writings of the church fathers, but there was no formal theology of icons. What could be said in their defense?

### THE VENERATION OF ICONS

Those who revered the holy icons acknowledged that God had indeed forbidden the making of graven images, but they pointed as well to his demand to Moses: "Make two cherubims of gold, of beaten work shalt thou make them, in the two ends of the mercy seat" (Exod. 25:18). The second commandment—"Thou shalt not make unto thee any graven image"—was not a

prohibition against representational art per se but rather a prohibition against the attempt to portray God, for while God had revealed himself, he had not taken physical form. To the children of Israel, Moses declared: "For ye saw no manner of similitude on the day that the Lord spake unto you in Horeb out of the midst of the fire" (Deut. 4:15).

But in time, "the Word was made flesh, and dwelt among us" (John 1:14). He who could not be circumscribed by time and place, who could not be portrayed, assumed human form. Theodore the Studite (759–826) wrote that in Christ, divine nature and human nature were united in a single πρόσωπον (person), a single ὑπόστασις (subsistent entity), with individual characteristics.[12] And John of Damascus (676–749): "I do not venerate the creation instead of the creator, but I venerate the Creator, created for my sake, who came down to his creation without being lowered or weakened, that he might glorify my nature and bring about communion with the divine nature. . . . I do not depict the invisible divinity, but I depict God made visible in the flesh."[13] Icons bear witness to the historical Christ. A refusal to accept icons was a refusal to accept the full implications of the Incarnation.

Analogy was made to the courts of Roman law. There the image of the emperor was honored as though the emperor himself were present. Basil the Great, in the fourth century, proclaimed that this did not imply that there were two emperors, "because the honor offered to the image crosses over to the archetype."[14]

An image conveys likeness. Image and archetype are thus said to share the same likeness. In the treatise *On the Ecclesiastical Hierarchy*, attributed to Dionysius the Areopagite, we read that "the truth is shown in the likeness, the archetype in the icon. Each in the other with the difference of essence." This concept was taken up in the early ninth century by Patriarch Nikephoros of Constantinople: "Likeness is an intermediate relation and mediates between the extremes,

I mean the likeness and the one of whom it is a likeness, uniting and connecting by form, even though they differ by nature."[15]

The likenesses portrayed in the holy icons are those of Christ and the saints, reflections of archetypes in heaven. The Tabernacle was also regarded as an icon, as it too corresponds to a heavenly prototype. The Tabernacle constructed for the worship of God in the Sinai wilderness was modeled after the Tabernacle in heaven. In the Bible it is related that God said to Moses:

> And let them make me a sanctuary;
> that I may dwell among them. According to all that I shew thee, after the pattern of the tabernacle, and the pattern of all the instruments thereof, even so shall ye make it. (Exod. 25:8–9)

Thus did the Tabernacle on earth share a likeness with the Tabernacle in heaven, as revealed to Moses on the Mount (Exod. 25:40). Because of this correspondence the ministry of priests within the Tabernacle was, as we read in the Epistle to the Hebrews, "unto the example and shadow of heavenly things" (Heb. 8:5).

For John of Damascus, "[the] whole tabernacle was an icon. And look, said the Lord to Moses, that thou make everything after their pattern, which was shewed thee in the mount."[16] And for Theodore the Studite: "The copy shares the glory of its prototype, as a reflection shares the brightness of the light."[17]

Those who venerated the icons claimed that the Gospels were related through both words and images, and both the holy scriptures and the holy icons were complementary means of approaching the narrative. "Blessed are your eyes, for they see: and your ears, for they hear" (Matt. 13:16), said Christ to his disciples. It is a biblical verse invoked by John of Damascus when he cited the parallels between hearing the holy scriptures and seeing the holy icons: as our hearing is sanctified when we hear Christ's words in the Gospels, so we rejoice and are assured

Figure 9. Icon with Saint Irene and donor. Early Islamic Palestine, perhaps Sinai, 8th–9th century. Tempera on wood. The Holy Monastery of Saint Catherine, Sinai, Egypt

Figure 10. Detail of icon with Saint Irene and donor (fig. 9)

when we behold in the holy icons his bodily form, his miracles, and all that he endured.[18]

Where the Iconoclasts had created a dualism, depreciating the material world in their reverence for the spiritual, those who venerated the holy icons regarded the material world as sanctified by the Incarnation and a means of our ascent to the spiritual: "For since we are twofold," wrote John of Damascus, "fashioned of soul and body,

and our soul is not naked but, as it were, covered by a mantle, it is impossible for us to reach what is intelligible apart from what is bodily."[19]

And in similar vein, Theodore the Studite:

So whether in an image, or in the Gospel, or in the cross, or in any other consecrated object: there God is manifestly worshipped "in spirit and in truth," as the materials are exalted by the raising of the mind towards God. The mind does not remain with the materials, because it does not trust in them: that is the error of the idolaters. Through the materials, rather, the mind ascends towards the prototype: this is the faith of the Orthodox.[20]

Championed by John of Damascus, Theodore the Studite, and a multitude of other proponents, the theology of icons was formally proclaimed by the bishops who assembled in the year 787 at the Second Council of Nicaea, the Seventh Ecumenical Council.

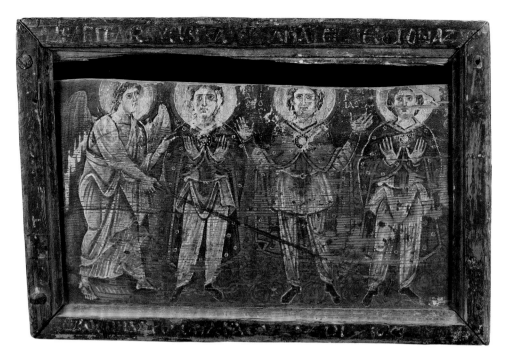

Figure 11. Icon with the Three Hebrews in the Fiery Furnace. Egypt or Sinai, ca. 7th century. Encaustic on wood. The Holy Monastery of Saint Catherine, Sinai, Egypt

## 8TH- AND 9TH-CENTURY ICONS AT SINAI

Sinai became a part of the world of Islam in the early seventh century. Nevertheless, protection was granted to monks and to Christian families living in the vicinity, and monks and pilgrims continued to travel to this remote wilderness, attracted by its austerity, its biblical associations, and its reputation as an established center of monasticism. Because it remained outside the Byzantine Empire in the eighth and ninth centuries, the area was unaffected by the Iconoclastic movement. Fourteen panel icons at Sinai have been dated to this time. They are of very special importance, for they document the continuity of the Iconographic tradition during the period of Iconoclastic prohibition.

One panel shows the Crucifixion (fig. 8). It has been dated to the eighth century on the basis of its many similarities with a fresco at Santa Maria Antiqua in Rome that can be dated to 741–52.[21] Christ is depicted on the cross wearing a red-brown colobium. Blood and water issue from his side. To his right stands the Virgin Mary, who points to

him with her right hand, while in her left she holds a handkerchief to her cheek. Above is the monogram for H ΑΓΙΑ ΜΑΡΙΑ (the Holy Mary). To Christ's left is a youthful John the Theologian, identified by the titulus ΙΩΑΝΝΗC (John). From the heavens angels gaze in wonder above a darkened sun and a (now-missing) moon. Three soldiers divide Christ's garments. This is the earliest surviving icon to give the names of the two thieves crucified with Christ: ΓΕCΤΑC (Gestas) to his right and ΔHM[ΑC] (Dismas) to his left.

Earlier icons invariably portray Christ before death, with his eyes open (see fig. 1 on page 71). The Sinai icon is the earliest known to depict Christ with his eyes closed and bearing the crown of thorns, features that serve to emphasize his humanity. The importance of depicting the reality of Christ's death had earlier been noted by Anastasius, abbot of the Holy Monastery of Saint Catherine, in his *Hodegos* (Guide), written in the 680s.[22] This, and several stylistic details, make it possible that the icon was painted at Sinai.

*The Icons of Sinai*     91

A second panel, dated to the eighth or ninth century, depicts Saint Irene, identified by the inscription Η ΑΓΙΑ ΗΡΕΙΝΗ (fig. 9). In frontal pose and dressed in a chiton—originally blue, now turned to green—a maphorion of carmine, and red shoes, she holds in her right hand a cross, emblem of her martyrdom, and in her left, a handkerchief. Emphasis is given to the face, large and glowing, with great staring eyes and framed by a golden halo.

At the base of the icon the humble donor, wearing a light brown tunic and black mantle, bows in veneration (fig. 10). An inscription gives his name, ΝΙΚΟΛΑΟC [CAB?] ATIANOC (Nikolaos [Sab]atianos). A quotation from John of Damascus concerning the veneration of saints finds special resonance here:

> The saints are the sons of God, sons of the kingdom, the co-heirs of God and of Christ. Therefore, I venerate the saints and glorify them: slaves and friends, and the co-heirs of Christ—slaves by nature, friends by choice, sons and heirs by Divine grace.[23]

## THE THREE HEBREWS IN THE FIERY FURNACE

A third panel depicts the Three Hebrews in the Fiery Furnace (fig. 11). Condemned to the flames for having refused to worship idols, the three youths, because they were protected by God, became models of endurance for the early Christian martyrs. Executed in the encaustic technique, the panel dates to about the seventh century. The inscriptions, now barely visible, serve to identify, from the viewer's left, Hananiah, Azariah, and Mishael. They are depicted wearing Persian garments. An angel has descended into the fiery furnace. He places his left hand comfortingly on the shoulder of Hananiah, and with a cross-surmounted staff he extinguishes the flames. The panel fits into a frame, which has been inscribed with verses from the Book of Daniel:

> The angel of the Lord came down into the furnace with Azariah and his companions, and made the furnace as if a dewy breeze were whistling through it. The fire did not touch them at all. (Dan. 3:49–50 Septuagint)

The Three Hebrews had inspired the early Christians. Exemplars of courage and steadfastness and reminders of God's protection, they were no less an inspiration to the monks of Sinai in the seventh, eighth, and ninth centuries.

## CONTINUITY

Painted in the isolation of the Sinai desert during the Iconoclastic period, these icons form a link to iconography that can be traced back to the Roman catacombs, where Christians expressed their faith in both words and images. John of Damascus defended the presence of icons in Christian veneration. In his writings we find, too, the same consciousness of immortality so pronounced in the Roman epitaphs. For it is not only the images that have survived but the belief that inspired them long ago.

1. Wilson 1894: 298–99.
2. Northcote 1878: 81.
3. Lightfoot 1895: 67.
4. Cyprian of Carthage, *De mortalitate*, par. 22; Wallis 1886: 474.
5. Cyprian of Carthage, *De mortalitate*, par. 20; Wallis 1886: 474.
6. Cyprian of Carthage, *De mortalitate*, par. 26; Wallis 1886: 475.
7. Eusebius of Caesarea, *Church History* 7.18; Schaff and Wace 1890: 304.
8. Weitzmann 1976: 24, no. B5.
9. Brubaker and Haldon 2011: 36.
10. Weitzmann 1976: 15.
11. Demetrius of Rostov 1997: 648–49.
12. Theodore the Studite, *On the Holy Icons* 3.18; Roth 1981: 84.
13. John of Damascus, *Three Treatises on the Divine Images* 1.4; Louth 2003: 22.
14. John of Damascus, *Three Treatises on the Divine Images* 1.35; Louth 2003: 42.
15. Quoted in Barber 2002: 116.
16. John of Damascus, *Three Treatises on the Divine Images* 2.14; Louth 2003: 70.
17. Theodore the Studite, *On the Holy Icons* 1.8; Roth 1981: 28.
18. John of Damascus, *Three Treatises on the Divine Images* 3.12; Louth 2003: 93.
19. Ibid.
20. Theodore the Studite, *On the Holy Icons* 1.13; Roth 1981: 34.
21. For the fresco at Santa Maria Antiqua, see Wilpert 1917, vol. 2, fig. 180.
22. *Patrologiae Graecae* 89.197.B9–C10. See Belting and Belting-Ihm 1966: 36.
23. John of Damascus, *Three Treatises on the Divine Images* 3.26; Louth 2003: 103.

## REFERENCES

**Barber, Charles**
**2002** *Figure and Likeness: On the Limits of Representation in Byzantine Iconoclasm*. Princeton, N.J.: Princeton University Press.

**Belting, Hans, and Christa Belting-Ihm**
**1966** "Das Kreuzbild im 'Hodegos' des Anastasios Sinaites: Ein Beitrag zur Frage nach der ältesten Darstellung des toten Crucifixus." In *Tortulae: Studien zu altchristlichen und byzantinischen Monumenten*, edited by Walter Nikolaus Schumacher: 30–39. Römische Quartalschrift für christliche Altertumskunde und Kirchengeschichte, Supplementheft 30. Rome: Herder.

**Brubaker, Leslie, and John Haldon**
**2011** *Byzantium in the Iconoclast Era, c. 680–850: A History*. Cambridge: Cambridge University Press.

**Demetrius of Rostov, Saint, comp.**
**1997** *The Great Collection of the Lives of the Saints*. Vol. 3, *November*. Translated from the 1914 Slavonic edition by Thomas Marretta. House Springs, Mo.: Chrysostom Press.

**Lightfoot, Joseph Barber**
**1895** "Christian Life in the Second and Third Centuries." In Joseph Barber Lightfoot, *Historical Essays*: 1–71. London: Macmillan.

**Louth, Andrew, trans.**
**2003** Saint John of Damascus. *Three Treatises on the Divine Images*. Crestwood, N.Y.: St. Vladimir's Seminary Press.

**Northcote, J. Spencer**
**1878** *Epitaphs of the Catacombs; or, Christian Inscriptions in Rome during the First Four Centuries*. London: Longmans, Green, and Co.

***Patrologiae Graeca***
**1860** *Patrologiae Cursus Completus . . . Series Graeca*. Edited by J.-P. Migne. Vol. 89, *S. P. N. Anastasii, Cognomento Sinaitae, Patriarchae Antiocheni, Opera Omnia*. Petit-Montrouge: J.-P. Migne.

**Rawson, Beryl, ed.**
**2011** *A Companion to Families in the Greek and Roman Worlds*. Malden, Mass.: Wiley-Blackwell.

**Roth, Catharine P., trans.**
**1981** Saint Theodore the Studite. *On the Holy Icons*. Crestwood, N.Y.: St. Vladimir's Seminary Press.

**Schaff, Philip, and Henry Wace, trans. and eds.**
**1890** *Eusebius: Church History, Life of Constantine the Great, and Oration in Praise of Constantine*. Vol. 1 of *A Select Library of Nicene and Post-Nicene Fathers of the Christian Church*, ser. 2. Oxford: Parker and Company; Buffalo, N.Y.: Christian Literature Company.

**Wallis, Ernest, trans.**
**1886** "The Treatises of Cyprian: On the Mortality." In *The Ante-Nicene Fathers*, edited by Alexander Roberts and James Donaldson, vol. 5, *Fathers of the Third Century: Hippolytus, Cyprian, Caius, Novatian, Appendix*: 469–75. Buffalo, N.Y.: Christian Literature Company.

**Weitzmann, Kurt**
**1976** *The Monastery of Saint Catherine at Mount Sinai: The Icons*. Vol. 1. Princeton, N.J.: Princeton University Press.

**Wilpert, Josef, ed.**
**1917** *Die römischen Mosaiken und Malereien der kirchlichen Bauten vom IV. bis XIII. Jahrhundert*. 2nd ed. 4 vols. Freiburg im Breisgau: Herder.

**Wilson, H. A., ed.**
**1894** *The Gelasian Sacramentary/Liber Sacramentorum Romanae Ecclesiae*. Oxford: Clarendon Press.

*Lawrence Nees*

# Muslim, Jewish, and Christian Traditions in the Art of 7th-Century Jerusalem

*In Memory of Oleg Grabar*

One of Oleg Grabar's last publications concerning Jerusalem, in his remarkably long and distinguished scholarly career, was a volume about the "sacred esplanade" at the heart of the city, a nicely chosen term that avoids having to choose between calling it the "Temple Mount," as is customary among Christians and Jews, and "al-Haram al-Sharif" (the Noble Sanctuary), as is customary among Muslims (fig. 1).[1] Joint sponsorship of the volume by Jewish, Muslim, and Christian scholarly organizations in Jerusalem was indicative of the desire to build bridges in the service of scholarship, at the very least, and the volume includes articles from the perspectives of the differing traditions that see this site as the center of the spiritual world.

It is a small area, enclosed by walls constructed in the sixteenth century at the command of the Ottoman sultan Suleiman the Magnificent (r. 1520–66), whose very name, Solomon, bespeaks the continuing links between the Islamic tradition and the kingdoms of David and Solomon. On the Haram al-Sharif in the southeast corner of the Old City are the structures most sacred to Muslims outside the two great mosques in Mecca and Medina; the Dome of the Rock and the Aqsa Mosque. Supporting one

side of the Haram is the Western Wall, the largest remaining accessible portion of the platform constructed by Herod the Great (r. 37–4 B.C.E.), on which his Second Temple was constructed. A few blocks to the west, and in sight of the Haram, is the complex of buildings surrounding the Church of the Holy Sepulchre, the center of Christian pilgrimage and worship, venerated as the place of Christ's death, burial, and Resurrection. My special focus in this study is none of these but rather the small structure known as the Dome of the Chain, Qubbat al-Silsila (fig. 2), which stands on the Haram just east of the much larger Dome of the Rock.

## THE DOME OF THE CHAIN

Some years ago Oleg Grabar wrote aptly of the Dome of the Chain that, in comparison with the better-known structures on the Haram, it was "a bit of an orphan." Although it is nearly as early in date as the Dome of the Rock, and conceivably even earlier, built during the Umayyad period (661–750), its function was—and remains—unknown, and its form, an unparalleled eleven-sided polygon, "strange," as was the fact that it was not really a building but an open structure, without walls.[2] A plan of the Haram today (fig. 3) shows that the Dome of the Chain stands due east of the Dome of the Rock and thus of the large rocky outcropping covered by that structure. What was its purpose? When was it built?

K. A. C. Creswell, in 1969, termed it an "exquisite little Monument" and found "its Architecture . . . in perfect harmony with that of the Qubbat as Sakhra [the Dome of the Rock]," but never discussed it at length.[3] The most sustained and important studies remain the three pages by Myriam Rosen-Ayalon in her 1989 book on the Early Islamic monuments of the Haram, in which she surveys the earlier scholarly literature and also the various Islamic sources,[4] and the more recent four pages by Denys Pringle in his 2007 volume on the churches of the Crusader Kingdom.[5] Although not dated by

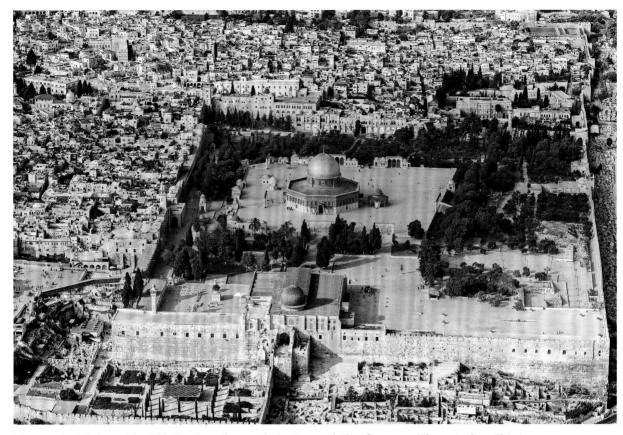

Figure 1. Aerial view of the Old City, Jerusalem, with the Haram al-Sharif at center (Photo: Andrew Shiva)

inscription or historical notice, it has been placed after the Muslim occupation of Jerusalem in about 636 C.E. and before the end of the Umayyad period in 750,[6] with little support of such a date or where within that range of slightly more than one century the structure might have been built. Heribert Busse and Georg Kretschmar suggested on purely textual grounds that it should be dated circa 675–85, earlier than the Dome of the Rock,[7] and Grabar posited that it might be the earliest building on the platform.[8]

This modern consensus more or less accords with that of the scattered Islamic sources, which commonly ascribe the building to the time of the caliph 'Abd al-Malik (r. 685–705).[9] As will be discussed shortly, the available evidence supports the view that the plan (fig. 4), an open structure with

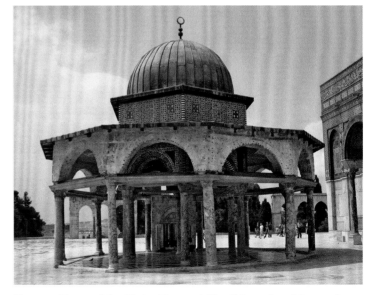

Figure 2. Dome of the Chain. Haram al-Sharif, Jerusalem. Umayyad, 670s (Photo: Lawrence Nees)

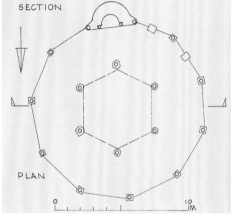

Figure 3. Plan of the Haram al-Sharif, Jerusalem (from Nuseibeh and O. Grabar 1996: 31)

Figure 4. Plan of the Dome of the Chain (from Pringle 2007, vol. 3: 184)

eleven columns in an outer circle and six columns in an inner circle, is original, except for the later addition of a mihrab flanked by two smaller columns on the qibla side, likely made during the Mamluk period (1250–1517), if not before. The superstructure above the wall of the outer arcade appears to have been reworked at a later date; the reports we have suggest that at some point the drum above the inner colonnade had openings—now blocked—and that the drum, as now, supported a small dome.

Islamic tradition offers three different explanations for the function of the structure.[10] The first accounts for its name. Already in the tenth century a Muslim writer noted that the name refers to the place where David and Solomon judged their people, linking this judgment, as does the Qur'an, with divine judgment at the end of time. In this view the Dome of the Chain marks a royal place of judgment, with powerful eschatological implications.[11] I believe this assessment to be more or less correct, but it does not explain why the structure was built, why it was given its particular form, or how it might have been used.

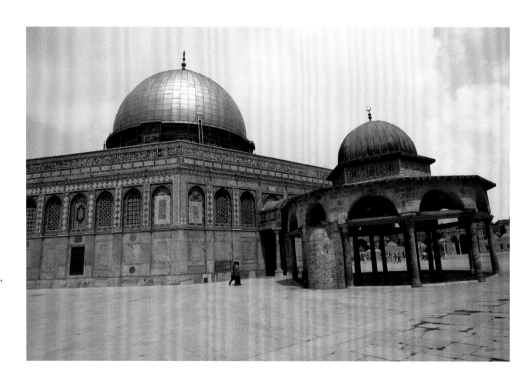

Figure 5. Dome of the Rock, completed 691/92, and Dome of the Chain, 670s. Haram al-Sharif, Jerusalem, viewed from the southeast (Photo: Lawrence Nees)

*Age of Transition: Byzantine Culture in the Islamic World*

The second explanation suggests that it was a treasury, by analogy with the small structures near mosques that also had an open ground story of columns supporting a closed superstructure, as at Damascus and at Homs. But this explanation just does not work, and no scholar known to me accepts it, if only because there is no closed area in the Dome of the Chain where anything might be stored; nor does there seem ever to have been such a space.[12] Furthermore, in the early eleventh century two separate buildings, a treasury and a domed structure, are referred to by the writer al-Wasiti.[13] We know, too, that by this period it already was known by the name still used for it today, the Dome of the Chain, for not only al-Wasiti but the writer Ibn al-Murajja as well refers to it as such.[14]

The third conjecture is that the Dome of the Chain was a "model" for the larger Dome of the Rock (fig. 5), one that rests on the general similarity in plans (fig. 6). Each, for example, has a double circle of columns, and in this they are highly unusual. The only other examples of central plan structures with double colonnades that I know of, Santo Stefano Rotondo in Rome (ca. 470)[15] and the early-sixth-century baptistery at Butrint in Albania,[16] also had domes. Of course, the Dome of the Rock is a "building," with an enclosing wall around the double colonnade. Nevertheless, the similarities are many. From the exterior one sees in each a slightly pointed dome resting on a tall drum and surrounded by a broad, relatively flat structure. The interiors and supporting structures are also broadly the same. In both the Dome of the Rock (fig. 7) and the Dome of the Chain (see fig. 2) there are unmatched column shafts, some brilliantly colored and patterned, all of them reused Roman supports. The column capitals are also reused Roman elements, widely varying in appearance. Both structures employ broad and massive tie beams, which are visible in the outer arcade of the Dome of the Rock and especially prominent in the Dome of the Chain. By no means unparalleled,

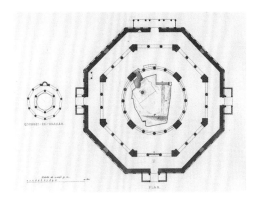

Figure 6. Plans of the Dome of the Chain (left) and the Dome of the Rock (right) (from Vogüé 1864, pl. XVIII)

this feature is, however, uncommon. Taken together, the similarities in structure are enough to support the view that these are roughly contemporary buildings.

The Dome of the Chain stands on the vast eastern portion of the raised platform on the central part of the Haram al-Sharif (fig. 8), visible on the left side of this view taken from the north, and there is good reason to believe that the earliest place of prayer for Muslims in Jerusalem was here, beside the sacred Rock, and not, as most believe, on the south side of the Haram, where the Aqsa Mosque now stands. I have addressed the issue in detail elsewhere,[17] but I would point out that there was ample space available here for worshippers, with the Dome of the Chain the only structure and, I would argue, the focus of prayer in the earliest period.

The Dome of the Chain stands at the center of the Haram as a whole, where the north–south and east–west axes drawn from the centers of the sides and diagonals drawn from the corners meet, a point of likely significance previously noted by, among others, Busse, Rosen-Ayalon, and Grabar.[18] It is important to note that from at least the tenth century, as described by Ibn Hawqal, it has been recognized that the entire Haram is the mosque, the enclosing wall demarcating the space as such, which is why the minarets are spread around the whole area and prayer is by no means restricted to the Aqsa Mosque.[19] The north–south axis not only goes through the Dome of the Chain

but also aligns with stairs and gates connecting the upper and lower platforms. Why are these staircases located here if not to give access to this space, which must have had an important function? Rosen-Ayalon notes that the Dome of the Chain is on an axis with the so-called Mihrab of ʿUmar in the Aqsa Mosque,[20] today considered a much later structure, but possibly suggesting that this axis was once the main one on the site, since the ʿUmar associated with the mihrab is the same caliph (r. 634–44) who, in the most common traditions, went to Jerusalem to receive the city's surrender and there inaugurated prayer—specifically on the Haram.[21]

## THE DOME OF THE CHAIN AS MIHRAB

Looking at the Dome of the Chain from the south (fig. 9) one cannot help but notice the intrusive structure of the mihrab, the niche indicating the qibla wall and the direction of prayer toward Mecca. This structure was a later addition, probably dating to after the Crusades; the most extended study, by Michael Burgoyne, suggests this was likely during the Mamluk period, thirteenth century or later.[22] The insertion of the mihrab forced the flanking columns to be shifted laterally, so that remarkably, unlike all the others, they are no longer

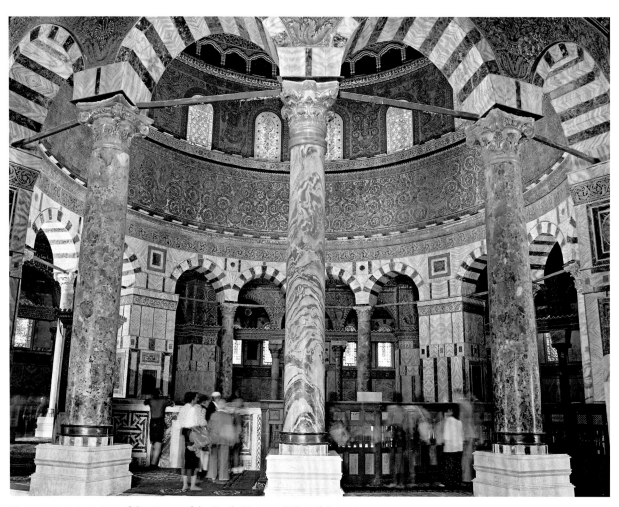

Figure 7. Interior view of the Dome of the Rock. Haram al-Sharif, Jerusalem

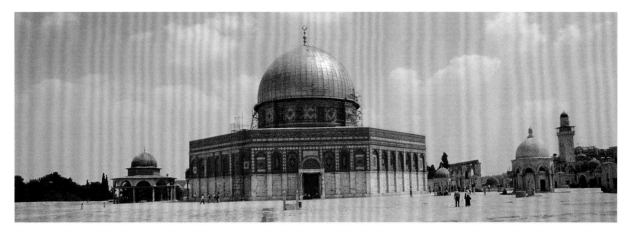

Figure 8. View of the Haram al-Sharif, Jerusalem, with the Dome of the Rock at center and the Dome of the Chain at left (Photo: Lawrence Nees)

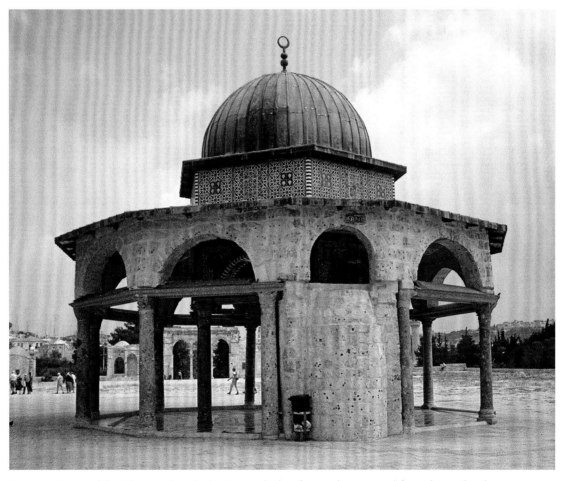

Figure 9. Dome of the Chain with mihrab. Haram al-Sharif, Jerusalem, viewed from the south (Photo: Lawrence Nees)

Figure 10. Gold
coin of 'Abd
al-Malik, dated
695. American
Numismatic
Society, New York
(1944.100.612)

like the later *maqsura*, an enclosure used by the ruler. From this colonnaded space the imam would lead the prayers, in the earliest mosques about which we have any information, in the seventh century.

No such open mihrab has been identified, but some years ago George Miles argued that a coin issued by Caliph 'Abd al-Malik in 695 showed a stilted arch on columns which represented exactly that (fig. 10).[26] A more recent study of the coinage by Luke Treadwell finds Miles's idea unpersuasive, if not necessarily incorrect, precisely because the coin does not seem to show a niche but simply a stilted arch on columns.[27] Nevertheless, the image on the coin certainly makes a startling comparison to the qibla side of the Dome of the Chain—if one imagines the later mihrab niche removed and the columns returned to their original positions.

The hypothesis I would like to advance is that the Dome of the Chain was constructed to serve as the centerpiece of the earliest place of Muslim communal prayer on the Haram al-Sharif, the place from which the caliph in his function of imam led the prayers, the reciting of the text of the Qur'an. I would argue that this caliph was Mu'awiyah ibn Abi Sufyan, governor of Syria and Palestine from about 641 and caliph by about 661.[28] Mu'awiyah's capital and primary residence was Damascus, where he built a palace with a domed reception chamber,[29] but the sources almost uniformly tell us that he was acclaimed as caliph in Jerusalem,[30] presumably on the Haram and most likely, I suggest, precisely here, where the Dome of the Chain is located. Whether it was constructed for that ceremony or erected later as a memorial to it, we cannot know.

Recognizing this site as the place from which the holy scripture was read helps us to understand the "strange" form of the eleven-sided structure with eleven columns in the outer arcade, and in turn this leads us to recognize the links with Christian and Jewish traditions. It is not easy to build a regular structure with eleven sides, and it

centered beneath the upper masonry that they support.

Noteworthy, too, is the arch above the mihrab. It is much narrower than all the others, which are roughly semicircular. Sharply stilted, it gives the (false) impression of greater height. As there is no visible evidence of disturbance in the masonry above it, the arch would appear to be in its original form.[23] Why are its dimensions so distinct from those of all the others? As already noted, this is the qibla wall, marking the direction of prayer, and this arch, aligned with the Mihrab of 'Umar, represents the original mihrab of the mosque on the Haram.

This interpretation might at first seem untenable, for, as is well known, the mihrab on a qibla wall usually takes the form of an empty niche, with an arch at the top and a receding space beneath it.[24] Such indeed has been the case for more than thirteen centuries. But the earliest evidence for such a "niche mihrab" (*mihrab mujawwaf*) is that constructed by Caliph al-Walid I in his rebuilding of the Mosque of the Prophet in Medina after 705.[25] The few descriptions of earlier mihrabs, in the earliest mosques in Egypt and Damascus, tell of an open space surrounded by columns—just what we see in the Dome of the Chain—somewhat

cannot be done with ancient geometry. One that has six, eight, ten, or twelve sides is easily built, but not one with eleven. It would have to be laid out on the ground by rule of thumb and by trial and error. Furthermore, it is difficult to doubt that the number was chosen because it held special meaning and import. To the best of my knowledge no other building with such a plan has been identified in the Islamic, Christian, Jewish, or Mesopotamian or other ancient tradition. We have neither an accurate, measured plan of the Dome of the Chain nor archaeological documentation. All we have are the indirect reports of unpublished restoration work carried out in 1976, which essentially indicated that what we see is in its original place and original form.[31] So how to understand it?

### THE DOME OF THE CHAIN AS BEMA

A remarkable literary source seems to me to offer the key that unlocks the puzzle: a hymn that describes the cathedral constructed in the ancient city of Edessa (modern Urfa) in the middle of the sixth century, which no longer exists in its original form. The text has been well known to scholars since it was introduced into the discussion in the mid-twentieth century by André Grabar and others.[32] Grabar was particularly interested in the description of the great domed building itself, and the description of it by a contemporary as a "temple" and especially as an image of the world and indeed of the cosmos.

Neither Grabar nor others have discussed in detail the section of the text of greatest interest in connection with the Dome of the Chain, namely its description of the pulpit under the great dome. According to the Edessa hymn (verse 15), in the middle of the building is "a podium after the model of the upper room of Zion, and underneath it are *eleven columns* [emphasis mine] like the eleven Apostles who were hidden therein."[33] Thus the text not only specifically mentions eleven columns but explicitly endows that

number with a significant symbolic referent: the upper room of Zion where, immediately after witnessing the Ascension of Christ on the Mount of Olives, the eleven apostles (those who remained following the suicide of Judas) went upon their return to Jerusalem (Acts 1:13). The allusion to Jerusalem continues in the next verse, noting a column behind the "podium" crowned by a cross and representing Golgotha, the hill also visible from the center of the Haram, to the west, where the Church of the Holy Sepulchre stands. The hymn in effect locates the eleven-sided "podium" of Edessa within a symbolic or virtually imagined Jerusalem.[34] That it should do so is not entirely surprising, for the text consistently refers to the cathedral of Edessa as the "temple" (Syriac: *haykla*), using a word more commonly applied to the Jerusalem Temple than to a Christian church.[35] Note also that what I have termed a "pulpit"—described by Cyril Mango with the Greek term *ambo*—is called in the original Syriac text a *bema*.

As in this text, the bema was an important structure within a sacred building, but not itself a building in the strict sense of the word. Its function is clear, as the place from which the religious leader of the community read the sacred scriptures or preached to the gathered worshippers. In the Islamic tradition the structure used for this purpose is called the *minbar*. In its classical form, of which the earliest surviving example is often thought to be in Qairawan,[36] the minbar has a different appearance: a long narrow set of stairs, usually with a covered space at the top—never used—which represents the absent Prophet Muhammad. The prototype for the minbar is thought to be the structure used by Muhammad, who stood to lead prayers at a specific spot in Medina (in some accounts he spoke from a seated position);[37] later references to the Prophet's minbar suggest that it was still in existence in the latter part of the seventh century.[38] Its form is variously described, but it seems to have been elevated. Could the Dome of the Chain have functioned not

Figure 11. Detail of the Codex Amiatinus, folios 3r–4v. Anglo-Saxon (Northumbria?), 716. Ink and color on parchment. Biblioteca Medicea Laurenziana, Florence (MS Laur. Amit. 1) (Courtesy Ministero per i Beni e Attività Culturali—Italia)

the Chain. We do not actually have evidence for the exact location of either temple, although this has not prevented scholars from presenting often quite detailed plans and reconstructions of the site.[39] It is important to note that the description of Solomon dedicating the holy place while standing on the platform before his people at the center of the space was known from the biblical text even after the Temple itself had long since been destroyed.

When, after the Babylonian captivity, Jews returned to Jerusalem and reestablished Temple worship based on the books of Moses, as described in Nehemiah 8:1–6, Ezra stood in a broad open space and read the holy scriptures to the assembled people from a wooden platform, designated in the Greek text as a *bema*. Steven Fine has pointed out that rabbinic commentary on this passage asserted that "the king stood [on a bema] in the Temple to read publicly from the Torah on the first day of Sukkot,"[40] indicating that the original presentation by Ezra was remembered as having been repeated at regular intervals. It is striking that at least in some of the surviving versions Ezra was surrounded by eleven men, recalling the Edessa hymn's eleven apostles.[41] Possibly this Old Testament passage was the inspiration for the hymn, which draws an explicit analogy between the new cathedral and the Temple in Jerusalem, even referring to it as "temple."

The passage in Nehemiah locates Ezra's reading from the scriptures before what is called "the water gate," which has been variously understood. It is interesting that in the only medieval Christian commentary on the books of Ezra and Nehemiah, written probably between 715 and 720 and thus very close to the period when the Dome of the Chain was constructed, the Northumbrian monk Bede understood the water gate to signify the area in front of the Temple, specifically on its eastern side. Moreover, Bede links the passage with Solomon's initial dedication, giving a Christian interpretation of Ezra's platform being wood rather

only as an early form of the mihrab but also as an early form of the minbar?

Here it might be useful to cite a few of the biblical texts concerning prayer in Jerusalem that could help elucidate the Dome of the Chain. All are problematic in various ways, and available in various languages and versions, so I shall provide only a very brief survey here. The first text, 2 Chronicles 6:13–14, relates to the dedication of the Temple built by Solomon, saying that Solomon mounted a bronze "platform" to pray, and that this platform was placed in front of the altar outside the Temple. We do not know, of course, precisely where on the Temple Mount either this altar or the Temple was located, nor do we know where seventh-century Muslims or, for that matter, Jews or Christians thought it was located. The commonly held view is that the Holy of Holies of Solomon's Temple, and subsequently of Herod's, was situated on the peak of the mountain now enshrined in the Dome of the Rock, with the altars of the two temples to the east, more or less in the area now occupied by the Dome of

than bronze.[42] Bede was fascinated with the Old Testament, in particular with the Tabernacle of Moses and with the Temple, and wrote a commentary about each.[43] He was also closely involved with the preparation of the earliest surviving one-volume Latin Bible, the famous Codex Amiatinus, completed in 716 and sent to the pope in Rome, which includes a double-page painting showing the Tabernacle and the altar for burnt offerings (fig. 11).[44] This special interest in Jerusalem and the Temple evinced in the farthest Christian West at this time was, in my own view, a response to news of happenings in the Islamic East—specifically, the constructions on the mount where the Temple had stood. For Bede demonstrably knew from a treatise on the Holy Places written before 704 by Adomnán, abbot of Iona, a monastery off the western coast of modern Scotland, that it was here that the Muslims worshipped.[45]

Let me now return to the bema. A substantial group of large churches in northern Syria are commonly referred to by scholars as "bema churches" because they house a large structure in the middle of the nave—or, rather, in the middle of the assembled people—referred to as a bema in contemporary texts. In this area of Syria, inland from the great city of Antioch and just south of Edessa, previously discussed in terms of its eleven-columned bema, a special liturgical practice developed in which the bishop and his clergy proceeded from the altar to the bema for the reading from the Gospels.[46] Not all churches in this area had such structures, but generally the most important ones did. The bema is consistently placed at the center of the church, regardless of its plan, whether basilican, octagonal, or cruciform.[47] An important example is the bema church at Resafa; the city is known in Greek as Sergiopolis from the name of the miracle-working saint whose shrine stood beside the church (the ruins of both survive) (fig. 12).[48] The city was briefly the primary residence of the caliph during the reign of Hisham ibn ʿAbd al-Malik, from 724 to 743. Hisham

Figure 12. View of the bema in Sergiopolis (Resafa), Syria, 4th–6th century (Photo: Jane Taylor/Art Resource, NY)

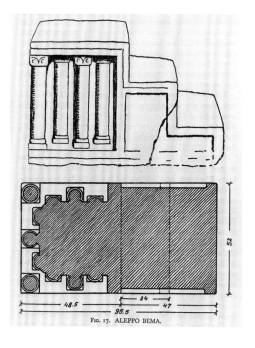

FIG. 17. ALEPPO BEMA.

Figure 13. Drawing of the bema/minbar in Aleppo, Syria, ca. 4th–7th century (from Sukenik 1934: 58, fig. 17)

built both his residence and his major mosque adjacent to the church. Proximity of the Islamic ruler to the liturgical practices of Christian subjects, including the reading of scripture from the bema, is thus certain here; it may have occurred elsewhere, and earlier as well.[49] At Resafa the bema took the usual form of what looks a bit like an arch on columns laid on the ground, with the flat end facing the altar, straight sides, and a curved apsidal structure at the far end. It was surrounded on the outside by attached colonnettes, making a possible, albeit apparently distant, connection with the Dome of the Chain and the bema described in the Edessa hymn.

The Resafa bema had twenty-one colonnettes. But we know of one extraordinary object that has precisely eleven colonnettes, as in the outer arcade of the Dome of the Chain. Not well known, it is a fairly small structure—roughly one meter long and one half meter wide, made of black basalt—from and, as of the last published report, still in Aleppo (fig. 13). Its date is uncertain and it has never been studied in depth, though it has always been placed in the Late Antique period, probably fourth to seventh century. The great scholar of Islamic art Ernst Herzfeld called it a *memor*, a little minbar, and dated it to the sixth century, seeing it as a Late Antique forerunner of the later Islamic narrow steps for reading and sermons.[50] The great scholar of Late Antique Judaism and Judaic art Eleazar Sukenik called it a bema, and regarded it as Jewish.[51] They may both be correct. The object comes from the Hayyat Mosque in Aleppo, again in northern Syria, which apparently had been a synagogue until converted for use as a mosque in 1241, and bears an inscription in Arabic written in Hebrew script. It may be a unique extant example of an object created for Jewish use and carried over for Islamic use without changing its function, if indeed it served as a bema in the synagogue and then as a minbar in the successor mosque on the site.

The bema was and remains an essential element in the Jewish synagogues that developed in the Late Antique period (in synagogues it is also known as a *bima* or *bimah*). Commonly it takes the form of a platform raised a few steps above the congregation, and stands before the sanctuary containing the Torah shrine. Although to my knowledge no synagogue bemata survive from the Late Antique period, some have left likely traces.[52] Furthermore, the Palestinian Talmud refers in two passages to a bema as a platform or podium in a synagogue.[53] The general absence of bemata from the archaeological record may be due to their being movable structures. The famous, probably sixth-century synagogue at Beth Alpha has

in front of its apse, where the Torah shrine would have stood, a mosaic panel with an image of the shrine flanked by two menorahs and other ritual implements, such as the shofar and incense shovels. To its left is an interposed stone structure that Sukenik interprets as possibly the base for a bema. A more likely base for a bema is the structure in the center of the huge synagogue built inside what had been part of a Roman bath complex at Sardis in western Anatolia.[54]

The Dome of the Chain may be understood—on the basis of contemporary Jewish and Christian texts and documents— as a structure from which the leader of the new Muslim community led prayers beside the ancient sanctuary associated with David and Solomon. But it might be more useful to think of Muslims and Jews and Christians during this period as drawing upon common traditions found in the ancient scriptures that they all honored rather than as influencing one another, and thus suggesting dependent relationships.[55] The rich exchange of ideas evidently extended beyond the three Abrahamic religions to include the heritage of the great Roman and Persian traditions that were predecessors and, in the case of the former, neighbors and rivals of the early caliphate. I shall here give only a few brief examples of this kind of interchange.

SPOLIA AND EAGLES

The Sardis synagogue has not only a bema but also what has been described as a table for offerings. The table's two lateral supports are eagles with outspread wings, taken from some Roman context and imported for use here as what are now commonly termed *spolia*.[56] Representations of eagles link all the cultures in the Late Antique Near East. They appear in many of the numerous synagogues in Galilee and the Golan, often with wings outspread and often associated with doorways and windows.[57] Strikingly similar are eagles seen in Christian art of the Late Antique period, the most remarkable perhaps being the capitals closely datable to the

second quarter of the seventh century from the aisled tetraconch church at Zuart'noc', Armenia, where they are associated with the four doorways.[58]

Scholars of Islamic art have somehow failed to notice that three of the capitals in the Dome of the Rock have flying eagles with outstretched wings—failed to notice them perhaps because they should not be there and seem to violate what has been thought a consistent ban on figural imagery in a Muslim religious building of any kind, much less so sacred a building as this one.[59] Here again, the eagle capitals are associated with entrances,[60] as are the eagle capitals in the Aqsa Mosque on the Haram al-Sharif and in the great tenth-century imperial Azhar Mosque in Cairo, only recently studied and their significance noticed for the first time.[61]

Whatever they signify—victory, ascension to heaven, or both, or something else—these eagles fly across our modern disciplinary and religious borders. They do so as well on another class of objects shared, albeit with differences of various kinds, across our borders, such as censers. The great "Byzantium and Islam" exhibition, in connection with which this paper was first presented, included a wonderful bronze eagle censer thought to be from Egypt, though from a Christian or Islamic context it is really not possible to ascertain in the absence of a cross or other distinctively confessional marker.[62] It was perhaps made by or for a Christian. But even if this were so, it would not mean that the related eagle censer in Washington's Freer Gallery, with eagles at the four corners, is necessarily Christian; indeed, it has generally been published as an Islamic object. On the other hand, either one or both could conceivably be Jewish!

The Brooklyn Museum has in its collection a bronze censer with birds, again possibly but not demonstrably from Late Antique Egypt, whose Greek dedicatory inscription is preceded by a menorah, thus presumably identifying it as intended for use by Jews, whatever one might choose to imagine the

religious affiliations of its maker.[63] "Byzantium and Islam" also included a small glass flask, hexagonal in form, dating most likely from the late seventh to the early eighth century. One of its sides was interpreted by Julian Raby as derived from a seventh-century Islamic coin type depicting the "standing caliph" with his sword.[64] If he is correct, the vessel joins a widespread class of such flasks used by Jews and Christians in their private devotions and indeed associated with pilgrimages to the sanctuaries that they often shared.

1. O. Grabar and Kedar 2009.

2. O. Grabar 2005, essay XIV: 208. Grabar avoided the unfamiliar mathematical terms for such a figure, termed either a "hendecagon" or sometimes, unhappily, an "undecagon." He may have rejected the terms because they are strictly applicable only to a regular eleven-sided figure, and the Dome of the Chain is not regular.

3. Creswell 1969, fig. 360.

4. Rosen-Ayalon 1989: 25–29.

5. Pringle 2007: 182–85, no. 319, fig. 32, pl. XCVIII.

6. For a suggestion that "some think" it might predate Islamic rule, without, alas, being more specific concerning who might think this, or why, see the website Archnet.org, entry for Qubba al-Silsila, first paragraph.

7. Busse and Kretschmar 1987: 24. In the authors' view it should be dated after 675 because "Arculf" does not mention it!

8. O. Grabar 1996: 51, 131, fig. 68 (schematic reconstruction). Grabar's statement that the Dome of the Chain is on "the exact geographical center of the platform" does not appear to be strictly true; it is more or less where the diagonals linking the opposite corners of the Haram as a whole intersect. In suggesting that it might be dated before the Dome of the Rock he follows and cites Busse and Kretschmar 1987: 24.

9. Bieberstein and Bloedhorn 1994, vol. 3: 154–56, at 154. I am grateful to Robert Schick for bringing this collection to my attention.

10. These are summarized in Rosen-Ayalon 1989: 25–29.

11. This interpretation rests in part with the Qur'an, where, in Sura 38, David is addressed as a divinely appointed "viceroy and judge"; see Arberry 1955, vol. 2: 160. The term translated as "viceroy" is in fact the Arabic word *caliph*, used in the seventh century for the successors of the Prophet Muhammad as leaders of the community; see Crone and Hinds 1986: esp. 4–19, 25.

12. Creswell (1969: 202) accepted the notion that the Dome of the Chain had once been a treasury on the evidence of texts citing such usage, but he recognized that such a view required us to believe that the present form, which he attributed to the Mamluk period—specifically, to Baybars I—replaced the earlier structure altogether. Subsequent archaeological evidence seems to make this view untenable.

13. Pringle 2007: 182. For the text that seems at least to refer to the construction of a treasury (*bayt al-mal*) by 'Abd al-Malik "to the east of the Rock," see Rabbat 1993.

14. See Elad 1995: 98, and Kaplony 2002: 300, no. B033.2.d.

15. On Santo Stefano Rotondo in Rome, see Krautheimer 1980: 52–54, 338 (for further references), figs. 48–50.

16. See Mitchell 2008 and www.butrint.org/explore _9_0.php (accessed April 6, 2011). I am very grateful to John Mitchell for bringing this wonderfully interesting and newly rediscovered structure to my attention.

The Church of the Kathisma, on the road from Jerusalem to Bethlehem, has a double ambulatory around a central dome, although the outer one seems to have been a sequence of rooms rather than an open space. For the recent excavations there, see Avner 2006–7.

17. See Nees 2014 and my forthcoming book *Perspectives on Early Islamic Art in Jerusalem* (Nees n.d.).

18. Busse 1982: 29; Rosen-Ayalon 1989: 27–28 and fig. 15; O. Grabar 1996: 131, fig. 68.

19. Ibn Hawqal 1938–39: 171. Discussed at length by Andreas Kaplony (2009: esp. 118–19). See the extended discussion of this issue in the second chapter of Nees n.d. (forthcoming).

20. Rosen-Ayalon 1989: 29.

21. The most commonly cited Islamic source is al-Tabari's *History*, for which see Friedmann 1992: 189–207 (lines 2403–18). For scholarly discussion, see the recent study Howard-Johnston 2010: 370–87, with the unusual proposal that the occupation of Jerusalem occurred not in the period 636–38, as generally believed, but in 634.

22. Burgoyne 1987: 48.

23. For an extended discussion of this important point, see Nees n.d. (forthcoming), chap. 4.

24. On the standard mihrab form, see Bloom and Blair 2009: 515–17, s.v. "mihrab," with extensive bibliography.

25. See Whelan 1986: 207–8 (reprinted in Bloom 2002: 373–91) for discussion of suggestions that some examples of the *mihrab mujawwaf*—that is, a mihrab in the form of a niche—may have survived from before the time of al-Walid, all of which Whelan rejects, see ibid.: 207–8, no. 13.

26. Miles 1952.

27. Treadwell 2005, cited in Johns 2003.

28. On Mu'awiyah ibn Abi Sufyan, see Humphreys 2006.

29. See Flood 2001: 147–59, esp. 149 (with al-Muqaddasi and other sources), and Bloom 1993.

30. Morony 1987: 6. I assume that the "allegiance" involves the pledge (*bay'a*) and handclasp, the essential ritual discussed in Marsham 2009: esp. 82 and 87, with several alternative Syriac phrases for "proffering the right hand." A near-contemporary Christian source occasions the "almost" qualifier, for that source gives three versions, of which the last and most elaborate sets the event in Jerusalem; see Palmer 1993: 29–31, and the recent discussion of this source in particular in Howard-Johnston 2010: 175–78.

31. Rosen-Ayalon 1989: 124; Pringle 2007: 184.

32. A. Grabar 1947. For the full text and French translation, see Dupont-Sommer 1947. For an

English version, see Mango 1972: 57–60. For more recent discussions, see Palmer 1988: esp. 152–55.

33. Quotation from Mango 1972: 58.

34. It is noteworthy in this topographic context that the sobriquet "Hagia Sophia" for the Edessa cathedral need not refer, at least not exclusively, to Justinian's great church in Constantinople. According to the Piacenza pilgrim, writing perhaps about 570, just below Sion in Jerusalem was the basilica of Saint Mary, and near it, where the Praetorium had been, the place of the trial of Jesus, "the basilica of Saint Sophia, which is in front of the Temple of Solomon"; quoted in Wilkinson 2002: 141.

35. For the argument that this terminology is deliberate and even "provocative," see Renhart 1995: 147–50, and McVey 1983: 96.

36. Hillenbrand 2000: 46 and fig. 34.

37. See, for extensive literature and citations from the Qur'an, *Encyclopaedia of Islam* 1954– , vol. 7 (1993), s.v. "minbar."

38. See Hillenbrand 2000: 46–48. According to one tradition related by al-Tabari, when 'Ali ibn Abi Talib was acclaimed as caliph, in the mosque in Medina, he was standing on the "Messenger of Allah's *minbar*"; see Brockett 1997: 2–4.

39. See, for example, Shanks 2007: 99, with schematic figures by twelve scholars of the proposed locations of Herod's Temple on the Haram.

40. Fine 1998: 75. Fine's argument is cited in Loosley 2003: 23.

41. Loosley 2003: 22, citing A. Grabar 1945: 130; Grabar refers to the eleven surrounding figures, citing the source as 2 Esdras 8:4, and also cites 3 Esdras 9:42 for specifying seven figures on either side of Ezra. The former passage, with eleven accompanying figures, is cited also by Levine 2005: 320.

42. See DeGregorio 2006.

43. For these texts see the recent English translations, with commentaries and references, in Holder 1994 and Connolly 1995.

44. The scholarly literature on this famous book is vast; for a recent study, including references to much of the earlier literature, see Chazelle 2006.

45. Meehan 1983: 42–43. The work was recently discussed in O'Loughlin 2007. Bede discusses Adomnán's work and wrote a work of the same title. See, for the former, Colgrave and Mynors 1969: 506–9; and for the latter, Fraipont 1965.

46. See Loosley 2003: 68–70. Emma Loosley discusses the Edessa bema, although not the possible significance of its eleven columns. She concludes that in form it was more like the Greek *ambon*, and that it was therefore probable that the Greek, rather than the Syriac, liturgy was used in that church. She also discusses (ibid.: 9–10) the relationship between bemata and *ambons*, and their geographical and chronological distribution.

47. The center of the church is defined by diagonals drawn from the outer corners. See the plans, with diagonals, in Tchalenko 1990: 242–56, figs. 1–45. In his drawings the central point is, in most cases, at the center of the flat side of the bema structure (the entrance) facing the apse and altar of the church; the churches at Qausiyeh, Seleucia in Pieria, and at Resafa are exceptions to this norm, with the bema near the church center.

48. Ibid.: 203–13, 252 (plan), fig. 30, pls. 307–15; Loosley 2003: 261–71, figs. 209–16; and, in greatest detail, Ulbert 1986.

49. Sack 1996 and Tohme 2009: 137–41, figs. 5.3 (aerial view) and 5.4 (plan).

50. Herzfeld 1955, part 1: 309–12, fig. 96, pl. CXV d and f.

51. Sukenik 1932: 53–54, fig. 48, and Sukenik 1934, fig. 17.

52. For evidence of wooden bemata, essentially the existence of postholes, see the evidence from 'En-Gedi and perhaps Ma'on, in Hachlili 1988: 183.

53. Fine 1997: 43–45; Fine 1998: 76–77.

54. On the possible evidence for a bema in the Sardis synagogue, see Seager 1972: 426 and n. 8, and Hachlili 1988: 182. For the date of the Sardis synagogue complex in the sixth rather than the fourth century, see Magness 2005.

55. For a trenchant exposition of this view, focusing on the earliest Islamic material, in the seventh century, see Donner 2010.

56. For a recent general discussion of spolia, see Brilliant and Kinney 2011.

57. The only comprehensive study is Werlin 2006. For one of the brief published discussions, see Hachlili 1995: esp. 185–86 (on eagles), no. 31 (now Golan Archaeological Museum, no. 720).

58. See Maranci 2001 and Kleinbauer 1972.

59. The capitals are published for the first and only time in Wilkinson 1987.

60. For full discussion of these remarkable capitals, see Nees n.d. (forthcoming), chap. 5.

61. Barrucand 2002 and Barrucand 2005: 23–44 and figs. 2.5 and 2.6 (the eagle capitals from al-Azhar).

62. Anastasia Drandaki in Evans 2012: 181–82, no. 122c.

63. On this group of objects, see Nees 2012.

64. Evans 2012: 264, no. 186.

## References

**Arberry, Arthur J.**
**1955** *The Koran Interpreted.* 2 vols. London: Allen and Unwin.

**Avner, Rina**
**2006–7** "The Kathisma: A Christian and Muslim Pilgrimage Site." *ARAM Periodical* 18–19: 541–57.

**Barrucand, Marianne**
**2002** "Les Chapiteaux de remploi de la mosquée al-Azhar et l'émergence d'un type de chapiteau médiéval en Egypte." *Annales islamologiques* 36: 37−75.

**2005** "Remarks on the Iconography of the Medieval Capitals of Cairo: Form and Emplacement." In *The Iconography of Islamic Art: Studies in Honour of Robert Hillenbrand*, edited by Bernard O'Kane: 23−44. Edinburgh: Edinburgh University Press.

**Bieberstein, Klaus, and Hanswulf Bloedhorn**
**1994** *Jerusalem: Grundzüge der Baugeschichte vom Chalkolithikum bis zur Frühzeit der osmanischen Herrschaft.* Beihefte zum Tübinger Atlas des Vorderen Orients. Reihe B, Geisteswissenschaften 100. 3 vols. Wiesbaden: Ludwig Reichert.

**Bloom, Jonathan M.**
**1993** "The 'Qubbat al-Khaḍrāʾ' and the Iconography of Height in Early Islamic Architecture." *Ars Orientalis* 23, *Pre-Modern Islamic Palaces*: 135−41.

**2002** as editor. *Early Islamic Art and Architecture.* The Formation of the Classical Islamic World 23. Aldershot: Ashgate.

**Bloom, Jonathan M., and Sheila S. Blair, eds.**
**2009** *The Grove Encyclopedia of Islamic Art and Architecture.* Vol. 2, *Delhi to Mosque.* Oxford: Oxford University Press.

**Brilliant, Richard, and Dale Kinney, eds.**
**2011** *Reuse Value: Spolia and Appropriation in Art and Architecture from Constantine to Sherrie Levine.* Farnham, Surrey: Ashgate.

**Brockett, Adrian, trans. and ann.**
**1997** *The Community Divided.* Vol. 16 of *The History of al-Tabarī (Tar'rīkh al-rusul wa 'l-mulūk).* Albany: State University of New York Press.

**Burgoyne, Michael Hamilton**
**1987** *Mamluk Jerusalem: An Architectural Study.* Jerusalem: World of Islam Festival Trust for The British School of Archaeology in Jerusalem.

**Busse, Heribert**
**1982** "Vom Felsendom zum Templum Domini." In *Das Heilige Land im Mittelalter: Begegnungsraum zwischen Orient und Okzident: Referate des 5. interdisziplinären Colloquiums des Zentralinstituts*, edited by Wolfdietrich Fischer and Jürgen Schneider: 19−32. Schriften des Zentralinstituts für Fränkische Landeskunde und Allgemeine Regionalforschung an der Universität Erlangen-Nürnberg 22. Neustadt an der Aisch: Degener.

**Busse, Heribert, and Georg Kretschmar**
**1987** *Jerusalemer Heiligtumstraditionen in altkirchlicher und frühislamischer Zeit.* Abhandlungen des Deutschen Palästinavereins. Wiesbaden: Otto Harrassowitz.

**Chazelle, Celia**
**2006** "Christ and the Vision of God: The Biblical Diagrams of the Codex Amiatinus." In *The Mind's Eye: Art and Theological Argument in the Middle Ages*, edited by Jeffrey F. Hamburger and Anne-Marie Bouché: 84−111. Princeton, N.J.: Department of Art and Archaeology, Princeton University, in association with Princeton University Press.

**Colgrave, Bertram, and R. A. B. Mynors, eds.**
**1969** *Bede's Ecclesiastical History of the English People.* Oxford: Clarendon Press.

**Connolly, Seán, trans.**
**1995** *Bede: On the Temple.* Introduction by Jennifer O'Reilly. Liverpool: Liverpool University Press.

**Creswell, K[eppel] A[rchibald] C[ameron]**
**1969** *Early Muslim Architecture.* Vol. 1, part 1, *Umayyads, A.D. 622−750.* 2nd ed. Oxford: Clarendon Press.

**Crone, Patricia, and Martin Hinds**
**1986** *God's Caliph: Religious Authority in the First Centuries of Islam.* University of Cambridge Oriental Publications 37. Cambridge: Cambridge University Press.

**DeGregorio, Scott, trans.**
**2006** *Bede: On Ezra and Nehemiah.* Liverpool: Liverpool University Press.

**Donner, Fred McGraw**
**2010** *Muhammad and the Believers: At the Origins of Islam.* Cambridge, Mass.: Belknap Press of Harvard University Press.

**Dupont-Sommer, André**
**1947** "Une Hymne syriaque sur la Cathédrale d'Edesse." *Cahiers archéologiques* 2: 29−39.

**Elad, Amikam**
**1995** *Medieval Jerusalem and Islamic Worship: Holy Places, Ceremonies, Pilgrimage.* Islamic History and Civilization 8. Leiden: Brill.

*Encyclopaedia of Islam*
**1954−** *Encyclopaedia of Islam.* Edited by H[amilton] A. R. Gibb and B. Lewis. New ed. 11 vols. Leiden: Brill.

**Evans, Helen C., ed.**
**2012** *Byzantium and Islam: Age of Transition, 7th−9th Century.* Exh. cat. New York: The Metropolitan Museum of Art.

**Fine, Steven**
**1997** *This Holy Place: On the Sanctity of the Synagogue during the Greco-Roman Period.* Christianity and Judaism in Antiquity 11. Notre Dame, Ind.: University of Notre Dame Press.

**1998** "'Chancel' Screen in Late Antique Palestinian Synagogues: A Source from the Cairo Genizah." In *Religious and Ethnic Communities in Later Roman Palestine*, edited by Hayim Lapin: 67−85. Studies and Texts

in Jewish History and Culture 5. Potomac: University Press of Maryland.

**Flood, Finbarr Barry**
2001    *The Great Mosque of Damascus: Studies on the Makings of an Umayyad Visual Culture.* Islamic History and Civilization 33. Leiden: Brill.

**Fraipont, J., ed.**
1965    *Beda: De locis sanctis.* In Paul Geyer et al., *Itineraria et alia geographica:* 245–80. Corpus Christianorum Series Latina 175. Turnhout: Typographi Brepols.

**Friedmann, Yohanan, trans. and ann.**
1992    *The Battle of al-Qādisiyyah and the Conquest of Syria and Palestine, A.D. 635–637/A.H. 14–15.* Vol. 12 of *The History of al-Tabarī (Ta'rīkh al-rusul wa 'l-mulūk).* Albany: State University of New York Press.

**Grabar, André**
1945    "Les Ambons syriens et la fonction liturgique de la nef dans les églises antiques." *Cahiers archéologiques* 1: 129–33.

1947    "Le Témoignage d'une hymne syriaque sur l'architecture de la Cathédrale d'Edesse au VIᵉ siècle et sur la symbolique de l'édifice chrétien." *Cahiers archéologiques* 2: 41–67.

**Grabar, Oleg**
1996    *The Shape of the Holy: Early Islamic Jerusalem.* Princeton, N.J.: Princeton University Press.

2005    "The Haram al-Sharif: An Essay in Interpretation." In *Jerusalem:* 203–15. Constructing the Study of Islamic Art 4. Aldershot: Ashgate. Originally published in *Bulletin of the Royal Institute for Inter-Faith Studies* 2 (2000): 1–13.

**Grabar, Oleg, and Benjamin Z. Kedar, eds.**
2009    *Where Heaven and Earth Meet: Jerusalem's Sacred Esplanade.* Jerusalem: Yad Ben-Zvi Press.

**Hachlili, Rachel**
1988    *Ancient Jewish Art and Archaeology in the Land of Israel.* Leiden: Brill.

1995    "Late Antique Jewish Art from the Golan." In "The Roman and Byzantine Near East: Some Archaeological Research," edited by John H. Humphrey, *Journal of Roman Archaeology, Supplementary Series* 14: 183–212.

**Herzfeld, Ernst**
1955    *Inscriptions et monuments d'Alep.* Vol. 1 of *Matériaux pour un Corpus Inscriptionum Arabicarum, Deuxième partie: Syrie du Nord.* 2 parts. Cairo: Institut Français d'Archéologie Orientale.

**Hillenbrand, Robert**
2000    *Islamic Architecture: Form, Function, and Meaning.* Reprint with amendments. Edinburgh: Edinburgh University Press. Originally published 1994.

**Holder, Arthur G., trans. and ann.**
1994    *Bede: On the Tabernacle.* Liverpool: Liverpool University Press.

**Howard-Johnston, James D.**
2010    *Witnesses to a World Crisis: Historians and Histories of the Middle East in the Seventh Century.* Oxford: Oxford University Press.

**Humphreys, R. Stephen**
2006    *Mu'awiya ibn Abi Sufyan: From Arabia to Empire.* Oxford: Oneworld.

**Ibn Hawqal (Abu al-Kasim ibn Ali al-Nasibi ibn Hawqal)**
1938–39    *Opus geographicum.* Edited by Johannes H. Kramers. Bibliotheca Geographorum Arabicorum 2. 2nd ed. Leiden: Brill.

**Johns, Jeremy**
2003    "Archaeology and the History of Early Islam: The First Seventy Years." *Journal of the Economic and Social History of the Orient* 46, no. 4: 411–36.

**Kaplony, Andreas**
2002    *The Haram of Jerusalem, 324–1099: Temple, Friday Mosque, Area of Spiritual Power.* Freiburger Islamstudien 22. Stuttgart: Franz Steiner Verlag.

2009    "635/638–1099: The Mosque of Jerusalem (Maṣjid Bayt al-Maqdis)." In O. Grabar and Kedar 2009: 100–131.

**Kleinbauer, W. Eugene**
1972    "Zvart'nots and the Origins of Christian Architecture in Armenia." *Art Bulletin* 54, no. 3 (September): 245–62.

**Krautheimer, Richard**
1980    *Rome: Profile of a City, 312–1308.* Princeton, N.J.: Princeton University Press.

**Levine, Lee**
2005    *The Ancient Synagogue: The First Thousand Years.* 2nd ed. New Haven, Conn.: Yale University Press.

**Loosley, Emma**
2003    *The Architecture and Liturgy of the Bema in Fourth- to Sixth-Century Syrian Churches.* Patrimoine Syriaque 2. Kaslik, Lebanon: Parole de l'Orient.

**Magness, Jodi**
2005    "The Date of the Sardis Synagogue in Light of the Numismatic Evidence." *American Journal of Archaeology* 109, no. 3 (July): 443–75.

**Mango, Cyril A.**
1972    *The Art of the Byzantine Empire, 312–1453.* Englewood Cliffs, N.J.: Prentice-Hall.

**Maranci, Christina**
2001    "Byzantium through Armenian Eyes: Cultural Appropriation and the Church of Zuart'noc." *Gesta* 40, no. 2: 105–24.

**Marsham, Andrew**
**2009**   *Rituals of Islamic Monarchy: Accession and Succession in the First Muslim Empire.* Edinburgh: Edinburgh University Press.

**McVey, Kathleen E.**
**1983**   "The Domed Church as Microcosm: Literary Roots of an Architectural Symbol." *Dumbarton Oaks Papers* 37: 91–121.

**Meehan, Denis, ed.**
**1983**   *Adamnan's De Locis Sanctis.* Scriptores Latini Hiberniae 3. Dublin: Dublin Institute for Advanced Studies.

**Miles, George C[arpenter]**
**1952**   "Mihrāb and 'Anazah: A Study in Islamic Iconography." In *Archaeologica Orientalia in Memoriam Ernst Herzfeld,* edited by George C. Miles: 156–71. Locust Valley, N.Y.: J. J. Augustin. Reprinted in Bloom 2002: 149–65.

**Mitchell, John**
**2008**   *The Butrint Baptistery and Its Mosaics / Pagëzimorja e Butrintit dhe mozaikët e saj.* London: Butrint Foundation.

**Morony, Michael G., trans. and ann.**
**1987**   *Between Civil Wars: The Caliphate of Muʿāwiyah,* A.D. *661–680 / A.H. 40–60.* Vol. 18 of *The History of al-Tabarī (Tar'rīkh al-rusul wa 'l-mulūk).* Albany: State University of New York Press.

**Nees, Lawrence**
**2012**   "A Silver 'Stand' with Eagles in the Freer Gallery." *Ars Orientalis* 42: 221–28.

**2014**   "Insular Latin Sources, 'Arculf,' and Early Islamic Jerusalem." In *Where Heaven and Earth Meet: Essays on Medieval Europe in Honor of Daniel F. Callahan,* edited by Michael Frassetto, Matthew Gabriele, and John Hosler: 81–100. Leiden: Brill.

**n.d.**   *Perspectives on Early Islamic Art in Jerusalem.* Leiden: Brill. Forthcoming.

**Nuseibeh, Saïd, and Oleg Grabar**
**1996**   *The Dome of the Rock.* New York: Rizzoli.

**O'Loughlin, Thomas**
**2007**   *Adomnán and the Holy Places: The Perceptions of an Insular Monk on the Locations of the Biblical Drama.* London: T & T Clark.

**Palmer, Andrew**
**1988**   "The Inauguration Anthem of Hagia Sophia in Edessa: A New Edition and Translation with Historical and Architectural Notes and a Comparison with a Contemporary Constantinopolitan Kontakion, with an Appendix by Lyn Rodley." *Byzantine and Modern Greek Studies* 12: 117–67.

**1993**   as editor and translator. *The Seventh Century in the West-Syrian Chronicles.* Liverpool: Liverpool University Press.

**Pringle, Denys**
**2007**   *The Churches of the Crusader Kingdom of Jerusalem: A Corpus.* Vol. 3, *The City of Jerusalem.* Cambridge: Cambridge University Press.

**Rabbat, Nasser**
**1993**   "The Dome of the Rock Revisited: Some Remarks on al-Wasiti's Accounts." In "Essays in Honor of Oleg Grabar," *Muqarnas* 10: 66–75.

**Renhart, Erich**
**1995**   *Das syrische Bema: Liturgisch-archäologische Untersuchungen.* Grazer theologische Studien 20. Graz: Institut für Ökumenische Theologie und Patrologie an der Universität Graz.

**Rosen-Ayalon, Myriam**
**1989**   *The Early Islamic Monuments of al-Haram al-Sharif: An Iconographic Study.* Qedem 28. Jerusalem: Institute of Archaeology, The Hebrew University of Jerusalem.

**Sack, Dorothée, ed.**
**1996**   *Die grosse Moschee von Resafa, Rusafat Hisam.* Resafa 4. Mainz: Philipp von Zabern.

**Seager, Andrew R.**
**1972**   "The Building History of the Sardis Synagogue." *American Journal of Archaeology* 76, no. 4 (October): 425–35.

**Shanks, Hershel**
**2007**   *Jerusalem's Temple Mount: From Solomon to the Golden Dome.* New York: Continuum.

**Sukenik, Eleazar L.**
**1932**   *The Ancient Synagogue of Beth Alpha: An Account of the Excavations Conducted on Behalf of the Hebrew University, Jerusalem.* Jerusalem: University Press; London: Oxford University Press. Reprinted Hildesheim: Olms, 1975.

**1934**   *Ancient Synagogues in Palestine and Greece.* The Schweich Lecture of the British Academy. London: Humphrey Milford, Oxford University Press, for the British Academy.

**Tchalenko, Georges**
**1990**   *Eglises syriennes à Bêma.* Institut Français d'Archéologie du Proche-Orient, Bibliothèque Archéologique et Historique 105. Paris: Paul Geuthner.

**Tohme, Lara**
**2009**   "Spaces of Convergence: Christian Monasteries and Umayyad Architecture in Greater Syria." In *Negotiating Secular and Sacred in Medieval Art: Christian, Islamic, and Buddhist,* edited by Alicia Walker and Amanda Luyster: 129–45. Farnham, Surrey: Ashgate.

**Treadwell, W. Luke**

**2005**   "Mihrab and 'Anaza or 'Spear in Sacrum'? A Reconsideration of an Early Marwanid Silver Drachm." *Muqarnas* 22: 1–28.

**Ulbert, Thilo, ed.**

**1986**   *Die Basilika des Heiligen Kreuzes in Resafa-Sergiupolis.* Resafa 2. Mainz: Philipp von Zabern.

**Vogüé, Melchior de**

**1864**   *Le Temple de Jérusalem: Monographie du Haram-ech-Chérif, suivie d'un essai sur la topographie de la Ville-Sainte.* Paris: Noblet & Baudry.

**Werlin, Steven H.**

**2006**   "Eagle Imagery in Jewish Relief Sculpture of Late Ancient Palestine: Survey and Interpretation." M.A. thesis, University of North Carolina, Chapel Hill. Electronic ed. available at http://dc.lib.unc.edu /cdm4/item_viewer.php?CISOROOT=/etd&CISOPTR =646.

**Whelan, Estelle**

**1986**   "The Origins of the Mihrab Mujawwaf: A Reinterpretation." *International Journal of Middle East Studies* 18, no. 2 (May): 205–23. Reprinted in Bloom 2002: 373–91.

**Wilkinson, John**

**1987**   *Column Capitals in al-Haram al-Sharif (from 138 A.D. to 1118 A.D.).* Jerusalem: The Adm. of Wakfs and Islamic Affairs, and the Islamic Museum al-Haram al-Sharif.

**2002**   *Jerusalem Pilgrims before the Crusades.* Essay, translation of 22 primary texts, and gazetteer by Wilkinson. Rev. ed. Warminster: Aris and Philipps.

*Claus-Peter Haase*

# Qasr al-Mshatta and the Structure of Late Roman and Early Islamic Façades

## THE FIRST GENERATIONS OF ISLAMIC RULE

Syria, as the central region of the Umayyad Caliphate and the center of the first Islamic world empire, functioned through social interaction between diverse ethnic and religious communities—Muslims, Christians, Jews, nomads—residing in towns and rural areas. Despite fundamental political and theological differences between Islam and the older monotheistic religions within the new empire, the Islamic state allowed these communities to continue their lives under various degrees of discrimination that were based on traditions originating in the time of the Prophet Muhammad. These included relatively neutral sayings of the Prophet about Christians (and Jews) which permitted self-administration under a religious community leader, though with subordinate status within the broader society.

In the earliest period of Islamic development and under the Umayyad Caliphate (661–750), closer intellectual and social exchange is reported between various religious communities both within the Islamic regions and beyond, and impressive monumental examples of Christian and Jewish architecture remained in urban regional settings for the first centuries of Islamic rule.[1] But continued contacts between existing populations and their new rulers led to increasing separation and alienation between the new subjects of the caliphate and their rulers, probably as a result of resistance to conversion. The gradual formulation of Shari'a

Figure 1. Ruins of Qasr al-Mshatta, mid-8th century. Mshatta, Jordan. Photograph, 1900, by Gertrude Bell (1868–1926). A_232 from Album A 1905—Italy, Turkey, Lebanon, West Bank, Syria, Jordan, Israel, Gertrude Bell Archive, Newcastle University Library, Newcastle, United Kingdom

law in the first centuries of Islam further limited the integration of unbelievers into the Islamic Empire.

Recent archaeological data and art-historical observations have provided new insight into the questions of whether and how this societal divide was mirrored in the cultural and artistic expression of Islamic society. The excellent presentation at The Metropolitan Museum of Art of the art and culture of Greater Syria during its transition from a Byzantine province to the central region of the Umayyad Caliphate provided an occasion to reconsider the question of possible sources of, and changes in, the area's representative architecture and ornamentation.

It was especially surprising to find in this exhibition three slabs from the southern façade of the mid-eighth-century Qasr al-Mshatta in Jordan, hitherto documented only in early photographs (figs. 1, 2).[2] Most of the related slabs from the side to the west of the entrance to the perimeter wall of the palace were dismantled and transported to Berlin as gifts of the Ottoman sultan Abdul Hamid II (r. 1876–1909) to Kaiser Wilhelm II of Germany (r. 1888–1918). They are now installed in Berlin's Museum für Islamische Kunst (fig. 3).[3]

In contrast, the slabs in the exhibition remained at Mshatta until loaned for the exhibition to the Metropolitan Museum in 2012. Their presence encouraged a reconsideration of the possible purpose of the palace, a unique and extraordinary architectural monument situated outside the Roman and Byzantine centers of trade and power in the province of Greater Syria, close to the Bedouin areas and near one of the routes to the major Muslim shrines of Mecca and Medina. There are no inscriptions or literary sources to explain the function of this vast, but unfinished, desert palace whose external walls formed a square of approximately 144 meters to a side (fig. 4). With little archaeological or textual information about the site, its interpretation has necessarily been left entirely to theoretical concepts.

Figure 2. Gateway of Qasr al-Mshatta. Photograph, 1900, by Gertrude Bell (1868–1926). A_232 from Album A 1905—Italy, Turkey, Lebanon, West Bank, Syria, Jordan, Israel, Gertrude Bell Archive, Newcastle University Library, Newcastle, United Kingdom

Figure 3. Western façade of Qasr al-Mshatta installed in the Museum für Islamische Kunst, Pergamonmuseum, Staatliche Museen zu Berlin

The discussion begun a century ago with the façade's initial presentation in Berlin has recently been revived as a result of several new archaeological soundings and architectural studies. These have yielded surprising finds as to the structure of the façade, as well

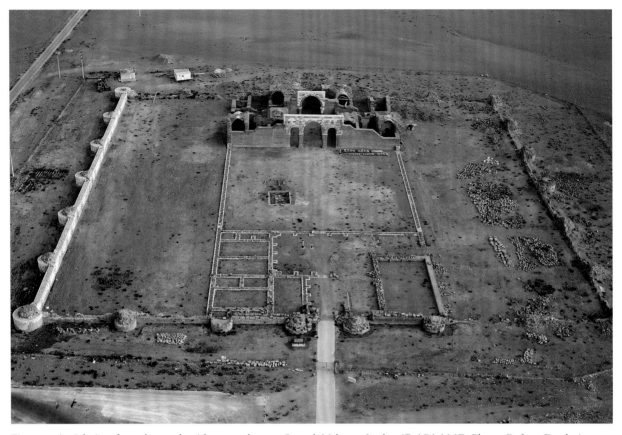

Figure 4. Aerial view from the north with restored areas. Qasr al-Mshatta, Jordan (© APAAME. Photo: Robert Bewley)

as an early Abbasid coin in a stratified layer that further complicates interpretations.[4]

From the beginning, scholarly opinion has favored identifications of the site as an Islamic foundation of the Umayyad period, probably dating to the end of the dynasty, during the reign of Caliph al-Walid II ibn Yazid (r. 743–44), considered an eccentric in later Arabic sources. Stylistic analysis and comparison with other palaces connected to al-Walid or to his predecessor, Hisham, have tended to confirm this dating.

The meaning of the ornamentation of Mshatta's entrance wall remains an enigma. Two completely antithetical programs of sculptural ornament appear on either side of the façade—the western (left) half displays figurative and vegetal motifs; the eastern (right) half, except for the field next to the portal, displays nonfigurative, mainly vegetal ornament. The individual motifs of the figurative programme can be traced back to Roman, Late Roman, and Sasanian origins; the nonfigurative motifs are a blend of Late Roman, Byzantine, and Sasanian forms, with newly invented scroll systems and vegetal and geometric motifs.[5] Even today, with advanced scientific means for studying comparative material but still little or no literary sources on the site, the origin and purpose of this palace remain uncertain. Destruction by later dynastic, cultural, and religious forces have left few Byzantine, Sasanian, or Umayyad sites for comparative study. Still it is necessary to reconsider whether the builders of this monumental

residential structure meant to suggest or initiate new interpretations of its elements, which show a broadly based mix of architectural forms and features drawn from earlier cultural contexts in combination with new formal proportions. One approach of some merit seeks to answer whether the new authorities of Early Islam were trying to use older images to attract Christians to the new faith and its values or were attempting to create meaningful examples of solely Islamic self-representation.

This paper will offer a glimpse into a possibly new conception of the meaning of the palace façade's ornamental programme by placing it within the context of the communal and intellectual interaction of the Early Islamic period, and will define the architectural form of the sculpted façade within the tradition of representative buildings of earlier and contemporary rulers. As noted earlier, in the Near East the transition from the Byzantine era to Islamic rule meant an epochal shift in every aspect of the political sphere and public life that must have quickly resulted in great change in social, spiritual, and economic affairs.[6] In the cultural arena the old Christian and Jewish communities gradually lost their public roles but preserved their traditions and artistic expressions within their homes and religious institutions. Even with the change in political and religious authority, everyday life continued as usual. Archaeologists have had great difficulty detecting the political shift during the seventh and the first half of the eighth century as there were no changes in the material culture of ordinary houses, churches, and monasteries or they were reconstructed in traditional ways in Early Islamic times.[7]

The first decades after the rapid Arab conquest brought a mixed administration that balanced the ruling class of the aristocracy of Medina and Mecca with the local sedentary population and Arab tribal society. Greek- as well as Arabic-speaking-and-writing administrators and "secretaries" worked for the new authority. Arab, mainly Miaphysite Christians—as opposed to Greek-speaking members of the Church of Constantinople, the Imperial Church of the Byzantine Empire—served caliphs, and, as in Iran, former lower officials of the pre-Islamic powers, as well as scholars trained in Christian theology and classical studies, were admitted to proceedings at court.

In the former Byzantine provinces of the caliphate in Greater Syria, Byzantine gold coin types with figures of emperors such as Heraclios and his heirs were transformed by mint officials into coins showing the caliph in similar poses, while in Iran, in former Sasanian territories, Sasanian silver coin types were altered by adding inscriptions in Arabic. A marked shift happened around 692–95, during the reign of the Umayyad caliph 'Abd al-Malik, when the caliphal administration was reformed, tax registration was translated into Arabic, and a new type of coinage was created in purely Arabic style—dirhams and dinars.[8]

The significance of these events has not yet been fully evaluated, but they are representative of a major transformation in all fields and levels of social and cultural expression that also affected the interpretation of the arts, including architectural forms and ornament. This can be observed in the presentation of the great mosaics in the Dome of the Rock in Jerusalem and the Umayyad Great Mosque in Damascus with their differing motifs. The complex processes of "transmission" and "translation" of different forms of ceremonial and mythical subjects and visualizations in the second, so-called Marwanid cycle of the Umayyad dynasty (after Caliph Marwan I; r. 684–85) have been analyzed in the exemplary study of the Great Mosque by Finbarr Barry Flood.[9] Byzantine style and techniques of representation, even Byzantine artists, were still admired during this period and had not lost their leading role in the arts.[10] Later reports in Arabic sources of the Umayyad caliph al-Walid I's (r. 705–15) request of the Byzantine emperor for craftsmen and supplies, such as mosaic tesserae

Figure 5. Courtyard view of the Great Mosque, ca. 705–10. Damascus, Syria

for building the mosques in Damascus and Medina, are supported.[11]

Art-historical sources have long identified these important Early Islamic monuments as being built in a "Byzantine style" under Arab caliphal patronage. This stylistic change is no longer taken as a sign of an inability on the part of the Arab Muslim elite to express the new religious and imperial concepts. The long history of pre-Islamic Arab adaptations of Ancient Near Eastern, South Arabian, and Hellenistic forms in architecture and the arts and the resulting differences and alterations in programmatic details of these buildings and their ornaments are now appreciated. Examples of this transformation appear in Nabataean art and architecture of the Late Hellenistic and Early Roman Imperial periods, for example in Petra (Jordan) and Mada'in Salih (Saudi Arabia). The main characteristics of the adaptation to Arab taste throughout these earlier periods were various degrees of stylization of figurative and vegetal motifs and a reduction of architectural façade ornamentation.

It is important to recognize that early Muslim expansion occurred in provincial regions of the Byzantine—formerly Roman—Empire, home to rather unruly separatist Christian communities and followers of pre-Christian beliefs, communities that extended beyond the imperial borders. Critical as it was for the defense of the empire against the Sasanians, the region had no spectacular imperial architecture, except for the major lost cathedrals of Antioch (Antakya) and Edessa (Ruha) in Turkey and the vast, partly preserved pilgrims' centers in Qal'at Sem'an and Rusafa in Syria. Even Qasr ibn Wardan, the sixth-century Byzantine fortress and palace complex in Syria, clearly shows the features and technology of provincial architecture. By contrast, under the patronage of the new Arab caliphs a

demand arose for a more refined, luxurious quality of workmanship.

Robert Schick and Sidney Griffith have provided new insights into Christian culture under Islamic rule.[12] Garth Fowden and Elizabeth Key Fowden collected material evidence for Hellenistic, Christian, and other pre-Islamic traditions and instigations under, and in coexistence with, the Umayyads.[13] With respect to the representations of Umayyad caliphs in the baths of the Qusayr 'Amra in Jordan and the stucco sculptures in the Qasr al-Hayr al-Gharbi in Syria, Fowden and Fowden argue that the obvious allusions to Sasanian and Byzantine ceremonial in the depictions of the ruler must have been chosen to address not only Muslim Arabs but also the newly converted, and perhaps others still to be drawn to the new order. Apart from the question of whether wall paintings in a bath of rather "private" dimensions were accessible to non-Muslims, these representations could have been only a minor aspect of the programme.

The focus of these studies on the significance of other traditions has inadvertently minimized the enormous vitality of the development and formulation of the new Islamic religious and secular values. It is necessary to look more closely for signs of the differences between the old and new orders and to seek more evidence, to investigate why certain forms and motifs were chosen and others not, and to define possible new Islamic interpretations of features and motifs representative of both the old and new cultures.

THE LATER UMAYYAD PERIOD:
EXPERIMENTAL SYNTHESIS OF
OLD ARCHITECTURAL TRADITIONS
AND QUICK NEW SOLUTIONS AS
EXEMPLIFIED BY A SERIES OF NICHES

In Syria new religious building types—and mosques were a new form in the region—made use of pre-Islamic architectural features such as naves and domes but in new combinations. The transverse nave of the

Great Mosque in Damascus (ca. 705–10), for example, leads the eye both to the qibla, directed toward the Ka'ba in Mecca, and to a central dome that towers over the roof, opening it to the sky (fig. 5). This previously unknown combination of architectural features and effects demonstrates a kind of rivalry with the impressive Christian monuments of the region.[14] In the same way, buildings were covered by ornaments based on traditional motifs, executed in traditional techniques, and applied to traditional spaces and wall partitions—but obviously changed in composition and meaning.

The use of the niche (*canopus*) as an architectural ornament derived from Hellenistic and early Imperial Roman architectural forms. Columns were often integrated into a series of niches which then seemed to converge with the structural motif of the arcade, providing an ornamental and possibly meaningful framing element within the space. Arcades could serve as indicators of entire architectural monuments. Corroboration of this concept is found in Classical and early Hellenistic theater paraskenia with decorated laterally protruding sides, recently interpreted as ideal "palaces" that functioned in the Classical Greek world as residences of the gods. Andreas Scholl has connected the theater palaces to the monumental altar from Pergamon in the Berlin Pergamonmuseum, which he convincingly interprets as a palace with an ornamental façade.[15]

By definition, a niche has a rear wall that closes off a space in which an object can be safely displayed. In pre-Islamic architecture framing systems derived from the so-called minor arts, such as textile hangings, were transformed into decorative schemes that extended up walls, forming outlines for mosaics and murals. According to Hornbostel-Hüttner's analysis of the early Imperial Roman examples in the Domus Augustana and the *aula regia* (reception hall) in the Domus Flavia on the Palatine Hill in Rome, interpretation of the single or serial niche as a structural element or as an ornamental simulation of an opening remains ambiguous.[16]

Figure 6. Roman nymphaeum, ca. 191 C.E. Gerasa (Jerash), Jordan

The Roman examples usually reflect an interior use, sometimes as functional spaces for books, as in the Celsus Library in Ephesus (135 C.E.). The library's façade, with its column divisons, illustrates an exterior use that is also seen on nymphaea, such as the one in Gerasa (Jerash), Jordan (fig. 6). The sculptures, scenes, and objects depicted in these frames or series of frames were chosen either to be highlighted or as parts of a narrative sequence. This motif, or signifier (*semeion*), of a single *canopus* or a series of blind niches forming an arcade provides a way to reinterpret and reevaluate the messages that their use enhances—a field of programmatic importance framed by Hellenistic architectural features.

Coins also demonstrate this phenomenon, as they employ the most elaborated art of abbreviation. The Hellenistic image of the Jewish Ark with an arched top supported by a series of four columns on a tetradrachm of Simon bar Kokhba from the time of the Second Revolt (132–35; fig. 7) is typical of the way deities and symbols on coins were depicted within their temples.[17]

On the interior walls of the Dome of the Rock (completed 691/92), where the niche motif appears prominently on friezes as a series of single small arcades alternating with medallion compositions, the motif must have served more than a decorative function (fig. 8).[18] Similar niche motifs are repeated with slightly varied vegetal elements on several other religious and secular buildings of the Umayyad period, where they too must have carried a signifying function and meaning. The combination of an architrave with a vine scroll or a tree also appears among the architectural motifs on some of the mosaics in the courtyard galleries of the Great Mosque in Damascus.[19]

These stylized views of nature may be understood as the patron's definition of wall

ornament appropriate to the enhancement of reflection on God as the sole Creator rather than on the religious and mythical figures and idols placed in the niches of sacred places in other religions. The small and very large niches in the inner walls of the reception hall of the palace at the Amman Citadel, with their finely stylized tree representations in stone relief, are an example of this function (fig. 9).[20]

Façades of palaces were often decorated with series of arcades. An exemplary case is Diocletian's palace compound in Spalato (Split; ca. 295–311), with its arcaded gallery of nearly 200 meters in length (fig. 10). Arcades were also used to represent palace façades, as on the mosaic image of a palace in the Church of Sant'Apollinare Nuovo in Ravenna (ca. 550; fig. 11). In Late Antiquity variations of these structural forms developed, including façades and side walls with blind niches. Such a variation is quoted in the original blind niche decoration of the outer walls

Figure 7. Tetradrachm of Simon bar Kokhba, 132–35. British Museum (© Trustees of the British Museum)

of the Dome of the Rock, now partly hidden behind later tile decoration (see page 99, fig. 8). There are indications of a former mosaic ornament in the original niches.[21]

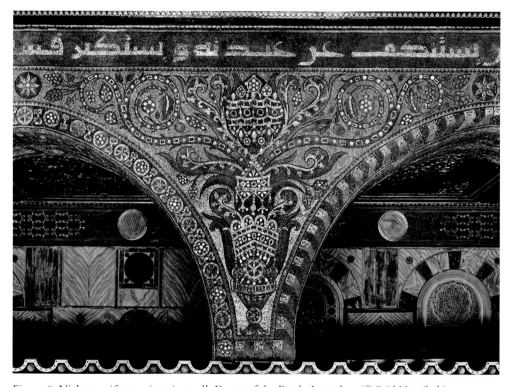

Figure 8. Niche motif on an interior wall. Dome of the Rock, Jerusalem (© Saïd Nuseibeh)

Figure 9. Detail of niche showing stylized tree motif, mid-8th century. Citadel, Amman, Jordan (from Northedge 1992, pl. 23, A.40)

The importance of the use of one or a series of niches to frame motifs cannot be overestimated. The Metropolitan Museum exhibition catalogue alone illustrates thirty-seven examples from the Late Antique, Byzantine, Coptic, Ethiopic, and Islamic periods in all media, from architecture to manuscript illumination. Common features of the niche frames are columns, standing alone or in front of the niche; a curved or gabled cornice, with or without lateral horizontal extensions; and above the archivolt or cornice, further motifs on both sides of a single or repeated arch—mainly vegetal motifs, but also rosettes, medallions, and figures.[22] In some compositions an arched lintel is used to emphasize the most prominent figure or action, as on the medium-sized Byzantine silver plates from the series depicting the life of David, which Helen Evans convincingly dates to the period of Emperor Heraclios's victory over the Sasanians in Syria in 628 (see fig. 2 on pages 2–3).[23] The architectural setting thus becomes part of the action, directing the viewer's eye toward the central motifs.

A clear typology of the diversified first generations of Early Islamic palace architecture has not yet been established. For lack of evidence, Creswell's attempts to determine the extent of Late Roman, Byzantine, and Sasanian Imperial architecture's influence on Islamic architecture has not been further studied. Few Islamic ornamental motifs have survived in their original state. To a classicist's eye they appear more as simplified stylizations of antique motifs than as compelling reinterpretations of the past. Western art historians have been slow to develop an understanding of the wide architectural spaces, the ornamental devices, and the evidence of a new spirit behind these innovative Islamic architectural projects.

These features are prominently recognizable on the reconstructed eastern façade of the Qasr al-Hayr al-Gharbi in northern Syria (fig. 12), dated by inscription to the reign of Caliph Hisham (r. 724–43). The extensive decoration with various types

Figure 10. Diocletian's Palace, Spalato (Split). Late Imperial Roman, ca. 295–311 (from Adam 1764, pl. VIII)

Figure 11. Detail of mosaic with palace. Sant'Apollinare Nuovo, Ravenna, ca. 550 (Scala/Art Resource, NY)

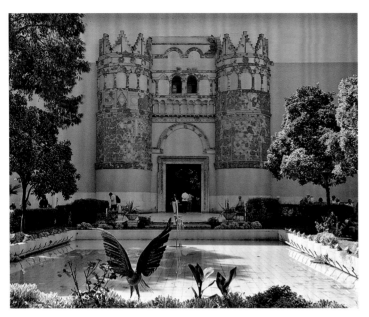

Figure 12. Reconstructed eastern façade of the Qasr al-Hayr al-Gharbi, northern Syria, ca. 724–43; now main entrance, National Museum of Damascus (Photo: Ian M. Butterfield, Syria/Alamy)

representation of a palace and a possible source for an early form of prayer niche. In the Qur'an the term *mihrab* denotes either a temple (Sura 3:37) or a palace (Sura 38:21). This terminology originally may also have pointed to the iconographic use of blind niches in a series as ornaments of palaces or as palace embellishments.[25]

Our effort to place the shape of the cornices and friezes of Mshatta's façade within the tradition of "signifying niches" is perhaps more understandable when compared with the Qasr al-Hayr al-Gharbi. The Mshatta palace, one of the largest of its period, shows a unique example of an extended sculptural relief façade on both sides of the entrance portal (see figs. 1, 2). It is structured as a continuous series of angular friezes that divides into interlocked triangles the area between the base and the heavier upper cornice. Seen from a distance the surface of the façade appears to stand free from the base and cornice, with the lines that form the triangles providing an elegant sense of motion to the architectural decoration. The pattern does not frame the façade but disappears into the towers at the corners, as if repeating into infinity. Only the portal—its original height unknown—breaks the rhythm of the façade's surface decoration.[26] This relates the scheme of the design to some of the beautifully structured church façades in the Aleppo region, with flat friezes rounding the windows in sweeping curves, as in Qalb Loze and Qal'at Sem'an (fig. 13), and in a few instances also swinging in a curve to the next window, as in the churches of Turmanin, lost long ago, and Me'ez.[27]

At Mshatta, the zigzag lines that form the interlocked triangles also divide the surface into two zones, with their pattern functioning as if they were the cornices of the niches. The columns traditionally in the lower part of the niche are omitted. The types of ornamentation above and below the cornices—except for the medallion motif—differ in importance. The upper triangles are decorated with fewer ornaments, indicating their secondary position, while the primacy of

of arches on the central section between the half-round towers offers especially interesting evidence for meaning being conveyed by ornamental niches. The restored niche patterns extend into the stucco ornamentation of the courtyard façades and even into one floor painting. The window grilles of the upper courtyard galleries show vegetal and geometric stucco ornaments framed by daringly curved and "broken" cornices combined with innovative column positions.[24]

An interesting speculation by an Islamic art historian helped to throw unexpected light on the role of niches. A note by R. B. Serjeant on the pre-Islamic meanings of the Arabic term *mihrab* (pl. *maharib*) for the prayer niche led Géza Fehérvári to think about possible connections between mihrabs and tombs—obviously applying one of these early meanings but not necessarily one associated with the niche. He also presented evidence for another meaning of the term as a sort of "flat niche" behind a throne or in a palace, perhaps meant to be an abbreviated

*Age of Transition: Byzantine Culture in the Islamic World*

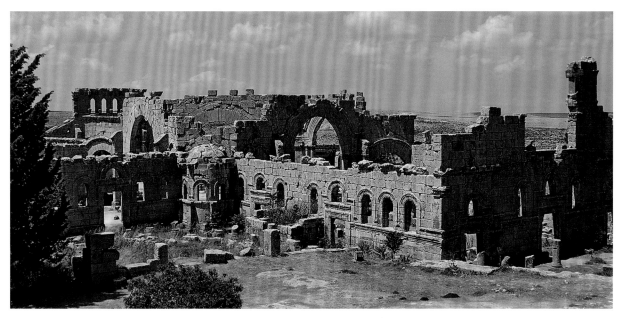

Figure 13. Qal'at Sem'an, northwest of Aleppo, Syria, ca. 475–500 (Photo: Joel Carillet)

the lower triangles is indicated by the presence of the opposed creatures that decorate the western (left) side. On the eastern (right) side the decoration is limited to vegetal and geometric patterns.

### AN INTERPRETIVE APPROACH TO THE TWO CYCLES ON THE MSHATTA FAÇADE

Ernst Herzfeld and Josef Strzygowski detected manifold origins for certain of the motifs on the façade's decoration. Strzygowski characteristically overemphasized Iranian–Sasanian and Eastern Anatolian influence, but he convincingly pointed out the Coptic origins of such details as the grape clusters in the scrolling vines. Carl-Heinrich Becker saw the decoration as representing a continuity from, and development of, trends established in Late Antiquity.[28] Both the specialist for Islamic architecture Herzfeld and the Byzantinist Oskar Wulff, following Becker, argued in favor of an Early Islamic date. Herzfeld pointed to al-Walid II as the possible patron of the palace.[29] Creswell

followed Herzfeld, as did most other authors.[30] Oleg Grabar questioned the palace's Umayyad origin by comparing the plan of the very complex site with that of the less ambitious palace at Ukhaydir, Iraq, built by an Abbasid governor (ca. 775).[31] No one else appears to have followed Grabar's interpretation.

After the pioneering interest in the "Mshatta problem," attention to the site waned to some extent, without, however, actually coming to a halt. Leo Trümpelmann, in his 1962 dissertation, inspiringly concluded his art-historical study with detailed observations on the differences between the façade's ornamentation and antique canons on architectural ornament. These were partly taken up by Rina Talgam, who examined Mshatta in relation to two other Umayyad palaces, Khirbat al-Mafjar and Qasr al-Hayr al-Gharbi. She detected a type of stylistic unity in the Mshatta façade based on an eclectic merging of motifs carved by the workshops that produced the ornamentation, an approach that closely follows formulations established by Herzfeld in 1910.[32]

It would, however, seem more probable that the main impetus for this fusion of varied stylistic sources was inspired by the patron, based on the cultural and political outlook shared by the elites recently established at court. A new way of interpreting these motifs must have contributed to the decision to entrust "designers" representing different traditions with the planning of the decorative schemes even as their execution appears to have been done in close cooperation with workshops of Syrian tradition, as the observations detailed by the Berlin team have revealed.[33] Thomas Leisten, following Herzfeld, saw parallels between the façade decoration and designs in floor plans of Sasanian palaces.[34] New findings from excavations at the site by Cramer and Perlich have also brought to light a problematic early Abbasid coin from under a courtyard floor, which may prove an Abbasid subphase; publication of their findings is forthcoming.[35]

Another Syro–Palestinian aspect of Mshatta's ornamental programme can be recognized both in the subject and in the very distinctive local style of the motifs on mosaic floors in churches in the region, where mosaic art flourished from the fourth century through the Christian era well into the Islamic period. Vegetal and geometric ornaments seen in these mosaics would be adopted in an Islamic context. Thus the vine scrolls inhabited by birds and even humanoid figures, as well as most of the animals that appear on the Mshatta façade, can be connected with the Christian imagery preserved on the church floors, where the motifs are often interpreted in a Christian context as images of terrestrial life.[36] These images made a twofold journey, as they were first reused by Muslim patrons in a secular context and then moved from the floors of non-Muslim religious sites onto the walls of the new buildings. This new use surely changed their significance.

This was a deliberate choice made by the ruling "monarchic elites" of the Umayyad Empire, who carefully studied the arts of both the vanquished Sasanians and the still-powerful Byzantines, as well as the traditions of the regions now under their control. None of these could be copied directly, but a combination and reinterpretation not only would be acceptable but would be an expression of Muslim authority. Introduction of the new style was facilitated by the lack of truly imperial monuments in the greater Syrian region, as mentioned above, in spite of major pilgrim centers such as Rusafa and Qal'at Sem'an. This absence of great secular palaces—with the exception of the edifice in Damascus—may in fact have proved the impetus for the development of a new artistic language.

"Provincial Syria" provided the Umayyad caliph with the conditions necessary for creating a center for the new world empire established by the Arab conquests. Ancient Arab traditions and new Islamic principles were

Figure 14. Post-Sasanian bronze tray. Iran, 6th–7th century. Museum für Islamische Kunst, Pergamonmuseum, Staatliche Museen zu Berlin (inv. I 5624) (Photo: Petra Stuening/Art Resource, NY)

expressed by selectively using existing art forms, elevating them into a new unity, and bestowing upon them a new splendor. Oleg Grabar's influential opinion that early (and later) Islamic ornament was merely a playful exercise in combating horror vacui, "outlining the sensorial impact on and pleasure of the eye," cannot be correct.[37] There is nothing to be said *against* the pleasures of the eye with which the ruling elites graced their built environment, but is "pleasure of the eye" what the rulers of a new religion, a new political system, and a novel culture would wish to use to visually impress their new subjects—Christians, Jews, and Muslims?

When speaking of Mshatta and its unique position in Mediterranean art history, it is usually the splendor of the extensively carved sections now preserved in the Museum für Islamische Kunst that is meant—the complete western section to the left of the entrance portal and a portion of the section to the right. All the carvings remained uncompleted when the site was abandoned, probably at the death of the patron, perhaps al-Walid II, in 744. The rest of the eastern wing remained in situ and is now primarily known from old photographs and from the slabs seen in the Metropolitan Museum exhibition.[38]

The façade's ornamental programme is restricted primarily to highly stylized scrolling vines that cover the surface like a finely embroidered veil. No living creatures appear in the scrolls on the eastern side. Small winged palmettes and a pomegranate flower motif in the design have been recognized as royal emblems on Sasanian works. Similar motifs appear also on a large, probably post-Sasanian bronze tray in Berlin (fig. 14). The workmanship is nearly the same as that on the western side of the Mshatta façade; it is the subjects—except for a few motifs, such as the three small grape clusters on vine leaves—that vary significantly. Furthermore, the scrolls on the tray are more freely carved and less formally arranged.

Mshatta's decorative programme extends to both sides of the entrance façade and should be read from the outer peripheries toward the central portal, similar to how one would advance through the decoration on the parallel walls of the Achaemenid stair ramps toward the palace portals at Persepolis.[39] The ornamentation was surely meant to impress the Muslim and non-Muslim subjects of the caliph from both sides as they passed by, or approached, the entrance.

The dual appearance of nature on the façade, with one half inhabited by creatures and the other half nonfigurative, was a didactic choice drawn from representations in Christian religious buildings but leaving out the essential Christian messages of Christ and the saints. The unanimated motifs of the eastern side appear also in Islamic religious architecture. The ruling caliph perhaps wished to express more of his wordly power than allowed by the religious admonishment to avoid competition with the Creator.

In the Qur'an the king or ruler is somewhat negatively presented—the oppressive pharaoh, for example, and Nimrud, who challenged the authority of Allah. Four types of rulers are found in the holy revelation: the tyrant, the king installed by a prophet (Saul/Talut), the queen who converts to Islam by conviction (Balqis, queen of Sheba), and finally the prophet-kings (David and Solomon/Suleiman).[40] Of David it is written that he ruled both unanimated nature (e.g., the mountains) and animated nature (e.g., the birds; Sura 21:79; 38:18; 34:10). His son Suleiman also asked for supreme power: "My Lord," he said, ". . . give me a kingdom such as may not befall anyone after me; surely Thou art the All-giver" (Sura 38:34–37).[41]

David and Suleiman's rule over the animated and unanimated worlds would accord with the caliph's claim of supreme sovereignty. The "animated" animals and human head on the western side of the entrance together with the "unanimated" scrolls and Sasanian imperial motifs on the eastern side could be taken to represent these two spheres. It has been suggested that the decorative programme of the eastern half was designed without animated figural motifs

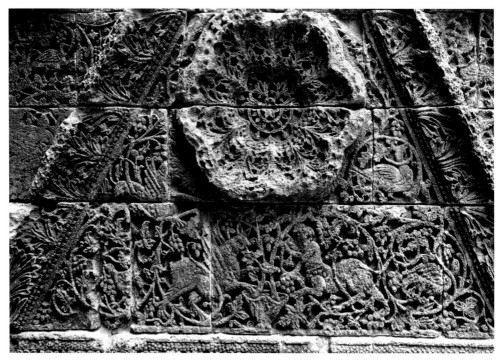

Figure 15. Detail of the Mshatta façade with Sagittarius (Courtesy Museum für Islamische Kunst, Berlin)

because it was located directly in front of the mosque. But it would not have been necessary to remove animated figures from the entire length of the wall. It should also be noted that the eastern side of a building is the more respected one, not only in the Islamic tradition.

While the entire programme includes neither scenery nor a narrative, it may be understood as a new representation of power. The animals correspond in part to scenes on the mosaic floors of sixth- to eighth-century churches in Syria and Palestine, which are usually interpreted as depictions of the terrestrial nature created and preserved by God. At Mshatta mythical animals are added. Among them is the centaur represented in a new attitude. Best known in the West as Sagittarius, the half-animal, half-human warrior-like Zodiac figure is usually represented bearing a bow and arrow. On the Mshatta façade he appears without his weapons, climbing through the vegetation

(fig. 15). The image perhaps conveys the peaceful world that prevails under the right and balanced guidance of Islam.

The cultural background of the Umayyad Caliphate, if better understood, would no doubt help us to interpret the decorative programme of Mshatta, but that is difficult to determine as most of the Arabic sources are from later periods. It is rather the material culture that can provide a clearer and perhaps more complex indication of the Umayyad caliphs' vision of their place in the world and how they wished to present their state. It was their responsibility to make the new Islamic imperial idea visible, intentionally contrasting it with the preceding Hellenistic, Roman, and Byzantine Empires; the Sasanian Empire and its predecessors; and the rising Abbasid dynasty.

It is possible to understand the role of the Mshatta façade as an intermediate step by studying the many stucco ornamentations of the mid-ninth-century caliphal

*Age of Transition: Byzantine Culture in the Islamic World*

Figure 16. Drawing of wall decoration with stylized vegetation, Jawsaq al-Khaqani. Samarra, mid-9th century (from Herzfeld 1921: 139, fig. 14)

palace of Jawsaq al-Khaqani in Samarra, with its famous quotation of the triangles and medallions of the Mshatta cornices (fig. 16). The small triangles are now outlined by thin bands and densely filled with large medallions that leave no space for limited scrolling designs. The view of nature is more abstract, less organic, a repetitive series of formalized leaves. The stylized shapes into which the natural world have been transformed has the strong, suggestive appeal of formal beauty, perhaps offering a very different lesson for the subjects visiting the new, more monumental residences.

From 2008 to 2013 a joint German-Jordanian project was undertaken for the preservation of the ruins remaining at Mshatta.[42] Fortuitously, a parallel project was begun at Khirbat al-Mafjar in 2010, a joint Palestinian-American mission under the direction of Donald Whitcomb and Hamdan Taha.[43] The rescue and reconstruction work at Mshatta is preserving the extensive stone and brick that survives there

from further deterioration, including that from the impact of the small industrial factories proliferating in the area. In its time Mshatta's astounding novelty was to assemble traditions from all over the new empire and to merge them in the creation of a new era in the arts of mankind. Today, the Arab world is much in need of such a message of cultural integration.

1. Guidetti 2009: 8–22.
2. Evans 2012: 209–11, no. 141.
3. The façade shown in the Pergamonmuseum since 1932 will soon be reinstalled in renovated form in a larger gallery of that museum. The project was initiated by Volkmar Enderlein and Michael Meinecke in 1992. For further history, see Weber and Troelenberg 2010: 120–26.
4. Creswell 1969; Creswell and Allan 1989: 201–8, 211–14. For the recent restorations and archaeological soundings, see Cramer and Perlich 2014; further publication of this research is forthcoming.
5. For stylistic analyses, see Trümpelmann 1962; Talgam 2004; and Katharina Meinecke in Cramer and Perlich n.d. (forthcoming).
6. Levtzion 1990: 289–311.
7. Compare the examples in Shboul and Walmsley 1998 and Walmsley 2007: 146–47; for Edessa (Ruha), see Guidetti 2009; for literary and material sources on Early Islamic churches and mosques, see Guidetti 2013.
8. Foss 2012: 136–43.
9. Flood 2001: esp. 1–14, 57–113 (on the vine scroll encircling the prayer hall of the Great Mosque), and 192–205 (on the Imperial Style).
10. For Arabic legends on Byzantine architecture and luxury ornamentation, see El Cheikh 2004: 54–59; for examples of major Christian churches cited in Arabic sources, see Guidetti 2009: 8–22; as for the later medieval Syriac sources on early Abbasid tolerance of church restoration, Mattia Guidetti relies too much on earlier hearsay; Lara Tohme (2009: 129–45) also exaggerates the smoothness of the transition from pre-Islamic to Islamic rule, but see p. 141.
11. al-Tabari, *Ta'rikh* 2: 1194; al-Muqaddasi 1906: 155; El Cheikh 2004: 57–58.
12. Schick 1995; Griffith 2008.
13. See G. Fowden 2004: esp. 248–315 on his theory of the "inculturation" of Antique and Late Antique ideas in Umayyad society; and G. Fowden and E. Fowden 2004: esp. 113–45, 149–74. The Italian restoration team currently working on the wall paintings at Qusayr 'Amra discovered an inscription in 2012 attributing the site to al-Walid II ibn Yazid between 723 and 743, before his brief reign as caliph; see www.wmf.org/project/qusayr-amra.
14. See Flood 2001: 223–43.
15. Scholl 2009: 257–60, 267–69.
16. See Hornbostel-Hüttner 1979: 157; cf. 115 for the niche structures on the walls of the Domus Augustana, and 123–25 for the reconstruction of the *aula regia*. Further study of this motif is needed, including its use in the Great Temple of Baalbek.
17. Hill 1914, nos. CV, CVI, pls. XXXII, XXXIII; this interpretation was recognized by Carl Wendel, who compared it with the depiction of the Ark in the Temple above the Torah niche in the wall paintings of the Dura-Europos synagogue in the National Museum, Damascus; see Wendel 1950: 14 and pls. II.5 and II.6; see also Fine 2005: 86.
18. See Flood 2001: 57–113 on the vine scroll in the Great Mosque of Damascus.
19. See Evans 2012: 251–52, figs. 101–3. Flood (2001: 238–39 and pl. 28) interprets as original the two series of small blind niches in the mihrab of the Great Mosque as they appear in the historic photograph taken before the 1893 fire; rather, they are of the Mamluk period; but see note 22 below.
20. For an image of the niche in the Amman Citadel, see Evans 2012: 203, fig. 82.
21. Creswell and Allan 1989: 24–25 with figs. 7 and 8.
22. Consular diptychs of the fifth and early sixth centuries displayed the dominant figure in arched and gabled niches with and without visible supporting columns; see Volbach 1976, nos. 1–6, 16–21, 36, 38, 43, 51, 52, and 54; others, such as nos. 8–11 and 15, show the niche as the loggia of the consul at the circus.
23. Evans 2012: 16–17.
24. See the realization of the eastern façade as the main entrance to the National Museum of Damascus, based on its reconstruction with ornamental fragments, in Schlumberger 1986, pls. 24, 34, 58, 63, 68, 69, and 76–81a, c; see also Genequand 2012: 166–69.
25. Serjeant 1959: 439–53; Fehérvári 1972: 249–50, with references to early Arab poetry.
26. This was briefly noted in Trümpelmann 1962; on framing with vines, see Flood 2001: 68–77.
27. Qalb Loze: Tchalenko 1953–58, vol. 3 (1958): 59, figs. 13–15; the church at Turmanin: ibid., pls. 168.4 and 168.6; the church at Me'ez: ibid., pl. 185.5.
28. Becker 1905–6: 419–28; cf. Becker 1910.
29. Herzfeld 1910: 105n2; see Leisten 2004: 374–75.
30. See Creswell 1969, part 2: 623–31, esp. tables on 633–34.
31. Grabar 1987: 245.
32. Talgam 2004: 12; Herzfeld 1910: 147; see also Leisten 2004: 375.
33. Holger Grönwald in Cramer and Perlich n.d. (forthcoming).
34. Leisten 2004: 375.
35. See note 4 above.
36. Ognibene 2002: 67–69.
37. Grabar 1992: 223.
38. See note 2 above.
39. Haase 2013.
40. Busse 1979: 59–64; cf. Neuwirth 2010: 620–23.
41. Translation from Arberry 1964: 273.
42. See note 4 above.
43. Whitcomb and Taha 2013.

**Adam, Robert**
**1764**   *Ruins of the Palace of the Emperor Diocletian at Spalatro in Dalmatia by R. Adam F.R.S F.S.A Architect to the King and to the Queen.* London: n.p.

**Arberry, Arthur J., trans.**
**1964**   *The Koran Interpreted.* London: Oxford University Press.

**Becker, Carl-Heinrich**
**1905–6**   Review of Strzygowski 1904. *Zeitschrift für Assyriologie und verwandte Gebiete* 19: 419–32.

**1910**   "Der Islam als Problem." *Der Islam* 1: 1–21.

**Busse, Heribert**
**1979**   "Herrschertypen im Koran." In *Die islamische Welt zwischen Mittelalter und Neuzeit: Festschrift für Hans-Robert Roemer zum 65. Geburtstag,* edited by Ulrich Haarmann and Peter Bachmann: 56–80. Beirut and Wiesbaden: Franz Steiner.

**Cramer, Johannes, and Barbara Perlich**
**2014**   "Reconsidering the Dating of Qasr al-Mshatta." *Beiträge zur islamischen Kunst und Archäologie* 4: 220–33.

**n.d.**   Scientific outcome of the Qasr al-Mushatta project (http://baugeschichte.a.tu-berlin.de/bg /forschung/projekte/islam/mushatta2.html), with contributions by Holger Grönwald, Katharina Meinecke et al. Forthcoming.

**Creswell, K. A. C.**
**1969**   *Early Muslim Architecture.* Vol. 1, *Umayyads* A.D. *622–750.* 2 parts. 2nd ed. Contribution by Marguerite Gautier-van Berchem. Oxford: Clarendon Press.

**Creswell, K. A. C., and J. W. Allan**
**1989**   *A Short Account of Early Muslim Architecture.* Revised and supplemented by J. W. Allan. Aldershot: Scolar.

**El Cheikh, Nadia Maria**
**2004**   *Byzantium Viewed by the Arabs.* Harvard Middle Eastern Monographs 36. Cambridge, Mass.: Harvard University Press.

**Enderlein, Volkmar, and Michael Meinecke**
**1992**   "Graben—Forschen—Präsentieren: Probleme der Darstellung vergangener Kulturen am Beispiel der Mschatta-Fassade." *Jahrbuch der Berliner Museen,* n.s., 34: 137–72.

**Evans, Helen C., ed.**
**2012**   *Byzantium and Islam: Age of Transition, 7th–9th Century.* Exh. cat. New York: The Metropolitan Museum of Art.

**Fehérvári, Géza**
**1972**   "Tombstone or Mihrab? A Speculation." In *Islamic Art in The Metropolitan Museum of Art,* edited by Richard Ettinghausen: 241–54. New York: The Metropolitan Museum of Art.

**Fine, Steven**
**2005**   *Art and Judaism in the Greco-Roman World: Toward a New Jewish Archaeology.* Cambridge: Cambridge University Press.

**Flood, Finbarr Barry**
**2001**   *The Great Mosque of Damascus: Studies on the Makings of an Umayyad Visual Culture.* Islamic History and Civilization 33. Leiden: Brill.

**Foss, Clive**
**2012**   "Arab-Byzantine Coins: Money as Cultural Continuity." In Evans 2012: 136–43.

**Fowden, Garth**
**2004**   *Qusayr 'Amra: Art and the Umayyad Elite in Late Antique Syria.* Berkeley: University of California Press.

**Fowden, Garth, and Elizabeth Key Fowden**
**2004**   *Studies on Hellenism, Christianity and the Umayyads.* Athens: Kentron Hellēnikēs kai Rōmaikēs Archaiotētos.

**Genequand, Denis**
**2012**   *Les Etablissements des élites omeyyades en Palmyrène et au Proche-Orient.* Bibliothèque Archéologique et Historique 200. Beirut: Institut Français du Proche-Orient.

**Grabar, Oleg**
**1987**   "The Date and Meaning of Mshatta." *Dumbarton Oaks Papers* 41: 243–47.

**1992**   *The Mediation of Ornament.* Bollingen Series 35, 38; A. W. Mellon Lectures in the Fine Arts 1989. Princeton, N.J.: Princeton University Press.

**Griffith, Sidney H.**
**2008**   *The Church in the Shadow of the Mosque. Christians and Muslims in the World of Islam.* Princeton, N.J.: Princeton University Press.

**Guidetti, Mattia**
**2009**   "The Byzantine Heritage in the Dar al-Islam: Churches and Mosques in al-Ruha between the Sixth and the Twelfth Century." *Muqarnas* 26: 1–36.

**2013**   "The Contiguity between Churches and Mosques in Early Islamic Bilad al-Sham." *Bulletin of the School of Oriental and African Studies* 76: 229–58.

**Haase, Claus-Peter**
**2013**   "Ancient Creatures and New Ornaments: Studying the Program of the *Mshatta* Façade in Berlin." In *Synergies in Visual Culture—Bildkulturen im Dialog: Festschrift für Gerhard Wolf,* edited by Manuela de Giorgi, Annette Hoffmann, and Nicola Suthor: 167–83. Paderborn and Munich: Wilhelm Fink Verlag.

**Herzfeld, Ernst**
**1910**   "Die Genesis der islamischen Kunst und das Mshatta-Problem." *Der Islam* 1: 27–63, 105–44.

**1921**   "Mshatta, Ḥīra und Bâdiya: Die Mittelländer des Islam und ihre Baukunst." *Jahrbuch der Preussischen Kunstsammlungen* 42: 104–46.

**Hill, George Francis**
**1914** *Catalogue of the Greek Coins of Palestine (Galilee, Samaria, and Judaea).* Catalogue of the Greek Coins in the British Museum 27. London: Trustees of the British Museum.

**Hornbostel-Hüttner, Gertraut**
**1979** *Studien zur römischen Nischenarchitektur.* Studies of the Dutch Archaeological and Historical Society 9. Leiden: Brill.

**Leisten, Thomas**
**2004** "Mshatta, Samarra, and al-Hira: Ernst Herzfeld's Theories Concerning the Development of the Hira-style Revisited." In *Ernst Herzfeld and the Development of Near Eastern Studies, 1900–1950*, edited by Ann C. Gunter and Stefan R. Hauser: 371–84. Leiden: Brill.

**Levtzion, Nehemia**
**1990** "Conversion to Islam in Syria and Palestine and the Survival of Christian Communities." In *Conversion and Continuity: Indigenous Christian Communities in Islamic Lands, Eighth to Eighteenth Centuries*, edited by Michael Gervers and Ramzi Jibran Bikhazi: 289–311. Toronto: Pontifical Institute of Mediaeval Studies.

**Meinecke, Katharina**
**2014** "The Encyclopaedic Illustration of a New Empire: Graeco-Roman-Byzantine and Sasanian Models on the Façade of Qasr al-Mshatta." In *Using Images in Late Antiquity*, edited by Stine Birk, Troels Myrup Kristensen, and Birte Poulsen: 283–300. Oxford: Oxbow Books.

**al-Muqaddasi, Muhammad ibn Ahmad**
**1906** *Kitab Ahsan al-taqasim fi ma'rifat al-aqalim.* Edited by M. J. de Goeje. Leiden: Brill.

**Neuwirth, Angelika**
**2010** *Der Koran als Text der Spätantike: Ein europäischer Zugang.* Berlin: Verlag der Weltreligionen.

**Northedge, Alastair**
**1992** *Studies on Roman and Islamic Amman: The Excavations of Mrs. C-M Bennett and Other Investigations.* Vol. 1, *History, Site and Architecture.* British Academy Monographs in Archaeology 3. Oxford: Oxford University Press for the British Institute in Amman for Archaeology and History.

**Ognibene, Susanna**
**2002** *Umm al-Rasas: La chiesa di Santo Stefano ed il "problema iconofobico."* Rome: L'Erma di Bretschneider.

**Schick, Robert**
**1995** *The Christian Communities of Palestine from Byzantine to Islamic Rule: A Historical and Archaeological Study.* Princeton, N.J.: Darwin Press.

**Schlumberger, Daniel**
**1986** *Qasr el-Heir el Gharbi.* Drawings by Marc Le Berre; contributions by Michel Ecochard and Nessib Saliby; edited by Odile Ecochard and Agnès Schlumberger. Institut Français d'Archéologie du Proche-Orient, Bibliothèque Archéologique et Historique 120. Paris: Librairie Orientaliste Paul Geuthner.

**Scholl, Andreas**
**2009** "Olympyou Enthoten Aulee: Zur Deutung des Pergamonaltars als Palast des Zeus." *Jahrbuch des Deutschen Archäologischen Instituts* 124: 251–78.

**Schulz, Bruno**
**1904** "Mschatta I: Bericht über die Aufnahme der Ruine." *Jahrbuch der Preussischen Kunstsammlungen* 25: 205–24.

**Serjeant, R. B.**
**1959** "Miḥrāb." *Bulletin of the School of Oriental and African Studies* 22: 439–53.

**Shboul, Ahmad, and Alan Walmsley**
**1998** "Identity and Self-Image in Syria and Palestine in the Transition from Byzantine to Early Islamic Rule: Arab Christians and Muslims." *Mediterranean Archaeology* 11: 255–87.

**Strzygowski, Josef**
**1904** "Mschatta II: Kunstwissenschaftliche Untersuchung." *Jahrbuch der Preussischen Kunstsammlungen* 25: 225–373.

**al-Tabari, Ibn Jarir**
**1879–1901** *Ta'rikh al-rusul wa'l-muluk* [Annals of the prophets and kings]. Edited by M. J. de Goeje et al. 10 vols. Leiden: Brill.

**Talgam, Rina**
**2004** *The Stylistic Origins of Umayyad Sculpture and Architectural Decoration.* Wiesbaden: Harrassowitz.

**Tchalenko, Georges**
**1953–58** *Villages antiques de la Syrie du Nord: Le Massif du Bélus à l'époque romaine.* 3 vols. Institut Français d'Archéologie de Beyrouth, Bibliothèque Archéologique et Historique 50. Paris: Librairie Orientaliste Paul Geuthner.

**Tohme, Lara**
**2009** "Spaces of Convergence: Christian Monasteries and Umayyad Architecture in Greater Syria." In *Negotiating Secular and Sacred in Medieval Art: Christian, Islamic, and Buddhist*, edited by Alicia Walker and Amanda Luyster: 129–45. Farnham, Surrey, and Burlington, Vt.: Ashgate.

**Trümpelmann, Leo**
**1962** *Mschatta: Ein Beitrag zur Bestimmung seines Kunstkreises, zur Datierung und zum Stil der Ornamentik.* Tübingen: M. Niemeyer.

**Volbach, Wolfgang Fritz**
1976  *Elfenbeinarbeiten der Spätantike und des frühen Mittelalters.* 3rd ed. Mainz: Philipp von Zabern.

**Walmsley, Alan**
2007  *Early Islamic Syria: An Archaeological Assessment.* London: Duckworth.

**Weber, Stefan, and Eva-Maria Troelenberg**
2010  "Mschatta im Museum: Zur Geschichte eines bedeutenden Monuments frühislamischer Kunst." *Jahrbuch Preussischer Kulturbesitz* 46: 104–32.

**Wendel, Carl**
1950  *Der Thoraschrein im Altertum.* Halle: Max Niemeyer.

**Whitcomb, Donald, and Hamdan Taha**
2013  "Khirbat al-Mafjar and Its Place in the Archaeological Heritage of Palestine." *Journal of Eastern Mediterranean Archaeology and Heritage Studies* 1, no. 1: 54–65.

*Robert Schick*

# The Destruction of Images in 8th-Century Palestine

In the eighth century C.E. images of living beings in mosaic floors in more than one hundred fifty churches in Palestine were deliberately obliterated. This strange case of image destruction has raised questions that remain to be answered satisfactorily. What damage was done? Where and when did it occur? Who carried it out? And, most important, why was it done? This paper seeks to address these questions, giving special consideration to the church at ‘Ayn al-Kanisah at the foot of Mount Nebo in Jordan and the last known church mosaic floors of the early Abbasid period in the mid-eighth century.

Examples of deliberate damage to figurative images were noticed from the beginnings of archaeological research in the region, most notably during the excavations at Gerasa (modern Jerash) beginning in 1928.[1] Scholars have tended to associate the damage with historical accounts of an edict issued in 721 by the Umayyad caliph Yazid II (r. 720–24) that all images in the caliphate were to be destroyed,[2] or with the Iconoclastic movement in the Byzantine Empire at the time.

Over the years continued excavations have uncovered many more mosaic floors with deliberate damage, typically one or more coming to light every year; Susanna Ognibene’s list, now outdated, includes one hundred fifty examples.[3] Among the most spectacular are those found during the excavations led by Michele Piccirillo at Umm

al-Rasas in central Jordan beginning in 1986.[4] The mosaic floor in the church at Ya‘mun in northern Jordan is also of special interest owing to its rare depictions of biblical figures, in this case Abraham, Isaac and Daniel, Hananiah, Mishael, and Azariah.[5]

The topic was a major chapter of my Ph.D. dissertation in 1987 about the Christian communities in Palestine, published in revised form in 1995.[6] Two decades have passed since that study, and a reexamination of the issue, including insights gained from discoveries since the early 1990s, is in order. Other scholars who have recently addressed the subject include Susanna Ognibene, Glen Bowersock, Basema Hamarneh and Karin Hinkkanen, Henry Maguire, and Juan Signes Codoñer.[7] Yet with all the attention the topic has received, the questions listed above have not yet been fully addressed. Even the most basic question—whether the damage was an internal Christian issue or was in some way motivated by Muslim opposition to images—remains unresolved. Rather than focusing in this essay on the historical sources, I shall turn my attention to the archaeological evidence.

## WHAT DAMAGE WAS DONE?

Images of living beings, human and animal, were common features of mosaic floors in the Byzantine period, both in religious settings—churches and synagogues—and in secular buildings. There are many cases where such images were not deliberately damaged, but in more than one hundred fifty churches they were. Each case has its own idiosyncrasies, but the damage typically entailed the removal of mosaic tesserae, often preserving the outline of the image, followed by careful patching by replacement with random cubes, as at Umm al-Rasas (fig. 1). Sometimes great care was taken to patch the damaged spots with geometric patterns or flowers; the church on the acropolis in Ma‘in, Jordan, is the most remarkable example, with an ox replaced by a pomegranate tree and an amphora with vine

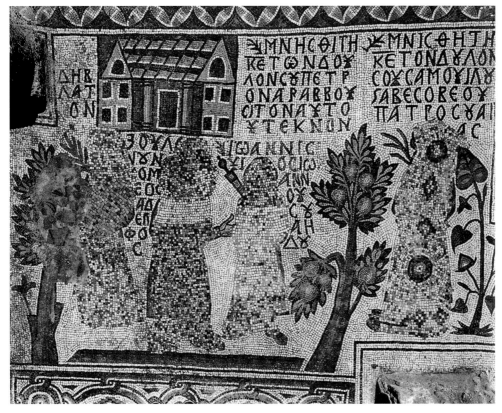

Figure 1. Damage and patching of images in the mosaic floor of the Church of Saint Stephen. Umm al-Rasas, Jordan, 718 (from Piccirillo 1992: 238, fig. 381)

scrolls, leaving the tail and hooves of the ox intact (fig. 2).

In some cases the damage was done less carefully, that is, the outline of the figure is not strictly followed but rather includes irregular chunks of the surrounding background as well. At times it is difficult to distinguish deliberate from accidental damage. In many cases only parts of figures were removed, leaving other parts intact, as, for example, in the churches at Khildah and al-Quwaysmah, where only the heads and feet of the birds were destroyed, leaving the bodies undamaged (figs. 3, 4).[8]

In many cases the tesserae in the patch appear to be the original, though now scrambled, cubes, while in other cases different cubes, typically larger and plain white, were laid in (fig. 5). The use of different tesserae could suggest that the damage and the

patches were separate operations. In a few cases mortar or pieces of marble or other stones, rather than tesserae, were used.

Deliberate damage was typically more or less thorough, although occasionally some but not all of the images were destroyed. Sometimes deliberately damaged images appear right next to images left intact. The chancel area of the Church of the Lions at Umm al-Rasas provides a good example (fig. 6). Such damage also extended to images on marble chancel screen panels in a number of churches,[9] and in the synagogue at Susiya, south of Hebron.[10] It is important to note that the deliberate damage to figurative images in Palestine was distinct from the damage that occurred in the Byzantine Empire during the Iconoclastic period (726–74; 813–42), when the focus was solely on icons—images of veneration.

Figure 2. Patching in the mosaic floor of the church on the acropolis. Ma'in, Jordan, 719–20 (from Piccirillo 1992: 198, fig. 302)

## WHERE DID THE DAMAGE OCCUR?

The more than one hundred fifty known cases of damage are concentrated in the relatively small geographical area of what are today Jordan and Israel/Palestine, with the highest concentration in north and central Jordan. With the exception of one outlier in northern Syria at Nabgha,[11] there are no known examples elsewhere in Syria or in Lebanon, Egypt, or North Africa—the

Figure 3. Peacock, partially damaged, in the church at Khildah, Jordan, 687 (Photo: Mohammad Najjar)

former Byzantine territories conquered by the Muslims in the seventh century—or in the remaining territories of the Byzantine Empire, where, during the Iconoclastic period, only icons were damaged. Had this episode been more widespread, there is an abundance of mosaics that one might have expected to be candidates for damage. One notable example from southern Syria is the mosaic pavement at Deir al-'Adas, with a dedicatory inscription dated to 722.[12] The mosaics in the Holy Monastery of Saint Catherine at Mount Sinai, along with the icons there, are another case of images that were not damaged.

It is difficult to account for why the damage occurred in such a narrow geographical area, at the time covering more or less the Byzantine provinces of Arabia and the three Palestines (Palaestina Prima, Secunda, and Tertia) and the Umayyad provinces (*jund*) of al-Urdun, Filastin, and Dimashq. But the

area does not follow the provincial boundaries exactly; there are no known cases of destruction in southern Syria, the northern part of the province of Arabia. Furthermore, if civil authorities were in some way involved, as with the edict of Yazid II, there is no compelling reason why the area should have been defined by the political boundaries of only a few provinces.

The three Palestines were part of the Patriarchate of Jerusalem, but the province of Arabia was part of the Patriarchate of Antioch. So one cannot claim that the damage occurred under the jurisdiction of only one ecclesiastical authority unless one wanted to speculate that it was specific to the Patriarchate of Jerusalem and that the occurrence of damage in the former province of Arabia indicates that ecclesiastical authority over that province was transferred from Antioch to Jerusalem after the Muslim conquests. There are only slight hints from lists of ecclesiastical sees that such a transfer may have occurred.[13]

## WHO DID THE DAMAGE?

The damage nearly always occurred to images in churches, indicating a Christian religious connection. There are no cases of damage in secular buildings, although there are mosaics that would have been candidates which have been found in secular buildings clearly still in use in the mid-eighth century. The case of the Burnt Palace in Madaba will be discussed below, and there is also an example of damage in the synagogue at Susiya.[14] Many Early Islamic mosaics are found in buildings—both secular

Figure 4. Birds with damaged heads and feet in the lower church at al-Quwaysmah, Jordan, 717–19 (from Piccirillo 1992: 267, fig. 485)

Figure 5. Patch set with larger plain white cubes in the Church of Saint George. Gerasa (Jerash), Jordan (Photo: Robert Schick)

*The Destruction of Images in 8th-Century Palestine*     135

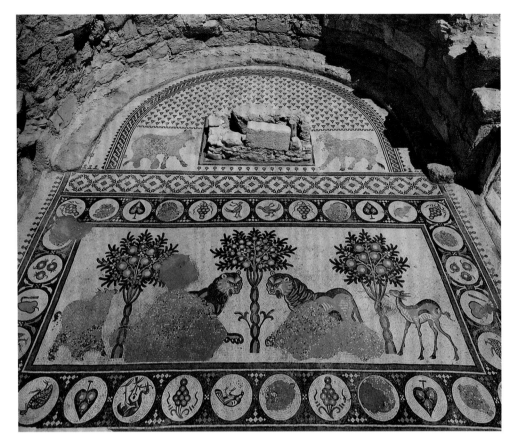

Figure 6. Random damage to the animal figures in the apse and chancel of the Church of the Lions. Umm al-Rasas, Jordan, late 6th century (from Piccirillo 1992: 211, fig. 338)

and religious—associated with Muslims, but most of these have geometric or vegetal motifs. Of the few mosaics that do have images of living creatures, as in the bath at Khirbat al-Mafjar in Jericho, those images were not destroyed.

The people who did the damage often showed great care in removing the mosaic cubes from the images and great care in their repair, an indication that the users of the buildings wanted to continue to have attractive mosaic floors. This would point to the Christians themselves, as they would have been the ones using the churches after the damage was done. Only Christians would have had the interest in undertaking such elaborate conversion of images in their churches as seen, for example, on the mosaic floor in the church on the acropolis at Ma'in. And only Christians would have inserted the cross in the patch of a medallion

at Masuh in Jordan (fig. 7). So it seems clear enough that it was Christians who did the damage—with the exception of Jews in the case of Susiya.

The denominational affiliation of the Christians (i.e., Chalcedonians or Miaphysites) cannot generally be determined from the physical remains of the church buildings, although the assumption is that most Christians in the area were Chalcedonians. However, two churches with damaged mosaic images can be associated with the Ghassanid/Jafnid tribal rulers, based on the dedicatory inscriptions in the floors: the Church of Saint Sergius at Nitl and the Church of Saint Sergius at Tall al-'Umayri East, both south of Amman.[15] The Ghassanid/Jafnid tribal rulers were known to be staunch supporters of the anti-Chalcedonian Miaphysites in the sixth century. One assumes that the Christians using the churches in

*Age of Transition: Byzantine Culture in the Islamic World*

the eighth century were still Miaphysites, although this cannot be conclusively proven from the archaeological remains. Thus it would seem that figurative images were deliberately damaged by both Chalcedonians and anti-Chalcedonians.

The alternative idea that Muslims did the damage when they took over churches for their own use is less plausible. Despite some references in historical sources,[16] there are very few cases of even possible Muslim take-over of churches for use as mosques, and the changes involved in those takeovers transcended damage to images in the mosaic floors. One such case is the Numerianus Church at Umm al-Jimal, where the entire mosaic floor was removed and replaced by a plaster floor in the Umayyad period (661–750), marking the end of the use of the building as a church and its possible conversion into a mosque;[17] the Julianos Church, also at Umm al-Jimal, looks like a second such case.[18] The best example of a church being used as a mosque is the Kathisma Church, on the road between Jerusalem and Bethlehem. Although the mosaic floor remained, it had only geometric and floral motifs.[19]

## WHEN DID THE DAMAGE OCCUR?

In a number of cases dedicatory inscriptions in the mosaic floors provide a terminus post quem for the damage. There is no case that clearly predates the Muslim conquests of the 630s, but many that must be later. For example, the dates in the dedicatory inscriptions of 686 in the Church of Saint Sergius at Rihab in northern Jordan,[20] of 687 in the church at Khildah in Amman,[21] and of 692 in the church of the Monastery of Aghios Lot at Deir 'Ain 'Abata in Jordan[22] date the damage to the Umayyad period or later.

The date of 717–18 in the lower church at al-Quwaysmah, the date of 718 in the nave of the Church of Saint Stephen at Umm al-Rasas,[23] and the date of 719–20 in the acropolis church at Ma'in all fall just prior to 721, when Yazid II issued his edict. The damage at these three churches could, of

Figure 7. Careful placement of a cross in a mosaic patch in the church at Masuh, Jordan (from Piccirillo 1992: 253, fig. 443)

course, also date to well after the reign of Yazid II; the lower church at al-Quwaysmah, for example, clearly remained in use well into the ninth century.[24]

The church at Tamra, in eastern Galilee, had a first-phase mosaic floor with birds that did not suffer any deliberate damage.[25] Above that mosaic a second-phase mosaic floor was laid with only geometric motifs. An inscription dates the second-phase floor to between May 19 and August 725, based on the Islamic Hijra dating system. It is tempting to think that the second-phase floor was laid in response to the edict of Yazid II, who died in January 724. That the use of the Hijra calendar indicates a shared use of the church building by Christians and Muslims, for which a mosaic floor without images was laid, is more speculative.

Another dedicatory inscription, at the church near Jabaliyah in Gaza, apparently dates to after 732, which would indicate that the damage took place after the time of Yazid II, although this remains uncertain because so little information about the church and the inscription is available.[26] The mosaic floor of the Church of Saint Constantine in Rihab incorporates two enigmatic Greek letters, perhaps suggesting repairs to the deliberately damaged images in 832, but this interpretation remains highly speculative.[27]

Beyond uncovering mosaic floors with dated dedicatory inscriptions, the results

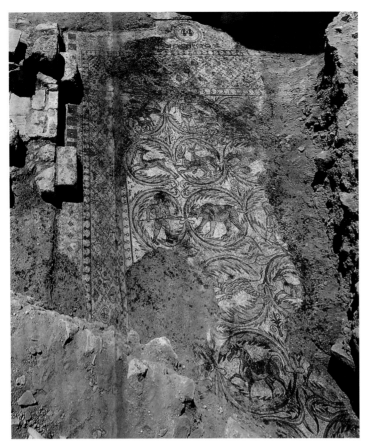

Figure 8. Floor mosaic with undamaged images in the Burnt Palace, destroyed in the mid-8th century. Madaba, Jordan (from Piccirillo 1992: 78–79, fig. 50)

What is of interest here is the fact that none of the images in the Burnt Palace were deliberately destroyed (fig. 8) while all the images in the nearby Church of the Martyrs were destroyed (fig. 9), as were those in a number of other churches in the city. One could speculate that the Burnt Palace mosaics were left intact because the episode of damage took place after the 749 earthquake. But other explanations are possible—for example, that they were undisturbed because they were in a secular building rather than a church.

In any event, it still seems to hold true that virtually every mosaic pavement in a church in the area known to have been visible around the mid-eighth century had its figurative images deliberately destroyed. It would also seem that any pavement with images not damaged must no longer have been visible at the time of the damage, with very few exceptions. It is my impression that all such cases occurred throughout the region simultaneously rather than being implemented haphazardly over a period of decades. This claim, however, is an impression, and not a demonstrable fact.

## The Church at ʿAyn al-Kanisah

The mosaic floor in the monastery church of ʿAyn al-Kanisah warrants detailed examination because of its crucial importance for determining the date and nature of the damage and repairs.[29] The church was excavated in 1994.[30] It has a pavement whose images were deliberately damaged and repaired,[31] and an inscription of 762 that dates the rebuilding of the church.[32]

The monastery was built in the mid-sixth century, with a mosaic floor depicting two sheep in the chancel area and a floor in the nave with horizontal rows of vine scrolls in five columns and images of animals. At some point, presumably after the 717–20 dates at al-Quwaysmah, Umm al-Rasas, and Maʿin, the images were deliberately damaged and carefully patched with the original cubes, now scrambled.

of the archaeological excavations at these churches rarely contribute to determining a close date for the damage. A vague eighth-century date for many cases is based on the types of pottery found in the layers above the floors. One exception may be the Burnt Palace in Madaba, a large building, plausibly the residence of the local bishop, with figurative mosaic floors in both the east and the west wings. The palace was destroyed by a massive fire, which buried the floors under thick debris; pottery recovered from excavations in 1985 and 1992–93 point to a date in the mid-eighth century. The earthquake that erupted in January 749 was most likely the cause of the fire, but this cannot be confirmed.[28]

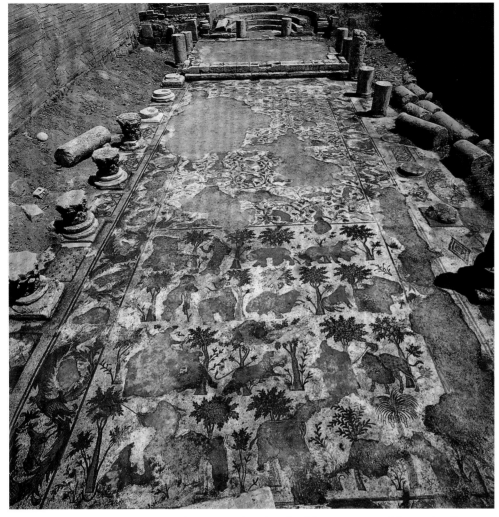

Figure 9. Floor mosaic with damaged images in the Church of the Martyrs. Madaba, Jordan (from Piccirillo 1992: 129, fig. 142)

A fire that later occurred left burn marks on the mosaic floor; the date cannot be precisely determined, but that of the 749 earthquake is plausible. In 762 the church was rebuilt and the floor skillfully redone, the western end relaid with geometric designs apparently replacing two rows of vine scrolls from the sixth-century mosaic. The 762 dedicatory inscription was placed in this new western end. Other parts of the mosaic were relaid in an effort to restore a few of the images to their original state, including, most notably, the phoenix in the middle of the second row and two birds toward the west end. The 762 repairs incorporated slightly smaller white cubes and are thus clearly distinguishable from the earlier patching that had reused the original cubes.

Such restoration of images is not paralleled in any other example of deliberate damage, with the exception of the crude fish set into a patch in the 718 mosaic in the nave of the Church of Saint Stephen at Umm al-Rasas (fig. 10).

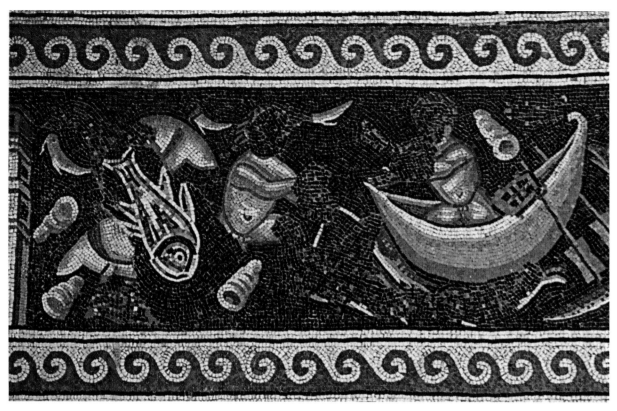

Figure 10. Patch with fish in the Church of Saint Stephen. Umm al-Rasas, Jordan, 718 (from Piccirillo 1992: 239, fig. 385)

### THE LAST CHURCH MOSAICS

Around the time that the church at 'Ayn al-Kanisah was rebuilt, in 762, other mosaic floors with purely geometric or vegetal motifs were being installed, such as that in the Church of Saint Stephen at Umm al-Rasas in 756,[33] in the church at Ramot near Jerusalem in 762,[34] in the Church of the Virgin in Madaba in 767,[35] and in the church at Khirbet el-Shubeika in western Galilee in 785–86 or 801–2.[36] None of these later church mosaics had figurative images, indicating a shift in artistic motifs.

These later pavements from the early Abbasid period also reveal another shift that occurred in the first years after the Abbasid takeover. Until the time of the 756 mosaic at Umm al-Rasas, dedicatory inscriptions were dated using the local provincial eras from the Roman and Byzantine periods,

such as the era of the province of Arabia, which began in 106, when the emperor Trajan annexed the Nabataean kingdom. Inscriptions were also dated according to the fifteen-year indiction taxation cycle that was established as early as the time of Diocletian (r. 284–305). Such dating of Christian inscriptions by local Roman eras and indiction cycles continued throughout the Umayyad period, despite the fact that, following the Muslim conquests of the 630s, the territory was no longer part of the Byzantine state and the Hijra dating system had been adopted for Islamic inscriptions.

This practice, however, changed abruptly shortly after the Abbasid takeover, when Christians dropped that open statement of residual loyalty to the Byzantine state in their inscriptions and adopted a neutral dating system based on their understanding of the date of the Creation.[37] The shift in

*Age of Transition: Byzantine Culture in the Islamic World*

dating looks like an act of prudence on the part of Christians given the conditions they faced under the Abbasid rulers. One might speculate that there was a link between the shift away from using Byzantine dating systems and the episode of deliberate damage, both being a Christian response to Muslim pressure. But any such link is unconfirmed.

## Why Did the Deliberate Damage Occur?

Explanations are divided as to whether the motivation behind the deliberate damage was an accommodation to external Muslim sensibilities or policies, notably the edict of Yazid II, or was initiated by internal Christian issues perhaps tied to the Iconoclastic Controversy. Henry Maguire places the phenomenon in the context of internal Christian views of images and icons.[38] He argues that the damage was focused especially on the removal of personifications of nature, such as the seasons and the four rivers of paradise, in order to clearly distinguish between acceptable icons worthy of veneration and other images of nature that could be regarded as promoting the worship of nature rather than the worship of the Creator. He views the damage as part of a wider phenomenon within Byzantine art tied into the Iconoclastic Controversy, in the aftermath of which images of nature were never again as exuberantly rendered.

Maguire's argument, however, I find problematic. The last mosaic floors laid in Palestine in the second half of the eighth century all avoided figurative images, which indeed demonstrates a shift in artistic style. But the case of the mosaic at 'Ayn al-Kanisah, where images were restored in 762, points to the episode of deliberate damage being a passing one, after which at least some Christians were still happy to have images. To my mind, the idea of the episode being a Christian response to Muslim pressure, such as the edict of Yazid II, remains more likely, although neither explanation leaves me fully convinced.

## Summary

Images of living beings, both humans and animals of all kinds, were damaged in the mosaic floors of churches, often by the careful removal of the mosaic tesserae followed by careful patching. This deliberate damage was often not complete. It occurred in the limited geographical area of modern Jordan and Israel/Palestine, with only one known exception in northern Syria. Christians did the damage and patching themselves, reflecting the interest they had in continuing to use the mosaic floors. Both Chalcedonians and Miaphysites appear to have damaged their images, as did Jews in at least one instance. The damage seems to have occurred no earlier than the early 720s and no later than 762.

But the question of motivation remains unresolved. A strong possibility for the cause of the damage is the implementation between the years 720 and 724 of the edict of Yazid II. This would make the phenomenon a response to external Muslim governmental policy rather than an internal Christian issue.

In the absence of a clear historical text that identifies the motivation for this episode in Palestine, our understanding is based on an examination of the physical evidence, with which one can answer, with a greater or lesser degree of confidence, four of the questions raised in the beginning of this essay. But the fifth question, why the damage was done, will most likely remain a conundrum unless some unexpected findings provide better evidence.

1. Kraeling 1938.
2. Vasiliev 1956.
3. Ognibene 2002: 467–85.
4. Piccirillo 1992; Piccirillo and Alliata 1994; Piccirillo and Alliata 1998.
5. El-Najjar 2011.
6. Schick 1995, chap. 9: 180–219.
7. Ognibene 2002; Bowersock 2006; Hamarneh and Hinkkanen 2008; Maguire 2012; Signes Codoñer 2013.
8. Najjar and Sa'id 1994.
9. Schick 1995: 201.
10. A reconstruction of the Susiya synagogue is installed in the Israel Museum, Jerusalem. The damaged chancel screens are illustrated in Foerster 1986: 1811, figs. 4, 5.
11. Sabbagh et al. 2008.
12. Donceel-Voûte 1998: 45–54.
13. Gelzer 1892.
14. Werlin 2012.
15. Piccirillo 2001; Piccirillo 2002: 209, 214–17; al-Shāmī 2010; Bevan and Fisher 2014.
16. Bashear 1991.
17. Schick 1995: 470–71.
18. Corbett and Reynolds 1957; Schick 1995: 471–72.
19. Avner 2003; Avner 2006–7.
20. Piccirillo 1992: 253.
21. Najjar and Sa'id 1994.
22. Politis 2012: 176–77.
23. Schick 1995: 472–73, pls. 12, 13.
24. Schick and Suleiman 1991.
25. Di Segni and Tepper 2004.
26. Humbert 1999.
27. Di Segni 2006: 578–79; Di Segni 2006–7: 119.
28. Schick n.d. (forthcoming).
29. Ognibene 1998; Maguire 2012: 43–44.
30. Piccirillo 1995.
31. Piccirillo and Alliata 1998: 359–64; Ognibene 1998.
32. Di Segni 1998: 449–50.
33. Piccirillo and Alliata 1994: 136–38, figs. 24–28.
34. Arav, Di Segni, and Kloner 1990.
35. Di Segni 1992.
36. Tzaferis 2003.
37. Di Segni 2006–7.
38. Maguire 2012: 11–47.

## References

**Arav, Rami, Leah Di Segni, and Amos Kloner**
**1990** "An Eighth-Century Monastery near Jerusalem." *Liber Annuus* 40: 313–20.

**Avner, Rina**
**2003** "The Recovery of the Kathisma Church and Its Influence on Octagonal Buildings." In Bottini, Di Segni, and Chrupcala 2003: 173–86.

**2006–7** "The Kathisma: A Christian and Muslim Pilgrimage Site." *ARAM Periodical* 18–19: 541–57.

**Bashear, Suliman**
**1991** "Qibla Musharriqa and Early Muslim Prayer in Churches." *Muslim World* 81, nos. 3–4 (October): 267–82.

**Bevan, George, and Greg Fisher**
**2014** "The Church of St. Sergius at Tell al-'Umayri: New Evidence for the Jafnid Family and Arab Christianity in Northern Jordan." *Bulletin of the American Schools of Oriental Research* 372 (November): 157–77.

**Bottini, Claudio G., Leah Di Segni, and L. Daniel Chrupcala, eds.**
**2003** *One Land, Many Cultures: Archaeological Studies in Honour of Stanislao Loffreda OFM.* Collectio Maior; Studium Viblicum Franciscanum 41. Jerusalem: Franciscan Printing Press.

**Bowersock, Glen Warren**
**2006** *Mosaics as History: The Near East from Late Antiquity to Islam.* Revealing Antiquity 16. Cambridge, Mass.: Belknap Press of Harvard University Press.

**Corbett, G. U. S., and J. M. Reynolds**
**1957** "Investigations at 'Julianos' Church' at Umm-el-Jimal." *Papers of the British School at Rome* 25: 39–66.

**Di Segni, Leah**
**1992** "The Date of the Church of the Virgin in Madaba." *Liber Annuus* 42: 251–57.

**1998** "The Greek Inscriptions." In Piccirillo and Alliata 1998: 425–67.

**2006** "Varia Arabica: Greek Inscriptions from Jordan." In "Ricerca Storico-Archeologica in Giordania—XXVI—2006," edited by Michele Piccirillo, *Liber Annuus* 56: 578–92.

**2006–7** "The Use of Chronological Systems in Sixth–Eighth Centuries Palestine." *Aram* 18–19: 113–26.

**Di Segni, Leah, and Yotam Tepper**
**2004** "A Greek Inscription Dated by the Era of Hegira in an Umayyad Church at Tamra in Eastern Galilee." *Liber Annuus* 54: 343–50.

**Donceel-Voûte, Pauline**
**1998** *Les Pavements des églises byzantines de Syrie et du Liban: Décor, archéologie et liturgie.* 2 vols. Publications d'histoire de l'art et d'archéologie de l'Université Catholique de Louvain 69. Louvain-la-Neuve: Université Catholique de Louvain.

**El-Najjar, Mahmoud Y., ed.**
**2011** *Ya'mun: An Archaeological Site in Northern Jordan.* Irbid, Jordan: Faculty of Archaeology and Anthropology, Yarmouk University.

**Foerster, Gideon**
**1986** "Decorated Marble Chancel Screens in Sixth Century Synagogues in Palestine and Their Relation to Christian Art and Architecture." In *Actes du XIᵉ Congrès international d'Archéologie chrétienne: Lyon, Vienne,*

*Grenoble, Genève et Aoste, 21–28 septembre 1986*, edited by Noël Duval: 1809–20. Rome: Pontificio Istituto di Archeologia Cristiana; Ecole Française de Rome.

**Gelzer, Heinrich**
**1892**   "Ungedruckte und wenig bekannte Bistümerverzeichnisse der orientalischen Kirchen." *Byzantinische Zeitschrift* 1: 245–82.

**Hamarneh, Basema, and Karin Hinkkanen**
**2008**   "The Mosaic." In *Petra—The Mountain of Aaron: The Finnish Archaeological Project in Jordan*. Vol. 1, *The Church and the Chapel*, edited by Zbigniew T. Fiema and Jaakko Frösén: 244–62. Helsinki: Societas Scientiarum Fennica.

**Humbert, Jean-Baptiste**
**1999**   "The Rivers of Paradise in the Byzantine Church near Jabaliyah—Gaza." In *The Madaba Map Centenary 1897–1997: Travelling through the Byzantine Umayyad Period; Proceedings of the International Conference Held in Amman, 7–9 April 1997*, edited by Michele Piccirillo and Eugenio Alliata: 216–18. Jerusalem: Studium Biblicum Franciscanum.

**Kraeling, Carl Hermann**
**1938**   *Gerasa, City of the Decapolis: An Account Embodying the Record of a Joint Excavation Conducted by Yale University and the British School of Archaeology in Jerusalem (1928–1930), and Yale University and the American Schools of Oriental Research (1930–1931, 1933–1934)*. New Haven, Conn.: American Schools of Oriental Research.

**Maguire, Henry**
**2012**   *Nectar and Illusion: Nature in Byzantine Art and Literature*. Onassis Series in Hellenic Culture. Oxford: Oxford University Press.

**Najjar, Mohammad, and Fatema Sa'id**
**1994**   "New Umayyad Church at Khilda/Amman." *Liber Annuus* 44: 547–60.

**Ognibene, Susanna**
**1998**   "The Iconophobic Dossier." In Piccirillo and Alliata 1998: 372–89.

**2002**   *Umm al-Rasas: La Chiesa di Santo Stefano ed il "Problema Iconofobico."* Studia Archaeologica 114. Rome: L'Erma di Bretschneider.

**Piccirillo, Michele**
**1992**   *The Mosaics of Jordan*. Edited by Patricia M. Bikai and Thomas A. Dailey. American Center of Oriental Research 1. Amman, Jordan: American Center of Oriental Research.

**1995**   "La Chapelle de la Theotokos dans le Wadi 'Ayn al-Kanisah au Mont Nébo en Jordanie." *Annual of the Department of Antiquities of Jordan* 39: 409–20.

**2001**   "The Church of Saint Sergius at Nitl: A Centre of the Christian Arabs in the Steppe at the Gates of Madaba." *Liber Annuus* 51: 267–84.

**2002**   *L'Arabie chrétienne: Archéologie et histoire*. Paris: Mengès.

**Piccirillo, Michele, and Eugenio Alliata, eds.**
**1994**   *Umm al-Rasas: Mayfa'ah*. Vol. 1, *Gli scavi del Complesso di Santo Stefano*. Collectio Maior 28. Jerusalem: Studium Biblicum Franciscanum.

**1998**   *Mount Nebo: New Archaeological Excavations 1967–1997*. 2 vols. Collectio Maior 27. Jerusalem: Studium Biblicum Franciscanum.

**Politis, Konstantinos D.**
**2012**   *Sanctuary of Lot at Deir 'Ain 'Abata in Jordan: Excavations 1988–2003*. Contributions by Mark Beech et al. American Center of Oriental Research Publication 7. Amman: Jordan Distribution Agency.

**Sabbagh, Rana, et al.**
**2008**   *Le Martyrion Saint-Jean dans la moyenne vallée de l'Euphrate: Fouilles de la Direction Générale des Antiquités à Nabgha au nord-est de Jarablus*. Documents d'archéologie syrienne 13. Damascus: Ministère de la Culture, Direction Générale des Antiquités et des Musées.

**Schick, Robert**
**1995**   *The Christian Communities of Palestine from Byzantine to Islamic Rule: A Historical and Archaeological Study*. Studies in Late Antiquity and Early Islam 2. Princeton, N.J.: Darwin Press.

**n.d.**   *The Excavations in the Madaba Archaeological Park 1992–1993*. Amman: American Center of Oriental Research. Forthcoming, work in progress.

**Schick, Robert, and Emsaytif Suleiman**
**1991**   "Preliminary Report of the Excavations of the Lower Church at el-Quweisma, 1989." *Annual of the Department of Antiquities of Jordan* 35: 325–40.

**al-Shāmī, Ahmad Jum'a**
**2010**   "Mashrū' al-Tanqībāt al-Atharīyah fī Tall al-'Umayrī al-Sharqī al-Mawsim al-Awwal 2009" [Archaeological excavations at Tall al-'Umayri, 2009 season]. *Annual of the Department of Antiquities of Jordan* 54: 35–42 (Arabic section).

**Signes Codoñer, Juan**
**2013**   "Melkites and Icon Worship during the Iconoclastic Period." *Dumbarton Oaks Papers* 67: 135–87.

**Tzaferis, Vassilios**
**2003**   "The Greek Inscriptions from the Church at Khirbet el-Shubeika." In Bottini, Di Segni, and Chrupcala 2003: 83–86.

**Vasiliev, Alexander A.**
**1956**   "The Iconoclastic Edict of the Caliph Yazid II, A.D. 721." *Dumbarton Oaks Papers* 9–10: 25–47.

**Werlin, Steven H.**
**2012**   "The Late Ancient Synagogues of Southern Palestine." Ph.D. diss., University of North Carolina, Chapel Hill.

*Alan Gampel*

# The Origins of Musical Notation in the Abrahamic Religious Traditions

Music in Late Antiquity was omnipresent in the three Abrahamic religions in the form of cantillation of sacred texts. In this paper I shall briefly contextualize this "music," discuss the early notation for cantillating Christian scripture, and suggest a path for the early development of modern musical notation. Systems of notation specific to Jewish and Christian cantillation appeared in the ninth and early tenth centuries, and systems of musical notation for singing Greek and Latin Christian hymns appeared during the same period. A controversial theory of the "ultimate origins" of these notational systems and of modern musical notation will be supported by papyri and ostraka found in Egypt.[1]

### "MUSIC" IN THE THREE ABRAHAMIC RELIGIONS

Cantillation is a form of semi-improvised chant that lies somewhere between regular speech and singing.[2] The cantillated texts of the three Abrahamic religions, Jewish and Christian scripture and the Qur'an, are considered to be of divine origin. The words are sacred and their correct pronunciation is therefore essential, as is the understanding and proper delivery of their syntax. The practice of cantillation has historically served to

guide and remind the reader of this accurate pronunciation and of the hierarchy of word importance within sentences. Clerical leaders have generally viewed the musical element of cantillation to be ancillary to the grammatical and syntactical contributions that help to accurately transmit the word of God. This insistence on the primacy of the text and on a clear understanding of each word led to the imposition of restrictive musical guidelines, which in turn resulted in limited melodic freedom in the traditional cantillation of all three religions.

In Jewish worship instrumental music and songs to accompany ritual sacrifices were abandoned when the Second Temple was destroyed in 70 C.E. As an expression of grief, the former musical celebrations were banned and large-scale Temple rites were replaced by prayer at local synagogues.[3] The tradition of cantillating biblical texts was, however, later revived when endorsed by the Talmud in the fourth and fifth centuries: "If one reads the Scripture without a melody, of him the Scripture says 'I gave laws that were not good.'"[4] The development of a system of notation to guide melodic cantillation is believed to have begun as early as the fifth century,[5] with signs called *te'amim*.[6] The earliest biblical manuscripts that include *te'amim*, the Cairo Codex of the Prophets[7] and the Aleppo Codex,[8] are dated to the ninth and tenth centuries.[9] It is likely that these signs served initially as aides-mémoire for the recall and transmission of musical information for those who were already familiar with the biblical modes and with their melodic formulas.[10]

Although the written signs have not changed over time, the musical motives that they represented have evolved and adapted to local musical cultures throughout the diaspora. Sixteenth- and seventeenth-century transcriptions of *te'amim* into modern musical notation illustrate the different musical motives that they represented in different communities.[11] Notwithstanding these variations, the information that *te'amim* provided about syntax and word

importance have remained intact. No evidence of the early development of *te'amim* has yet been discovered, and whether they represented specific motives during their formative stage remains to be determined.

It has often been suggested that the cantillation of Jewish scripture was very similar to the chant of Christian scripture in the Christian rites of Late Antiquity.[12] There were deep-seated ties between Jewish and Christian worship and a close relationship between the two communities in apostolic and postapostolic times through to the fifth century.[13] The two religions often shared places of worship, and Jewish cantors were hired by Christian communities to teach the "correct" manner of cantillating Jewish scripture.[14] The development of a system of ekphonetic accents to notate the cantillation of Christian scripture in Greek began to evolve as early as the fourth century.[15] A fully developed ekphonetic system is found in manuscripts from the tenth to the twelfth century.[16] A form of shorthand, it has yet to be completely deciphered and does not represent specific notes for each syllable. Nevertheless, it represents certain aspects of the musical setting of the sacred text, similar in function to the Hebrew *te'amim* but without the same syntactical and hierarchical functions.

Although scriptural cantillation was welcomed in Christian clerical and monastic circles, there was a concern that music might bring more pleasure than the words it conveyed.[17] Many church fathers were influenced by their classical Greek education, which admonished that one might become the wrong kind of person if one listened to the wrong kind of music.[18] However, the ancient philosophers were also outspoken about the importance and necessity of music in "noble" contexts, such as prayer and lyric poetry: "What a poor appearance the tales of poets make when stripped of the colors which music puts upon them, and recited in simple prose."[19] Notwithstanding the opposition by some church fathers, the practice of composing and singing hymns was widespread in early Christianity.

In the Islamic tradition Muhammad and later Muslim leaders instructed that the cantillation of the Qur'an, called *qira'a* (reading) or *tajwid* (to improve), be different from the songs of professional musicians. Although music is not banned by the Qur'an, there is strong disapproval of music because it is thought to have seductive powers that lead one away from religion to "a waste of lifetime in pastime and amusement."[20] Some *hadiths* are aggressive in this respect: "Music and singing cause hypocrisy to grow in the heart as water makes corn grow."[21] Many Muslims consider the cantillation of the Qur'an to be "nonmusic" and thereby circumvent the controversy over music's morally corrupting influence. Nevertheless, it is generally accepted that the correct performance of *qira'a* involves musical "characteristics."[22]

The most obvious influence on the development of Qur'anic cantillation was the tradition of ritual chanting and poetry common in Arab communities during the *jahiliyya*, or pre-Islamic period.[23] The influence of Jewish and Christian cantillation can be deduced from the *hadith* commanding Muslims to "recite the Qur'an in the tunes and songs of the Arabs, and beware the tunes of the People of the Two Books."[24] At the dawn of Islam a large number of Jewish communities—which included converts, and descendants of migrants and refugees—existed throughout Arabia. Some scholars argue that Judaism was one of the principal sources of inspiration for the Qur'an, with respect to both its content and its form.[25] The sound of the cantillation of Jewish scripture was not unusual in important Arab centers such as Medina.[26]

The Christian biblical tradition may have been equally influential on Muslims during the first century of the Islamic Caliphate, before the eastward move from Damascus to Baghdad.[27] A strong Christian presence was felt in many of the formerly Byzantine towns and urban centers. However, while written notation developed for the preservation and transmission of cantillation within the Jewish and Christian faiths, the "musical

notation of the Qur'an [was] regarded with suspicion and discouraged by religious authorities because of the fear that it . . . would establish a single human and created form of the recited Qur'an as a model for all future recitation."[28] As a result, the Islamic obligation to "chant the Qur'an like a chant" is a tradition that has survived orally through both training by repetition and vigilance against innovation on the part of religious leaders.[29] Scholars claim that this system of musical transmission has resulted in little or no change to the cantillation technique over time.[30]

## GREEK ACCENTS AND CHRISTIAN NOTATION

In the majority of Late Antique Mediterranean languages, among them Coptic and Syriac, words were given "stress" accents, whereby a syllable was accentuated by increasing its loudness.[31] By contrast, classical Greek had a polytonic system of "pitch" accents, in which emphasis was made by variation in tone; thus, on a single syllable the voice would rise, descend, or both rise and descend. Aristoxenos (fl. 335 B.C.E.), a pupil of Aristotle, explained that this form of accentuation created a natural melody in the spoken language.[32] Three centuries later Dionysios of Halicarnassus (fl. 20 B.C.E.) wrote that "the distinction between oratory and music is simply one of degree," and he described the three pitch accents:

> The melody of spoken language is measured by a single interval, which is approximately that termed a *fifth*. When the voice rises towards the acute, it does not rise more than three tones and a semitone; and, when it falls towards the grave, it does not fall more than this interval. Further, the entire utterance during one word is not delivered at the same pitch of the voice throughout, but one part of it at the acute pitch, another at the grave, another at both. Of the words that

have both pitches, some have the grave fused with the acute on one and the same syllable—those which we call circumflexed.[33]

This passage clearly describes the melodic pitch change conventions inherent in classical Greek, and the placement and musical direction of pitch accents on nearly every spoken word were a matter of course for native Greek speakers.[34] However, in the Eastern Mediterranean from the Alexandrian period through Late Antiquity, Koine Greek was the lingua franca, and for most inhabitants of the Hellenized world Greek was not the mother tongue and they were not accustomed to pronouncing pitch accents. In addition, the decline in the oral tradition of reciting epic poetry in Greek exacerbated the lack of familiarity with correct pronunciation,[35] and polytonic sounds were heard less frequently from one generation to the next.

In the second century B.C.E. in Alexandria grammarians developed a system of written signs in four areas—τόνοι (tones), χρόνοι (time units), πνεύματα (breathings), and πάθη (declamatory signs)—in an attempt to reverse this trend and to preserve the correct pronunciation of classical Greek.[36] In the area of "tones," three signs were used to represent the pitch accents of the polytonic system: acute (´), grave (`), and circumflex (˜).[37] These served as aides-mémoire for placing the syllabic accents and for indicating the pitch variation. There is no papyrological evidence of the use of accents in documentary texts or letters, which confirms the premise that this system of pitch accents was primarily intended for texts that were recited or declaimed, such as poetry and orations. One example of the early use of the Greek pitch accent can be found on a papyrus from the second century C.E. that transmits a poetic text from the fifth century B.C.E.[38] On this papyrus, and on others from the same period, not all words carry accents.[39] Rather, there is generally one accent per phrase, which may have served

Figure 1a, b. Fragments from a lectionary (P. Mon. Epiph. 583), from the Monastery of Epiphanios, ca. 580– 640. Papyrus with ink inscription. The Metropolitan Museum of Art, Rogers Fund, 1914 (14.1.527)

either as a reminder that the musical aspect of pitch accents was vital to a correct pronunciation of the text or as a clarification of a homophonic or homographic ambiguity.

Evidence for the use of pitch accents in a pedagogical context is found beginning in the third and fourth centuries, when accents appear systematically on nearly every word. These enabled students who were not native Greek speakers to learn correct syllabic placement and pitch inflection. An early example of this systematic usage is found on a wooden tablet on which are inscribed verses of the *Iliad* and a glossary with explanations of some of the words.[40] The text appears to have been written by a student, with corrections— including many to the accents—made by a teacher. Another example is a fourth-century inscription discovered in the excavation of the ancient city of Trimithis, in the Dakhleh Oasis in Egypt, where, on eight epigrams written on a classroom wall, probably by a teacher, nearly every word is accented.[41]

Christian scripture was written in Greek and thus had inherent musical characteristics by virtue of the polytonic accentuation of the language. Those Christian monks and members of the clergy who had received a classical education were familiar with the

function of the Alexandrian pitch accents as indications for musical expression. The influence of the cantillation of Jewish scripture may have inspired an accurate, and perhaps exaggerated, polytonic accentuation for the cantillation of Christian scripture. The natural melodic movement of the Greek text provided a basis for cantillation, and over time signs added to the pitch accents created an increasingly detailed system of ekphonetic notation.

This development is illustrated in a publication of New Testament papyri at the Österreichische Nationalbibliothek, Vienna, in which the editors trace the evolution of ekphonetic accents in twenty-three papyri from the fourth to the tenth century.[42] A marked increase is observed in the use of the pitch accent, and "as the more specific symbols of ekphonetic notation are added, phrases of the text are delineated in smaller . . . units."[43] All the pitch accents on these papyri accurately reflect polytonic practice. In other words, the correct accents—acute, grave, or circumflex—were placed on the correct syllables.

Another example of the use of pitch accents in Christian scripture can be seen in a collection of papyri fragments from a late-sixth-century lectionary in The Metropolitan Museum of Art with a series of passages from the Gospels of Matthew and John (fig. 1a, b). The fragments were found in the Monastery of Epiphanios, a converted Egyptian tomb in western Thebes. There are more than twenty accents, all of them accurately reflecting polytonic practice and serving as a guide in the correct performance of the biblical readings. These accented papyri and other similar examples were in regular use in monasteries and churches, as opposed to complete editions of Christian scripture in Late Antiquity, which were primarily for presentation or were part of distinguished libraries and which were not accented.[44]

During the course of the early Byzantine Empire, the spoken Greek language underwent a transformation from pitch accent to stress accent throughout the Hellenized Eastern Mediterranean region.[45] This was a further consequence of the influence of local languages, which had prompted the invention of the written accent several centuries earlier. The accents were still used to indicate dynamic prominence, and thus, as before the change from pitch to stress, they continued to be used over the same syllables. However, one function of the written accent became obsolete as a result of the loss of pitch accents in speech. The information that the specific type of accent—acute, grave, or circumflex—had once provided regarding the melodic contour of a poetic verse or colon was now irrelevant. Use of the three accents was nevertheless retained, although they served only as an occasional guide in the case of ἀμφιβολία, grammatical or syntactic ambiguity. When minuscule script was introduced and *scriptio continua* disappeared, in the eighth and ninth centuries, the systematic accentuation of every word in all Greek texts, documentary and literary, became standard practice.[46]

The "accent theory" of the origins of modern musical notation[47] posits that ninth- and tenth-century Latin and Byzantine neumes evolved gradually from ancient Greek pitch accents.[48] For this hypothesis to be plausible the accents must have shed their nonmusical functions, including the indication of accent placement and of certain grammatical and syntactic elements, and been transformed into purely musical symbols. This transformation is apparent if we compare the use of pitch accents in lyrical poetry, pedagogical texts, and Christian cantillation, illustrated above, with their use in Christian hymns. Monks and clerics who were familiar with the use of pitch accents in the context of the cantillation of Christian scripture used the written accents in hymn texts as purely musical indications and not according to polytonic practice. They used the accents as aides-mémoire in relation to the known melody of a hymn, or *hirmos*. Byzantine hymns in Late Antiquity were often sung to a *hirmos*, which was a

melody that provided the rhythmic model for the number of syllables per phrase and for the pattern of accented syllables. It was necessary for the number of syllables in a hymn text to correspond with the rhythmic "length" of the *hirmos* melody and for the specific accented syllables to correspond with the accentuated notes of the *hirmos*.[49] The written accents helped the singers remember and adapt the melodies to the hymn texts.[50]

A sixth-century strip of parchment from the Oxyrhynchus excavation, P. Oxy. LXXV 5023 (fig. 2), offers an example of this use of Alexandrian accents. There are three separate texts on the two sides of the parchment: a *chairetismos* or hymn to the Virgin, a cento of Psalm verses, and a prayer of Zacharias. An abbreviation for one of the modes of the *oktoechos*, ἤχ(ος) β (*echos beta*), appears at the top of the hymn text.[51] The *oktoechos* is a musical system of eight modes whose notation served to guide the musical performance of a hymn. The editor of the editio princeps of this parchment wrote in reference to the *chairetismos*: "In [lines] 1–15 the text has been marked up sporadically with accent-like signs, ´ ` ˜. Presumably these belong to a system of musical notation."[52] All the accents on the parchment are over the text of the *chairetismos*, and there are only seven accents over more than sixty words. Five of the accents appear on successive words toward the beginning of the first sentence of the hymn: τού ἀρχαγγελου πρὸς τὴν θεοτόκον (Archangel to the Mother of God).[53] The other accents appear over the first word of the second strophe, ιδόυ (Behold), and on a preposition in the third strophe, πρὸς. None of the accents are the correct pitch accents with respect to the polytonic system.

It is unlikely that the accents functioned solely as stress accents, to change the syllabic accentuation, because of the unusual use of the grave, acute, and circumflex. Furthermore, it would not have been musically appealing to have stress accents on successive monosyllabic words. However, the variation

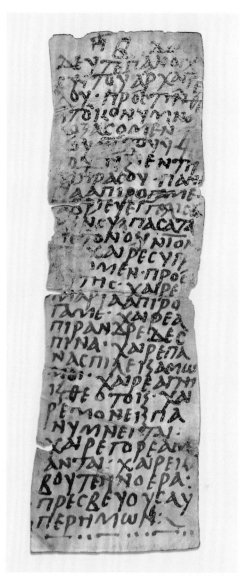

Figure 2. *Chairetismos* to the Virgin, cento of Psalm verses, and prayer of Zacharias (P. Oxy. LXXV 5023). Oxyrhynchus, Egypt, mid- to late 6th century. Parchment. Sackler Library, Bodleian Libraries, University of Oxford

in accent type in the first five accents—two acutes, a grave, a circumflex, and a grave—suggests a natural musical rise and descent in the melody. These accents were possibly a primitive reminder of the particular *hirmos*. With respect to the other two accents: the accent on the first word

Figure 3. Greek Christian liturgical hymn (P.CtYBR inv. 1584), 7th–8th century. Yale Papyrus Collection, Beinecke Rare Book & Manuscript Library, Yale University, New Haven

of the second strophe may have indicated an ascending movement of the melody on the second syllable; the final accent is over the same word as the third accent,

and because the two passages with these prepositions are somewhat parallel—"Arch-angel to the Mother of God [you]" and "We to you [Mother of God]"—the accent on the

*Age of Transition: Byzantine Culture in the Islamic World*

second preposition probably indicates that the parallel melody should begin its descent in the same way as in the first passage.

Another example of this use of accents is the papyrus CtYBR inv. 1584 (fig. 3), which includes a Greek Christian liturgical hymn dated to the seventh or eighth century on side A and a Coptic documentary text on side B.[54] There are three accents over the sixteen extant words in the Greek text. All three are circumflex, and they all appear over the iotas of the words καινόν (l.1, new), αἰώνων (l.2, of the ages), and δοξολουκοῦσιν (l.9, they glorify).[55] In the examples of cantillation of Christian scripture, the accents were meticulously placed in order to preserve the correct pronunciation of the words. By contrast, none of these three accent marks accurately reflect polytonic practice. Rather, they appear over syllables that normally do not receive the stress accents and, in two out of three cases, they are circumflex rather than acute. The accents may have served as a reminder to fit the text with the *hirmos*, or perhaps to add a melisma to these particular sections. But without a more recent, musically notated version of this hymn it would be difficult to ascertain what the specific musical function of the three accents may have been.

The next two examples are hymns dated to the late sixth or early seventh century. Both hymns are on ostraka that were discovered under the same mat in the excavation of the Monastery of Epiphanios. P. Mon. Epiph. 598 (fig. 4) contains a *trisagion* (l.1–7) followed by three *troparia*.[56] All thirteen accents are over the texts of the three *troparia*: four in the first, six in the second, and three in the third; the editor of this text remarked that "these accents were mostly incorrect."[57] P. Mon. Epiph. 600 (fig. 5) contains a single *troparion* that includes a citation from Matthew 1:23 and has six accent marks.[58] The use of grave and circumflex accents on these ostraka does not correspond with accurate polytonic accentuation, and seventeen of the nineteen accents are not placed over the regularly accented syllables. It is likely that

Figure 4. Ostrakon with *trisagion* and *troparia* (P. Mon. Epiph. 598), from the Monastery of Epiphanios. Thebes, Egypt. ca. 580–640. Pottery fragment with ink inscription. Papyri & Ostraka, Rare Book and Manuscript Library, Butler Library, Columbia University (O. Col. inv. 3099)

these accents, similar to those in the earlier examples, served to coordinate the hymn text with the melody of the *hirmos*.

The next example, a small fragment in the Ägyptisches Museum und Papyrussammlung in Berlin, P. Berol. 21319 (fig. 6a, b), dated to the sixth or seventh century, contains four lines of a *troparion* on each side. Two signs and several partial signs appear at the bottom of the verso: a small circle followed by an attached, diagonally ascending line, a symbol resembling a small *v* with a very extended right line, and three partial signs. Above these signs is the Greek word ἄλλος, which indicates that another hymn is to follow, and the abbreviation πλ(άγιος) β', which represents a musical mode of the *oktoechos*: *plagal beta*. These signs probably indicate the melodic pattern of the *hirmos* over the first words of the hymn, similar to the earlier example of the *chairetismos*. The second symbol

Figure 5. Ostrakon with *troparion* (P. Mon. Epiph. 600), from the Monastery of Epiphanios, ca. 580– 640. Pottery fragment with ink inscription. The Metropolitan Museum of Art, Rogers Fund, 1914 (14.1.198)

is similar to one that is also found over the epsilon on line four of the recto, which was identified in two publications as a *petaste*,[59] found in Byzantine musical neumatic notation dating from the tenth to the twelfth century.[60] These signs, which are visually related to acute, grave, and circumflex accents, suggest that various systems of musical notation for Christian hymns existed in more or less advanced states in different areas of Egypt.[61]

Our final example combines the use of accents with other musical signs in an increasingly comprehensive system of musical notation. Inscribed on the recto of this eighth-century papyrus, in the Bibliothèque Nationale et Universitaire in Strasbourg (fig. 7a, b), is part of a hymn by Kosmas of Maiuma that is still sung today in Eastern services.[62] Kosmas was one of four renowned eighth-century Byzantine hymnographers, together with Patriarch Germanos I of Constantinople, John of Damascus, and Andrew of Crete.[63] The papyrus shows seven circumflex accents and two signs that are found in the later system of Byzantine neumes. In this example, the use of circumflex accents, which were called *elaphron* in the context of Byzantine neumes, does not reflect correct polytonic accentuation. Two signs and two accents are found on three successive words on line nine of the recto: a *parakletike*[64] over the omega, a double slash called a *diple*[65] over the first epsilon of κερεῖς (a misspelling of καίροις, Rejoice), and

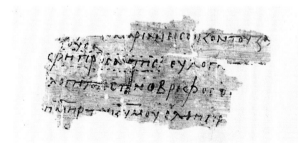
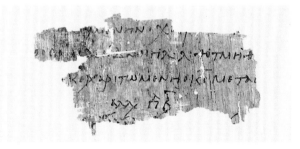

Figure 6a, b. *Troparion* (P. Berol. 21319), 6th–7th century. Papyrus. Ägyptisches Museum und Papyrussammlung, Staatliche Museen zu Berlin (Art Resource, NY)

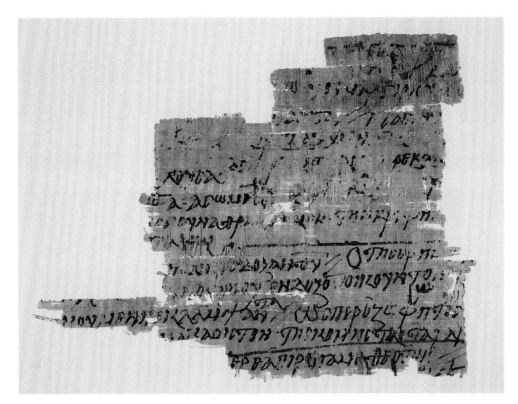

Figure 7a, b. Hymn for the Festival of Hypapante, ode 5 (P. Strasbourg, Gr. 1185), 8th century. Papyrus with ink inscription. Bibliothèque Nationale et Universitaire, Strasbourg

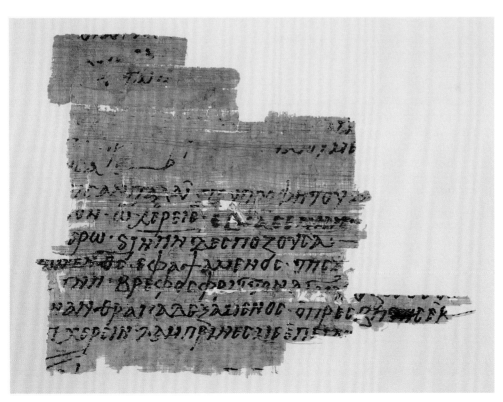

circumflexes over the iota of κερεῖς and over the alpha of εβοᾶ (accented ἐβόα, I cried). This group of signs creates a musically comprehensible melodic phrase, particularly the two signs on a single word that signify the lengthening of the first syllable and the melodic descent of the second. Once again, the Alexandrian accents appear to have been used as purely musical indications.

### Summary and Conclusion

Each of the three Abrahamic religions expressed concerns about the presence of music in their sacred rites, and yet cantillation was accepted by all three as an important component of worship. Christians in Late Antiquity used a system of written Greek accents as the basis for notating the cantillation of Christian scripture. This function of the accents was consistent with their earlier secular use, which was to transmit the correct oral polytonic accentuation of classical Greek. Further signs were added to the three pitch accents to provide greater musical precision for the cantillation. Evidence indicates that within the context of cantillation, pitch accents were used in accordance with the standard polytonic practice of accentuating classical Greek.

On the other hand, the function of the pitch accent changed when used in the context of Christian hymns. A group of papyri with Alexandrian accents that were seen never to follow polytonic practice was used to illustrate this transformation. In two cases some accents are grouped together and appear to represent a model melody, or *hirmos*. In three other cases the accents are spread farther out in the hymn texts, as if to help them fit with a *hirmos*. Other examples of this unusual use of Alexandrian accents exist within the context of Christian hymns. These papyri support the plausibility of the Greek accent theory of the ultimate origins of musical notation. It is to be hoped that further research and evidence will lead to a more conclusive understanding of the bridges between the notation of ancient Greek prosody, Late Antique and medieval cantillation, and liturgical song. This research may also lead to a resolution of the questions of the origin of Hebrew *te'amim* and of Latin neumes.

1. Levy 1987: 62–64.
2. For background and bibliography of the term "cantillation," see Idelsohn 1948; Corbin 1961; Ibsen al Faruqi 1987; and Shiloah 1992.
3. Moses Maimonides, Mishneh Torah, Hilchot Ta'anit 5:14.
4. Talmud, Meg. 32a.
5. Randhofer 2004.
6. Three different systems of te'amim were used before the Tiberian system became predominant in the seventh to the tenth century: a Babylonian system, which used letters of the alphabet and is similar to the ancient Greek Alypian musical notation; a Palestinian system, which used points similar to Syriac diacritic marks; and the Tiberian system, which has various signs, some of which may have been based on chironomic signs or on ancient Greek accents; see Díez Merino 1975 and Shiloah 1992: 100.
7. The Seforim Online Project, www.seforimonline .org/seforimdb/pdf/266.pdf. The Cairo Codex is dated to 895 C.E. according to the colophon; see Kahle 1959: 91; Würthwein 1973; and Lyons 1999: 4–7.
8. The Aleppo Codex Online homepage, Ben-Zvi Institute, Jerusalem, http://aleppocodex.org; see also Friedman 2012.
9. Levi 1964.
10. Idelsohn 1948: 69; Herzog 1971; Yeivin 1980: 33.
11. Four important manuscripts are those of Reuchlin (1518) in the Ashkenaz tradition; Kircher (1650) in the Egyptian Sephardic tradition; Bartolocci (1675) in the Spanish tradition; and Jablonski and Pinna (1699) in the Portuguese tradition.
12. See Christ and Paranikas 1871: 19; Høeg 1935: 143; and Engberg 1966.
13. See Reed n.d. (forthcoming) and Yuval 2006.
14. See Wellesz 1961 and Holleman 1972.
15. "The guiding principle in setting the ekphonetic signs was the following: each sentence, or part of a sentence, each word or part of a word to be 'cantillated' in a certain manner, was encompassed in the beginning and at the end by a sign" (Wellesz 1961: 252); see also Høeg 1935 and Engberg 1980: 99.
16. Fleischer 1895; Thibaut 1913; Hannick 1979; Engberg 1995.
17. Saint Augustine, Confessions 238–39.
18. Plato, Republic 3.398–403.
19. Harmon 2003: 21 (Republic).
20. Qur'an, Sura 53:57–62.
21. Mishkat al-masabih 2.425, and Ibn Masud, Al Ghazali, 248; as translated in Farmer 1929: 24.
22. Ibsen al Faruqi 1987: 14.
23. Farmer 1929: 8. Al-Farabi recounts that a renowned late-sixth-century Arab poet was refused a hearing by the king until he had set his verses to music; Al-Farabi, Leyden MS. Or. 651, fol. 7.
24. Nelson 1985: 174.
25. Robin 2004.
26. Donner 2010.
27. Khalek 2011: 15.
28. Ibsen al Faruqi 1987: 7.
29. Ibsen al Faruqi 1978: 54.
30. Ibsen al Faruqi 1979: 108–13.
31. Charles Atkinson (2008: 44) explains the origin of the word "accent" as deriving from the Latin ad cantus and its parallel in Greek, pros ode, which brought "prosody."
32. Allen 1987: 108.
33. Roberts 1910: 127.
34. Allen 1987: 114.
35. Ibid.
36. Wellesz 1961: 250.
37. Important literature on the Greek accents includes Reil 1910: 495–529; Laum (1928) 1968; Moore-Blunt 1978; Mazzucchi 1979; Allen 1987; Devine and Stephens 1994; and Probert 2006.
38. P. Lond. 733 (Brit. Libr. inv. 733 = P. Lit.Lond. 46) and PSI 12.1278.
39. For the editio princeps, see Kenyon 1897; see also Jebb 1994: 121, 135–36.
40. P. Berol. inv. 11636; Raffaelli 1990; Cribiore 1996: 257–58.
41. Cribiore, Davoli, and Ratzan 2008.
42. S. Porter and W. Porter 2008.
43. W. Porter 2007: 582.
44. None of the four earliest manuscripts of the Greek Bible have accentuation that was written by the first hand. The Codex Sinaiticus (4th century) has no accents at all. The complete accentuation in the Codex Vaticanus (4th century) was added by a later hand. The Codex Alexandrinus (5th century) has no accentuation in the first or third hands and only single or double dots indicating diaeresis in the second hand. And the Codex Ephraem (5th century) has accentuation added to the second layer of writing, which is minuscule Byzantine.
45. Allen 1987: 119, 134; Devine and Stephens 1994: 215: "The development of stress accentuation in Greek was part of a more general process of restructuring the entire prosodic system which also involved the loss of distinctions of vowel quantity and syllable weight. This process began in less educated sociolinguistic strata, perhaps as early as the fourth century B.C. in vulgar Attic. It was probably promoted by bilingual interference from languages lacking quantity distinctions and having stress accentuation, for instance by Coptic in Egypt."
46. Nagy 2000: 14–21; Carlo Mazzucchi (1979: 167) suggests that the systematic and wide use of accents in the ninth century was a result of the work of the famous grammarian Giorgio Cherabosco.
47. Kenneth Levy (1987: 62) describes the accent theory for Latin neumes as the three Alexandrian

accents "with the addition of some nuance signs like the quilisma, oriscus and liquescences" and for Byzantine–Greek notation as a variant of the accent theory because "the Byzantine *oxeia* and *bareia* reproduce the Alexandrian acute and grave accents" (ibid.); for other arguments, see Coussemaker 1852; Müller 1892: 307; Thibaut 1899; Gastoué 1907: 4–12; Høeg 1935: 137–38; Revell 1979; Atkinson 1995: 42; Papathanasiou and Boukas 2004: 12; and Atkinson 2008: 111.

48. The term *neume* comes from the Greek word for breath, πνεῦμα. Neumes are symbols of musical notation that indicate the general shape of a musical inflection. On Latin neumes, see Corbin 1977; on Byzantine neumes, Wellesz 1952.

49. Wellesz 1961: 181.

50. Ibid.: 262.

51. See Gampel 2012, appendix.

52. Römer 2010: 12.

53. The accurate spelling and accentuation are: τῷ ἀρχαγγέλῳ πρὸς τὴν θεοτόκον.

54. Gampel and Grassien 2012.

55. The change in the spelling of the last word, from δοξολουκοῦσιν to δοξολογοῦσιν, reflects changes in the sound of some consonants (e.g., "g" to "k") and vowels (e.g., "o" to "ou") in various regions. These changes do not, however, suggest that there were changes in the accented syllables.

56. A *trisagion* is a short, sung invocation for which a single well-known melody may have been used. A *troparion* is a short hymn. See Levy 1974 and Stefanovic 2001.

57. White 1926: 316.

58. For the editio princeps, see ibid., no. 600.

59. Ibid., and Alexandru 2006: 117–19.

60. See Tillyard 1916: 65; Tillyard 1935; Wellesz 1952: 77; and Wellesz 1961: 286.

61. Leuven Database of Ancient Books (LDAB) 6410; for the editio princeps, see Sarischouli 1995: 48–55.

62. LDAB 8896; for the editio princeps, see Husson 2001.

63. Harris 2004: 176.

64. According to Wellesz (1961: 253): "indicates a phrase executed in an entreating, praying manner."

65. According to Wellesz (ibid.: 283): "a sign to indicate doubling the duration of the note."

## REFERENCES

**Alexandru, Maria**
**2006** "The Paleography of Byzantine Music: A Brief Introduction with Some Preliminary Remarks on Musical Palimpsests." In *El palimpsesto grecolatino como fenómeno librario y textual*, edited by Ángel Escobar Chico: 113–30. Saragossa: Institución "Fernando el Católico."

**Allen, W. Sidney**
**1987** *Vox Graeca: A Guide to the Pronunciation of Classical Greek*. 3rd ed. Cambridge: Cambridge University Press.

**Atkinson, Charles M.**
**1995** "De Accentibus Toni Oritur Nota Quae Dicitur Neuma: Prosodic Accents, the Accent Theory and the Paleofrankish Script." In *Essays on Medieval Music in Honor of David G. Hughes*, edited by Graeme M. Boone: 17–42. Cambridge, Mass.: Harvard University Press.

**2008** *The Critical Nexus, Tone-System, Mode and Notation in Early Medieval Music*. AMS Studies in Music. Oxford: Oxford University Press.

**Bartolocci, Giulio**
**1675** *Bibliotheca Magna Rabbinica de Scriptoribus et Scriptis Hebraicis Ordine Alphabetico*. 4 vols. Rome: Ex Typographia Sacrae Congreg. de Propag. Fide.

**British Museum**
**1897** *The Poems of Bacchylides: Facsimile of Papyrus DCCXXXIII in the British Museum*. London: Trustees of the British Museum. See Kenyon 1897 for the commentary.

**Christ, W[ilhelm von], and M[atthaios] Paranikas**
**1871** *Anthologia Graeca Carminum Christianorum*. Leipzig: B. G. Teubner.

**Corbin, Solange**
**1961** "La Cantillation des rituels chrétiens." *Revue de musicologie* 47, no. 123 (July): 3–36.

**1977** *Die Neumen*. Vol. 1, fasc. 3 of *Palaeographie der Musik*. Cologne: Volk.

**Coussemaker, E[dmond] de**
**1852** *Histoire de l'harmonie au Moyen Age*. Paris: Librairie Archéologique de Victor Didron.

**Cribiore, Raffaella**
**1996** *Writing, Teachers and Students in Graeco-Roman Egypt*. American Studies in Papyrology 36. Atlanta: Scholars Press. Originally the author's Ph.D. diss., Columbia University, New York, 1993.

**Cribiore, Raffaella, Paola Davoli, and David M. Ratzan**
**2008** "A Teacher's Dipinto from Trimithis (Dakhleh Oasis)." *Journal of Roman Archaeology* 21, no. 1: 170–91.

**Devine, A. M., and Laurence D. Stephens**
**1994**   *The Prosody of Greek Speech.* Oxford: Oxford University Press.

**Díez Merino, Luis**
**1975**   *La biblia babilónica.* Madrid: n.p.

**Donner, Fred M.**
**2010**   *Muhammad and the Believers: At the Origins of Islam.* Cambridge, Mass.: Harvard University Press.

**Engberg, Gudrun**
**1966**   "Greek Ekphonetic Neumes and Masoretic Accents." In *Studies in Eastern Chant*, vol. 1, edited by Milos Velimirovic: 37–49. London: Oxford University Press.

**1980**   "Ekphonetic Notation." In *The New Grove Dictionary of Music and Musicians*, edited by Stanley Sadie, vol. 6: 99–103. Washington, D.C.: Grove's Dictionaries of Music.

**1995**   "Greek Ekphonetic Notation." In *Palaeobyzantine Notations. Vol. 1, A Reconsideration of the Source Material: Acta of the Congress Held at Hernen Castle (The Netherlands) in November 1992*, edited by Jørgen Raasted and Christian Troelsgard: 33–55. Hernen: A. A. Bredius Foundation.

**Farmer, Henry George**
**1929**   *History of Arabian Music to the XIIIth Century.* London: Luzac.

**Fleischer, Oskar**
**1895**   *Neumen-Studien: Abhandlungen über mittelalterliche Gesangs-Tonschriften. Vol. 1, Über Ursprung und Entzifferung der Neumen.* Leipzig: Verlag von Friedrich Fleischer.

**Friedman, Matti**
**2012**   *The Aleppo Codex: A True Story of Obsession, Faith, and the Pursuit of an Ancient Bible.* Chapel Hill, N.C.: Algonquin Books.

**Gampel, Alan**
**2012**   "Papyrological Evidence of Musical Notation from the 5th to the 8th Centuries." *Musica Disciplina: A Yearbook of the History of Music*, 2012: appendix.

**Gampel, Alan, and Céline Grassien**
**2012**   "A Greek Christian Liturgical Hymn." *Bulletin of the American Society of Papyrologists* 49: 31–40.

**Gastoué, Amédée**
**1907**   *Les Origines du chant romain: L'Antiphonaire grégorien.* Paris: A. Picard & Fils.

**Hannick, Christian**
**1979**   "Les Lectionnaires grecs de l'apostolos avec notation ekphonetique." In *Studies in Eastern Chant*, vol. 4, edited by Milos Velimirovic: 76–80. Crestwood, N.Y.: St. Vladimir's Seminary Press.

**Harmon, William, ed.**
**2003**   *Classic Writings on Poetry.* New York: Columbia University Press.

**Harris, Simon**
**2004**   "The 'Kanon' and the Heirmologion." *Music & Letters* 85, no. 2 (May): 175–97.

**Herzog, Avigdor**
**1971**   "Masoretic Accents (Musical Rendition)." In *Encyclopaedia Judaica*, vol. 11, cols. 1098–1111. Jerusalem: Encyclopaedia Judaica; New York: Macmillan.

**Høeg, Carsten**
**1935**   *La Notation ekphonétique.* Monumenta Musicæ Byzantinæ 1, fasc. 2. Copenhagen: Levin & Munksgaard.

**Holleman, A. W. J.**
**1972**   "The Oxyrhynchus Papyrus 1786 and the Relationship between Ancient Greek and Early Christian Music." *Vigiliae Christianae* 26: 1–17.

**Husson, Geneviève**
**2001**   "P. Strasb. Inv. 1185: Hymne pour la fête de l'Hypapantè (2 février)." In *Atti del XXII Congresso Internazionale di Papirologia, Firenze, 23–29 agosto 1998, Instituto Papyrologico "G. Vitelli,"* edited by Isabella Andorlini, vol. 2: 681–87. Florence: Instituto Papirologico G. Vitelli.

**Ibsen al Faruqi, Lois**
**1978**   "Accentuation in Qur'ānic Chant: A Study in Musical *Tawāzun*." *Yearbook of the International Folk Music Council* 10: 53–68.

**1979**   "Tartil al-Qur'an al-Karim," by Lamya al-Faruqi. In *Islamic Perspectives: Studies in Honour of Mawlana Sayyid Abul A'la Mawdudi*, edited by Khurshid Ahmad and Zafar Ishaq Ansari: 105–19. Leicester: The Islamic Foundation.

**1987**   "The Cantillation of the Qur'ān." *Asian Music* 19, no. 1: 1–25.

**Idelsohn, Abraham Zvi**
**1948**   *Jewish Music in Its Historical Development.* New York: Tudor Publishing Company.

**Jablonski, Daniel Ernst, and David Pinna**
**1699**   *Biblia Hebraica cum Notis Hebraicis et Lemmatibus Latinis.* Berlin: H. H. Knebelii.

**Jebb, Richard C., ed. and trans.**
**1994**   *Bacchylides: The Poems and Fragments.* Reprint of 1905 ed. Hildesheim: Georg Olms.

**Kahle, Paul**
**1959**   *The Cairo Geniza.* 2nd ed. Oxford: Blackwell.

**Kenyon, Frederic G., ed.**
**1897**   *The Poems of Bacchylides: From a Papyrus in the British Museum.* London: Trustees of the British Museum. See British Museum 1897 for the facsimile.

Khalek, Nancy
2011   *Damascus after the Muslim Conquest: Text and Image in Early Islam*. Oxford: Oxford University Press.

Kircher, Athanasius
1650   *Musurgia Universalis sive Ars Magna Consoni et Dissoni*. 2 vols. Rome: Corbelletti; Grignani.

Laum, Bernhard
1968   *Das alexandrinische Akzentuationssystem unter Zugrundelegung der theoretischen Lehren der Grammatiker und mit Heranziehung der praktischen Verwendung in den Papyri*. Studien zur Geschichte und Kultur des Altertums 4. Reprint. New York: Johnson Reprint. Originally published Paderborn: F. Schöningh, 1928.

Levi, Leo
1964   "Traditions of Biblical Cantillation and Ekphonetics." *Journal of the International Folk Music Council* 16: 64–65.

Levy, Kenneth
1974   "The Trisagion in Byzantium and the West." In International Musicological Society, *Report of the Eleventh Congress, Copenhagen, 1972*, edited by Henrik Glahn, Søren Sørensen, and Peter Ryom: 761–65. Copenhagen: W. Hansen.

1987   "On the Origin of Neumes." *Early Music History* 7: 59–90.

Lyons, David
1999   *The Cumulative Masora: Text, Form and Transmission* [in Hebrew]. Beer-Sheva: Universitat Ben-Gurion ba-Negev.

Mazzucchi, Carlo Maria
1979   "Sul sistema di accentazione dei testi greci in età romana e bizantina." *Aegyptus* 59: 145–67.

Moore-Blunt, Jennifer
1978   "Problems of Accentuation in Greek Papryi." *Quaderni urbinati di cultura classica*, no. 29: 137–63.

Müller, Iwan von, ed.
1892   *Handbuch der klassischen Altertums-Wissenschaft in systematischer Darstellung*. Vol. 1, *Einleitende und Hilfs-Disziplinen*. Munich: Beck.

Nagy, Gregory
2000   "Reading Greek Poetry Aloud: Evidence from the Bacchylides Papryi." *Quaderni urbinati di cultura classica*, n.s., 64, no. 1: 7–28.

Nelson, Kristina
1985   *The Art of Reciting the Qu'ran*. Austin: University of Texas Press.

Papathanasiou, Ioannis, and Nikolaos Boukas
2004   "Early Diastematic Notation in Greek Christian Hymnographic Texts of Coptic Origin: A Reconsideration of the Source Material." In

*Palaeobyzantine Notations III: Acta of the Congress Held at Hernen Castle, The Netherlands, in March 2001*, edited by Gerda Wolfram: 1–26. Eastern Christian Studies 4. Leuven: Uitgeverij Peeters.

Porter, Stanley E., and Wendy J. Porter
2008   *New Testament Greek Papyri and Parchments: New Editions*. 2 vols. Mitteilungen aus der Papyrussammlung der Österreichischen Nationalbibliothek, n.s., 29–30. Berlin: Walter de Gruyter.

Porter, Wendy J.
2007   "The Use of Ekphonetic Notation in Vienna New Testament Manuscripts." In *Akten des 23. Internationalen Papyrologenkongresses, Wien, 22.–28. Juli 2001*, edited by Bernhard Palme: 581–85. Vienna: Verlag der Österreichischen Akademie der Wissenschaften.

Probert, Philomen
2006   *Ancient Greek Accentuation: Synchronic Patterns, Frequency Effects, and Prehistory*. Oxford: Oxford University Press.

Raffaelli, Lucia M.
1990   "P. Berol. 11636: Omero E 265–317 + Scholia minora a E 265–286." *Archiv für Papyrusforschung und verwandte Gebiete* 36: 5–12.

Randhofer, Regina
2004   "By the Rivers of Babylon: Echoes of the Babylonian Past in the Musical Heritage of the Iraqi Jewish Diaspora." *Ethnomusicology Forum* 13, no. 1: 21–45.

Reed, Annette Yoshiko
n.d.   "'Jewish-Christian' Apocrypha and the History of Jewish/Christian Relations." In *Christian Apocryphal Texts for the New Millennium: Achievements, Prospects, and Challenges*, edited by P. Piovanelli. Forthcoming. Preprint available on Academia.edu.

Reil, Moritz
1910   "Zur Akzentuation griechischer Handschriften." *Byzantinische Zeitschrift* 19: 476–529.

Reuchlin, Johannes
1518   *De Accentibus, et Orthographia, Linguae Hebraicae*. Haguenau, France.

Revell, E. J.
1979   "Hebrew Accents and Greek Ekphonetic Neumes." *Studies in Eastern Chant* 4: 140–70.

Roberts, W. Rhys, trans. and ed.
1910   *Dionysius of Halicarnassus, On Literary Composition: Being the Greek Text of the De compositione verborum*. London: Macmillan.

Robin, Christian
2004   "Himyar et Israël." *Comptes-rendus des séances de l'Académie des Inscriptions et Belles-Lettres* 148, no. 2: 831–908.

**Römer, Cornelia Eva, ed.**

**2010**   "P. Oxy. no. 5023." In *The Oxyrhynchus Papyri*, vol. 75, edited by Herwig Maehler, Cornelia Eva Römer, and R. Hatzilambrou: 9–14. London: Egypt Exploration Society.

**Sarischouli, Panagiota**

**1995**   *Berliner griechische Papyri: Christliche literarische Texte und Urkunden aus dem 3. bis 8. Jh. n. Chr.* Wiesbaden: L. Reichert Verlag.

**Shiloah, Amnon**

**1992**   *Jewish Musical Traditions.* Detroit: Wayne State University Press.

**Stefanovic, Dimitrije**

**2001**   "The Trisagion in Some Byzantine and Slavonic Stichera." In *The Study of Medieval Chant, Paths and Bridges, East and West,* edited by Peter Jeffery: 303–12. Woodbridge, Suffolk: Boydell & Brewer.

**Thibaut, Jean-Baptiste**

**1899**   "Etude de musique byzantine: Le Chant ekphonétique." *Byzantinische Zeitschrift* 8: 122–47.

**1913**   *Monuments de la notation ekphonétique et hagiopolite de l'église grecque.* St. Petersburg: n.p.

**Tillyard, H. J. W.**

**1916**   "The Problem of Byzantine Neumes." *American Journal of Archaeology* 20: 62–71.

**1935**   *Handbook of the Middle Byzantine Musical Notation.* Copenhagen: Levin & Munksgaard.

**Wellesz, Egon**

**1952**   "Early Byzantine Neumes." *Musical Quarterly* 38: 68–79.

**1961**   *History of Byzantine Music and Hymnography.* 2nd ed. Oxford: Clarendon Press.

**White, H. G. Evelyn**

**1926**   *The Monastery of Epiphanius at Thebes.* Part 2, *Greek Ostraca and Papyri.* The Metropolitan Museum of Art, Egyptian Expedition 2. New York: The Metropolitan Museum of Art.

**Würthwein, Ernst**

**1973**   *Der Text des Alten Testaments: Eine Einführung in die Biblia Hebraica.* 4th ed. Stuttgart: Württembergische Bibelanstalt.

**Yeivin, Israel**

**1980**   *Introduction to the Tiberian Masorah.* Translated by E. J. Revell. Missoula, Mont.: Scholars Press.

**Yuval, Israel Jacob**

**2006**   *Two Nations in Your Womb: Perceptions of Jews and Christians in Late Antiquity and the Middle Ages.* Berkeley: University of California Press.